Reader's Digest

COMPLETE
LANDSCAPE
COURSE

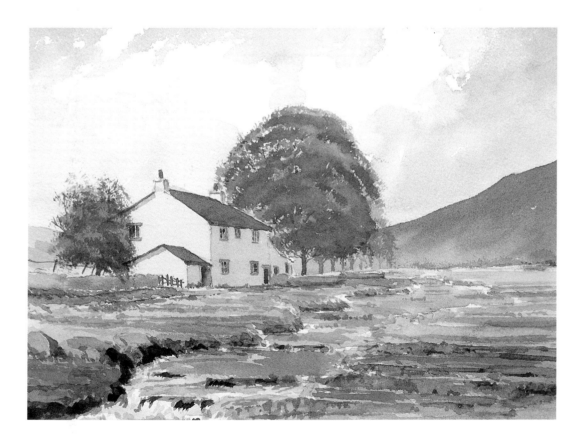

A READER'S DIGEST BOOK

Published by The Reader's Digest Association Limited
11 Westferry Circus
Canary Wharf
London
E14 4HE

www.readersdigest.co.uk

We are committed to both the quality of our products and the services we provide to our customers. We value your comments, so please feel free to contact us on 08705 113366, or via our website at www.readersdigest.co.uk If you have any comments about the content of our books, you can contact us at gbeditorial@readersdigest.co.uk

Copyright © 2003 De Agostini UK Ltd

ISBN: 0-276-42805-6

A CIP data record for this book is available from the British Library

This book was designed and edited by De Agostini Uk Ltd based on the partwork *Step-by-Step Art Course*

Produced by Amber Books Ltd
Bradley's Close
74–77 White Lion Street
London N1 9PF
www.amberbooks.co.uk

Printed in Singapore

Contributing Artists

Nick Ashton: 20–23, 24(tl,tr,br), 25, 32–34, 35(tl,bl,br), 36, 37; James Bartholomew: 106–110, 111(tl,tr), 112, 113, 174–177, 178(tl,tr), 179–181, 218–221, 222(tl,tr), 223–225; Paul Cousins: 140–143, 144(tl,tr), 145–150, 151(tl,tr), 152, 153, 182–186, 187(tl,tr), 188, 189; Derek Daniells: 190–193, 194(tr,br), 195–197; Abi Edgar: 205–209, 210(tl,tr), 211, 250–254, 255(tl,tr), 256; Michael Grimsdale: 26–28, 29(tr,cr,br), 30, 31, 86–88, 89(tl,bl,br), 90, 91; Frank Halliday: 92, 93, 94(tl,tr,cl,cr), 95–97; Lavinia Hamer: 68–71, 72(tl,tr,br), 73, 116–118, 119(tl,tr), 120, 121; Ian McCaughrean: 100, 101, 102(tl,tr), 103–105, 244, 245, 246(tl,tr), 247–249; William Newton: 198, 199, 200(tl,tr), 201–204; John Palmer: 226, 227, 228(tl,tr), 229–231; Melvyn Petterson: 56–61, 62(tl,tr), 63–65, 128, 129, 130(tl,tr), 131–133; Tom Rob: 9, 10, 154–157 158(tl,tr), 159–161, 168–170, 171(tl,tr) 172, 173, 232–235, 236(tl,tr), 237; Michael Sanders: 162–165, 166(tl,tr), 167, 212–216, 217(b); Ian Sidaway: 12, 46, 47, 54, 55, 66, 67, 80–82, 83(tl,bl,br), 84, 85, 98, 99, 114, 115, 122–124, 125(tl,tr), 126, 127; Adrian Smith: 6, 7; Hazel Soan: 14–16, 17(tl,tr), 18, 19, 74, 75, 76(tl,tr,br), 77–79; Frances Treanor: 238, 239, 240(tl,tr), 241–243; Albany Wiseman: 38–42, 48, 49, 50(tl,tr), 51–53.

Picture Credits

Bridgeman Art Library: ©ADAGP, Paris and DACS, London 2003 17 (b), © Courtesy of the Artist's Estate 111(b), 138(t), © Permission trustees of Winifred Nicholson 178 – Agnews & Sons, London, UK 8, 158(b), © Courtesy of John Wonnacott 210 – Ashmolean Museum, Oxford, UK 217(t) – Blackburn Museum and Art Gallery, Lancashire 222(b) – Barber Institute of Fine Arts, University of Birmingham 240(b) – Bury Art Gallery and Museum, Lancashire 138(b) – Bonhams, London © Tate, London 2003 89(cr) © By kind permission of the Trustees of the Estate of Edward Seago, courtesy of Thomas Gibson Fine Art Limited 139 © – Chris Beetles, London 194(l) – Christie's Images, London, UK 255(b) – Fitzwilliam Museum, University of Cambridge, UK 45, 228(b) – The Fleming-Wyfold Art Foundation © Courtesy of the Artist's Estate 236(b) – Haags Gemeentemuseum, Netherlands 187 – Hamburg Kunsthalle, Hamburg, Germany 43, 50(b) – Johnny van Haeften Gallery, London 72(bl) – Louvre, Paris, France 11, 200(b) – Musee d'Art et d'Histoire, Palais Massena, Nice 125(b) – Musee d'Orsay, Paris 35(tr), – Musee d'Orsay, Paris/Giraudon 151(b) – Musee d'Orsay, Paris/Lauros/Giraudon 83(tr) – Musee Fabre, Montpellier, France 13 – National Gallery, London 76(bl) – National Museum of American Art, Smithsonian Institute, USA, Lent by U.S. Dept of the Interior, National Park Service 246(b) – Noortman, Maastricht, Netherlands 137 – Osterreichische Gallerie, Vienna, Austria 102(b) – Penlee House Gallery and Museum, Penzance, Cornwall, UK © Courtesy of the Artist's Estate 44 – Phillips, The International Fine Art Auctioneers, UK © Jonathan Clark Fine Art 62(b) – Skagens museum, Denmark 130(b) – Spink and Son Ltd © By kind permission of the Trustees of the Estate of Edward Seago, courtesy of Thomas Gibson Fine Art Limited 136 – Tretyakov Gallery, Moscow 171(b) – Victoria and Albert Museum, London UK 94(bl) – Yale Centre for British Art, Paul Mellon Collection 144; De Agostini: – George Taylor 6–10, 12, 14–42, 46, 47, 54, 55–133, 140–204, 212–249 – Shona Wood 48–53, 205–211, 250–256; IGDA: – A. Dagli Orti 119(b) – G. Dagli Orti 24(bl) – Tate 29; National Gallery London: 134, 166(b); University of Michigan Museum of Art: © Nolde-Stifftung Seebull 135.

While the Publishers have made every effort to contact the copyright holders they would be pleased to hear from any they have failed to locate.

Reader's Digest

COMPLETE
LANDSCAPE
COURSE

*projects, practical
lessons, expert hints and tips*

CONTENTS

SKETCHING LANDSCAPES 6

CREATING THE ILLUSION OF DEPTH 8

BROADENING YOUR HORIZONS 11

LANDSCAPE WITH CLOUDS 14

LOCAL PARK SCENE IN OIL PASTELS 20

SANDBANKS AT LOW TIDE 26

COUNTRY LANE IN OILS 32

CAPTURING REFLECTIONS 38

PAINTING THE WEATHER 43

SEASONAL PALETTE – SPRING 46

BLUEBELL WOODS 48

PAINTING TREES 54

THE BIG PICTURE 56

SEASONAL PALETTE – SUMMER 66

LANDSCAPE WITH HILLS 68

SEASCAPE WITH CLOUDS 68

CREATING FOLIAGE IN WATERCOLOURS 80

BEACH HUTS 86

LANDSCAPE WITH TREES 92

SEASONAL PALETTE – AUTUMN 98

A WALK IN AUTUMN WOODS 100

AFTER THE HARVEST 106

SEASONAL PALETTE – WINTER 114

SNOWSCENE IN WATERCOLOUR 116

IMPRESSIONIST LANDSCAPE 122

A BEACH IN WINTER 128

COMPOSING SKIES 134

DEPTH IN SKIES 137

ATMOSPHERIC SKYSCAPE 140

SKYSCAPE WITH DRIFTING STEAM 146

STORMY SKYSCAPE 154

PAINTING A SUNSET IN OILS 162

THE DRAMA OF THE SKY 168

BIRDS IN FLIGHT 174

INTO THE GARDEN 182

COUNTRY GARDEN 190

TREE-LINED ROAD 198

SEASIDE STUDIES 205

ACRYLIC SEASCAPE 212

CRASHING SURF 218

ROMAN BRIDGE AT CORDOBA 226

LEAVING THE SUBJECT BEHIND 232

RURAL VIEW IN PASTEL 238

AMERICAN LANDSCAPE 244

PICTURE POSTCARDS 250

Sketching landscapes

Simplicity is the key to sketching outdoors. This allows you to work quickly, capture fleeting light effects and end up with the essence of the scene.

The landscape artist frequently has to contend with changing light. This means working quickly to record as much information as possible before the scene alters completely. In addition, materials and equipment must be portable – often a handful of watercolours and a small sketchbook.

Working on a small scale does not necessarily mean painting with a small brush or recording minute detail. On the contrary, the changing landscape allows no time to depict every branch on the tree, or every cloud in the sky.

The minimum of brush strokes
The best approach to landscape sketching is to use as large a brush as is practical, and to simplify what is in front of you. A sweeping expanse of grass or water can often be described in one or two strokes of colour; a tree or bush may be painted with a single brush mark.

The watercolour sketches here appear effortless because they contain very little detail. However, this impression is misleading. It is often more difficult to describe a scene in half a dozen strokes than it is to include every detail. You will need a little practice to gain the necessary skill and confidence.

Wet and wild
Working wet-on-wet, for instance, is a vital skill – it lets you work quickly (before the paper dries) and is ideal for capturing mist, clouds and reflections. However, to control the runs of colour, you must be able to judge the dampness of the paper.

If you have problems eliminating details, look at your subject through half-closed eyes. This excludes much of the detail and some of the local colour from your vision. You see only the main shapes and tones which, in turn, helps you to simplify the composition. Try to be selective – include only those elements in the subject that you either like or are essential to the painting. Is it the tones or colours that attract you? Make up your mind firmly and execute your ideas quickly.

Simplification need not be limited to sketches. Once you have mastered economic brushwork and minimal colour, there is no reason why these techniques should not be used in finished paintings. Many artists prefer to take this broad approach in all their work.

Scaling up
As a first step, try working on a large sheet of paper. You will then need to scale up the size of your brushes and strokes in proportion to the support. For example, use 50–75mm (2–3in) brushes on a sheet of A1 paper. These will seem ludicrously large compared with your usual brushes. But, for simple, suggestive marks and a 'no detail' approach, they are perfect.

▼ **Working wet-on-wet can create visually stunning sketches. Here the technique was used for the mist over the mountaintops and the beautiful silvery surface of the water.**

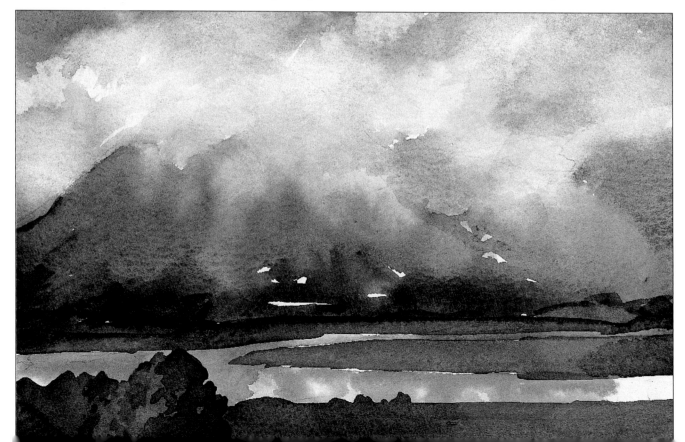

CAPTURING THE MOMENT

CHASING THE SUN

This sunset was as transient as it was beautiful. The artist had to work quickly to capture it, as the colours and the tonal relationship between the sky and the landscape were rapidly changing. The hills are rendered in Payne's grey and ultramarine; the sky is cerulean with cadmium orange and vermilion bleeding into it to capture the colour of the sun.

 Palette: Cerulean, cadmium orange, vermilion, ultramarine, Payne's grey

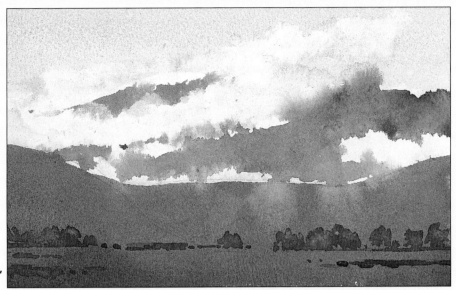

A 'SNAPSHOT' SKETCH

Again, the light was changing rapidly in this scene. The clouds were scudding across the sky creating ever-changing shadows and patches of pale sunlight. As a result, the artist mixed up the washes of green, yellow and grey before starting to paint. The artist describes the resulting sketch as a watercolour 'snapshot', a moment frozen in time.

 Palette: Payne's grey, ultramarine, raw sienna, indigo, burnt sienna

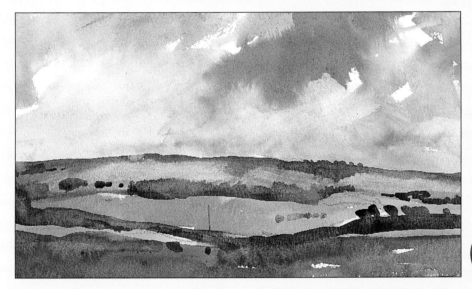

SPONTANEOUS CLOUDS

On this damp day at the seaside, the paint took forever to dry. However, the artist used this to his advantage. Working wet-on-wet, the colours of the sky and horizon immediately ran together to create the hazy effect of low clouds hanging over water. The rest of the sketch is painted wet-on-dry, with flecks of white paper left untouched to represent highlights.

 Palette: Cerulean, Payne's grey, ultramarine, raw sienna, indigo

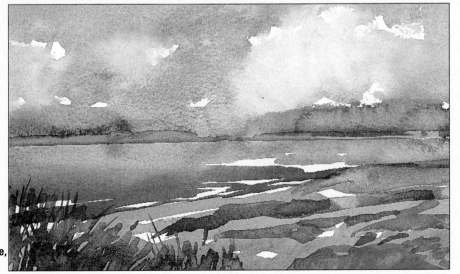

Creating the illusion of depth

Discover how to give your landscapes a real sense of depth simply by modifying the tones, colours and brush strokes you use in the background.

Ever since the Renaissance, Western painters have tried to represent three-dimensional space on a two-dimensional surface. Today, more than 500 years later, contemporary artists are still very much concerned with the same problem.

Linear perspective depends on an understanding of structure. The artist is guided by the knowledge that parallel lines on the same plane always meet at the same place – the vanishing point. If the perspective is wrong, the whole painting might look odd.

Rural landscapes

However, it can be a mistake to become too anxious about linear perspective. So long as you understand the basic principles, success will come with time and practice. In any case, when painting many subjects – such as rural landscapes – converging parallel lines might not be relevant.

Our perception of space and distance can be depicted in a number of other ways, including the use of tone and colour. This is particularly the case with landscape subjects.

INVITING THE EYE INTO THE PICTURE

Claude Lorraine (1600–82) was a master of creating the illusion of distance and enticing the eye into the painting, as shown here in his *Pastoral Landscape* (*c*.1640). Note how the warm brown-greens of the foreground turn into cool blue-greens in the distance. The actual (or local) colour of the background grass may be exactly the same as the foreground grass – but seen through the dust and damp of the atmosphere, it takes on a bluish tinge. Indicated below are other devices used to create a convincing impression of depth.

The sky is deeper in tone at the top of the image than it is in the distance – creating a sense of recession.

The foreground figure stands out clearly with his warm red skin tones and deep blue clothing.

The contrast of tones in the foreground is very bold – the dark animals are almost black, the pale ones are nearly white.

Details in the foreground are sharply defined and well-modelled.

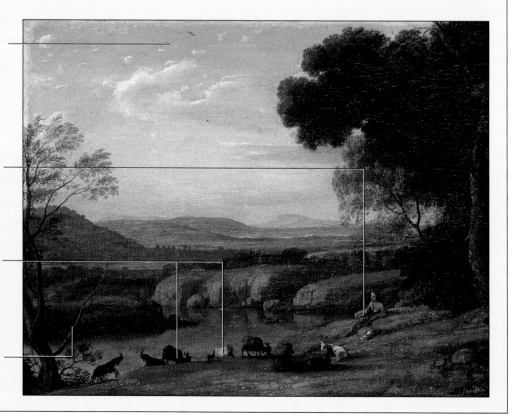

In landscapes, the distance often seems very hazy and pale. This is caused by the blurring effect of the atmosphere. The further away an object is, the more it is dulled by the dust and moisture in the air. The effect is known as 'atmospheric' or 'aerial' perspective.

Visual clues

Distant hills may be so light that they appear to merge into the sky on the horizon. This is especially likely to happen in damp, misty conditions. In comparison, the foreground will contain greater detail and contrast and the subject matter will therefore be more clearly defined.

If a painting looks flat, you can also often improve the sense of space by adding crisp details in the foreground and blurring the objects in the distance. Look, for example, at foliage on trees. In foreground trees, you are likely to be able to see the leaves and to pick out several different shades of green within the leaves. Compare this with a similar tree in the distance on which the foliage will appear dull and faded.

A certain amount of space is created automatically in a painting simply because the subject is familiar and therefore recognisable. The subject itself provides the clues. For instance, everyone knows that a path appears to get narrower as it tapers into the distance and that faraway trees seem smaller than those in the foreground.

Even so, many paintings which should look airy and spacious often turn out disappointingly flat. Usually this is

LIGHTENED TONES

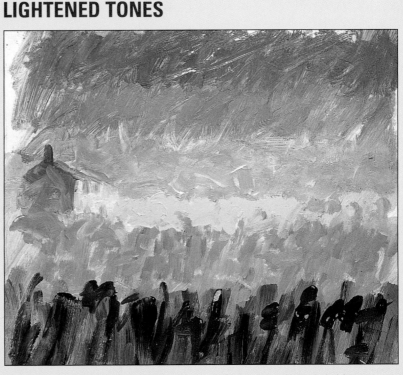

In this colour sketch, both the field of corn and the blue sky are painted in three bands of tone – dark, medium and pale. The strongest tones and colours are in the foreground – at the top and bottom of the composition – and the lightest tones represent the distance.

The eye of the viewer is led from the strong reds and browns in the foreground back towards to the horizon at the centre of the composition. The eye is then guided forward through the graded sky colours to the top front edge of the picture.

because the artist has failed to recognise and exploit the properties of the colours themselves.

Bright, warm colours tend to jump forward, whereas cool, subdued colours appear to recede (see below). Similarly, strong colours advance from pale or diluted colours.

When these colours are used in landscapes and other figurative works, exactly the same thing happens: by using warm or strong colours in the foreground and pale or cool colours in the background, you will automatically

Large, closely packed brush marks in the foreground leap forward from the small, spaced out marks in the distance.

Back to basics

When trying to give your painting a sense of recession, keep in mind the basics of painting – in particular, your brush strokes and your palette. In the illustration on the left, brush strokes alone are used to give a sense of recession. Without varying either the tones or colours, the artist has suggested space simply by painting foreground grass and sky in larger, closer brush strokes than those used in the distance. In the illustration on the right, on the other hand, you get a feeling of recession simply from colour – the warm colours appear to come forward while the cool ones fall back.

Orange jumps forward from its cool complementary – blue – while red leaps out from its complementary – green.

create an illusion of space in a painting. For instance, if you were painting a field of poppies, you would probably need to use a warmer, strong red for the flowers in the foreground and gradually make this mix cooler and paler as you work into the distance.

Eliminate the white

To create three-dimensional space on paper or canvas, it is first necessary to destroy the flatness of the surface. For instance, any sizeable patches of white paper or primed canvas showing through between paint strokes challenge the illusion of space by reminding viewers that they are looking at a two-dimensional surface. A traditional way round the problem is to get rid of the flat white from the outset by roughly blocking in all the initial tones before starting work on specific areas and details.

However, if you work subtly, you can use a white support to lighten a tone. Look at the skies in the landscapes on this page – the artist hasn't left large areas of the support unpainted, but near the horizon he has used thin washes of blue paint so that a lot of white shows through. This helps give the sky a sense of recession.

FOREGROUND DETAIL

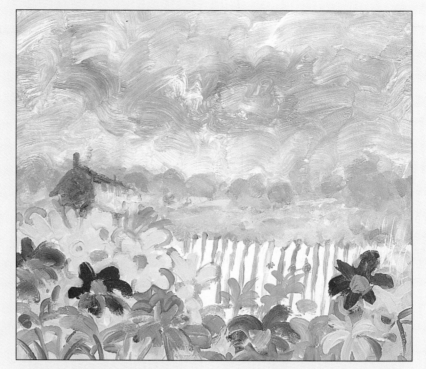

Here, the flowers in the foreground are painted in bold detail, immediately capturing and holding the attention of the viewer. The rest of the picture is vague and undefined in comparison. Gradually the eye moves towards the amorphous background, explores the distant landscape, and is then guided back to the more specific forms at the forefront of the image. The sense of recession is helped by the pale bluish green used for the background.

COLOUR AND ATMOSPHERE

In this landscape, the foreground fence is painted in bold green, red, black and white. The strong colours, applied undiluted and directly from the tube, stand out starkly from the lighter colours used in the rest of the picture. For example, the trees – painted in subdued green – become progressively paler as they recede into the distance.

The artist has also taken the opportunity to emphasise the three-dimensional form of the house by painting the nearest chimney in a dark tone and the farthest one in pale grey.

A second building, further away, is painted with a range of light blues and greens. This building is almost as pale as the sky and is therefore barely visible as it appears to merge with the horizon and disappear into the background.

Broadening your horizons

There are certain 'rules' about the best position for the horizon. However, the most successful paintings are often the result of breaking the conventions.

In any landscape, the standard place to put the horizon is at either a third of the way up or a third of the way down the picture. This division is restful and balanced, and yet keeps the eye on the move. However, there are other, more unusual options to consider – in the middle, very low, very high or indeed eliminated altogether.

Art teachers generally advise against putting the horizon in the middle because the half-and-half split of sky and land can lead to a dull, static composition. This is, after all, the position invariably favoured by young children.

Half-and-half division

However, all rules are made to be broken. One method of creating an effective composition around a half-and-half division of the picture area is to introduce verticals such as trees, figures or buildings that project from the ground plane into the sky area. These create a link between the two parts of the composition, and interrupt the dominant horizon.

The French artist Gustave Courbet (1819–77) uses this device to dramatic

▼ In *On the Beach* (1873), Edouard Manet uses a very high horizon – an innovative composition for its day. This allows him to emphasise the shapes of the foreground figures against a flattened background, creating a semi-abstract image.

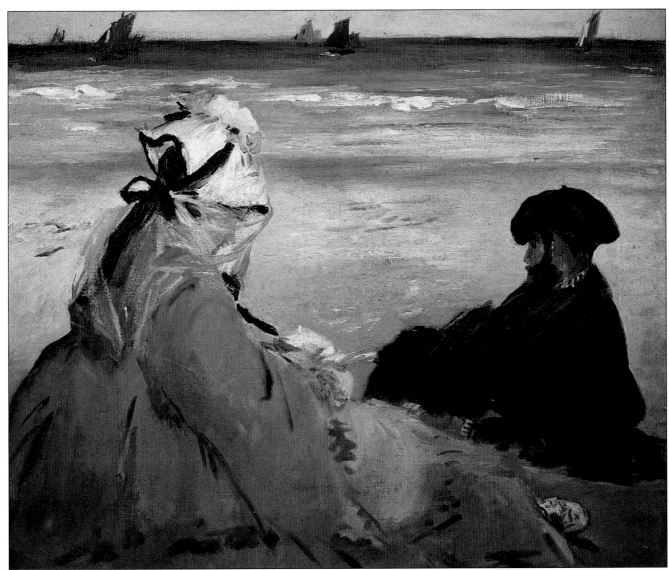

JUGGLING THE HORIZON

In these watercolour studies of Battersea Power Station in London, the artist has explored different locations for the horizon. Putting the horizon on a third is probably most restful on the eye. But high and low horizons allow the artist to emphasise the exciting colours and patterns in the river and sky respectively.

HORIZON ON A THIRD
▶ Here the horizon is placed roughly one-third of the way up. This produces a well-balanced composition, but one which possibly lacks the drama of the other versions.

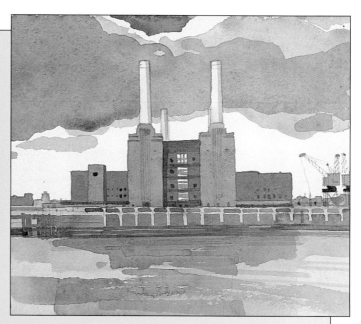

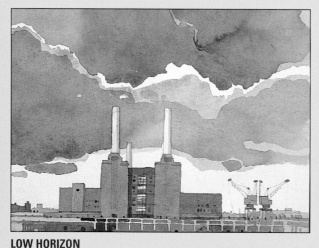

LOW HORIZON
▲ Here the greater part of the picture area is devoted to the sky. The power station sits four-square at the bottom of the picture, its towers set against a blustery sky. This solution places equal emphasis on the building and the background so that the eye wanders in a leisurely manner between the two.

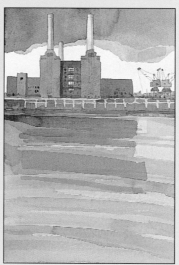

HIGH HORIZON
◀ In this version, the eye is drawn up through the foreground, across the water to the power station, which is unmistakably the focus of the composition. If the foreground is filled with interesting detail, textures or – as here – reflections, consider using a high horizon.

effect in his famous painting *Bonjour, Monsieur Courbet* (1854), right. In Peter Blake's (b. 1932) homage to Courbet, *The Meeting or 'Have a nice day, Mr Hockney'* (1981-83), the artist protagonists – Howard Hodgkin (b. 1932), Peter Blake and David Hockney (b. 1937) – are seen from a higher viewpoint.

Although the poses and gestures have a mannered quality, the higher horizon means that they are seen against the ground plane rather than the sky. They are a part of their surroundings in a way that Courbet's more theatrical triumvirate are not.

Low horizon

When the horizon line is set low in the picture area, the greater part of the image can be devoted to the sky. This allows plenty of scope for atmospheric sky effects such as sunsets, or for depicting cloud or weather conditions. Indeed, a low horizon is often used to evoke the grandeur and immensity of nature. In a later Courbet painting entitled *The Immensity* (1869), the horizon is placed well into the bottom third so that the focus is on the colours and forms of the stormy clouds.

Light mood

In a short but prolific life, Richard Parks Bonnington (1802–1828) returned time and again to coastal studies in which boats, fisher folk and horses are set against a vast sky. In contrast to the brooding nature of Courbet's *The Immensity*, Bonnington usually conjures up a carefree mood. His low horizons, together with a high-key palette, contribute to the light, open and airy feel of the seaside.

A sense of recession is often sacrificed with a low horizon, especially when combined with a narrow, upright format. Choosing a wide format, or including tall trees, allows more scope for introducing perspective lines or other clues to scale. Meyndert Hobbema (1638–1709) achieved this in his famous painting *Avenue at Middleharnis* by using tall poplars receding in plunging perspective.

High horizon

With a high horizon, only a sliver of sky is visible, which limits the scope for depicting the effects of light and weather, and creates an enclosed feeling. Edvard Munch (1863–1944) often combined a high horizon and cropped figures for his

claustrophobic and intensely psychological figure studies.

A high horizon can also be used to emphasise a towering mountain landscape. In the series of paintings of Mont Sainte-Victoire that French painter Paul Cézanne (1839–1906) produced from 1900 until his death, he often placed the mountain right at the top of the picture area. The sky becomes a negative shape around its brooding outline and the eye is swept up to its summit.

▼ In *Bonjour, Monsieur Courbet*, Gustave Courbet puts the horizon line halfway up the picture. This works because the figures link the top and bottom halves of the composition. Also, the symmetry is broken laterally, with two figures on the left balancing Courbet himself on the right.

Eliminating the horizon

Placing the horizon line right at the very top of the picture area, or omitting it altogether, removes an important clue to spatial relationships. This device is often used when the artist wants to flatten the picture and play up the abstract or decorative aspects of the painting.

This can be seen in many of the compositions of the French Post-Impressionist Paul Gauguin (1848–1903) – for example, *The Vision after the Sermon: Jacob Wrestling with the Angels*. Here, the foreground figures are severely cropped and the wrestlers are seen against a bright red background. The advancing red emphasises the background so that figure and ground jostle for attention in a very shallow space.

Putting it into practice

One of the best ways of understanding this complex subject is to study the work of other artists, and analyse the choices they have made. Then try to apply these thought processes to your own work. When you next paint a landscape, explore different horizon locations in a series of quick thumbnail sketches. Remember, you can change the horizon position by taking a higher or lower viewpoint or simply by cropping out areas of sky or land.

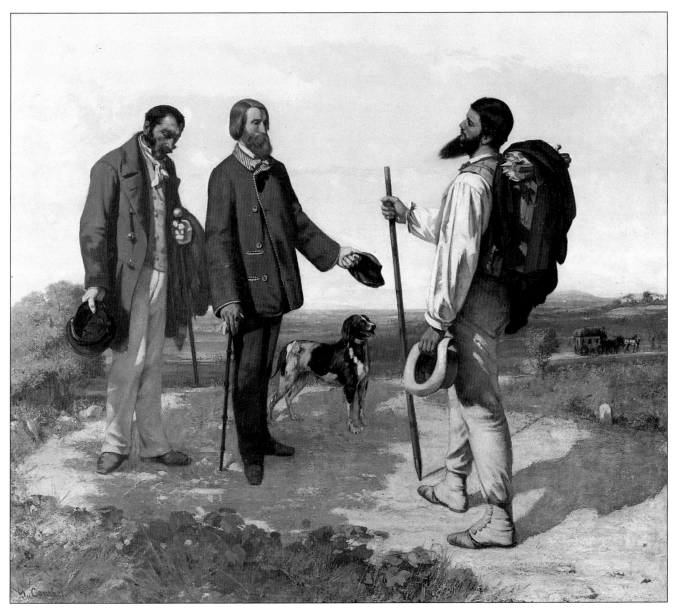

Landscape with clouds

The simplest compositions are often the most effective. In this understated country view, the sky is the dominant feature.

The sky is one of the most important elements in a landscape, yet in the majority of such paintings it occupies less than a third of the composition. However, by simply reversing this proportion of sky to land, you can create an instant impression of open space and sweeping countryside.

With this in mind, our artist decided to make a feature of the sky, which takes up most of the picture area and dominates the painting. The landscape itself plays a comparatively secondary role as a narrow strip along the lower edge of the composition.

Choose a sky

The landscape was taken from a photograph, but at the time, the sky was disappointingly flat with not a well-defined cloud in sight. Nothing daunted, the artist found another reference picture – one with a brilliant blue sky and billowing rain clouds. By 'borrowing' from the second photograph, it was possible to paint the original scene but to give it a far more imposing sky.

Painting clouds

Wet-on-wet watercolour is ideal for painting cloudy skies. With very little help from the artist, colours run and find their own billowing shapes. Brush strokes dry with soft, feathery edges and the result is like natural cloud formations.

There was no outline drawing for the painting, but before introducing any colour, the artist estimated the positions of the clouds and dampened them with plenty of clean water. The sky was then painted with a graded blue wash, the colour becoming paler and cooler towards the horizon.

Two or three layers of grey shadow were applied to the underside of each cloud. After each application, the brush strokes were softened with a damp natural sponge.

▼ **In this watercolour, a solitary tree provides a visual link between the field and the cloudy sky.**

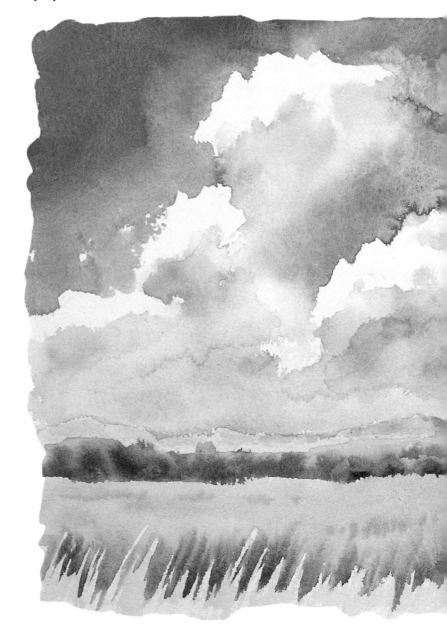

Piece of 600gsm (300lb)
Not watercolour paper
60 x 40cm (24 x 16in)

Watercolour brushes: 25mm
(1in) flat; Nos.10 and 7
rounds; Rigger

Clean water

5 watercolours:
Ultramarine; Cobalt blue;
Ivory black; Alizarin crimson;
Yellow ochre

Mixing dish or palette

Kitchen paper

Small natural sponge

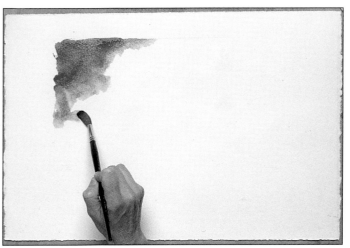

FIRST STEPS

1 ▲ **Wash in the sky** Use a 25mm (1in) brush to wet the cloud shapes with clean water. Change to a No.10 round brush and paint the sky with a wash of ultramarine, adding a little more water as you work down towards the horizon. Paint around the tops of the clouds trying not to touch the wet areas, but on the undersides allow the colour to run to form soft edges.

2 ▲ **Blot excess paint** Remove excess colour by dabbing with absorbent kitchen paper. This stops the colour from running out of control and also creates realistic pale patches in the sky.

EXPERT ADVICE
Mixing sky washes

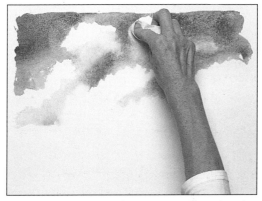

Mix a number of blue sky washes in advance. Not only does this save time, but it also means you will not run out of paint in the middle of a wash, which can result in an unwanted ridge of dry colour.

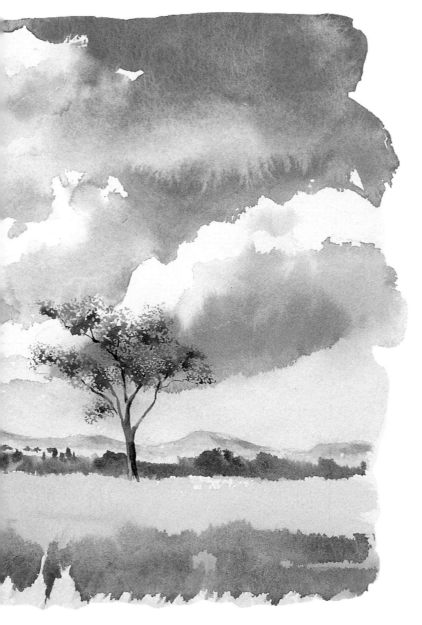

3 ▼ Complete the wash Add more water and a touch of cobalt blue to the ultramarine wash and finish painting the blue sky, still allowing the colour to run into the undersides of the clouds.

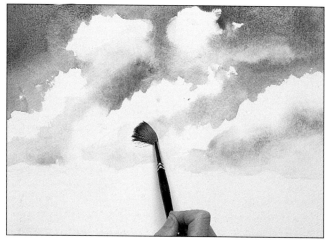

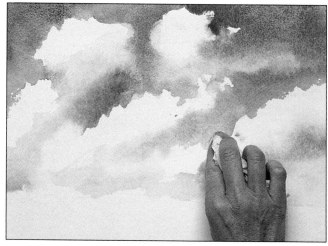

4 ▲ Sponge hard edges Where necessary, soften the edges of the clouds by dabbing with damp kitchen paper. This will break up any hard lines of colour and make the clouds appear light and fluffy.

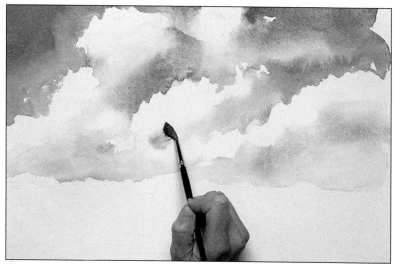

5 ▲ Add grey shadows Before the damp colour dries, mix a pale grey wash of ivory black and alizarin crimson and apply this quickly to the lower half of the central mass of clouds with a No.7 brush.

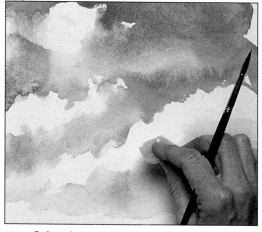

6 ▲ Soften the grey Dab a damp sponge along the top of the wet grey wash to soften the edge of the brush marks. Working from the sky reference, continue to paint the rest of the clouds in this way.

WORK FAST

Have a piece of tissue paper handy when you put in the clouds' shadows. If you need to lighten tones, you must work quickly to soak up the paint before it dries.

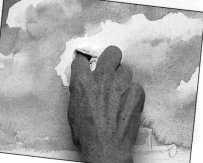

TROUBLE SHOOTER

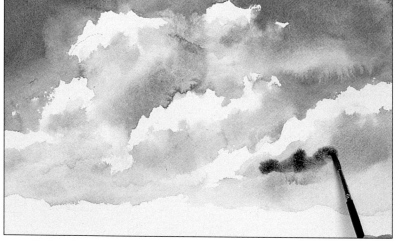

7 ▲ Darken the shadow While the clouds are still wet, mix a darker wash of ivory black and alizarin crimson and apply this along the lower edge of each cloud, allowing the colour to run slightly.

16

8 ▼ **Blot the shadow** Blot the top edge of the newly applied deep shadow with the damp sponge, leaving a narrow strip of dark grey along the bottom of each cloud. The resulting graduated tone gives the clouds a three-dimensional form.

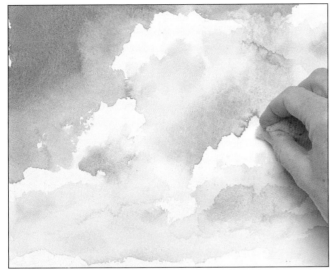

You have now completed the sky – the most important part of the painting. You have used strong colour and confident brush strokes to shape the clouds, so make sure the rest of the painting is equally bold and striking.

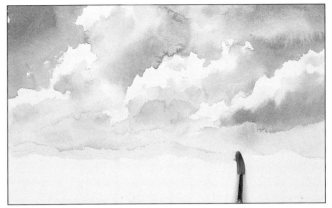

9 ▲ **Paint the hills** When the sky is dry, use the No.10 brush to paint the distant hills in dilute yellow ochre with a touch of alizarin. Paint this as a continuous horizontal stroke, taking the colour up to the sky along the horizon line.

Master Strokes
— ∞ —
Achille Emile-Othon Friesz (1879–1949)
Wooded Landscape

In this striking painting, the large tree is the dominant feature in the landscape and divides the picture area vertically. To avoid a completely symmetrical composition, the artist has extended the foliage on the right of the tree so that it dips down into the valley. The cream sky provides a neutral backdrop to the richly coloured leaves and branches.

The individual brush strokes can be seen in the thickly applied swirls of oil paint that form the leaves.

The cool, grey hills appear to recede, giving an impression of distance. In contrast, the warm colours in the foreground seem closer to the viewer.

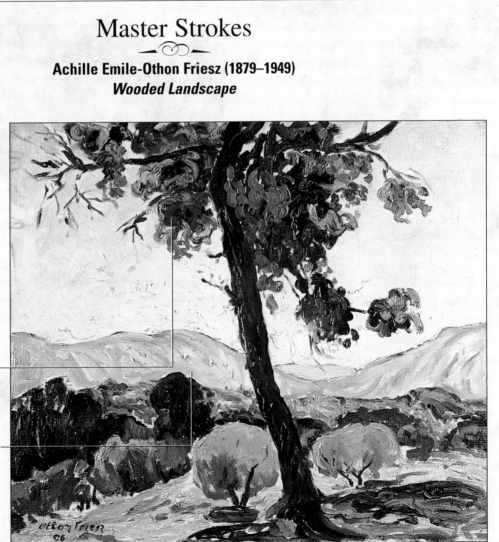

10 ▼ **Add the hedge** While the background hills are slightly damp, paint the shrubby hedge in the middle distance in dabs of cobalt blue mixed with black. As you work, vary the mixture slightly with added touches of alizarin crimson and yellow ochre.

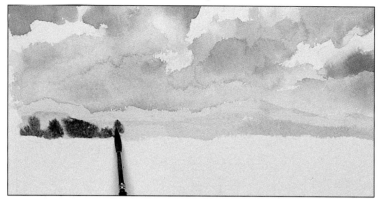

11 ▼ **Block in the field** Wait until the hedge is dry, then change to the 25mm (1in) flat brush and paint the yellow field in long, slightly slanting strokes of yellow ochre. Work with the narrow edge of the flattened bristles, leaving occasional streaks of white paper showing between the strokes.

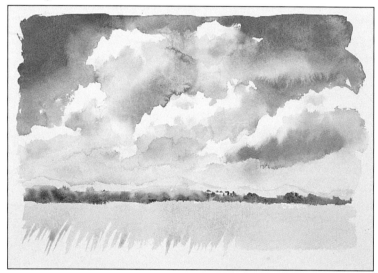

You now have a basic landscape painting of fields, distant hills and a cloudy sky. However, two important elements are missing. The tree – the focal point – and the foreground grass are still to be painted.

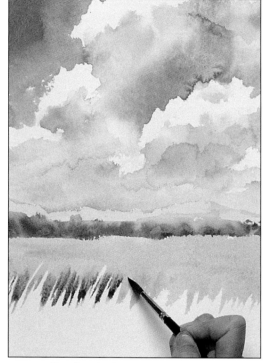

12 ▲ **Develop the foreground** With the No.7 brush, start to paint the blades of grass in the foreground with ivory black and cobalt blue, working slanting strokes to give the impression of long grass stalks blowing in the wind.

Express yourself
Sky sketches

Cloudy skies provide an endless source of material for artists. If you are interested in skyscapes, keep a record of different weather conditions and cloud formations in a sketch book. This study of threatening rain was worked in watercolour wet-on-wet so that the mauve, grey and blue washes merged gently together. Simple bands of green give an impression of open moorland. Sketches like this are quick to do and can capture an atmosphere perfectly.

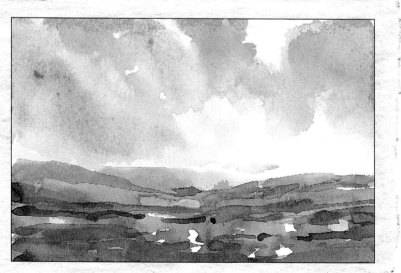

13 ▼ Sponge the tree Finish painting the grass, allowing the paint to run into any wet patches of background colour. Add a few clumps of grass to the yellow field. Wait for the paint to dry, then start work on the tree, establishing the foliage in yellow ochre dabbed on with a clean, damp sponge.

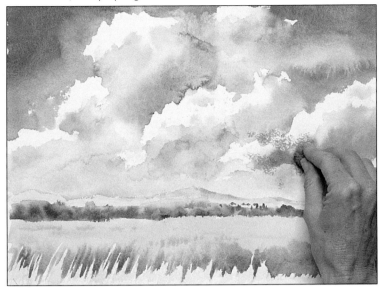

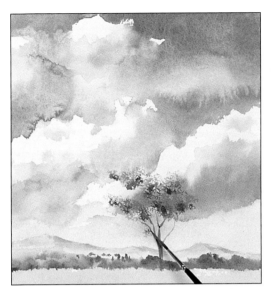

14 ▲ Add tree shadows Sponge some darker shadows on to the underside of the foliage in a mixture of ultramarine and yellow ochre. Change to a rigger brush and paint the trunk and lower branches with mixes of yellow ochre, ultramarine and a touch of ivory black.

THE FINISHED PICTURE

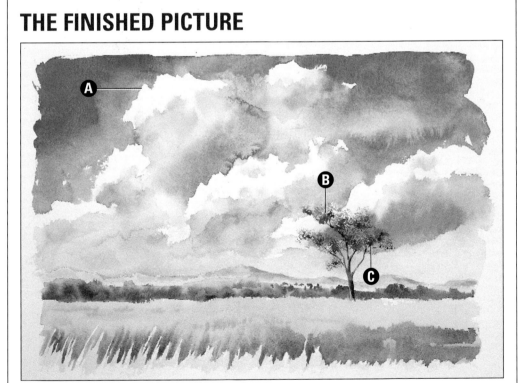

A Cloud outlines
The top edge of each cloud is sharply defined – this contrasts with the fuzzy lower edges where the colour is diffused.

B Sponged texture
Tree foliage was suggested with light sponging – yellow ochre for the top of the foliage, and a darker tone for the shadows.

C Black branches
As a final touch, the smallest branches on the tree were painted in black with the fine tip of the rigger brush.

Local park scene in oil pastels

This view of buildings on the edge of a park, seen against a vividly drawn cloud-filled sky, is ideally suited to oil pastels.

This park scene is relatively simple to do, but its different elements give you the chance to make full use of oil pastel techniques. Broad, expressive strokes convey movement, particularly in the sky and the branches of the trees.

Strong marks on the trees and grass verges contrast with more subtle shading on the houses and windmill, creating a sense of distance. Layers of colour are used to suggest light and dark areas. The warm glow on the façade of the houses under the trees is achieved by combining burnt umber, cadmium orange and yellow ochre. The main shadow cast by the trees is created by layering greens, yellow and grey, and adding blue to reflect the colour of the sky.

Make your strokes as quickly and vigorously as you can. Oil pastels are a bold medium and call for a confident approach. Remember, you can choose to leave out elements of the scene if it will enhance the composition. The artist used his photographs and sketches as a guide, but decided to emphasise the buildings by playing down the foliage.

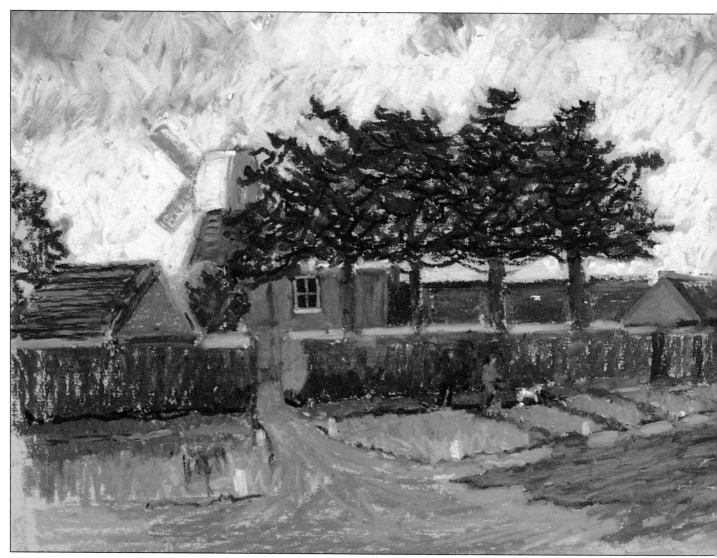

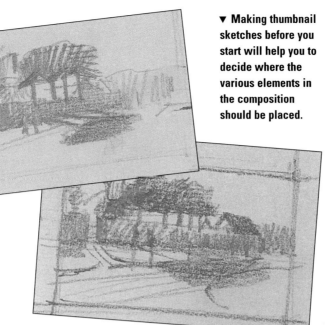

▼ Making thumbnail sketches before you start will help you to decide where the various elements in the composition should be placed.

YOU WILL NEED

Mid-grey pastel paper
40 x 50cm (15¾ x 19¾in)

18 oil pastels: Green-grey;
Moss green; Hooker's green;
Sepia; Green-yellow;
Cadmium yellow; Yellow
ochre; Mars violet;
Cadmium orange; Burnt
umber; Light grey; Black;
Emerald green; Phthalo blue;
Naples yellow; White;
Cadmium red; Light blue

Craft knife or scalpel

Kitchen paper

▼ Lively mark-making on the sky area and layered colour on the foliage and the shadow create an atmospheric scene with a strong sense of movement.

FIRST STROKES

1 ▶ Make a sketch Using a green-grey oil pastel, draw the buildings and trees, outlining the cast shadows of the trees on the road. Work lightly, without filling in too much detail. Concentrate, instead, on establishing the main elements in the composition.

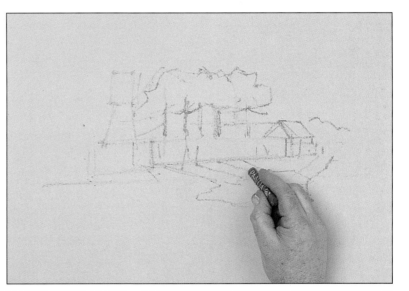

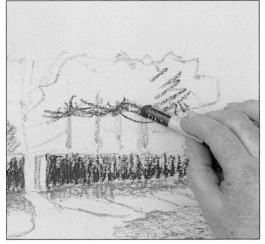

2 ▲ Fill in the dark areas Use moss green to shade in the bushes and cast shadows. Changing to Hooker's green, fill in the hedge and the shadows under the tree foliage.

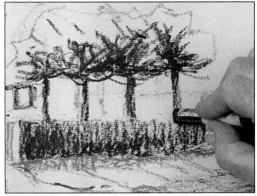

3 ▲ Develop the foliage Establish the stems of the hedge and the outline of the window with short lines in sepia, then add a few curved lines to the path and indicate the tree trunks. Use Hooker's green to fill in the foliage, then use sepia to draw the branches. Shade the sides of the tree trunks with Hooker's green.

21

4 ▶ Build up the hedge colours

Shade moss green over the Hooker's green on the hedge. Fill in the area between the eaves on the left and go over the bush next to it. Stroke green-yellow firmly across the top and side of the hedge, and use light strokes of the same colour for the verge, toning it down with moss green.

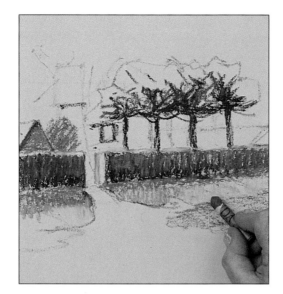

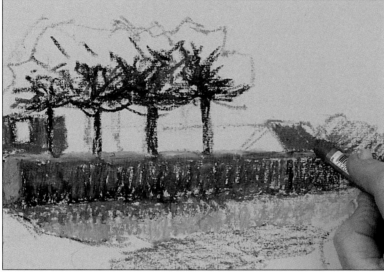

5 ▲ Find the right colour for the hedge

Add a green-yellow highlight to the bush on the left. Blend cadmium yellow into the top of the hedge. Add yellow ochre and more cadmium yellow, then blend in moss green and Hooker's green until the colour is right. Shade in the house and the right-hand roof with Mars violet.

6 ▶ Layer colours on the buildings

Indicate the figures under the trees with lines of cadmium orange. Shade burnt umber over the house and long, low roof. Use broad strokes of cadmium orange over this, and in the space between the right-hand eaves. Shade more burnt umber over the cadmium orange, with yellow ochre over that.

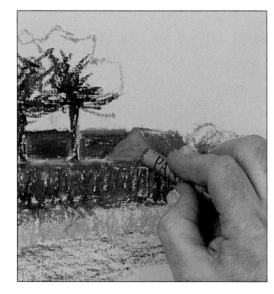

DEVELOPING THE PICTURE

Now that the main areas of the composition have been established, you can start to fill in the details. Adding greys will cool the picture down, and will also provide a subtle contrast to the lively sky and the intense greens that will be built up as you progress.

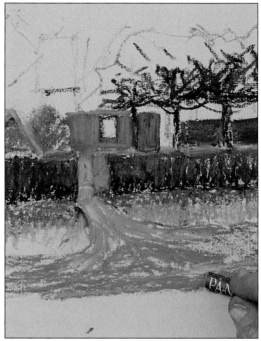

7 ▲ Add some grey

Shade light grey over the bushes on the right. Define the eaves of both roofs and fill in the roof on the left. Make a couple of strokes to indicate the door to the house. Use broad strokes to develop the road and the path leading from the house. Go over the road with green-grey.

EXPERT ADVICE
Making fine lines

Oil pastels are chunky and not suited to making fine lines. If you want to add these to a picture, put a layer or layers of colour over the relevant area. Then use the point of a blade to draw the details you want, scratching through the colour until the paper shows. Rest your hand on kitchen paper while you do this.

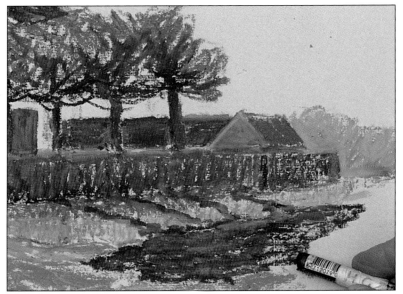

8 ▲ Intensify the greens Use Hooker's green and moss green to define the shadows of the trees. Block in the tree foliage with moss green, drawing in the topmost part with Hooker's green.

9 ▲ Develop some details Use short, broad strokes of Hooker's green for the bush on the right and to intensify the colour at the base of the hedge. Add a few light strokes to the verge edges. Soften the roof on the right with burnt umber and define its eaves. Fill in the base of the windmill with black, then light grey. Shade light grey over the top of the windmill.

Express yourself
A different viewpoint

An interesting view has many possibilities. You might find that, if you look at a scene from various different angles, you will find several interesting compositions to paint. By walking around this group of buildings in a park, the artist has discovered a second, equally pleasing composition, with the windmill slightly more dominant in the picture. Below, a grass verge frames the bottom of the painting, whereas in our step-by-step the road came right into the foreground. Oil paints were used for this version of the park view, enabling the artist to depict the scene in greater detail.

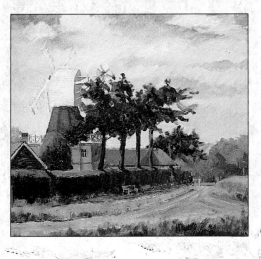

10 ▲ Continue developing details Use black for the network of branches in the foliage and to go over the cadmium orange figures. Redraw the foliage over the windmill with Hooker's green. Develop the verge with strokes of yellow ochre and light grey, then add touches of these colours to the shadow of the trees. Blend more moss green over the shadow below the hedge. Shade emerald green over the verges.

11 ▶ **Start on the sky**
Define the door with Mars violet and yellow ochre. Shade yellow ochre over the verges, and emerald green and yellow on top of the hedge. Fill the window with black pastel, then scratch in the frame with a blade. Sketch the clouds in green-grey, then shade the sky and clouds with phthalo blue, Naples yellow and white.

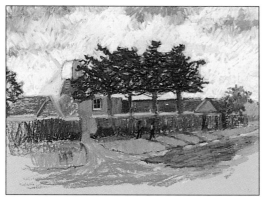

12 ▲ **Finish filling in the sky** Using the edge of the phthalo blue pastel, make strokes in different directions to deepen the sky colour. Then blend in white to tone down the colour and to suggest clouds. Use white, too, for the top of the windmill and the suggestion of road markings in the foreground.

Master Strokes
—⚬—

Pierre-Auguste Renoir (1841–1919)
La Balançoire

In this park scene, the emphasis is more on the figures enjoying the leafy surroundings than on a wider view. The path is a prominent feature, leading the eye past the figures by the swing in the foreground through to the group in the background. Renoir has used many spots of light and dark colours to suggest dappled sunlight falling on the path through the trees. The effect is echoed on the clothes of the main figures. Even the backdrop of trees, painted in deep, rich greens and browns, is dotted with highlights, giving the painting a sparkling luminosity.

The brilliant effect of sunlight and shade in this painting is typical of Renoir's early work in the Impressionist style.

The woman, her white dress dappled by sunlight, stands out as a light figure against the dark trees.

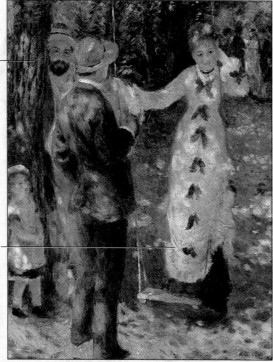

A FEW STEPS FURTHER

Although the main part of the picture is complete, you might wish to add further details. You could intensify the light and shade, strengthen elements such as the roof and use the figures to bring a flash of colour into the composition.

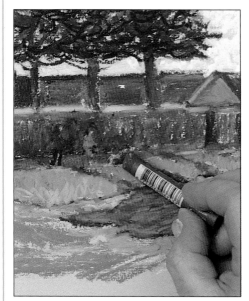

13 ▲ **Bring the figures into focus** To emphasise the figures, scrape away the black shapes with the blade and redraw them with Hooker's green. Use white for their faces and cadmium red, green-grey and light blue for the clothes. Draw the dog in black and white. Fill in around the figures with Hooker's green.

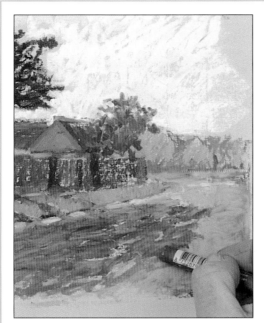

14 ▲ **Intensify the light and shade** Emphasise the lighter areas on the buildings with cadmium orange. Blend phthalo blue into the main shadow. Extend the shadow with Hooker's green followed by light grey and a little yellow ochre.

15 ▲ **Strengthen the details** Shade light grey over the sails of the windmill and over the blues in the main shadow. Strengthen the hedge under the left-hand roof with Hooker's green and moss green. Add lines of burnt umber to the roof and its eaves and strokes of yellow ochre to the path. Finally, make dashes of white for the posts at the roadside and to highlight the dog.

THE FINISHED PICTURE

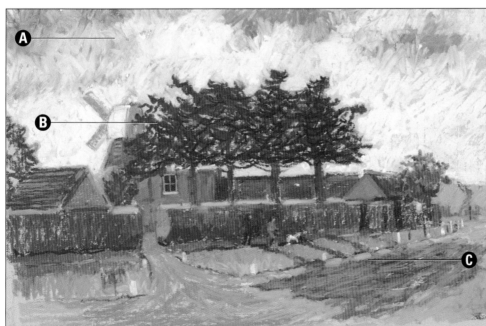

A Lively sky
The sense of movement in the sky was achieved by applying broad strokes of white, blue and yellow in different directions, and then working them into each other.

B Focus on foliage
The strong, dark marks used to suggest a network of branches in the foliage bring the trees forward in the picture and make them a focal point in the composition.

C Shadow colours
The shadow was built up with layer upon layer of greens, yellows and greys and the blue used in the sky. The final grey strokes suggest the surface of the road.

Sandbanks at low tide

Paint an endless landscape of golden sandbanks, water and rushes under a wide sky.

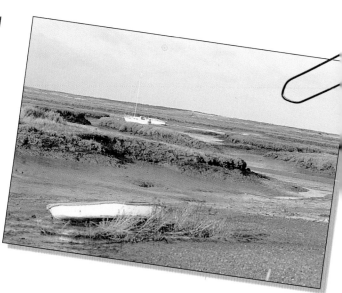

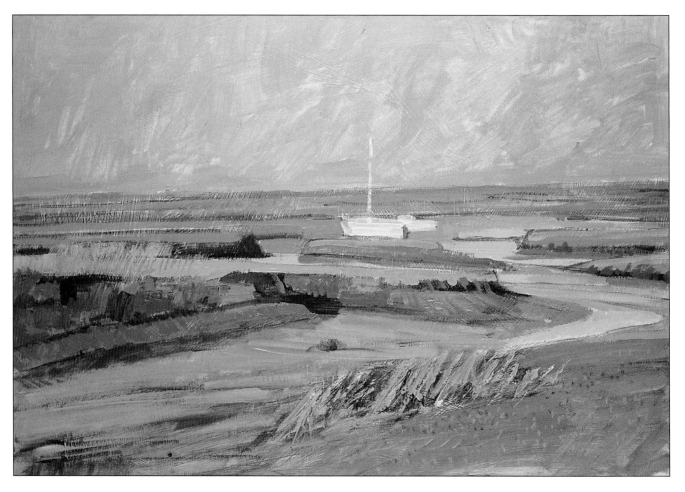

A watery landscape at low tide presents quite a challenge to the artist: how to paint mud, and the water that surrounds it, without 'muddying' the colours. Acrylics are the ideal medium for this. They are translucent when applied thinly, and the initial colours continue to show through when layers are painted over them.

Always clean your brush between applications of paint by dipping it in clean water and then wiping the bristles on a rag. They should be just damp for opaque colour and retain more water for a thinner layer. All excess water must be removed for the dry brush technique. Be bold with your brush strokes for a lively effect.

For your support, you will need a hardboard panel primed with three coats of acrylic gesso. This coating is important because it will give texture to your work right from the start.

▲ The artist decided not to paint the boat in the foreground of the photograph, as it tended to pull the overall composition towards the left.

FIRST STROKES

1 ▶ Lay the background wash Give the rough side of the hardboard three coats of acrylic gesso primer. Leave to dry. Mix cerulean blue with about the same amount of acrylic medium until it is liquid enough to cover the primed board easily. Use a 38mm (1½in) decorator's brush to apply the colour. As you work, you will see that the colour is picking up texture from the gesso coating on the board. Don't overwork the wash: the brush strokes should remain visible to add further texture to the background. Leave to dry.

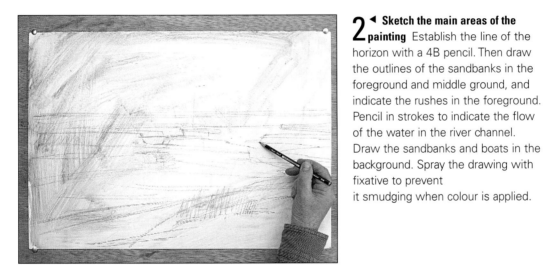

2 ◀ Sketch the main areas of the painting Establish the line of the horizon with a 4B pencil. Then draw the outlines of the sandbanks in the foreground and middle ground, and indicate the rushes in the foreground. Pencil in strokes to indicate the flow of the water in the river channel. Draw the sandbanks and boats in the background. Spray the drawing with fixative to prevent it smudging when colour is applied.

3 ▶ Build up the shapes Use a wet No.5 flat brush and undiluted burnt umber to 'draw' the horizon line and outline the sandbanks and boats. Paint in the deepest shadows and darker areas with a drier brush to give shape to the sandbanks. The paint will pick up the texture of the gesso to create interesting shapes. Dry the brush on a rag, pick up a little burnt umber and indicate the rushes with vertical strokes.

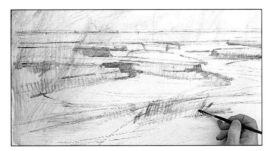

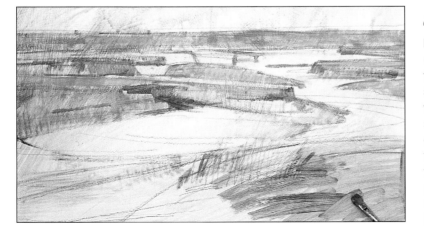

4 ◀ Block in the sandbanks Mix green oxide with a touch of raw sienna and use a dry brush to paint in the grasses on the sandbank under the horizon. Add a touch of yellow oxide to the mixture and paint in the other sandbanks; remember to cover the sides as well as the tops! Now add a little more raw sienna and use vertical strokes to indicate the grasses on the main sandbank on the left and the one below the boats. Changing to a No.14 flat brush, mix raw sienna and burnt sienna to paint the foreground area in front of the rushes. Use free brush strokes to create a base for the pebbles.

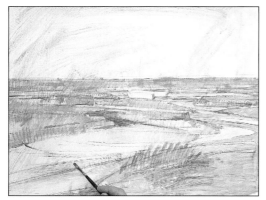

5 ▲ Indicate the direction of the water Dry the No.5 brush on a rag. Mix burnt umber with a little water and add more foreground rushes. Change to the No.2 brush and paint the boats white. Using the No.5 brush and cerulean blue, paint in the distant water with thin colour so that the initial wash still shows through. Then follow the direction of the water with your brush strokes as it flows towards the rushes.

DEVELOPING THE PICTURE

Now that you have laid down the basic shapes, start on the details. Paint in the muddy area in the foreground and the sunlight on the sandbanks, then add texture to the rushes and the pebbled area. Finally, further strengthen the shapes of the sandbanks and their shadows. It's a good idea to half-close your eyes occasionally to check the balance of tones.

6 ▶ Create the effect of mud Mix brown with enough acrylic medium to cover easily. Using the No.14 brush, paint over the original wash between the rushes and the sandbank, and in the bottom left-hand corner. Now paint over some of the blue from step 5. This is the first stage in creating the effect of water filtering through mud. Fill in the unpainted side of the main sandbank.

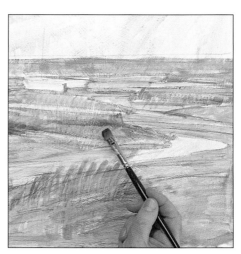

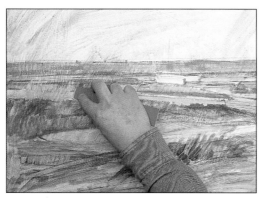

7 ▲ Use card to create rushes Using the No.5 brush, deepen the shadows of the sandbanks with raw umber and burnt umber. Paint over the muddied area at bottom left and add to the rushes in the foreground. Make an opaque mix of cadmium yellow, yellow oxide and white to paint in the sunlight on the sandbanks with the No.2 brush. Take an offcut of card and scrape the edge up and down to create sunlit rushes.

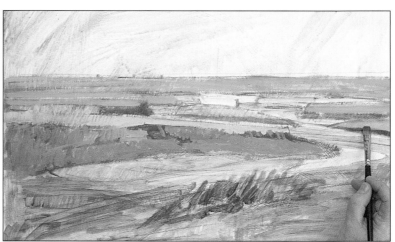

8 ▲ Strengthen the sunlit grasses Mix yellow oxide, raw sienna, cadmium yellow, white and a touch of green oxide. Use the No.5 brush to paint in the tops of the sandbanks. Add burnt umber to the sunlight mix in step 7, and paint the lighter shadows under the main sandbank. Mix raw umber, burnt umber, raw sienna and white and fill in the other shadows with the No.2 brush. Indicate the texture of mud and rushes with strong brush strokes.

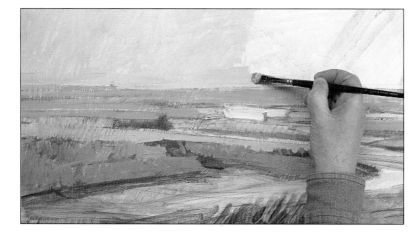

9 ◀ Paint the sky Dry the No.5 brush and paint in the reflection of the main sandbank at its base using burnt umber. Put a few random brush strokes next to the rushes in the foreground to add texture. Mix cerulean blue with an equal amount of white to make a light blue. Then add a very little raw umber to prevent the mixture being too blue. Use the No.14 brush and paint freely over the sky area until it is more or less covered but some of the original wash still comes through.

10 ▶ **Paint the horizon and water** Mix green oxide and burnt umber and paint in the line of the horizon with the No.2 brush. Mix cerulean blue with enough white to make an opaque version of the sky colour. Using the No.2 brush for smaller areas and the No.5 for bigger ones, paint over the water that you added in step 5, as well as the muddy area behind the rushes. Use short, horizontal brush strokes, making sure they are not too close together, so that the mud-brown shows through

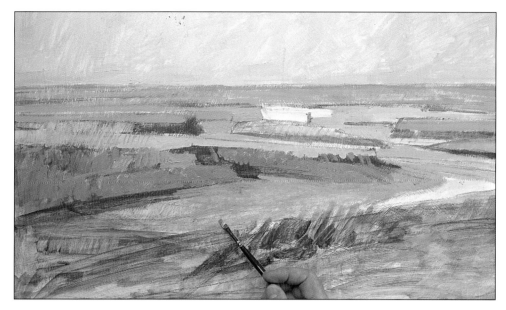

Master Strokes

William Dyce (1806–1864)
Pegwell Bay

Pegwell Bay (1858-60) is one of William Dyce's most famous landscapes, and a classic example of Victorian art. The charming fine details in the foreground of a family outing to the sea are offset by the brooding image of the cliffs and clouds in the distance. The wide sky and the expanse of water dominate his painting. Reflections and shading in the shallow water make you aware of the sand just beneath its surface, as in the low tide project.

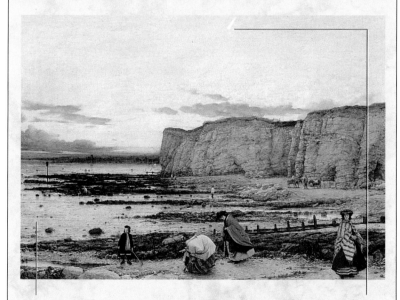

The grey sky is reflected in the calm sea, giving it a silvery sheen which forms a neutral backdrop to the splashes of colour on the figures.

An amateur astronomer, Dyce included Donati's comet very faintly at the top of the painting. This small detail adds richness to the picture.

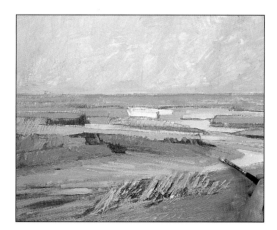

11 ▲ **Add texture to the foreground** Paint over the area in front of the rushes with raw umber. Then take the card and dip the edge into a mix of raw sienna, burnt umber and white, and scrape it over the rushes with a diagonal motion.

12 ▲ **Add reflections and more texture** Dry the brush and use burnt umber to paint the shadows in the water at the bottom left. Now mix white with a very little cerulean blue and use the No.5 brush to paint the pale reflections on the water. Add a little more blue for the reflections just beyond the rushes.

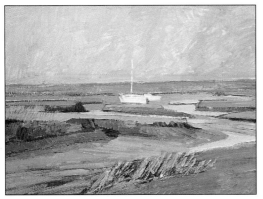

13▲ **The finishing touches** Using the No.2 brush, add a little burnt umber to the main sandbank. Use touches of black for the deep shadow along its side, then mix raw sienna with red oxide for its base. Add dashes of raw sienna on the left. Mix raw sienna and yellow oxide for the sandbank beneath the boat, adding white for the grass. Use white for the boat's mast.

Although the picture is now complete as it stands, you may wish to add further details. Painting the pebbles in the foreground will give texture to the sandbank; adding detail brings this part of the composition forward. Emphasise the different areas and the line of the horizon to create a sense of space and distance.

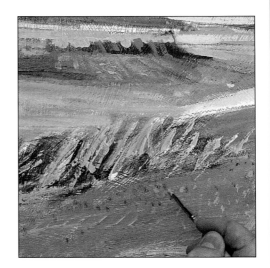

14▶ **Paint some pebbles in the foreground** Mix raw sienna, red oxide, raw umber and burnt umber and dot this on to the area around the rushes with the No.2 brush. Add yellow oxide, more raw sienna and a little white to the mixture and repeat the process.

15◀ **Accentuate the different areas** Add a little white and a touch of raw sienna to green oxide and paint this over the tops of the sandbanks on the right. Put dashes of raw sienna on the sides. Mix cerulean blue with white to make mid-blue and use this for the pool of water on the right. Use burnt umber and the No.5 brush to paint the muddy patch between the rushes and main sandbank.

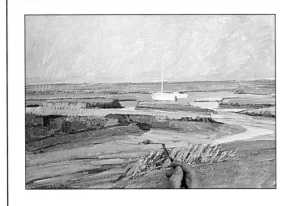

EXPERT ADVICE
Using a dry brush

If paint is applied with a dry brush over another colour, it will allow traces of the underlying layer of paint to show through. And because the direction of the strokes remains visible in the finished picture, a dry brush is useful for creating texture. The key to success with the technique is to make sure the bristles are as dry as possible and to work quickly with the flat of the brush.

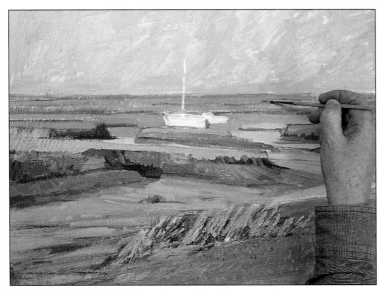

16▲ **Add to the impression of distance** Dry the No.2 brush on a rag and bring out the line between the sandbank immediately below the horizon and the one in front of it with burnt umber. Add more horizontal brush strokes to give the impression of sandbanks stretching away into the distance.

Express yourself
A pastel approach

The artist has created the same landscape using soft pastels instead of acrylics. The mid-grey pastel paper is left plain at the top to represent a dull sky threatening rain. To depict the sandbanks and the water, broad bands of colour were laid down first with the side of the pastel sticks. Grey patches of paper were left to show through in the foreground, suggesting the sky reflected in the water. Details such as the rushes and the boat's mast were added with fine pastel strokes.

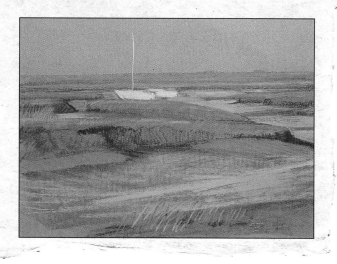

THE FINISHED PICTURE

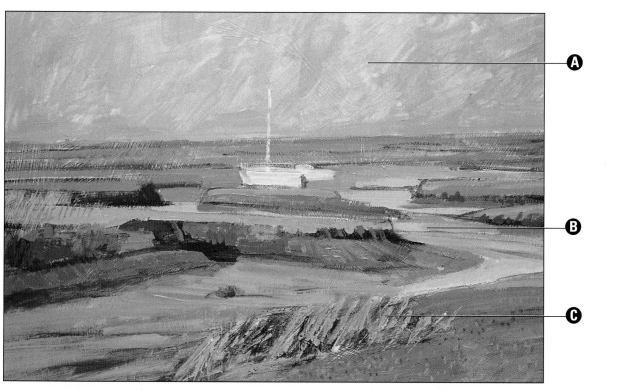

A Sense of space
By applying colour with loose brush strokes that allowed the initial wash to show through, the artist has lightened the sky and given a feeling of space.

B Water and sky
The same blue was used for the water as for the sky, either undiluted or with white, linking the river channel with the sky and bringing the composition together.

C Texture in the foreground
The strong texture of the rushes and pebbles adds interest to this part of the picture and has the effect of bringing it forward.

Country lane in oils

Whenever you go for a walk in the country, you will be presented with any number of vistas that will inspire a traditional oil painting.

Like many landscapes, this country scene has no hard edges or clearly defined shapes. It is soft and subtle, composed mainly of dappled light and broken lines. There are very few areas of solid tone and colour.

The versatility of oils

Daunted by the idea of painting so much nature? Oil paints make it very easy. They can be dabbed on, rubbed in, moved around, wiped back and scraped off to create all the tones and textures of the countryside, like the leafy trees and shady lane here. In short, landscape offers a wonderful opportunity to explore every possibility of the medium.

Composing the picture

Working from photographs is a good starting point, especially for landscape painters, because it means you are not dependent on the weather or hindered by constantly changing light. They also allow you to paint sunny summer scenes in the middle of winter! But there is no need to slavishly copy everything you

▼ **The versatility of oil paints makes them ideal for creating the textures of landscape.**

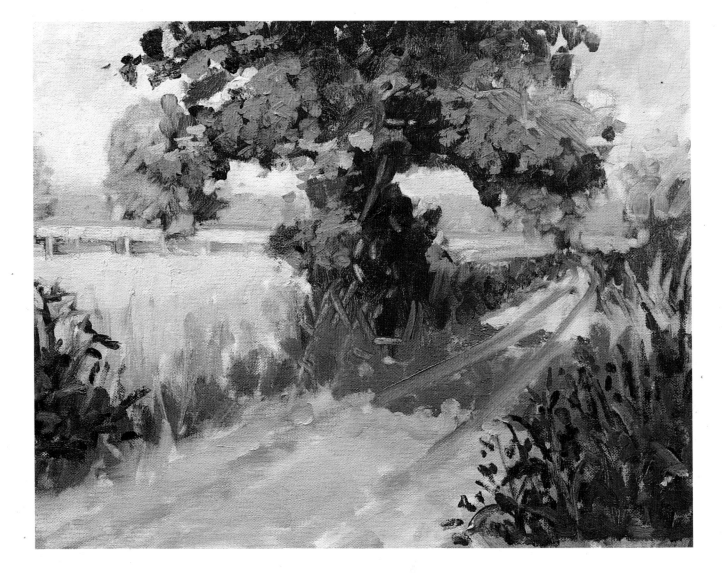

see in the photograph. It is up to you to choose which bits you like and which you want to leave out. This painting was done from two photographs, joined together to give the artist more scope to choose the best composition. Don't forget, though, that working outdoors on a 'real' landscape can give your work extra spontaneity.

Composition and distance

As a general rule, anything in a picture that divides the composition in half, vertically or horizontally, should be avoided. But rules can be broken, and in this picture the artist deliberately chose to place a tree in the centre of the composition and to counteract the resulting symmetry by offsetting other elements. The lane divides the picture diagonally into two unequal shapes and takes the viewer's eye away from the tree and towards the top right-hand corner of the painting.

In most landscapes, things in the distance look fainter and slightly bluer than objects directly in front of us. Foreground objects are sharply defined with strong colours and tones. You can see much more detail in the foreground.

The differences between near and far can be captured in paint and will give your picture a genuine feeling of space. Do as the artist does here: use blue and white on the distant fields, hedges and trees and apply colour in broad, simple strokes. For the foreground shrubs and grasses, use bold tones and expressive strokes. Let shapes stand out clearly against the hazier background.

FIRST STROKES

1 ▶ Paint the outline Loosely sketch the main outlines using a No.4 filbert brush and a mixture of equal parts cadmium yellow and ultramarine blue with a touch of cadmium red. There is a reason for using a neutral colour at this early stage – the khaki shade, diluted with turps to a watery consistency, will be absorbed into the landscape and will not be noticed in the finished painting.

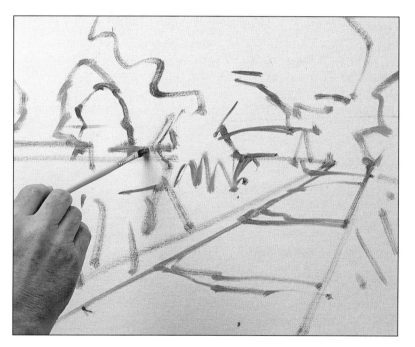

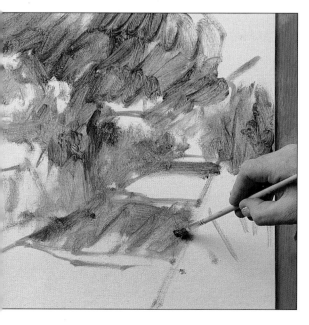

2 ◀ Paint the lights and darks Still with the No.4 filbert, loosely block in some of the main colours. The purpose is to get rid of a lot of the white canvas and to establish a few of the light and dark tones. For the trees and hedges try to take the brushstrokes in the direction of the growth and branches. Use the outline colour with a touch of cerulean blue for the dark area at the top of the tree.

TROUBLE SHOOTER

AVOIDING A LIMITED COMPOSITION

Don't let your composition be limited by the arbitrary design of a conventional photograph. When taking photos for a painting, take several views that will link up to form a panorama. This way you can choose the composition from any part of a wide view and then stick the relevant photographs together with masking tape.

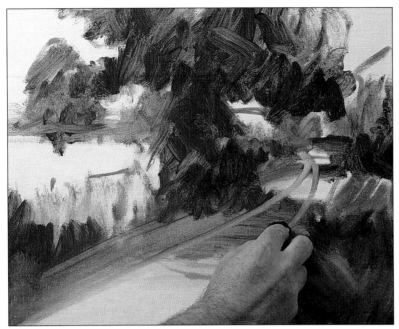

3 ▲ **Develop the dark areas** Add more dark tones in a mixture of yellow ochre and ultramarine under the tree, in the hedgerow and into the foreground, again using loose, sweeping brushstrokes. Use the outline colour with a touch of yellow ochre and white for the patch of brighter colour in the background. Take a cloth and wipe off some thick colour, still keeping the painting broad and lively. Use the cloth and boldly wipe in the cart tracks as sweeping curves.

DEVELOPING THE PICTURE

The main shapes in the composition are now blocked in. The next consideration is to create a sense of depth in the painting by working on the middle and far distances to differentiate them.

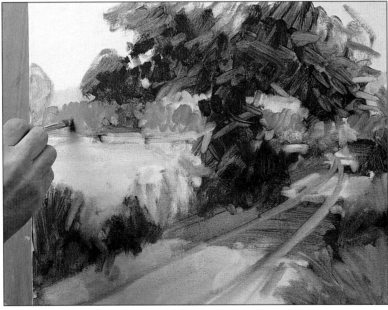

4 ▲ **Establish the distance** The far distance should be bluer to make it recede. Because you cannot see detail in a background, keep it very simple. Mix cerulean blue with an equal part of white and tone this down with a little of the green mixture on your palette. Use the No.7 flat brush to sketch in the background in loose, scribbly strokes.

▶ **A graduated mixture of cerulean blue and titanium white is used for both the far distance and the sky.**

EXPERT ADVICE
Painting leafy trees

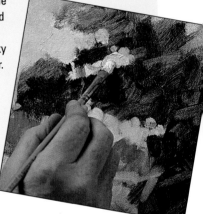

Start by painting the tree as a fairly solid mass of tone, then paint patches of sky over the tree colour. This is more effective than starting with the sky and trying to paint the leaves over the top.

5 ▼ **Paint the sky** Do some more wiping out in the sky area and paint the sky in pale and mid blue mixed from white with a touch of cerulean. Use short stabbing strokes, and try to keep the paint lively with lighter underpainting showing through the darker shades – rather like a sky with a few moving clouds.

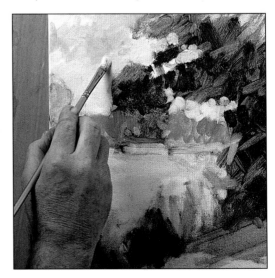

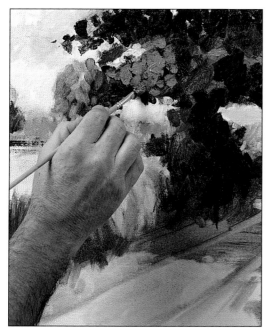

6 ▲ **Describe the foliage** Using the No.4 filbert brush, mix a deep shadow tone for the underside of the tree from ultramarine blue and cadmium yellow with a touch of burnt umber to darken the colour. Apply this in short, stubby strokes. Now, with cerulean blue and smaller amounts of yellow and white, mix a bluish-green. Try to imagine each brush mark as a cluster of leaves as you apply this lighter tone to the upper side of the branches. Add a few quick strokes of the same colour to the fore-ground for the grasses in the near hedgerow.

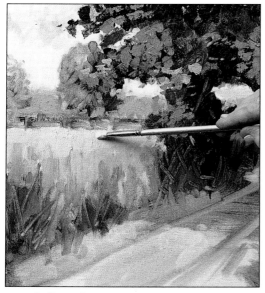

7 ▲ **Indicate distant sunlight** Mix equal parts of yellow ochre, white and cadmium yellow and, with the No.7 brush, broadly paint on to the bright yellow under-painting for the sunlit fields. Add a similar amount of white to the yellow mixture and apply this in broad horizontal strokes across the distant field.

Master Strokes

Claude Monet (1840–1926)
The Poppy Field

Monet grew up in the French port of Le Havre, where his first mentor, Boudin, instilled in him a lifelong enthusiasm for painting from nature. His interest in painting landscape purely in terms of atmosphere and light grew, and he was one of the first painters whose work was termed 'Impressionist'.

Small, seemingly random touches of pure red colour perfectly capture the fragile beauty and movement of the poppies in the breeze.

The sky is painted with a light palette to emphasise the airiness of the landscape and give a fleeting, sketch-like impression.

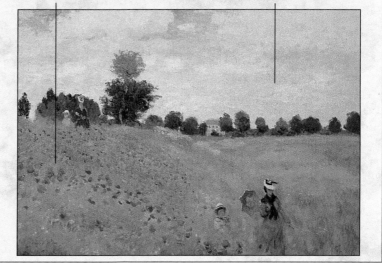

8 ▼ **Paint the middle distance** The pinkish-beige of the track is mainly Naples yellow with added white and a touch of cadmium red. Paint this in loose criss-cross strokes, leaving flecks of the pale underpainting showing through. The strong dark shadow thrown by the tree is a mixture of approximately equal parts ultramarine blue and burnt umber with touches of cadmium red and white.

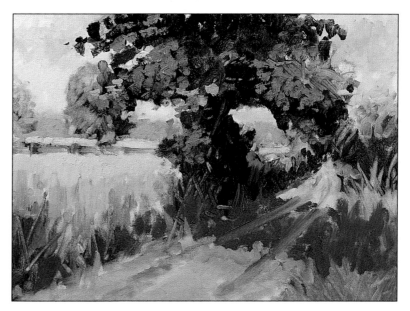

With the tonal values now established in the composition and the main details of the grass and foliage depicted with brush strokes and wiping back, the landscape stands alone as a finished painting. However, it would benefit from a few well-defined details, especially in the foreground, both to add interest to the painting and to increase the sense of depth.

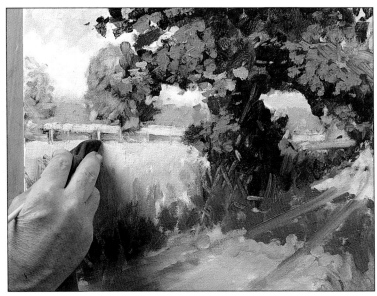

10 ▼ Establish the foreground Strengthen the foreground shapes by painting dark grass and flowers in burnt umber with added touches of ultramarine blue and cadmium red. These bold, silhouetted shapes stand out from the middle and far distances, which are paler and appear to recede by contrast.

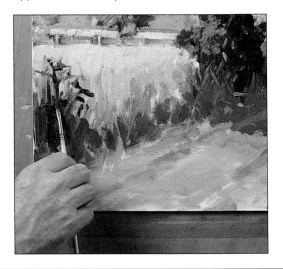

9 ▲ Wipe in the fence posts The far fence provides a focal point in the distance and, as such, is an important part of the composition. Instead of painting the fence posts, wipe them back so they stand out as flecks of pale canvas. Do this with a rag wrapped round the end of a paint brush handle and dipped in turpentine.

Express yourself
Concentrate on colour and detail

▲ Create these earthy tones for the foreground and shadowy areas under the tree by mixing ultramarine blue and cadmium yellow, using burnt umber to darken the colour.

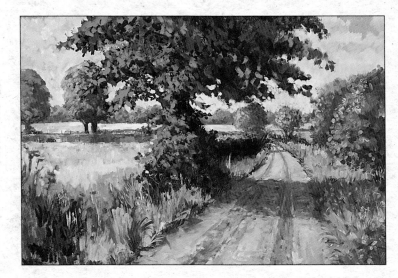

This painting shows a similar view, but with a few significant differences. The tree in this composition is slightly offset and there is less emphasis on the difference between the foreground and the distance. Instead, the artist has concentrated more on adding colour and detail, particularly when depicting individual shrubs, plants and flowers.

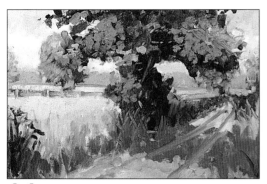

11 ▲ **Assess the painting** Stand back and take a critical look at the painting so far, paying particular attention to the foreground, middle distance and far distance. The foreground on the left has been developed and stands out well from the rest of the painting. However, the foreground on the right-hand side of the painting still needs strengthening.

12 ▶ **Strengthen the foreground** It is time to take a little artistic licence and to paint in some foreground shapes, even though these do not exist in the photograph. With the No.4 round brush, paint some bushy leaves in a mixture of burnt umber with touches of cadmium red and ultramarine blue. Add more red and blue to this mixture to paint the purple flowers.

THE FINISHED PICTURE

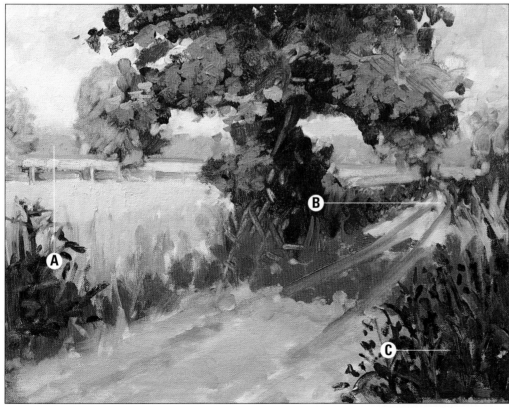

A Background blues
Broad brush strokes were used to give the impression of realistic trees and fields without the need to paint lots of detail.

B Space and perspective
The lane gets narrower as it recedes into the distance, creating an even stronger sense of space in the painting.

C Emphatic foreground
Foreground foliage and flowers are painted in strong, dark colours, which make them appear to jump forward from the painting.

Capturing reflections

The distorted reflections of two houses near Venice help to create a wonderfully vibrant image – perfect for coloured pencils.

Reflections in water are fascinating to draw. Unless the surface of the water is absolutely mirror-still, the reflected image will be distorted.

In this scene, the water has been disturbed by the swell of a passing boat. The reflection of the houses is clearest near the bank, where the water is calmest, but it becomes gradually more distorted by the ripples, especially in the upper window and roof areas.

▼ **The low evening sun brings the façades of the waterside houses to life, creating a bold, brightly coloured image.**

In the two waves created by the swell, an unusual effect has occurred – two narrow slivers of the reflection can be seen, as though they have broken off the main image. The shapes in these thin strips of colour are so distorted that the reflections have become an abstract pattern.

Coloured pencils are versatile drawing tools, ideal for capturing watery effects. Use them for linear work and for layering to give a rich depth of colour. Make broken marks where the reflections are distorted to create an impressionistic interplay of different colours.

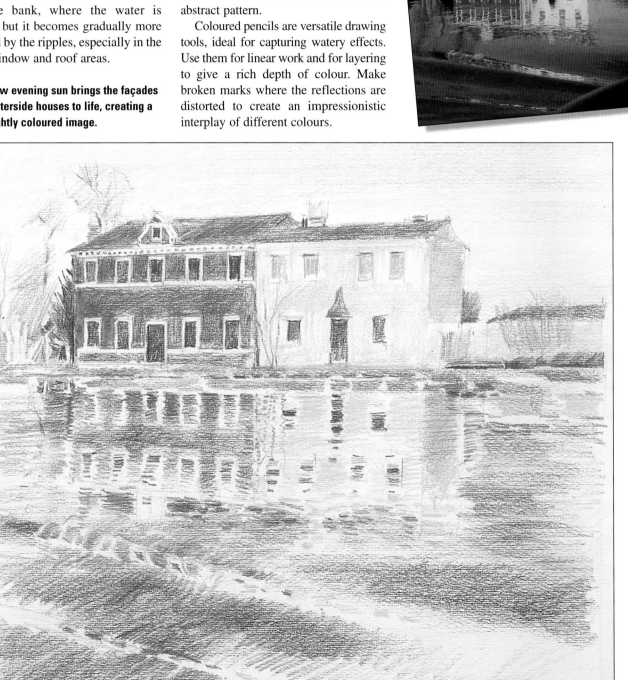

FIRST STEPS

1 ▶ Sketch the scene
Using a mid grey coloured pencil, put in the line of the bank, then draw the houses and outbuilding. Roughly indicate the trees. Now draw the reflections of the houses and trees directly underneath, describing the reflected windows with zigzag lines. Mark in the diagonals of the boat's wake in the foreground.

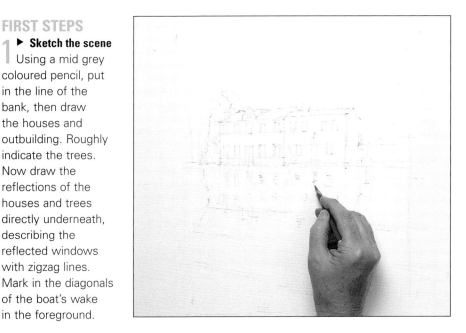

2 ▼ Introduce colour With a pale blue pencil, shade lightly over the sky and down into the water. Change to a pale lilac pencil and work across the sky to suggest clouds. Strengthen the sky above the houses with more pale blue.

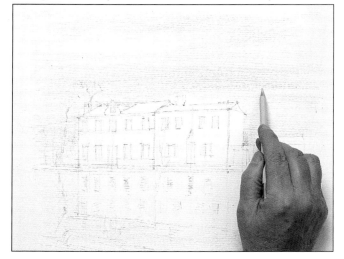

EXPERT ADVICE
Realistic reflections

If a house is set back from the water's edge, only its top part is reflected. Similarly, because the roof slants backwards, only the front edge is visible. Make sure you capture these effects to create a sense of recession.

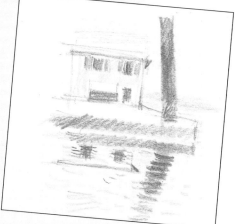

DEVELOPING THE DRAWING

As you begin to add colour, take care to show the differences between the houses and their reflections. In the reflections, the solid colours and firm lines of the façades are broken up, giving a feeling of movement to the water.

3 ▶ Work on the red house
Use a vermilion pencil to colour the wall and gable of the red house, working neatly around the windows. Take the same colour down into the reflection of the house, but this time use loose, hatched lines.

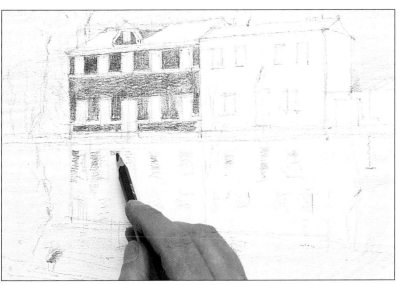

4 ▶ Layer some reds Continue shading the vermilion reflections, including the chimney, making looser marks where ripples of water break up the colour. Work, too, along the sliver of reflection visible in the boat's wake. Now create a more accurate colour for the house wall and its reflection by layering Venetian red, orange and then more Venetian red over the vermilion.

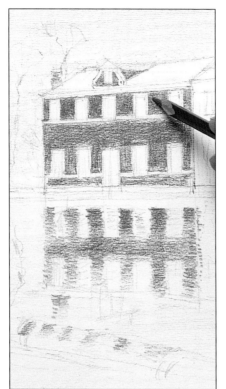

5 ▼ Colour the roofs Darken the water with cerulean blue, making loose, diagonal marks in the foreground. Now use Venetian red and deep olive green for the roof tiles. For their reflections, make broken marks to suggest the disturbed water. Show the tree on the left and the bank with deep olive green, then add their reflections.

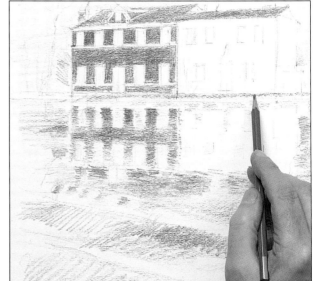

6 ▼ Work on the cream house Shade Naples yellow across the cream house and outbuilding, then layer very pale sap green on top. Work Venetian red on the roof of the outbuilding. Use the same colours for the reflections, making short, horizontal dashes of colour where the moving water distorts the image.

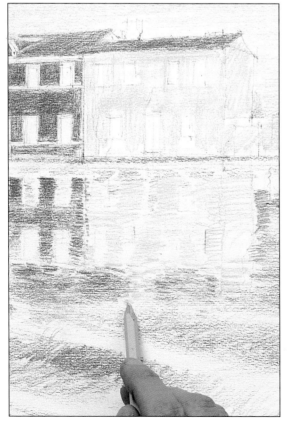

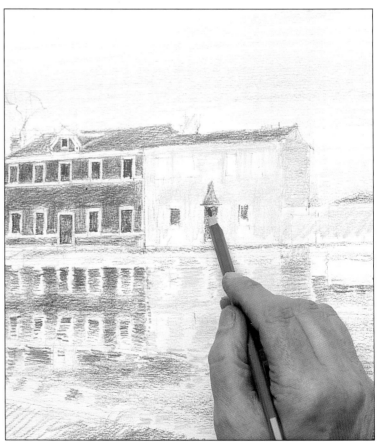

7 ▲ Put in some darks Strengthen the reflection of the cream house with more Naples yellow. Darken the shadowed side and reflection with deep olive green. Blend Prussian green and dark Prussian green to create an almost black shade for the doors and dark windows on both houses – use hatched lines for their reflections. Add a porch roof to the right-hand door with Venetian red.

8 ▼ Complete the windows On the right, work up the bank, trees and their reflections in raw sienna. Block in the upper windows of the cream house with pale olive green. Now hatch in the reflections of the lower windows, door and porch, using the two Prussian greens and Venetian red. For the distorted reflections of the upper windows, alternate bands of pale olive green and Prussian green.

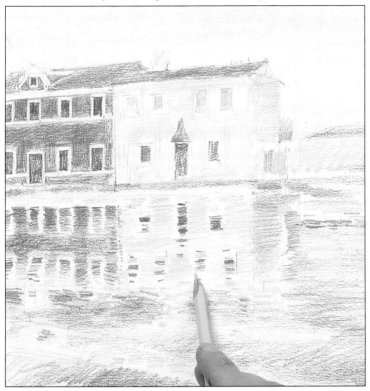

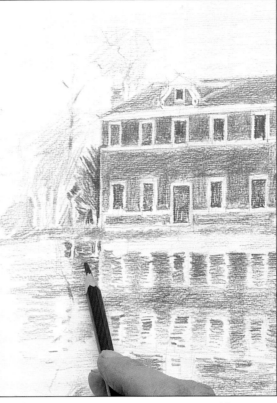

9 ▲ Define the trees With raw sienna, roughly indicate the trunks and bare branches of the trees on the far left. Then, using dark Prussian green, draw the diagonal branches of the conifer. Work up the reflections of the trees, using the same colours.

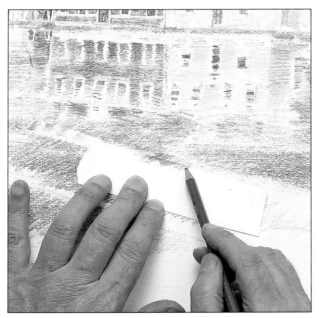

10 ▲ Darken the water Shade dark blue-grey across the whole water area. When you reach the boat's wake in the foreground, work over a strip of scrap paper to achieve straight edges along the shadows here. Layer cerulean blue over the dark colour, again using the paper strip along the wake.

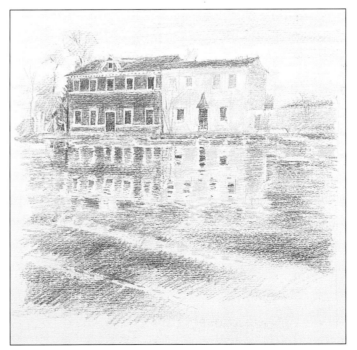

11 ▲ Add details Strengthen the reflections along the wake with Naples yellow and vermilion. Edge the bank with burnt umber, using raw sienna for its reflection. Draw a tree in front of the cream house, adding a reflection with dots and wavy lines, then hint at trees in front of the outbuilding with deep olive green. Decorate the eaves of the red house with burnt umber dashes.

A few extra colour accents will complete the drawing. Draw the pink-and-blue boat on the bank and add more colour where the houses are reflected along the wake.

12 **▼ Draw the boat** Using Venetian red, build up the trees to the right of the house and their reflections. Draw in the boat on the bank, using bands of deep rose and cobalt blue. Mark the boat's reflection with deep rose.

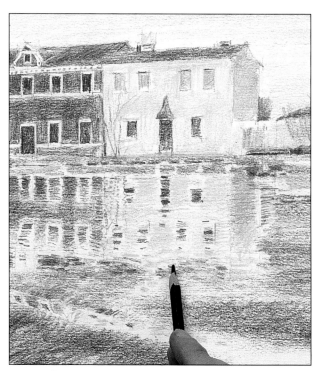

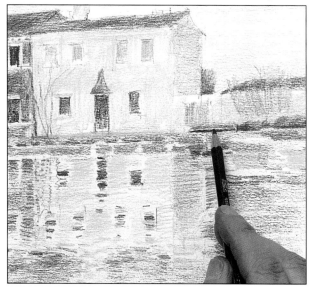

13 **▲ Develop the reflections** Shade over the end wall of the cream house with pale olive green, then define the windows and chimney with burnt umber. Work up the slivers of reflection with orange, Venetian red, dark blue-grey and Prussian green. Add touches of black to the broken-up reflection on the right.

THE FINISHED PICTURE

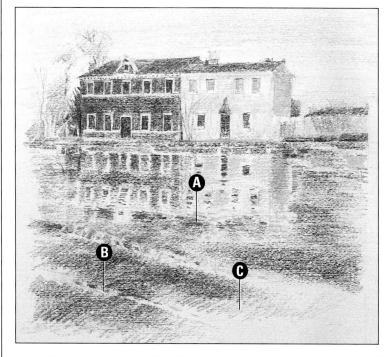

A Rippled surface
Dashed and dotted coloured pencil marks suggest the broken-up reflections of the roofs in the disturbed water.

B Abstract effect
The reflections along the line of the wake have been filled in with patches of colour that form a decorative, abstract pattern.

C Moving water
Diagonal, rather than horizontal, pencil lines in the foreground give the impression of movement in the water.

Painting the weather

During the nineteenth century, some of the great landscape painters became fascinated by the effects of light, atmosphere and, in particular, weather.

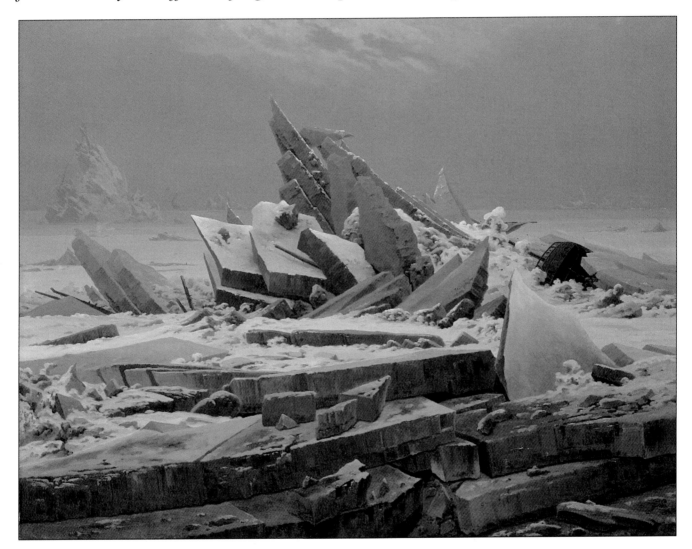

There's a fine tradition in painting the weather: as early as about 1500, the Venetian artist Giorgione (*c.* 1477–1510) depicted a thunderstorm with a flash of lightning illuminating the city in the background of his mysterious painting, *Tempesta*.

Dutch artist and theorist Karel van Mander (1548–1606), in his *The Book of Painters* (1604), advised artists to '...paint hazy atmospheres with sunbeams filtering through clouds and shining on towns and mountains, extreme conditions of thunder and lightning, storms at sea, snow, hail, gloomy weather, fog'. The painter was expected to refine his skills in observing nature's moods and then record them in the studio.

Romantic imagination

People's temperaments are affected by the weather – a sunny day lifts the spirits, rain can be depressing, swirling mist is rather eerie, snow can evoke a feeling of silence and solitude. Caspar David Friedrich (1774–1840) was a German artist romantically sensitive to shifting weather patterns. He wrote that his aim

▲ In *The Polar Sea* (or *The Wreck of Hope*) (*c.*1824), Caspar David Friedrich's crisp painting style helps to evoke the stark chill of the ice floe. Friedrich deliberately painted scenes such as these to evoke the emotions of desolation or loneliness.

was not 'the faithful representation of air, water, rocks and trees...but the reflection of [the artist's] soul and emotion in these objects'. A melancholy, reclusive man, he used landscape to convey his own feelings and, going further, gave natural elements religious significance.

crested waves and threatening clouds, flapping sails, sinking ships and men about to drown. In the words of art critic John Ruskin (1819–1900), it portrayed 'the utmost anxiety and distress, of which human life is capable'.

But his *Steamer in a Snowstorm* (1842), depicting a ship in distress – a mature work produced nearly 40 years later – is totally different in style. Gone are the heavy, almost architectural clouds and roughly pigmented surfaces characteristic of his earlier paintings. Instead, driving veils of mist lash the boat as it is sucked into a twisting vortex.

Impressions not details

In *Shipwreck*, the repeated shapes of waves, clouds and parts of the boat give the painting unity. In *Snowstorm*, however, the sweeping, circular rhythm of the swirling wind integrates the canvas. There are no details here, just the impression of a flag at the top of the mast and, below, the dark hull of the ship, battling with the elements.

Turner claimed that he had himself lashed to the mast of a ship for four hours in a storm before creating *Snowstorm*, just as he reputedly stuck his head out of a train window in the pouring rain to gain inspiration for *Rain, Steam and Speed* (1844).

Sketching outside

This practice goes back a long way but really took off in the nineteenth century. Turner's contemporary, John Constable (1776-1837), made detailed studies of clouds, but finished his works in the studio. The Impressionists were the first to claim that an outdoor sketch equalled a finished painting.

Pierre-Auguste Renoir (1841–1919) and Claude Monet (1840–1926) were two leaders of the movement. Unlike Friedrich, they considered subject matter and emotional content to be less important than capturing fleeting outdoor light effects. Renoir's *Boating on the Seine* (1878–80) is typical of the style. The canvas is barely primed and

His *Winter Landscape* (1811) shows an image of hope amid a hazy landscape of snow. A boy has thrown away his crutches and is praying to a vision of a crucifix set among the branches of a fir tree.

Subtly shifting colours

Friedrich used few pigments in *Winter Landscape*. He added grey to the pinkish dawn sky at the top of the picture and pink to the grey gloom below it, creating a subtle shift in the balance of colour from one area to the other. He achieved the see-through veil of mist by stippling with the point of his brush, using a blue pigment called smalt, which is transparent in an oil medium.

One common Romantic theme is to show the force of the elements overwhelming puny humans – see, for instance, the ship wrecked in the ice in the Friedrich painting on page 1632. The early paintings of English artist J.M.W. Turner (1775–1851) often feature weather-related disasters, particularly storms at sea. His *Shipwreck* (1805) shows a chaotic scene of huge-

often shows through, contributing to the overall lightness of tone. The picture shimmers with sunlight, created by unblended intense colours applied directly from the tube and placed side by side.

Dazzling complementaries

Using just lead white and seven pigments, Renoir played with complementary colours to dazzling effect, setting the chrome orange rowing boat against the cobalt blue river. But for all the Impressionists' claim of out-of-door spontaneity, they did, as here, usually plan their paintings and often finished them off in the studio.

Renoir's *The Gust of Wind*, below, is so convincing that the viewer can almost feel the breeze. The clouds scud across the sky in multi-directional daubs of grey and white. Strokes of impasto paint – some smudged, others left separate – give the sensation of the wind catching one area, then another. These alternating

▼ **Renoir's *The Gust of Wind* (*c*.1878) is a truly remarkable painting – he seems to be less concerned with the appearance of the landscape than the sensation of being in it.**

light and dark areas convey shadows racing across the field and woodland, as the sun goes in and out behind the clouds.

Monet's method

Monet developed a different method. He began to work simultaneously on many canvases with the same subject matter. He could then record his experience of the overall atmospheric effects, resuming whichever canvas was most suited to the light, weather and season. This way, he turned to his advantage the

inbuilt drawback of Impressionism: trying to convey momentary weather effects via the lengthy process of painting. His *Grainstacks* is one such series, and it is fascinating to see how different his palette and treatment is for sun and snow, winter and summer.

Pure Impressionism was as fleeting an artistic movement as the light effects it tried to recreate. However, its impact – together with that of Friedrich and Turner – was a major influence on the art of the twentieth century.

Working in watercolour

Watercolour is probably the most convenient medium for outdoor landscape painting. Working wet-on-wet can give an excellent impression of haze, clouds and swirling mists.

In contrast, sharp-edged washes of paint can give an impression of strong sunlight. Make sure you adjust your palette as well – the colours on misty or overcast days are much more muted than on sunny ones.

Try painting a series of images of the same subject in all weathers. If you don't want to be out in the cold and wet, find a scene you can paint through a window.

Seasonal palette – spring

A palette for springtime foliage should reflect the beautiful translucent greens of new leaves as well as the sunny yellows of flowering bulbs.

The green shades of spring are exceptionally fresh and vibrant. To capture them accurately in your painting, colour mixing should be kept to a minimum. Remember, the more colours you add to a mixture, the duller and more subdued the result will be. It is a good idea to limit your mixtures to no more than three colours although, in practice, most spring greens can be mixed from simple two-colour combinations of one blue and one yellow.

Alternatively, why not introduce one of the manufactured greens into your spring landscape? Depending on the subject, there is a good selection of strong, vivid colours to choose from.

Mixing greens

The majority of greens in a spring landscape contain a lot of yellow. Early flowers – including daffodils, forsythia and many crocuses – are also predominantly yellow in colour.

Later in the year, the emphasis changes. Summer flowers bloom in many different colours, and the foliage becomes darker with increased amounts of blue and other shades creeping into the leaf mixtures. But for the first fresh leaves of spring, yellow is dominant in the garden and countryside and, as such, is one of the most significant colours on the landscape artist's palette at this time of the year.

Important yellows

Cool, acid yellows are particularly useful for springtime subjects because, when mixed with blue, they create the sharp greens that are so characteristic of fresh leaves. The coolest yellows on the artist's colour wheel are those with a blue bias. A selection for your palette could include lemon yellow, cadmium yellow pale, Winsor lemon, cadmium lemon and aureolin.

Depending on the blue they are mixed with, these yellows will produce a range of the cool, vivid greens found in a typical spring landscape. The blues used in the watercolour of the verdant garden shown opposite are ultramarine, cerulean blue and phthalo blue, but it is worth experimenting with other blues to extend your repertoire of greens.

Golden yellows – those with a red bias – produce warm or subtle greens, depending on your choice of blue. Such yellows include cadmium yellow deep, Indian yellow and yellow ochre.

For the garden scene, our artist chose cadmium lemon as a cool yellow, mixing it with one or other of the blues on the palette to make the pale greens in the foreground. For the warmer greens and yellow flowers, yellow ochre was added or used instead of cadmium lemon.

Bought greens

As a general rule, a mixed colour is more easily integrated into a composition than a single colour used directly from the tube. This is particularly so with bought greens, which can be strident and stand out from the natural colours of a rural landscape.

However, fresh spring foliage is often so bright that it really does show up against the surrounding colours. With such a subject, breaking the rules can pay off and a few splashes of a clear, brilliant green, applied unmixed, will capture this dramatic effect exactly.

Palette for new foliage

This selection of watercolours in greens, yellows and blues provides all the colours you need for the fresh new foliage and flowers in the garden picture (opposite). The two green colours, sap green and viridian, were used neat in places. However, the main bulk of foliage was created by mixing the two yellows with the three blues to create a range of subtle, harmonious greens.

Sap green **Viridian** **Cadmium lemon** **Yellow ochre** **Cerulean blue** **Ultramarine** **Phthalo blue**

GARDEN IN FIRST LEAF

The palette shown on the opposite page was used to achieve the range of greens in this watercolour garden. Pale foliage and flowers in the foreground were painted thinly to allow the white paper to show through. Deeper greens were achieved by using stronger colour mixes with the addition of gum arabic to enhance the paint surface.

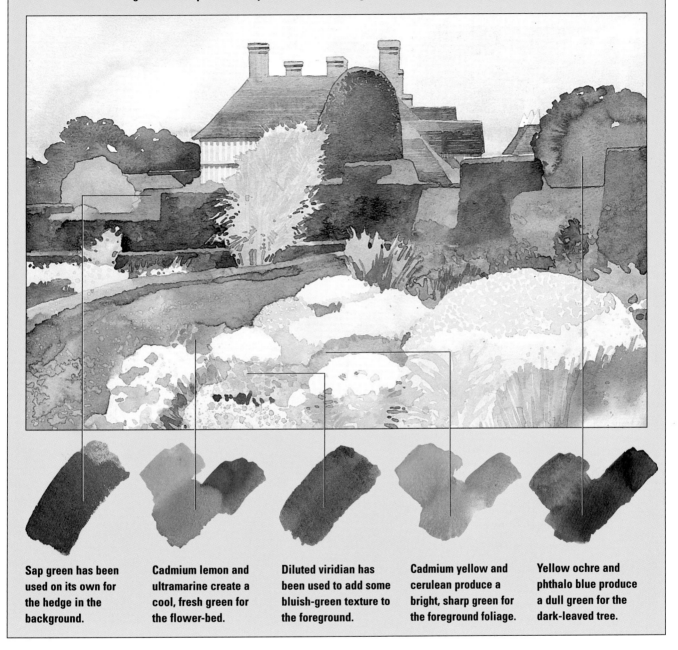

Sap green has been used on its own for the hedge in the background.

Cadmium lemon and ultramarine create a cool, fresh green for the flower-bed.

Diluted viridian has been used to add some bluish-green texture to the foreground.

Cadmium yellow and cerulean produce a bright, sharp green for the foreground foliage.

Yellow ochre and phthalo blue produce a dull green for the dark-leaved tree.

Useful bought greens include emerald, phthalo green, sap green and green-gold. Viridian is also an option, but this must be used in very small quantities. Applied on its own, it can dominate the composition.

In this painting, the hedges and many of the background plants are painted in varying tones of pure sap green. Instead of adding a darker pigment for the shadows, which could dull the colour, gum arabic is mixed with undiluted sap green to create areas of deep green shadow in the hedge.

Transparent colour

Lit by the low sunlight of early spring, colours can appear particularly bright and luminous. With watercolour, you can capture this translucent effect perfectly by applying the paint in a thin layer, so that the white paper shows through the wash of colour. Avoid using white paint in a spring landscape. Adding white to watercolour tends to produce a chalky, opaque effect – particularly unwelcome when you are striving to capture the fresh, sunny colours of spring. To create white flowers and highlights, do as the artist has done in this picture and leave these as patches of unpainted white paper.

Bluebell woods

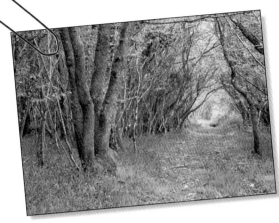

Bluebells are often seen as delicate flowers, but the use of acrylics gives an opportunity to play up the boldness of their colour.

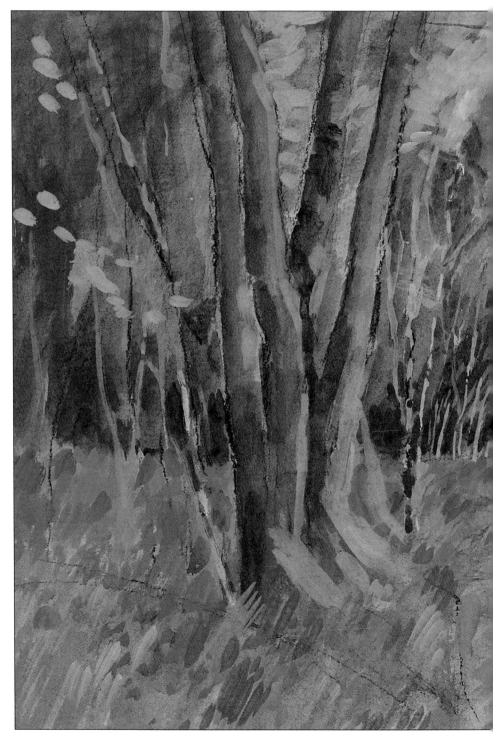

A haze of bluebells in the dappled light of a shaded wood is the essence of an English spring. Watercolour would be the first choice of many artists for such a scene, but acrylics can present the flowers in a different light, emphasising their strength of colour rather than the delicacy of their forms.

Acrylics can be used to build up washes, just like watercolour. Used in this way, they dry within ten to 15 minutes. And once a wash is dry, you can lay another one on top without picking up colour from underneath.

Paint an impression

At first sight, this woodland scene may seem complex, but the trick is to simplify it and paint an impression, rather than be overwhelmed by detail.

Try looking at the scene with half-closed eyes to screen out detail and help you see the picture as blocks of colour and shape. If you use this technique, each area can be treated first as a broad mass and then shadows and highlights added to suggest form.

A warm ground

A particular feature of this painting is its use of a warm ground. Traditionally, a ground was used for both visual and practical reasons. It gives a picture unity, and in this case the choice of red oxide creates a rich, atmospheric 'glow'. In practical terms, a ground stops the paint being absorbed into the paper and helps keep the colours true.

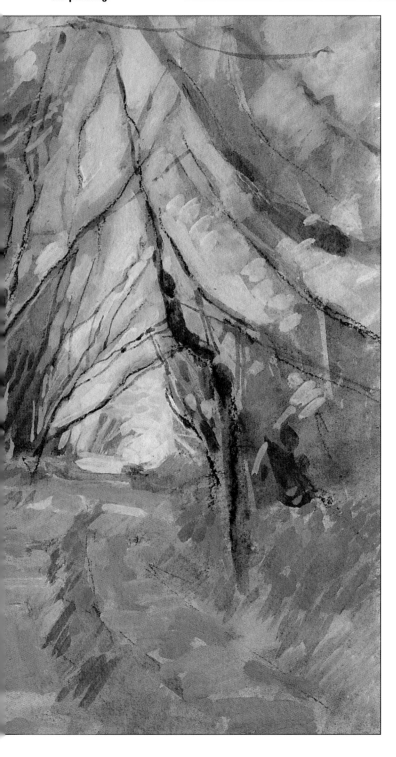

▼ In this scene, the track was given more prominence so as to emphasise the archway formed by the trees, the focal point of the painting.

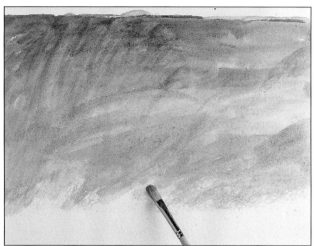

FIRST STEPS

1 ▲ Lay down the warm ground Mix red oxide acrylic with water on a stay-wet palette and use a No.5 filbert brush to lay down a wash. Roughly scrub on the paint in all directions for a textured effect. Leave to dry.

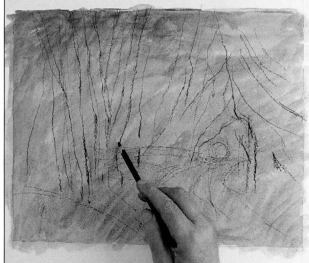

2 ▲ Rough in the preliminary sketch Use a well-sharpened charcoal pencil to block in the main features of the composition, including the sweep of the bluebell carpet, the arch of trees in the distance and the thick tree-trunks in the foreground. Keep your sketch simple and look for negative shapes. Use a putty rubber to adjust your lines if necessary.

49

DEVELOPING THE PICTURE

Once the wash has been laid down and the composition roughed in, you can begin to underpaint the main blocks of colour in the picture.

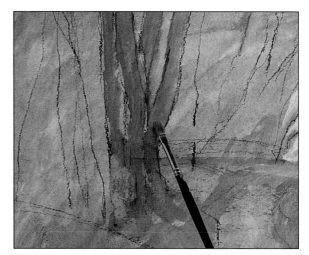

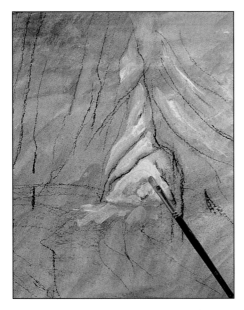

3 ◄ **Define the centre of interest** Change to a No.3 flat brush and mix titanium white, primrose yellow and a little cadmium yellow medium. Begin to underpaint the light areas, including the arch of trees that forms the focal point of the picture. Keep the strokes free and scrub on the paint for a textured effect. Leave to dry.

4 ▲ **Establish the foreground** Add chromium oxide green and raw sienna to the yellow mix, then block in the swathes of bluebell leaves. Add brilliant blue to this mix to make a brighter green and dab patches of this on top of the previous wash. Add more raw sienna to the original green mix and paint the large tree-trunks.

Master Strokes

Karl Buchholz (1849–89)
Early Spring at Weimar

The trees in this unusual landscape are painted with a light and delicate, yet realistic touch. Slim tree-trunks rise gracefully towards the sky, their branches forming a beautiful lacy pattern against the pale haze. Cast shadows link one tree to another, taking the eye across to the slanting path that leads from the copse in the foreground to the wide open spaces in the distance.

Pale greens and yellows are used in the cloud mixes, helping to create a sense of harmony with the landscape.

Distant trees are portrayed with sketchy trunks and branches. The foliage is added with sparse dry brushwork.

The slender silver birch trees, with their pale tone and detailed rendition, stand out in the foreground.

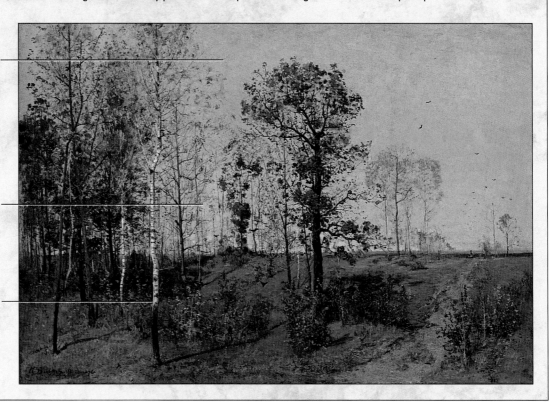

5 ▼ Create the woodland Rough in the woodland with a mix of Payne's grey and red oxide. Use a stronger mix of the same colours for the shadowed areas.

7 ▼ Define the trees Add titanium white and a little brilliant blue to the pale yellow mix from step 3 and use a No.1 flat to underpaint the foliage. Apply the original green mix to bring out the leaves. With a No.7 round sable brush and a mix of red oxide and Payne's grey, define the thin branches.

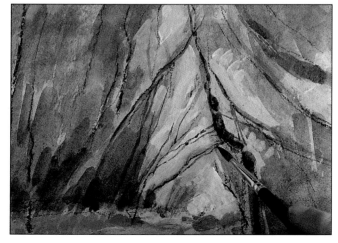

6 ▼ Underpaint the bluebells Use the original green mix from step 4 and a No.1 flat brush to highlight the foreground trees. With a mix of deep violet, red oxide and Payne's grey, deepen the shadows in the trees. Change to a No.6 flat and use a mix of deep violet, cobalt blue and titanium white to underpaint the bluebells.

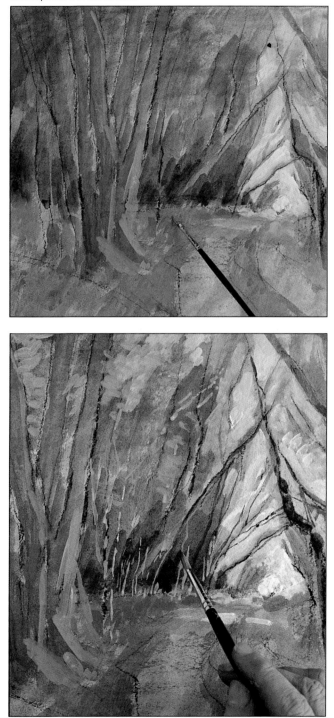

8 ▲ Build up detail Blend the original yellow and green mixes with titanium white and cadmium yellow medium. With short strokes of the No.1 flat, dab in more leaf texture. Add brilliant blue and continue building up the foliage. Change to the No.7 round brush and use a pale mix of titanium white with touches of chromium oxide green and raw sienna to put in the spindly birch trunks.

9 ▼ **Paint bluebells** Using the same pale mix, dab in dappled light on the track. Add shadows to the large trees with a Payne's grey/raw sienna mix, then combine Naples yellow and raw sienna to paint more fine trunks. Mix cobalt blue, deep violet and white and work up the bluebells with a No.3 flat. Then dab on a cobalt blue/white mix, followed by deep violet combined with the original bluebell colour.

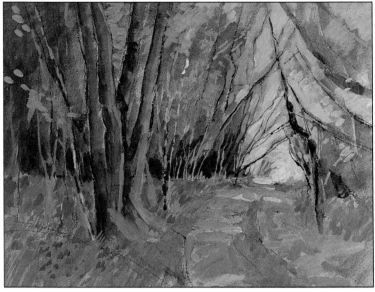

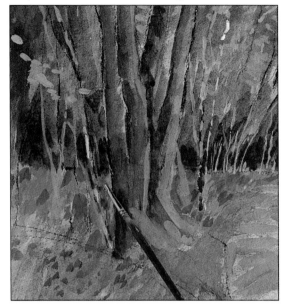

10 ▲ **Differentiate the greens** Mix together primrose yellow, titanium white and a little of the bluebell colour mix from step 9. With the No.3 flat brush, work up some detail under the arch. Add raw sienna to the green and use the No.7 round brush to paint some of the negative spaces behind the branches here. Darken the green with brilliant blue and use to work up the green on the thick foreground trunks.

Express yourself

An impression in pastel

In this small sketch, worked in oil pastels, the contrast between light and shade and bright and dark colours has been played up to give a vibrant impression of the woodland scene. The main areas of colour, such as the greens around the arch of trees and the blues of the flower carpet, have been blocked in with rapidly hatched pastel marks. Bold yellows pull the eye towards the archway in the distance.

Some of the fine branches are drawn using the thin edge of a pastel stick; other slender trees are scratched out from the background pigment with a craft knife – a technique known as sgraffito.

A FEW STEPS FURTHER

The painting makes a strong and striking landscape, but a little more attention to detail will strengthen the foreground and give the composition a greater feeling of recession.

11 ► Add detail to the track
Using the No.3 flat brush and cobalt blue mixed with raw sienna, bring out the detail of the bluebell foliage on the track with short, quick brush strokes. Add titanium white to primrose yellow and dab in some highlights.

12 ▲ Add deeper shadows Using the No.7 round brush and a mix of red oxide and Payne's grey, darken the shadows among the dense, thin birch trees to the left of the archway.

THE FINISHED PICTURE

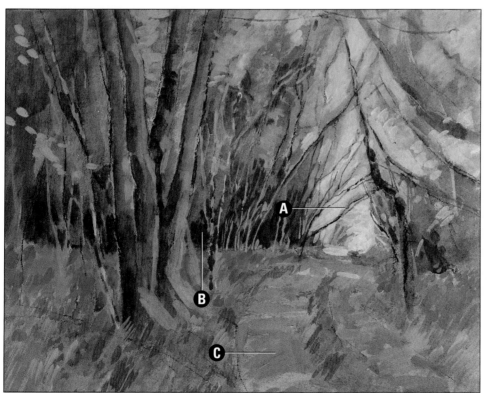

A Birch thicket
The charcoal lines of the original sketch are still visible and help create the effect of a tangled thicket made up of slender trees.

B Dark spaces
Emphasising the dark, negative spaces in the distance helps throw the tree-trunks forward.

C Leading lines
The strong lines of the track lead the eye to the focal point – the archway. And the red earth of the track echoes the colour of the trees.

Painting trees

If you want to paint successful landscapes, you need to be able to render trees confidently and convincingly.

Beginners often find trees difficult because they are intimidated by the web of tiny branches and thousands of leaves. The best approach is to ignore all such details and to treat a complete tree just like any other subject – as a mass of shape, colour and tone.

Tree shapes

Get to know the different species, if necessary by looking them up in a good reference book. Although trees are organic forms and, as such, individually unique, different species have characteristic shapes which often make them recognisable from a distance.

For example, poplars and cypress trees are tall and tapering with dense foliage; most fir trees have a distinctive triangular shape, with spiky branches through which the sky or background can be seen; and the branches of the Scots pine flare upwards like a fan.

Rather like the human figure, a tree has a skeleton which dictates the shape and form of the whole. Studying the winter 'skeleton' of trees that lose their leaves will help you understand the shape of a summer tree covered by thick foliage.

When painting or drawing deciduous trees in winter, it is a good idea to start with the main trunk and larger branches. As these have a visible solid form, you can make sure the shape and scale are correct by relating them to the rest of the composition. At this stage, you may also find it helpful to make a fine pencil outline of the overall tree shape. This will be a useful guide when you move on to paint the branches and twigs.

Effective brushwork

It is generally easier and more effective to paint each twig or branch as a single brush stroke. This gives you control over the width of the branches and allows you to paint flowing, natural lines. Use increasingly smaller brushes as you move outwards from the main trunk towards the finest branches.

Tapering twigs

A rigger brush is particularly useful for painting the tapering twigs at the tip

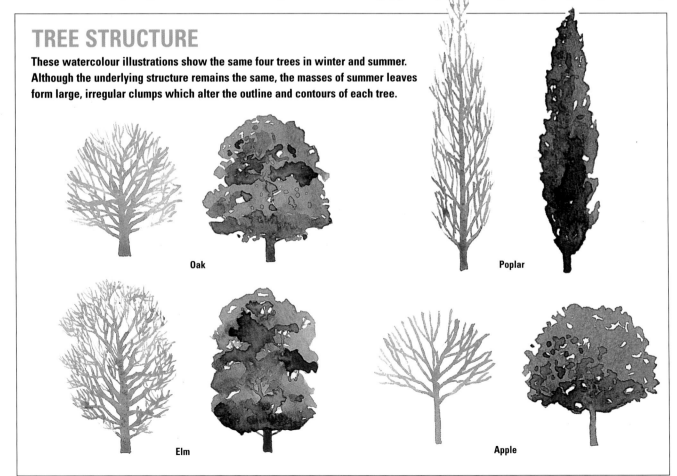

TREE STRUCTURE

These watercolour illustrations show the same four trees in winter and summer. Although the underlying structure remains the same, the masses of summer leaves form large, irregular clumps which alter the outline and contours of each tree.

Oak

Poplar

Elm

Apple

of each smaller branch. You can make the trees look three-dimensional rather than flat by painting the background branches in paler colours.

On deciduous trees, the shape remains the same, but in summer a mass of leaves hides most of the branches, so you cannot see the structure. There is no one 'right' way to paint tree foliage, but it is important to paint what you see, not what you think you know is there.

Simplifying the subject

Forget about the leaves and try to capture the overall shape and form – especially when you are painting trees from a distance. Simplify the subject into broad areas of colour and tone. If you find this difficult, look at the subject through half-closed eyes. This trick eliminates the detail and makes the main tones and colours much easier to pick out.

You can then create an impression of detail and texture by the way in which you apply the paint. Conventional brushwork is not necessarily the best way to capture the fullness and billowing appearance of most trees. Depending on the medium, the type of tree and the effect you want, there are any number ways to paint convincing and realistic foliage. It is worth experimenting with stippling, knife-painting, masking and sponging techniques.

WORKING IN ACRYLICS

Acrylics provide a new set of possibilities when painting trees. You can attain a real sense of solidity by building up pale colours over dark ones, or try for some textural effects by applying paint with a sponge.

▶ KNIFE-PAINTING
This tall poplar was painted with a small knife. The greens are simplified into three tones – dark, medium and light.

▲ MASKING
The chunky patches of light and shade on this oak were created by using paper shapes to mask off parts of the tree. The irregular torn edges give the shapes a natural look.

▶ SPONGING
The dappled light on this horse chestnut was achieved by applying paints with a natural sponge.

TECHNIQUES FOR WATERCOLOUR

◀ WET-ON-WET
The main masses of foliage of this elm tree were painted in diluted green. While the initial wash was wet, a darker mix of the same colour was flooded in to create shadows on the underside of the foliage.

▶ STIPPLING
Watercolour was applied with stippling technique to create this Italian cypress. The process allows the artist to build up the dense foliage in solid green yet give the tree a soft leafy outline.

◀ PRINTING WITH CARD
The distinctive spiky branches on this fir tree were painted with a piece of card. The edge of the card was dipped in the paint and the colour then printed on to the support.

▶ ROLLED BRUSH
This pine tree was painted by dipping a soft brush in diluted colour and then rolling the brush across the support to pick up the texture of the paper.

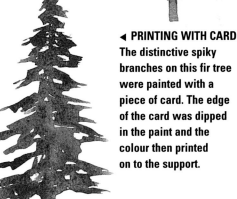

The big picture

Make a dramatic statement by drawing on a very large scale.
This coastal scene lends itself perfectly to the big treatment.

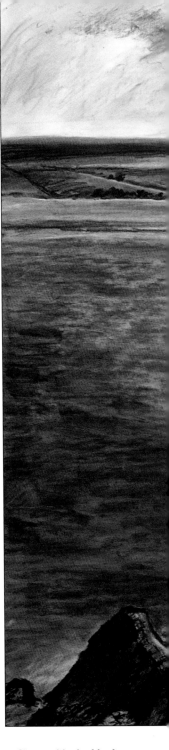

One simple method to produce radically new and different results is to work on a large scale. To create this coastline scene, a piece of watercolour paper measuring well over a square metre was used.

Energy and expressiveness

With a support of this size, you have to stand, kneel, move from one side to another, and work from the shoulder and elbow rather than the wrist. The process is extraordinarily exhilarating, and the end product will have an energy and expressiveness that is rare in smaller works.

Remember, the size you work at will be dictated by practical considerations. Assess the space you have to work in and measure the wall you are going to attach the paper to. Also check at your art-supply shop to see what size of support is available – you can order large rolls of watercolour paper but these are expensive.

From little to large

It is a good idea to start from a photograph or, better still, a very small drawing of a location with which you are familiar. Because a small drawing or a photograph can contain only a limited amount of information, you will be forced to rely on memory and experience. Eventually the drawing takes on a life of its own and you'll find that you are having a dialogue with your own creation, the marks you have already made indicating your next move.

When you are working on a large scale, it is important to find a composition that works. Start by making a series of thumbnail sketches in which you analyse the distribution of lights and darks, and explore the underlying geometry of the image. If your composition is solidly constructed, the elements will slot together easily and the final image will hang together well.

The drama of darkness

The step-by-step project on the following pages is based on a photograph of cliffs jutting into the sea. The cliffs are in shadow and this emphasises the drama – they are seen as dark shapes looming against the lighter areas of the sea and the beach it washes on to.

The artist decided to crop sections from both sides of a wide-format photograph (above left). This focuses attention on the cliffs and gives an approximately equal division between light and dark areas. It also places the top of the farthest headlands roughly halfway up the picture area, while the edge of the nearest headland splits the picture area in half vertically.

The dark clouds and sheets of rain are not in the reference photo, but the artist felt they would give the image a slightly unsettled, threatening atmosphere and improve the composition. They create a progression from light to dark at the top of the painting that helps lead the eye. The slanted rain also echoes the slant of the cliffs.

Versatile charcoal

Charcoal is a wonderfully responsive medium and ideal for working quickly and on a big scale. You can use the side of a chunky stick to apply broad swathes of colour and build up tone at speed, while a thin stick of willow charcoal can be used to make more precise marks.

Charcoal can be blended and softened to give a veil of pale grey or built up to create passages of velvety black tone. It is also a very forgiving medium – you can knock it back with a cloth or sponge or lift it off with a putty rubber to reveal the crisp white of the support. Furthermore, the medium can create rich textures and deep, dark calligraphic lines.

▲ Charcoal is the ideal medium to render a dramatic sweep of a stretch of shoreline. The broad, deep velvety tones used for the rain clouds and shadowy cliffs create a brooding atmosphere, while the finer marks used for the grass add textural interest.

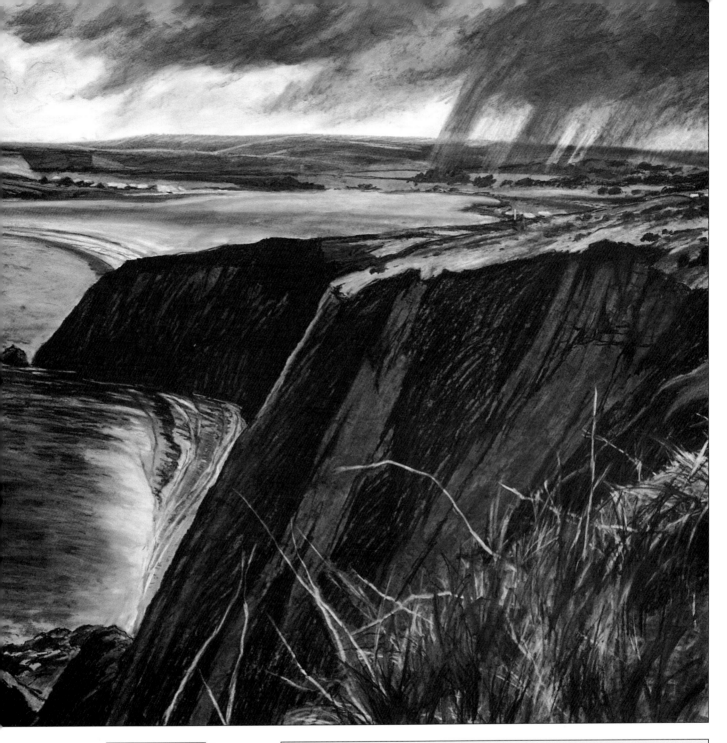

MARKING KEY POINTS

When you are working on a large scale, start by establishing some key points so that you have some reference marks within the picture area – otherwise the composition may go adrift. Use a ruler to take some measurements from the reference picture and plot them accurately on the drawing, ticking them in with a thin piece of charcoal.

FIRST STROKES

1 ▼ Sketch the outlines Pin or tape a large piece of paper to a wall to give you a firm working surface. Place your sketch or photograph close by for reference and take some key measurements (see page 1984). For example, the base of the far cliff lies halfway up the picture area and the horizon is about a quarter of the way down from the top of the picture. Using thin willow charcoal, tick in the horizon and the shapes of the cliffs.

2 ▼ Develop the underdrawing Complete the underdrawing, indicating the grass and rocks in the foreground. The slope of the near cliff provides an energetic lead-in to the composition, while the uninterrupted horizon provides a barrier that prevents the eye from wandering out of the picture space. If necessary, make adjustments by rubbing out with a cloth or tissue.

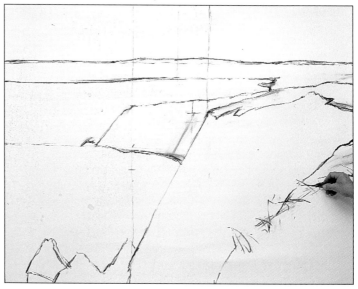

3 ▼ Apply graphite powder Graphite powder is useful for quickly blocking in large areas of light, even tone. It is grey rather than black so is less dominating than charcoal – use it in the early stages, before you want to commit yourself. Put some graphite powder on a plate, dip a sponge or tissue paper into it and apply the powder with a bold, sweeping gesture. Block in the main areas of dark tone on the shaded cliff face.

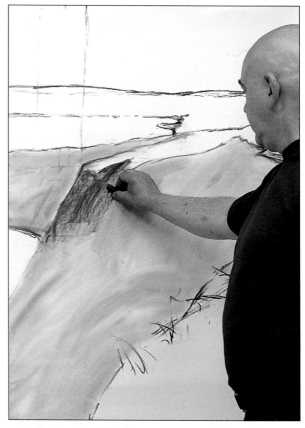

4 ▲ Darken the cliffs Once you are satisfied with the shapes of the cliffs within the picture area, make them more emphatic by applying charcoal. First, use a thick stick of willow charcoal on its side to block in the near cliff – make strokes that follow the fissures in the rock face. Notice that the charcoal picks up the dimpled texture of the watercolour paper.

5 ▶ Blend the charcoal
Use a small natural sponge to soften and blend the charcoal on the near cliff. Work lightly with sweeping strokes that follow the form of the rock face, creating a rugged texture.

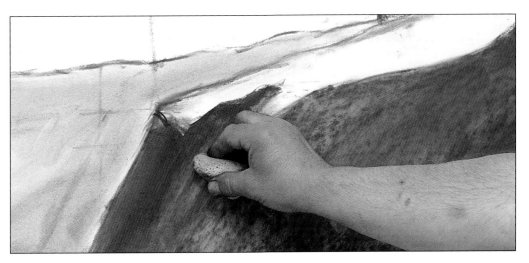

6 ▼ Complete the cliffs Now block in the far cliff with charcoal and soften it with the sponge as before. The dramatic shapes made by the two headlands are the focus of the image. Stand back and study them carefully, then, if you are satisfied with them, block in the rocky outcrops at the foot of the near cliff.

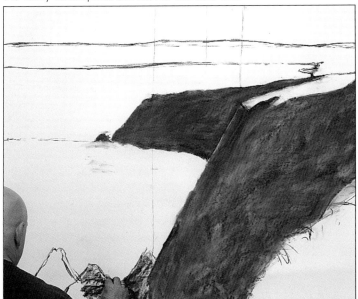

7 ▲ Suggest the grassy foreground Use your fingers to draw with the charcoal powder. Working from the edge of the blocked-in cliff, pull and flick out strands to suggest the edge of the grassy area in the immediate foreground.

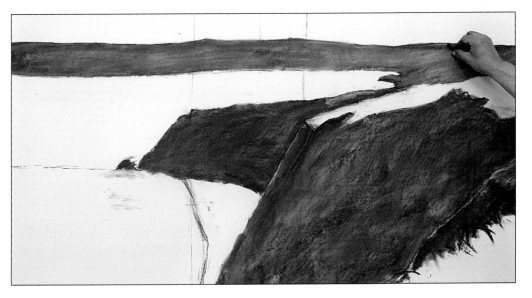

8 ◀ Continue blocking in The narrow band of land in the distance links up with the cliffs in the foreground to create a single shape that encloses the light sea. Using a thick stick of charcoal on its side, fill this area with sweeping horizontal marks – for the moment, keep it darker in tone than it actually is to link it to the foreground and draw attention to the shapes and patterns within the subject.

9 ▶ **Rough in the vegetation** The area of coarse grass in the foreground draws the eye and creates a sense of recession. Lay the charcoal on its side and suggest clumps of grass by passing the stick lightly over the paper surface in the direction of growth. The broken character of the pigment introduces an impression of light into the image. Use the tip of the charcoal to add linear marks that suggest individual stems of grass.

10 ▼ **Establish the sea** Apply charcoal over the sea with the side of the stick, blending the pigment with your fingers as you go. Use undulating marks that establish the horizontal plane of the sea. Add tone to the beach.

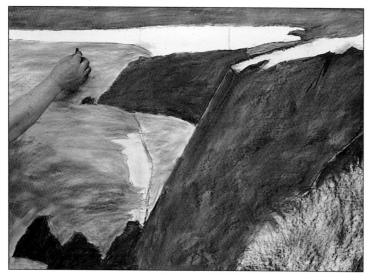

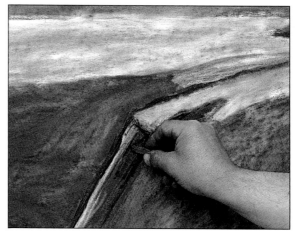

11 ▲ **Apply tone to the tops of the cliffs** To ensure that the separate parts of the image knit together, keep the entire picture progressing. Apply a light tone to the sandy area in the distance and to the top of the cliffs – they immediately become part of the landscape rather than abstract shapes. Crisp up the cliff edges and define the ridges in the rock with linear marks.

Express yourself
Reducing the scale

The same composition is rendered here in water-soluble coloured pencils and on a much reduced scale – it measures only 17 x 23cm (7 x 9in). This picture has an entirely different impact. At this size, the marks are more subtle and less expressive. There are no rain clouds and most of the tones are lighter. Bright colours give a summery feel and the blue sky lightens the mood. Notice how complementaries – purple and yellow – liven up the cliffs and how the lightly blended blue and green make the sea's surface shimmer.

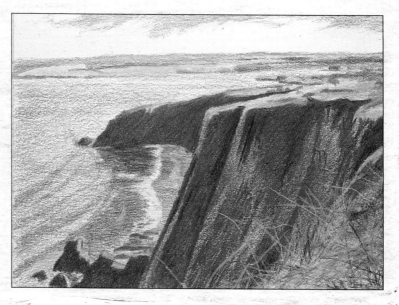

DEVELOPING THE PICTURE

Once you are happy with the balance of the composition, start to add details and adjust tonal relationships to create a sense of space. Stand back frequently to view details in the context of the drawing as a whole.

12 ▼ Indicate the sky With the sponge you used in step 5, suggest the sky – the charcoal powder picked up when you were softening the tones on the cliff will provide enough tone for the sky. Work in all directions and vary the pressure to create the effect of clouds.

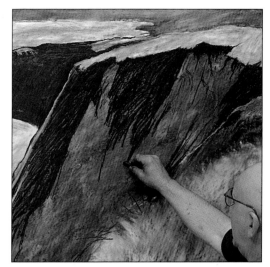

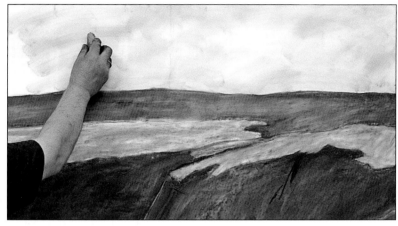

13 ▲ Work on the cliff face Using the side of a stick of compressed charcoal, work over the far cliff to create a velvety black shape. Then use the same stick to work over the near cliff face with a mix of line and tone. Use free, linear marks to explore the surface of the rock, indicating some of its fissures and ridges.

14 ◄ Develop the foreground textures Using black and grey compressed charcoal sticks, build up a web of lines and marks to suggest the intricacy of the rock face and the tangled vegetation. Don't draw every crack in the rock or every blade of grass, but use a generalised texture that will read at a distance.

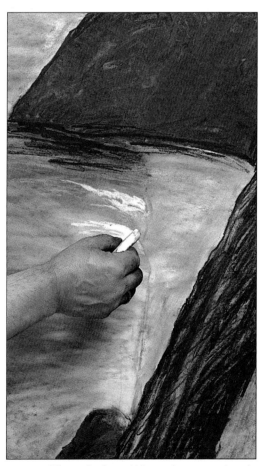

CHANGE DARK TO LIGHT

You can lighten dark areas of charcoal by using a putty rubber. Here, the rubber is pulled gently across the cliff face to lighten its tone. Twist the soft rubber to give a point for fine work. If the rubber gets clogged with charcoal dust, rub it on scrap paper or slice off a sliver with a craft knife.

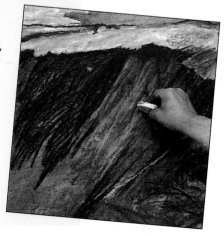

15 ▲ Lift out the foam Where the waves break on the shore, apply a clean putty rubber to the surface of the support and pull off the charcoal by exerting pressure on the rubber and then twisting and lifting it. This creates white foam and spray at the water's edge.

16 ▼ Add more details Use the rubber to pull out more whites around the two bays. Darken the horizon. Use a thin stick of willow charcoal to draw tide marks around the far bay and add details to the cliff top and fields, then develop the cliff face richly with black compressed charcoal.

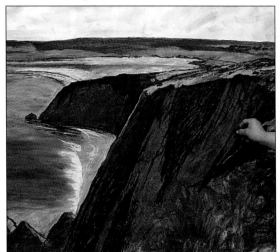

17 ▶ Add lights to the foreground Use the putty rubber to draw light into dark in the foreground vegetation. Using a clean point or edge of the rubber, press it on to the paper and pull it with a flicking gesture, following the growth patterns of the grasses and twigs. Turn the rubber to present a clean surface to the paper and repeat. If the rubber becomes clogged with charcoal, clean it as described in Trouble Shooter (see page 1988).

Master Strokes

Ivon Hitchens (1893–1979)
Landscape, Bracken-Fringed Path to a Wood

This scene by British landscape painter Hitchens borders on the abstract, evoking – in a highly personal way – the feel of a walk through the woods. The path, trees and bracken are treated as loose blocks of cheerful colour that convey a sunny, uplifting feeling, and plenty of the white support is left showing through to lighten the mood further. The wide format is typical of Hitchens's style.

© Jonathan Clark Fine Art

Shapes can convey mood – here, gently curved blocks of colour convey a feeling of peace and tranquillity.

Four vertical marks break through the horizontal bias of the composition, adding an element of contrast.

Paint scratched off to reveal the white support creates graphic lines and textural effects in the foreground.

18 ▼ **Work into the headland** Indicate foreground grasses with a thin stick of charcoal. With the putty rubber, refine the rough ground on top of the cliff, using light pressure to create mid tones.

19 ▶ **Add more foreground detail** Twist the putty rubber to form a point and add more light details in the foreground. The calligraphic lines are both descriptive and decorative.

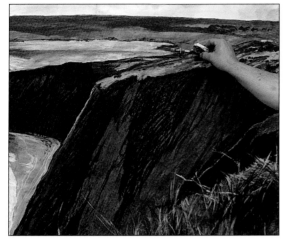

20 ▼ **Soften the tones** Some of the charcoal marks are too emphatic and leap forward unnaturally. Use a stump to blend them, so that they sit comfortably with the rest of the drawing.

21 ▲ **Draw more rocks** Using black compressed charcoal, draw the rocky outcrop behind the pointed rocks, then darken the rocks themselves with strong lines.

22 ◀ **Scumble in the sky** The sky encloses and completes the landscape, and also sets the mood. The clouds are an important part of the composition, leading the eye across the painting. Using the black compressed charcoal stick, make the sky on the right dark and overcast, becoming gradually lighter on the left.

23▼ **Soften and blend the sky** Work over the scribbled sky with the putty rubber, softening and blending so that the individual marks disappear.

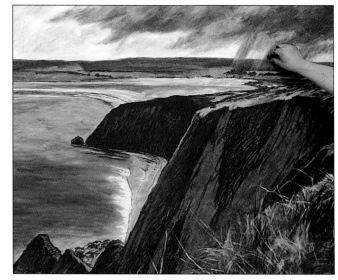

24▲ **Suggest rain** Place a thick stick of charcoal on its side and make a series of dragging downstrokes to indicate rain slanting across the distant countryside.

25◀ **Add tone to the sea** Lightly skim the charcoal over the surface of the sea to add texture and create shadows of the rain clouds above. The waves breaking in the bay are distractingly white – soften them by smearing charcoal over with your fingers and the stump.

A FEW STEPS FURTHER

Add finishing touches to bring the drawing into sharper focus – but resist the temptation to overwork the image. Drawing on a large scale forces you to make bold marks and to invent what you can't see in the original. Retain the freshness of this approach by being selective about the final adjustments.

26▼ **Add distant details** With the putty rubber, indicate roads and buildings on the far side of the main bay. Use a light touch – you need only the slightest suggestion here. The details enliven this area and provide tonal links with the rest of the image.

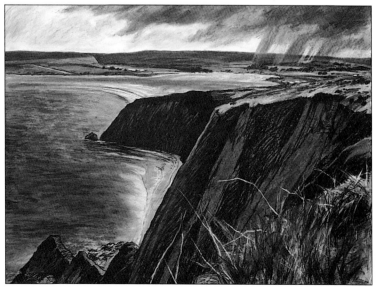

27▲ **Develop the shore** Use compressed charcoal to make marks that describe the successive surges of water being sucked back over the shingle in the small bay. Be aware of the arc-like patterns they make.

28 ▼ **Add background detail** Add some lightly scumbled tone to the dark cloud to bring it across to the left of the image. Use a thin stick of charcoal to add more bushes around the fields and to suggest parallel cultivation lines.

29 ▲ **Lighten the hills** Lift out lines of charcoal on the hills with the putty rubber. Use the rubber, too, to hatch a pale area on the crest of the hills. These pale streaks suggest light skimming over the countryside, beyond the rainstorm. Once the drawing is complete, prevent the charcoal from smudging by spraying with fixative.

THE FINISHED PICTURE

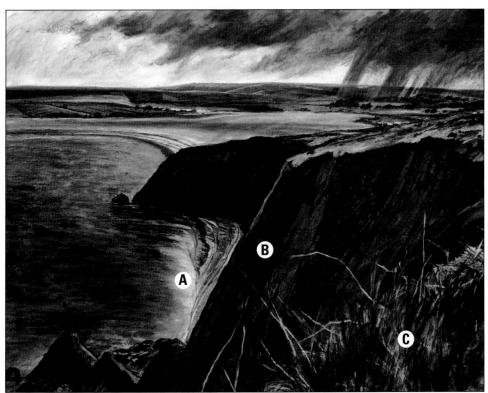

A Lifting out lights
A soft putty rubber was used to pull out the white of the breakers in the small bay. The ripples of foam near the beach were created with the edge of the rubber.

B Directional marks
Tones and textures were built up by working lines of charcoal up and down the cliff face. These emphasise the steepness and height of the cliffs.

C Complex textures
A complex mesh of light-against-dark and dark-against-light marks captures the cliff-top vegetation. The detail here brings this area forward in the picture.

Seasonal palette – summer

In summer, the brilliance of the flowers and the diversity of foliage shades offer the artist the perfect opportunity to use a vivid and varied palette.

For the landscape painter, summer is a liberating season. The days are at their longest and, weather permitting, painting on the spot for hours on end can be a real delight. There is time to think about colours, to choose a palette, and to make colour notes and sketches if necessary.

There are no rules or restrictions on summer colours. Unlike spring, with its predominance of cool, yellow-green foliage, or autumn with its mellow earth colours, summer has no particular palette to call its own. The colours can be as bright and varied as the artist chooses or as the subject suggests.

Summer foliage

During the summer months, leaves lose the sharpness of colour that causes many spring trees and plants to look very similar. The greens begin to diversify and each one takes on its own characteristics. Leaves are often tinged with a variety of colours, including silvery grey, blue, mauve and pink. As a result, it becomes easier to spot the different greens in the garden and in the landscape, and to pick out the local colours of the leaves.

Although greens can be mixed from the yellows and blues on the basic palette, summer is a good opportunity to try out new colours. For foliage, sap green or Hooker's green provide a good starting point. However, if you feel experimental, introduce one or two slightly more offbeat colours, such as cobalt turquoise – a strong blue-green – or green-gold – a glowing, warm shade.

Rendering flowers

For those who love to paint flowers, summer colours are often intensely brilliant and beautiful. Sometimes the colours of nature defy mixing, and only a bought colour from the manufacturer's chart can match the brightness of the subject. This is particularly so when painting orange or violet flowers because versions of these mixed from colours on the standard palette are rarely as bright as manufactured equivalents.

Experiment with new colours. Many summer flowers are crimson or deep vivid pinks. Again, these colours cannot be easily mixed, so try a bought version, such as carmine, permanent rose, rose madder or magenta. Not only are these cool reds beautiful in their own right, but they are excellent in mixtures, especially for capturing the elusive violets and oranges. For example, the orange of the Californian poppies in the picture is a mixture of permanent rose and cadmium lemon.

To capture the effect of light with paint is always a challenge. This is particularly so in summer, when sunlight often plays a dominant role. The transparent quality of watercolour is ideal for painting summer scenes, such as the one on the right, capturing both the brightness and the translucency of the petals. Even though the garden border is dense and colourful, note how the artist has still left quite a lot of white paper showing through to help capture the luminosity of summer light.

Oils and acrylics

There is no reason why a similarly colourful effect cannot be painted using oils and acrylics. The secret is to keep colours clean and the mixtures simple. An organised palette will help you to achieve this. Frequent changing of turps or water will also help to ensure clear, bright colours.

Bright, summery colours

There is no single definitive palette for summer scenes – however, make sure you include some bright, hot colours. For the painting on the right, the artist created the warm flowers from cadmium red, permanent rose and lemon yellow. For the foliage, sap green was the basis of most of the mixes, with the addition of sepia, lemon yellow and phthalo blue.

Cadmium red **Permanent rose** **Lemon yellow** **Sap green** **Phthalo blue** **Sepia**

A GARDEN IN FULL BLOOM

A garden border in summer creates a wonderfully exciting picture – but make sure you don't get too carried away with your bright colours. As always, you should check the colour and tone of each flower carefully. In this picture, for instance, note the delicacy of the pink used for the foxgloves and the subtle changes in the mixes for the poppies in the foreground.

Dilute permanent rose made a delicate pink for the foxgloves.

Sap green and sepia created a rather neutral green for the background.

Phthalo blue with a touch of permanent rose was used for the delphiniums.

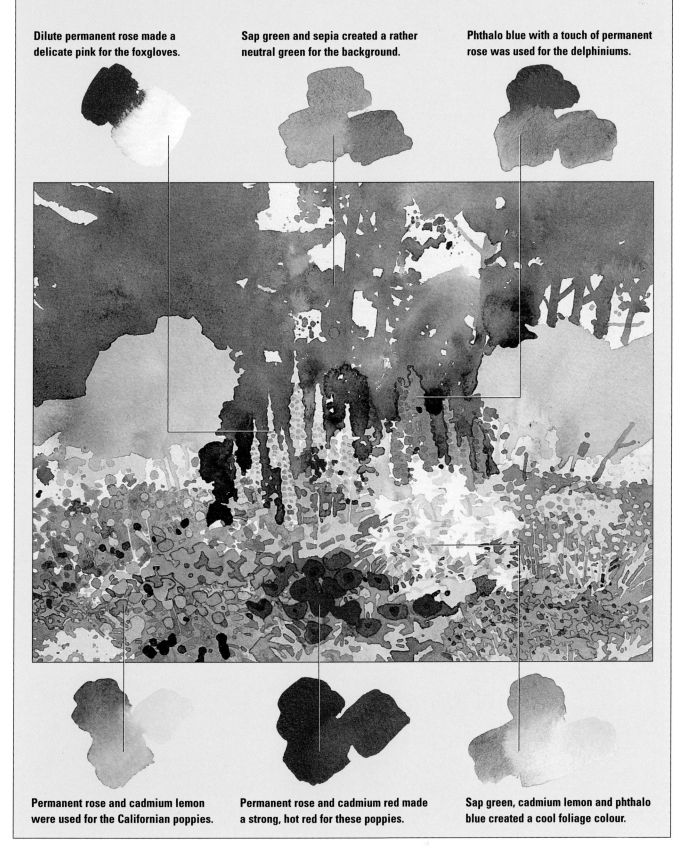

Permanent rose and cadmium lemon were used for the Californian poppies.

Permanent rose and cadmium red made a strong, hot red for these poppies.

Sap green, cadmium lemon and phthalo blue created a cool foliage colour.

Landscape with hills

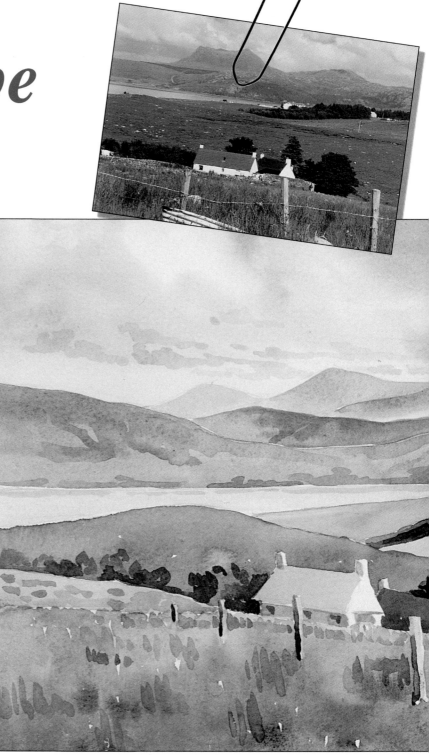

Using cool shades of blue for the distant hills gives this summer landscape a sense of perspective.

A little touch of blue can work wonders in a landscape painting, not only in the sky, but also in the fields, trees and hills. Although the lovely watercolour shown here is a summer landscape, painted when everything is at its greenest, only the grass in the foreground can be described as bright green. The rest of the scene becomes bluer as it recedes into the distance. In fact, the hills are not green at all, but are painted in pure ultramarine.

Atmospheric perspective

Distant colours in a landscape are affected by the intervening atmosphere, which makes them appear hazy. This natural phenomenon, sometimes called atmospheric or aerial perspective , is the reason why hills in the distance appear to get progressively bluer and paler.

Watercolour is the perfect medium in which to capture this gradually fading effect. Because the colours are translucent, hills will appear to get fainter if you add increasing amounts of water to the blue. Remember, watercolour dries paler and duller than its wet colour suggests, so be bold with the blue. It is better to exaggerate the blueness than to lose the effect of the atmospheric perspective.

Perspective with brushstrokes

Another effective way of suggesting distance is not only to make the foreground colours brighter, but also to apply the colour in larger, more distinctive brushstrokes. For example, the tufts of grass at the front of the picture are painted in bold strokes of bright colour which bring the foreground into focus. They also contrast with the smoothly washed colours of the distance, emphasising the difference between the two.

▲ This landscape in watercolour was painted from a limited palette. Most of the colour mixtures come from the same three basic colours – cadmium orange, ultramarine and burnt sienna.

FIRST STROKES

1 ▶ Flood in the sky Start with a light outline drawing in 2B pencil. Using a No.10 round brush, dampen the sky and clouds, then flood the wet area with Winsor blue. Leave fluffy white unpainted shapes for the clouds. Mix equal quantities of ultramarine and alizarin crimson and paint shadows on the underside of the clouds, letting the colour run into the wet paper.

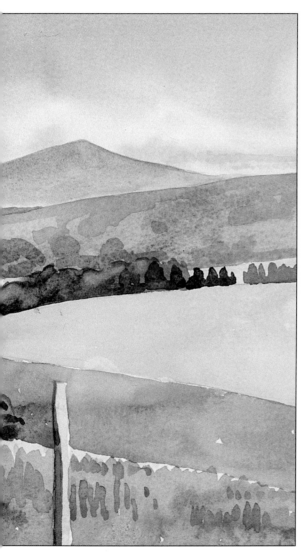

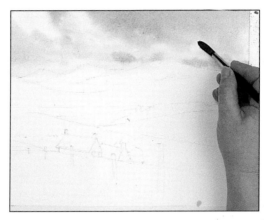

2 ◀ Soften the clouds Wash and squeeze the moisture from the No.10 brush and soften the edges along the top of the clouds by lifting the colour off with the damp brush.

3 ▶ Develop the landscape While the sky dries, start work on the rest of the painting. Change to a No.7 round brush and paint the small rooftop in burnt sienna. Use a diluted mixture of the same colour on the second roof and the fence posts. Start painting the water with a single streak of diluted Winsor blue to reflect the colour of the sky.

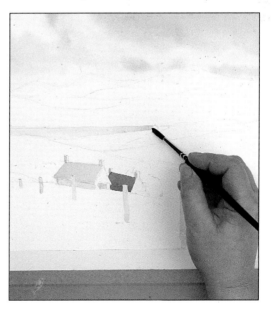

EXPERT ADVICE
Using a pen rubber

Use a pen rubber for correcting line drawings. This handy tool has a narrow, angled tip which allows you to erase a fine line without rubbing away the surrounding drawing.

DEVELOPING THE PICTURE

Now the sky and foreground are in place, it is time to establish the blue distant hills, then introduce a few warmer tones. Do this last by adding a little cadmium orange to the other landscape colours.

4 ▼ **Create a sense of distance** Paint the three palest distant hills using diluted ultramarine. The furthest hill is by far the palest of the three, so it should be painted with the thinnest mixture. Add a little more blue to the mixture for each of the other two hills.

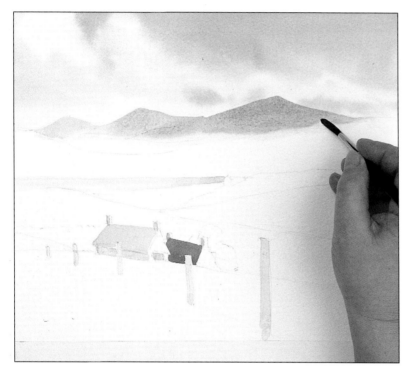

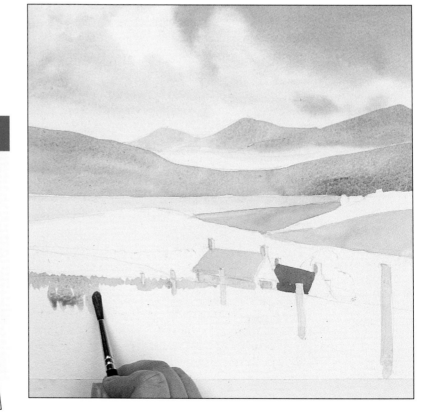

5 ▲ **Block in the middle distance** Paint the greenest fields in Hooker's green mixed with a little cadmium orange. Brighten this mixture with a little cadmium yellow and apply a little of the new colour to the first colour while it is still wet. For the darker hills, use ultramarine toned down with a little cadmium orange. Vary this by painting a few strokes of burnt sienna into the wet colour.

6 ▶ **Start the foreground grass** For the warm-toned foreground grass, mix cadmium orange and burnt sienna with a touch of ultramarine. Suggest the grass texture by applying the colour in short, vertical strokes.

TROUBLE SHOOTER

REMOVING WET PAINT

Working on a tilted board causes very wet colour to run and collect at the bottom of the painted area. If this reservoir of paint is not removed, it can dry to a much darker tone than the surrounding colour. To prevent this, soak up the unwanted paint using a dry brush or a piece of tissue.

7 ▼ **Indicate the grass texture** Mix a second grass colour from equal parts of ultramarine and cadmium orange. Change to the No.10 brush and continue with the foreground, alternating between the two grass mixtures and allowing the colours to run together. Increase the size of the vertical strokes as they get nearer to the lower edge of the picture.

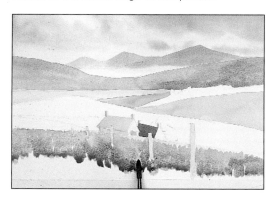

8 ▶ **Develop the background** Paint the wall in a diluted mixture of burnt umber and burnt sienna. Change to the No.7 brush and move on to develop the background. The hills should become progressively stronger and warmer as they come forward, so paint the remaining hill in ultramarine with a little added orange.

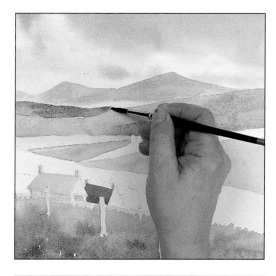

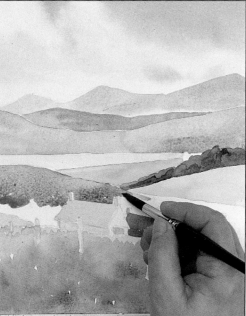

Express yourself
A simple sketch

A rapid watercolour sketch of the same subject is similar in colour to the finished painting. As in the painting, the hills are painted in ultramarine. However, in the sketch the artist is less concerned with the subtle gradation of tones than in creating a lively, instant impression of the landscape colours.

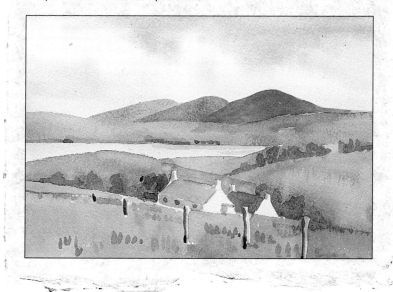

9 ▲ **Continue with the hills and trees** Paint the trees – initially as one continuous shape – using a dark bluish-green mixed from ultramarine and a little cadmium orange. Wait for the tree shape to dry, then paint into it, adding texture and a few tree shapes in varying mixtures of ultramarine and cadmium orange. Go back to the No.10 brush for painting the hill behind the house; this is mainly cadmium orange softened with touches of burnt sienna and ultramarine.

▶ **Experiment with different tones of ultramarine to discover its full potential. Start with three or four equal amounts of blue and add increasing amounts of water to each. Try the results on scrap paper.**

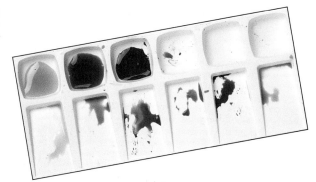

10 ▼ **Develop the trees** Before the orange hill is quite dry, paint the tree shapes in ultramarine with touches of cadmium orange and burnt sienna. The damp background gives these a nice soft edge.

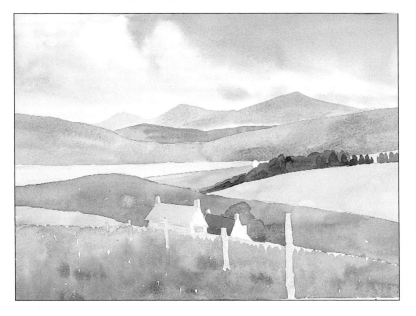

Master Strokes

Jan Brueghel the Elder (1568–1625) and Joos de Momper (1564–1635)
Mountain Landscape with a Lake

These two Flemish painters regularly collaborated with each other and other artists; figures in Momper's landscapes were often painted by Brueghel. This mountain scene exemplifies aerial perspective, with the furthest mountains painted in cool blue tones so that they recede into the distance, while warm shades of reddish-brown are used to make the foreground advance.

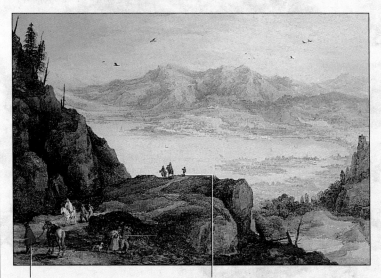

Little touches of red in the foreground are a favourite device used by artists to help create convincing perspective.

The small figures silhouetted against the pale background of the lake provide dramatic focus and a sense of scale.

A FEW STEPS FURTHER

Most of the main landscape features are now blocked in. The painting is not quite finished, but already the pale blue distance and the strong foreground have created a sense of space in the picture.

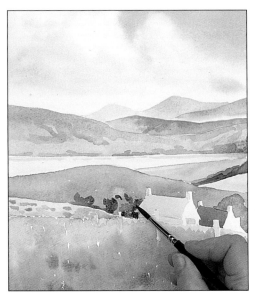

11 ▲ **Define the hill, wall and trees** Now for a few details. Use a No.7 brush to emphasise the edge of the hill. Add a few flecks for the individual wall stones in burnt umber. Paint a few sharp shadows into the distant trees in ultramarine; do the same to the trees behind the house in Hooker's green with a touch of burnt umber.

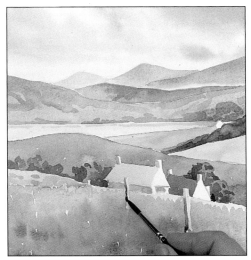

12 ▲ **Complete the house and fence** Paint the shaded side of the houses in ultramarine with a tiny touch of burnt umber. Define the fence by painting the shaded side of each post in a mixture of equal parts of burnt umber and ultramarine.

13 ▼ **Add shape to the clouds** To add a few more cloud shadows, first wet the area with clean water, then dot in a few shadows in ultramarine darkened with a little burnt umber.

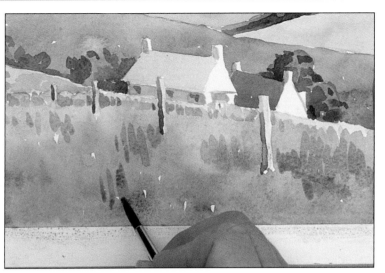

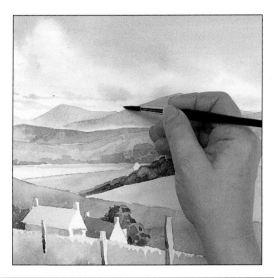

14 ▲ **Complete the foreground** Finally, bring the foreground into focus by painting a few crisp blades of glass and leaves on to the existing dry colour. Do this in varying mixtures of cadmium orange, ultramarine and burnt sienna.

THE FINISHED PICTURE

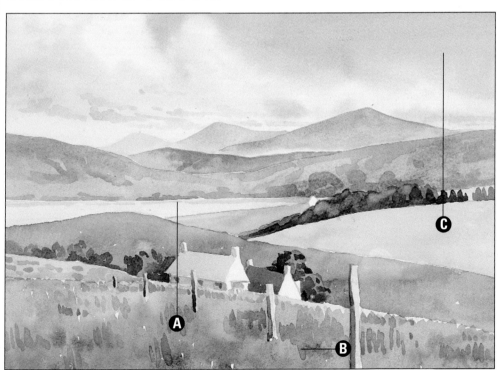

A Reflection of the sky
The water in the lake is practically colourless, so it was indicated only by a pale streak of Winsor blue to reflect the colour of the sky.

B Texture in the foreground
Foreground grass texture was added in the final stages and painted on to dry colour. This creates sharp shapes which bring the foreground clearly into focus. In comparison, the background scenery appears indistinct.

C Different blues
The sky was painted in Winsor blue, making a subtle distinction between the sky area and the distant blue hills, which were painted in ultramarine.

Seascape with clouds

A cloudy sky is the main focus of this seascape. Use cobalt blue and Ivory black watercolour paints for a realistic result.

Painting skies is easy – once you know how! Watercolour can be wonderfully unpredictable to work with, especially if you apply the paint quickly and freely. You'll find that the resulting wet washes and spontaneous runs of colour will do some of the job for you and will help you to capture the mood of the sky you are painting. You'll need a range of brushes to achieve the best effects.

Graded washes

Look at the sky, at any time of the day, and notice how it changes colour towards the horizon. This seaside sky becomes gradually paler and cooler – an effect you can obtain with a graded wash. To achieve this, dilute the ultramarine, the main sky colour, with water as you work downwards from the top of the paper. The coolness is emphasised by introducing a little cobalt, a particularly cold blue, into the diluted ultramarine.

Sponged clouds

Don't forget to leave patches of white paper to represent the clouds. A continual process of dampening and dabbing with tissue and a small sponge ensures that these white shapes take on the soft-edged, fluffy appearance of real clouds.

Composing from photographs

Clouds can move so quickly that there may be no time to draw and paint them. The solution is to take photographs so that you can paint the scene at leisure later. Another advantage of working from photographs is that you are not confined to painting a single scene. You can pick the best elements from several different photos and combine them in your picture, as the artist has done here.

▶ **The summer sky with its fluffy white and grey clouds forms a lively backdrop to the otherwise simple and tranquil beach scene.**

YOU WILL NEED

Sheet of 600gsm (300lb) Not watercolour paper

2B pencil

Watercolour brushes: Nos 3, 7 and 10 round; rigger; 25mm (1in) flat

Mixing dish or palette

Jar of water

Tissue or kitchen towel

Small natural sponge

6 watercolour paints: Ultramarine; Cobalt blue; Yellow ochre; Ivory black; Alizarin crimson; Cadmium red

FIRST STROKES

1 ▶ Start with a drawing Using your chosen photographs for reference, make a light pencil drawing of the subject with a 2B pencil. The drawing need not be detailed – just put in a few accurate lines as a guide to show you where to apply the colour when you start painting. However, because the large expanse of sky is such an important element in this composition, you should position the horizon line with care. Note that the sky takes up about two-thirds of the picture area.

2 ▲ Dampen the clouds Take the flat brush and dampen the cloud areas with clean water so that when you apply the blue paint below the clouds it will bleed into them. Make your strokes as light as possible by moving the brush from the wrist in short, flicking strokes.

3 ▲ Start painting the sky Now for the graded wash on the sky. Mix a small quantity of ultramarine and water in a small dish. Working from the top, use the No.10 round brush and begin to wash in the sky with rapid, loose strokes of colour. Take the blue up to the top edge of the cloud shapes without touching the dampened area. This preserves a clear outline.

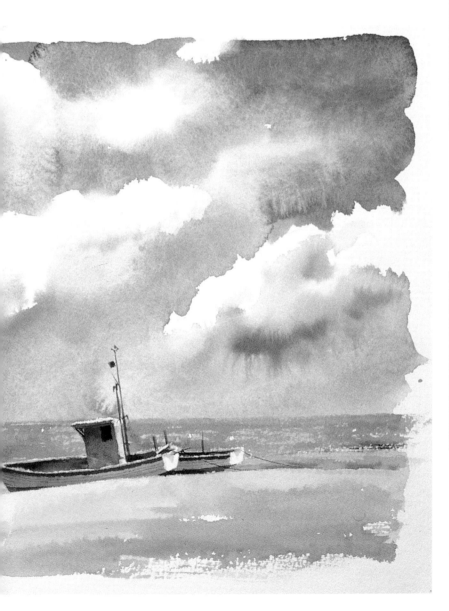

4 ▲ Dilute the blue wash Lighten the ultramarine colour by adding a little more water to the mix as you move downwards, and continue to spread the wash freely across the sky area. On the underside of the clouds, take the blue wash slightly over the edge of the previously dampened cloud areas. This will cause the blue to run slightly, giving the bottom edges of the clouds a realistic soft edge.

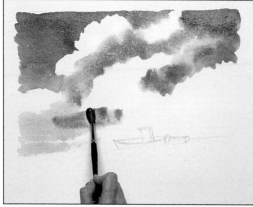

5 ▲ Lighten the horizon Finish the sky as quickly as possible – ideally before the dampened clouds start to dry (although you can give the clouds an occasional stroke of clean water if necessary). Make the sky paler and cooler at the horizon by adding more water to the ultramarine mix. At the same time, gradually add a little cobalt blue to the wash. Paint the sea in the same pale blue, using even strokes.

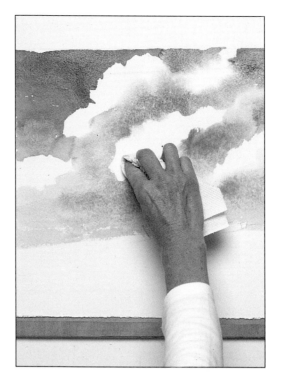

6 ◄ Remove excess moisture When the sky is complete, dab off excess paint and water with a tissue or kitchen towel. This creates lighter areas and also 'fixes' the runs and explosions of colour which are an essential part of the sky. Further soften the underside of the clouds by dabbing the edges with a clean, damp sponge.

Master Strokes

John Constable (1776–1837)
Weymouth Bay with Jordan Hill

Constable is the master of wide open spaces with large dramatic skies. In this seascape, painted in oils on canvas, the sky takes up more than half the picture area and is full of movement. Unlike the clouds in the watercolour project above, which are left unpainted so that the white paper can show through, Constable's clouds are made up of many colours ranging from cream to dark grey. Together, these colours create strong contrasts, suggesting a mixture of sunshine and storm.

The pinkish-brown and grey colours of the clouds are reflected in the turbulent sea.

Strongly applied strokes of cream oil paint highlight the clouds where the sun is falling on them.

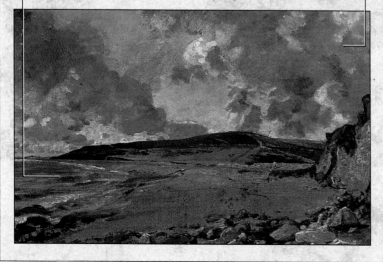

DEVELOPING THE PICTURE

Once you have completed the basic shapes of the clouds, you can develop them by adding shadows to their undersides. Avoid hard edges around the shadows by sponging, as before. If the paint has already dried, you will need to press and rub quite hard with the damp sponge to remove any unwanted edges.

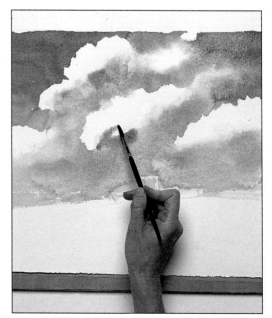

7 ▲ Add cloud shadows Into the underside of the damp clouds add a few shadows in diluted ivory black with an extra touch of alizarin crimson. Use a No.7 round brush, applying the colour in loose, broad strokes. Allow spontaneous runs of colour to remain.

8 ▶ **Soften the shadows**
Blot the shadows with a piece of tissue to remove excess paint and lighten the tones. Leave some darker patches along the bottom of each shadow area to help give the clouds a three-dimensional appearance. Then give the clouds a final sponging to get rid of any hard edges which may have formed.

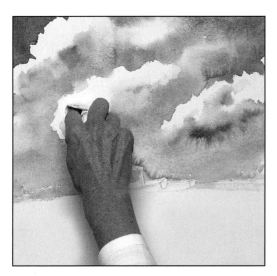

COLOUR TESTING

Colours on the palette can look completely different when applied to paper. Therefore, it is a good idea to test each colour before using it in the painting. This ensures that you have exactly the colour you want, and that it is not too light or too dark. The type and colour of paper affects the look of watercolours, so the test must be made on the same paper you are using – either on the edge of the painting, or on a scrap of similar paper.

TROUBLE SHOOTER

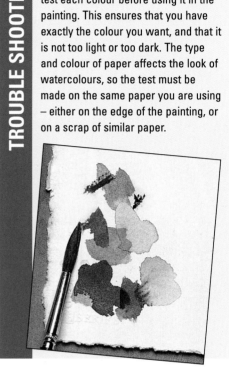

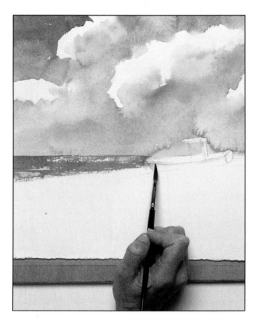

9 ◀ **Paint the sea**
Change to a No.3 round brush and paint over the existing sea colour with ultramarine mixed with a little black. Like the sky, the sea is paler towards the horizon. But for the sea, you start at the bottom with strong colour and a loaded brush, then gradually add more water as you move upwards. Paint horizontal strokes to show the waves, leaving flecks of the underpainting showing through to represent foam.

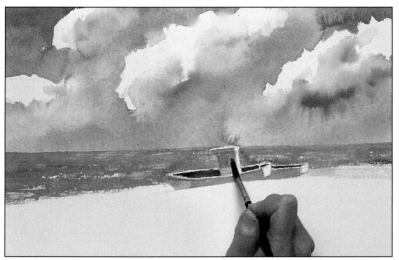

10 ▲ **Add the boat shadows** Still using the No.3 brush, paint the dark interiors of the boats in ivory black. Use the sea colour – a mixture of ivory black and ultramarine – for the main parts of the boat which are in shadow, leaving the rims, cabin edges and tail-ends of each boat unpainted so that the white paper shows through.

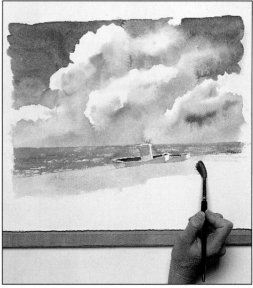

11 ▲ **Block in the foreground** For the sweeping shore and the sand dunes you need a bigger brush – the No.10 round. Paint the sand in broad horizontal strokes of yellow ochre mixed with a touch of alizarin crimson. Try to leave flecks of white paper showing between the brush strokes. This will give a sparkle to the sand and help to give the impression of a realistic, sunny beach.

The basic blocks of colour in the painting – the sky, the sea and the beach – have now been filled in. But if you want to work the picture up some more, you can give the foreground more form and enhance the sunny atmosphere of the scene. The final touch is to finish painting the two boats, which are the focal point of the picture, by adding fine details such as the mast and the ropes. These are depicted using a rigger brush.

EXPERT ADVICE
Graded wash

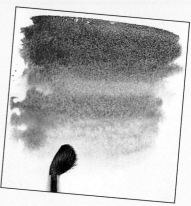

The sky here is painted with a graded wash, which, unlike the flat wash shown in Basics: Techniques in Issue 1, becomes gradually paler. Start with a strong colour, then add increasing amounts of water to achieve the graded effect. This helps give a sense of distance, as pale colours seem to recede, while strong ones seem nearer.

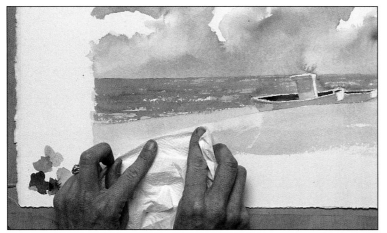

12 ▲ Lighten the sand Before the paint has had a chance to dry, use the straight edge of the tissue to soak up some of the sand colour along the top of the dune. This will create wedge-like shapes of light, giving the effect of sunlight falling on the undulating beach.

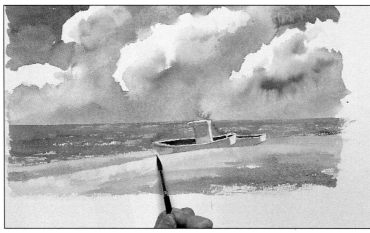

13 ▲ Add shadows to the beach Switch to the No.7 brush and paint the shadows in the sand using a warm-toned mixture of yellow ochre with touches of alizarin crimson and ultramarine.

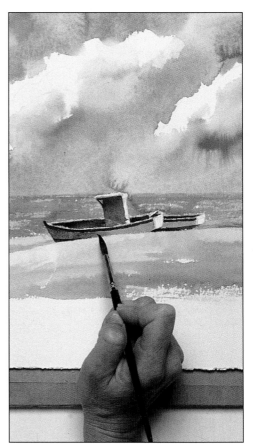

14 ▲ Paint the details on the boat The wheelhouse and bands on the boat are painted in using cadmium red, toned down with a touch of ivory black. The fine details, such as the mast, painted in black, should be completed using a rigger brush. Finally, strengthen the shadows on the side of the boat in a purplish mixture of ultramarine and alizarin crimson.

THE FINISHED PICTURE

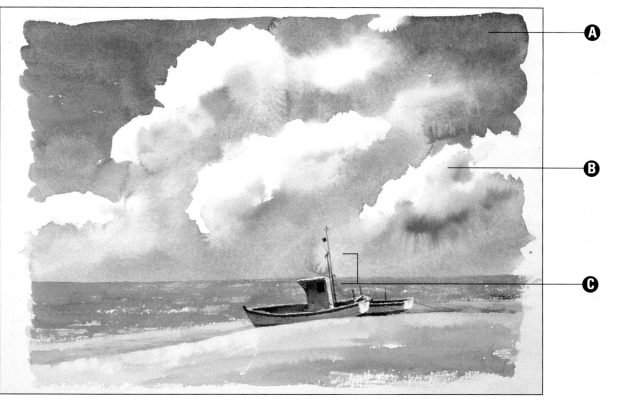

A Two blues
The wash for the sky was created using strong ultramarine at the top of the picture, becoming lighter and cooler with the addition of water and cool cobalt blue towards the horizon.

B Realistic clouds
Clouds must look softly rounded, with no hard edges – a constant process of dampening and gentle dabbing with a sponge and tissue was used to achieve this effect.

C Verticals and horizontals
The vertical shapes of the wheelhouse and mast, painted with a fine rigger brush, help break up the effect of the strong horizontal lines created by the beach and the horizon.

Express yourself Sunset silhouette

The same scene at sunset makes a dramatic picture. First, the artist washed the whole area with orange, mixed from equal quantities of Indian yellow, cadmium red and yellow ochre. Then, working quickly, she plunged mauve into the wet sky, letting the colours merge – a technique called 'wet on wet' – to create soft-edged clouds. When the picture was dry, she painted the beach in the sky colour mixed with mauve and the boat in solid black.

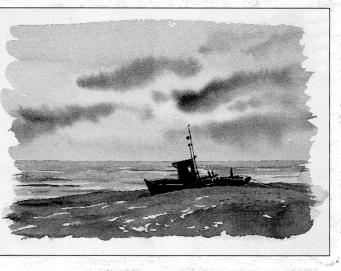

Creating foliage in watercolours

Trees, with their enormous variations in shape, colour and patterns of growth, are an important source of colour and texture in landscape paintings.

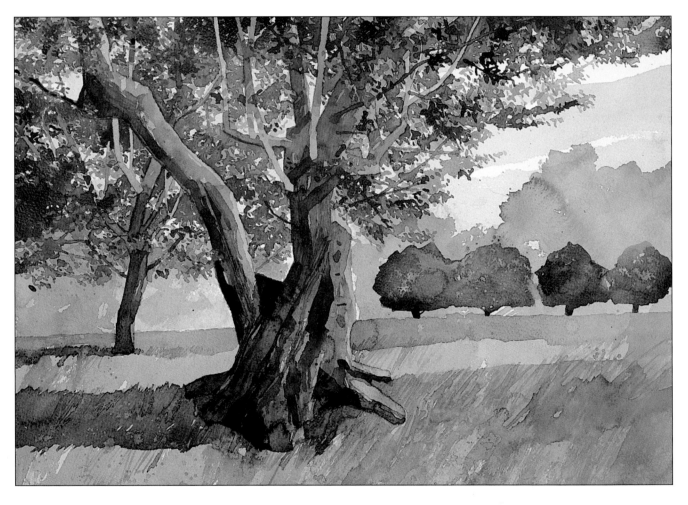

The flutter of leaves in a passing breeze is one of the most important elements in a convincing landscape painting. Using a few simple watercolour techniques, you'll soon be creating truly naturalistic effects.

When trees are in the foreground, you can make out the pattern made by the foliage and the shapes of some individual leaves. But you won't see every part of a scene with pinpoint accuracy, so don't paint every leaf. Instead, find a mark that describes the distinctive character of the foliage.

Study the subject carefully through half-closed eyes and put down the areas of tone. Gradually, a leaf-like pattern will begin to emerge. If you paint just a few leaves in detail, the viewer's brain will understand that the rest of the foliage follows the same pattern and will 'fill in the blanks'.

When a tree is further away, you can see only generalised leaf forms and the leaf masses around the boughs. And when trees are seen from even further away, only a broad silhouette of the leaves and trunk is discernible.

▲ **The grey-green foliage of this gnarled olive tree is shown in enough detail to suggest the leaves without being too precise. The trees in the distance are treated as silhouettes.**

FIRST STROKES

1 ▼ **Draw the outlines** Using a 2B pencil, establish the broad areas of the landscape. The branches and leaves of trees look complicated, so ignore the detail and concentrate on the underlying forms. Think about the composition – whether you are working directly from the subject or from references, adjust the drawing to create a pleasing arrangement.

YOU WILL NEED

Large piece of 300gsm (140lb) NOT watercolour paper

2B pencil

Brushes: Nos.10, 6, 3 soft rounds

7 watercolours: Cobalt blue; Sap green; Sepia; Yellow ochre; Payne's grey; Cerulean blue; Black

Mixing palette or dish

Natural sponge

▼ **A mix of sepia, sap green and yellow ochre makes a good foliage colour.**

2 ▶ **Block in the sky** Using a No.10 brush, mix a wash of cobalt blue and lay it in for the sky. Remember that, in watercolour, the paper is the lightest colour available, so leave patches of paper unpainted as clouds. Leave to dry.

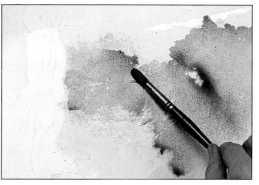

4 ▲ **Soften the sponged effects** The stippling created by sponging can be too unsubtle, so apply more colour and roll the No.10 brush through the wash to create a variety of edges to modify the sponged effects.

3 ▲ **Apply background greens** Make a wash of sap green and, using a natural sponge, apply this broadly and loosely in the grassy foreground area. Use sweeping, diagonal marks that suggest swaying grasses. Mix sap green and sepia to create a lighter green for the trees in the distance, and dab it on with a sponge.

5 ▲ **Add texture to the foreground** Mix sap green, sepia and yellow ochre to give a vivid grass green colour. Using a No.6 brush and making vigorous diagonal strokes, add more colour to the grassy area in the foreground. Leave the painting to dry.

6 ▼ Paint the trunks and branches Make a wash of sepia and Payne's grey for the tree trunks. Using the No.6 brush, apply flat colour, thinking about the way a tree grows: the boughs come out of the main trunk, and the branches and twigs grow out of each other in a logical pattern, becoming gradually thinner towards the edge of the tree. Allow to dry.

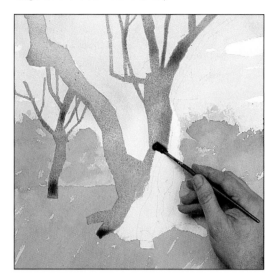

DEVELOPING THE PICTURE

The background and the main silhouette of the tree are established, so it is now time to create the foliage. The patches of leaves are built up gradually in three stages by layering a light, middle and dark tone of the same basic colour. This technique creates a sense of movement, suggesting light catching fluttering leaves.

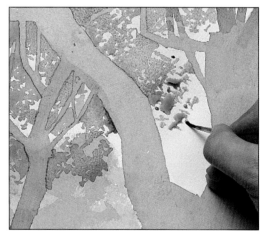

7 ▲ Start to apply foliage to the olive trees Mix Payne's grey, sap green and cerulean blue to make a pale blue-green for the first foliage tone. Use a small No.3 brush to apply this wash, pushing and pulling the colour with the tip of the bristles to create random clusters of leaves. Try not to space the marks too evenly, and vary the tone of the wash by adding differing amounts of water.

EXPERT ADVICE
Adding gum arabic

Gum arabic is the medium that carries the pigment in watercolour paint. Adding extra medium intensifies the colour and gives a slight sheen, as in the darkest foliage colour shown below. You can buy gum arabic in bottles from most art supply shops.

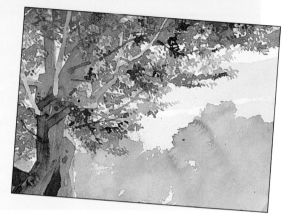

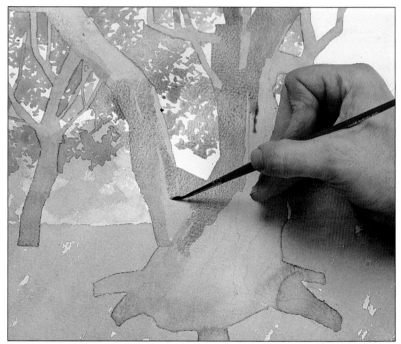

8 ▲ Add shadows on the tree trunk Using a more concentrated wash of the sepia/Payne's grey mix and the No.3 brush, lay in the shadows on the trunk and branches of the main olive tree. These shadows give form and solidity to the tree, and also help to describe its gnarled surface.

9 ▶ Finish adding the first tone Using the Payne's grey, sap green and cerulean blue wash and the No.3 brush, complete the first application of tone to the foliage. Take care to keep the marks a similar size as you work across the painting. Leave the paint to dry thoroughly.

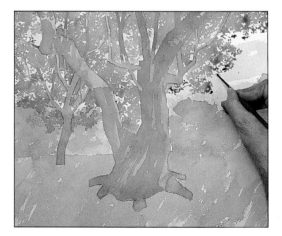

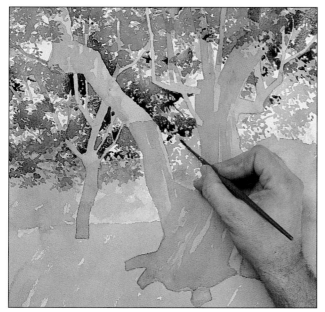

10 ▲ **Add a second tone to the foliage** Mix a darker tone of the foliage colour and use the No.3 brush to apply another layer of leaves. Screw up your eyes to isolate the main masses of foliage. Notice that the tops of each mass, especially those on the side from which the light is coming, are lighter than the undersides. Work as before, creating patches of wash and then painting detailed leaf shapes around the edges. Leave to dry.

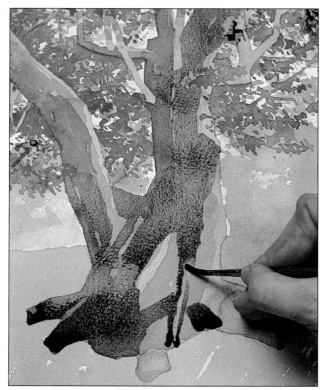

11 ▲ **Paint shadows on the trunk** Mix a darker tone of the sepia/Payne's grey wash and apply dark shadows to the left side of the trunk and the branches that are turned away from the light. Use the same wash to 'draw' some thin branches and twigs amongst the foliage. Allow to dry thoroughly.

Master Strokes

Gustav Klimt (1862–1918)
Roses under the Trees

The Austrian painter Gustav Klimt developed a highly decorative style. In his treatment of these trees in an orchard, the foliage is painstakingly built up dab by dab using a pointillist technique, until the surface glows with hundreds of different shades.

The painting is dominated by the vibrant foliage of the tree which fills the picture area, creating a decorative, almost abstract effect.

The ridged texture of the tree trunks is described in detail, using broken, curved lines. Patches of green lichen enliven the grey surface.

12 ▶ **Give texture to the bark** Prepare a third, dark tone of the basic foliage wash used in step 7. Add gum arabic to intensify the colour (see Expert Advice on the opposite page). Apply a final layer of this colour, painting clusters of leaves as before. Mix a wash of black and, using the No.3 brush, apply dark tone on the darkest side of the trunk. Use the same wash to describe fissures and textures in the bark of the tree.

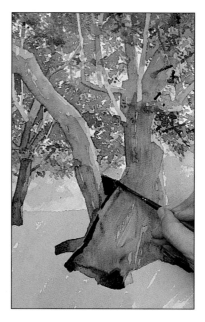

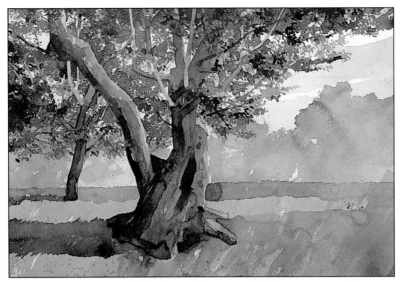

13 ▲ **Apply texture and shadows** Using a wash of sap green and the No.3 brush, apply wide brush marks to the grassy area in the foreground. Allow this to dry thoroughly and then use sepia with a little sap green to paint the shadows cast by both olive trees. These attached shadows help to 'fix' the trees to the horizontal surface of the ground.

Express yourself
Band of gold

The same olive tree has been given an arresting treatment here with the addition of bright orange and green bands dividing the composition in two. These are applied as a collage of coloured paper and represent the nets used to catch the harvested olives, which have been rolled up and tied. This unusual device not only adds a splash of almost fluorescent colour to the neutral grey-green background, but also acts as a counterbalance to the vertical trunks and branches that predominate in the painting.

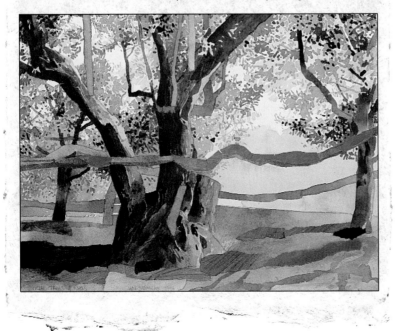

A FEW STEPS FURTHER

Applying the foliage as layers of washes gives the tree canopy depth and form. This area of the painting can be considered complete – it is convincing and has textural interest. You could, however, add more texture to the foreground – this will add eye-catching detail and increase the sense of recession. Consider adding to the background by painting in a line of simple silhouetted trees.

14 ▲ **Add texture to the grass** Mix sap green with sepia and paint vigorous diagonal marks with the No.3 brush to create grassy textures in the foreground. Spatter the wash over the area for varied textures.

▼ **Use increasingly concentrated mixes of sepia and Payne's grey for the bark.**

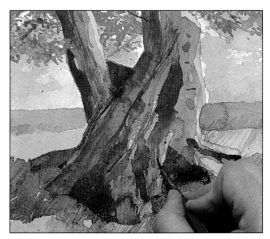

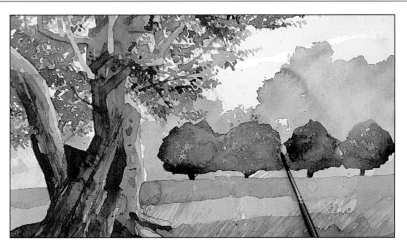

15 ▲ **Develop the textures in the bark** Mix black and sepia and, using the No.3 brush, work across the trunk adding a variety of textures. The bark of this ancient olive tree is twisted and gnarled, so you can use a range of brush marks to describe its surface.

16 ▲ **Add trees in the background** Mix Payne's grey and sap green to create a dark green. Use the No.3 brush to paint a row of trees in the middle distance. These trees add interest to the composition and create a sense of recession. However, at this distance you cannot see details of the foliage, so reduce the trees to simple silhouetted shapes.

THE FINISHED PICTURE

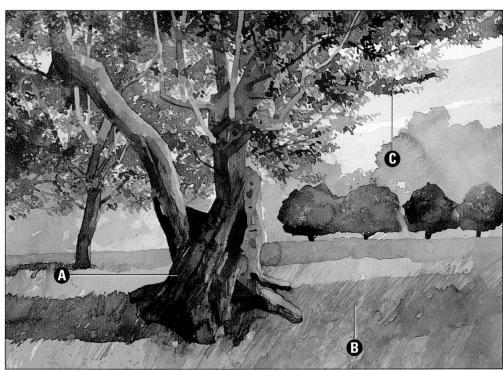

A Textured bark
The rough texture and fissured surface of the tree trunk is one of the interesting features of this subject. The textures were applied gradually, working light to dark.

B Foreground textures
Vigorous brush marks in the foreground capture the appearance of wild grasses. The foreground texture also helps to create a sense of space and recession.

C Simple leaf shapes
Simplified, shorthand marks capture the character of the foliage. These have been applied in layers to build up the volume and depth of the tree's canopy.

Beach huts

Use versatile acrylic paints to reproduce the vivid colours of these gaily decorated beach huts under a blue summer sky.

Acrylic paints keep the intense colour they have when wet even after they have dried – clarity of colour is among their outstanding qualities. In this painting of a row of beach huts, the strong blue of the sky enhances the light and shade on the coloured huts and really makes the white hut stand out. Highlights and shadows are built up by adding progressively denser paint over the initial colours of the huts, allowing parts of the more translucent underlayers to remain showing.

Artists do not necessarily paint exactly what they see. The picture in this exercise, for example, is rather different from the photograph on which it is based. The artist found pointed roofs more interesting to paint than flat ones, and by cutting off most of the flat-roofed hut on the right, the composition was opened up to create the impression of a wide beach.

The colours of the huts have been strengthened and even changed to take advantage of the brightness of acrylic paints. For this reason, you do not need to be too rigid about the exact proportion in which you mix the colours in the painting – the object is to experiment as you go along in order to appreciate their full, vibrant potential.

▼ **Use acrylics if you want to achieve clear, bright colours with maximum impact, as in this painting of huts strung along a beach.**

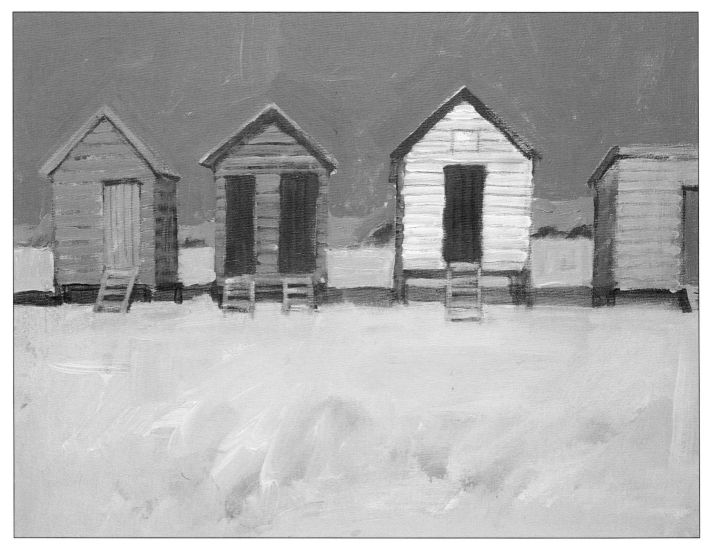

FIRST STROKES

1 ◄ Make a sketch Draw the shapes of the huts and the lines of the sand dunes behind them with a 4B pencil. Add details of the façades of the huts. The soft, slightly blurred pencil lines will encourage you to use strong, gutsy colours later on. Spray the sketch with fixative to prevent it smudging when colour is applied.

2 ► Start to lay the background wash
Mix purple with a touch of raw umber and enough water to make a mixture that covers the canvas easily. Mix in a little medium to add to the translucency of the wash. Paint the colour on with a No.8 flat brush, pressing down hard and using large, free strokes. Make the shadowed area on the hut on the right a slightly deeper purple.

3 ◄ Start the huts Fill in the sky and beach with the wash, then lift some colour off the huts and the sand with kitchen paper. Leave to dry. From now on work with undiluted paint, rinsing your brush and drying it on a rag between applications. Using a No.5 flat brush, paint the door on the left with cadmium yellow. Add orange to paint the hut on the right. Use turquoise green for the hut on the left and ultramarine mixed with phthalo blue for the one next to it. Mix more purple and a little raw umber into the background wash, then add a touch of this to crimson and paint the door of the unpainted hut.

4 ► Add the sand dunes and shadows Mix yellow ochre with a touch of chromium green for the sand dunes in the background. Mix equal amounts of purple and phthalo blue and indicate the shadows under the huts using horizontal brush strokes. Use cadmium red to paint the double doors of the blue hut.

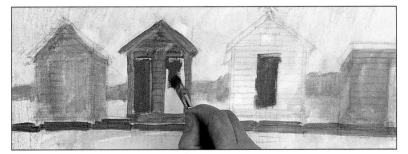

It can be difficult to know exactly how a picture is progressing, especially when you are working on a relatively small scale that doesn't allow you to view it from a distance. A good way to judge your work is to hold the picture upside-down or look at it in a mirror. This unfamiliar reverse view will help to reveal anything that is awkward

DEVELOPING THE PICTURE

Now that the main shapes and colours of the huts have been established, it is time to start creating texture. Adding white to the original mixes will give opaque colours that contrast with the earlier translucent ones and help to convey the solidity of the huts.

6 ▶ Start to use white Mix raw sienna with a touch of raw umber and indicate the shaded wall of the yellow hut with the No.2 brush. Redraw the steps of the hut with the crimson door with the 4B pencil. Paint in its boards with opaque white, using the width of the brush to apply horizontal strokes.

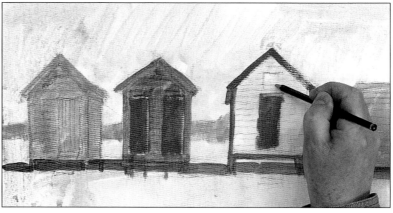

5 ▲ Continue adding details Use cadmium yellow for the roof of the turquoise hut and turquoise green for the roof and door of the hut on the right. Add more raw umber and purple to the shadow colour used in step 4. Paint in the shadows under the huts and their legs with a No.2 flat brush. Paint in the shadows on each side of the hut with the crimson door, then use red oxide for its eaves. Redraw the steps of the turquoise hut and the window of the white hut with the 4B pencil so that they are not 'lost' under the opaque paint used in the next stage.

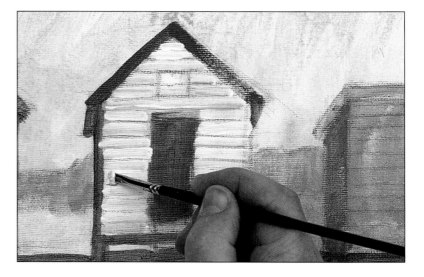

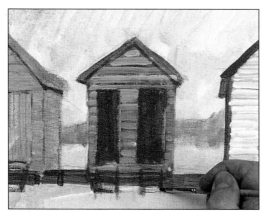

7 ▲ Continue using white Add phthalo blue to white for the boards on the blue hut, and turquoise green to white for those on the turquoise hut. Using the No.0 brush, shade the doors and eaves of these two huts with red oxide. Paint the steps with red oxide.

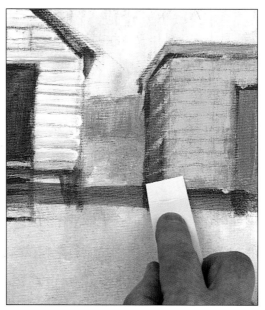

8 ◀ Add more texture Use red oxide for the shadows on the white hut, and paint it around the door, side and eaves of the yellow hut. Use the No.2 brush to paint horizontal strokes of opaque cadmium yellow over the front of the hut. Then, working quickly, scrape the end of an offcut of card from side to side over the yellow wall and drag it across the brown wall to break up the colour.

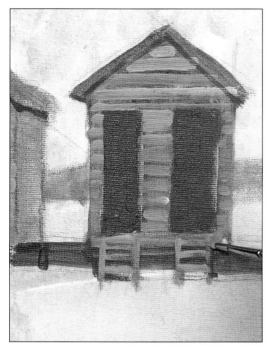

9 ▲ **Continue adding texture** Paint opaque cadmium red over the doors of the blue hut to make solid areas of colour. Mix white with a little phthalo blue and 'draw' in the steps of the two huts on the left with the No.0 brush.

10 ▼ **Begin the sky** Mix crimson, brown and white and, using the No.2 brush, paint the door of the white hut. Mix green oxide with ultramarine for the side wall of the turquoise hut, then paint its roof with a mix of cadmium yellow and orange. With the No.0 brush and a pale blue mix, 'draw' the steps of the huts on the right. Mix cobalt blue, ultramarine and white to paint the sky, using a No.14 brush for large areas and the No.2 brush between the huts.

Master Strokes

Philip Wilson Steer (1860–1942)
Figures Walking Beside a Line of Beach Huts

An English painter, trained in Paris, Steer looked to the French Impressionists for his inspiration. This seascape in oils is typical of his breezy, atmospheric beach scenes. As in our step-by-step, Steer has painted a large area of unoccupied beach in the foreground, creating a spacious, airy atmosphere.

Light brush strokes of pale grey-blue on the yellow sand subtly suggest pools of water and wet pebbles and boulders.

The beach huts form a decorative element in the picture and the diagonal arrangement leads the eye across the composition.

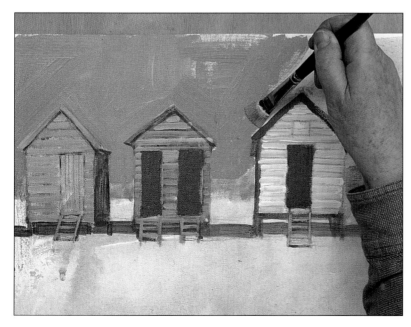

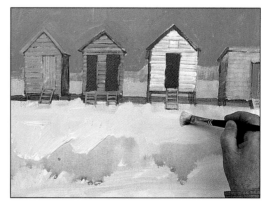

11 ▲ **Paint the sand** Mix equal quantities of cadmium yellow and white and paint the sand dunes between the huts. Then put a touch of orange and lots of white with this yellow mix and pick up the different colours on the No.14 brush, trying not to blend them too much. Paint the foreground with bold strokes.

12 ▼ **Lighten the sand dunes** The yellow on the sand dunes looks too dark now that the beach has been painted in. Paint over the dunes with the No.2 brush and the various colours you used for the foreground.

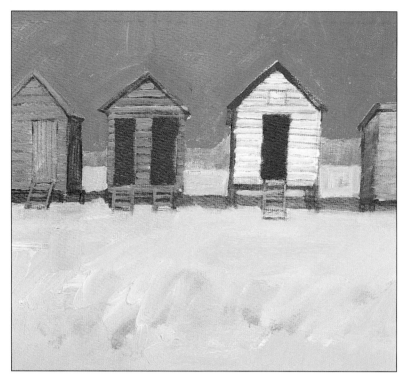

Express yourself
A bold and simple image

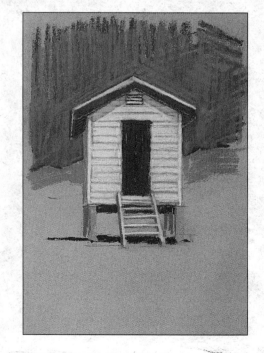

The simple geometric shape of this beach hut is strong enough to stand alone as an image. Isolate your favourite hut from the main painting and make a sketch of it with soft pastels, using bold horizontal and vertical strokes. Soft pastels rival acrylics in the intensity of their colours, and the grey paper chosen for the background is a perfect foil for the vivid shades.

A FEW STEPS FURTHER

You may now wish to take your painting a little further. Adding details, such as the scrubby plants on the sand dunes, as well as more layers of colour on the beach huts, will add texture and emphasise the bright colours of the huts against the sand and sky.

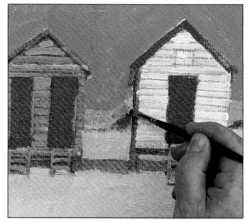

13 ▲ **Paint in the scrub on the sand dunes** Mix equal amounts of green oxide and yellow ochre to indicate the areas of scrub on the sand dunes with the No.2 brush. Add yellow ochre to the cadmium yellow, orange and white used for the foreground and paint the top of the sand dunes. As in step 11, try not to mix the colours too much – just use what your brush picks up.

▶ **A mixture of cadmium yellow, orange and white gives the beach its sunny colour.**

◀ **To create a pale blue shade for the hut steps, add ultramarine to white.**

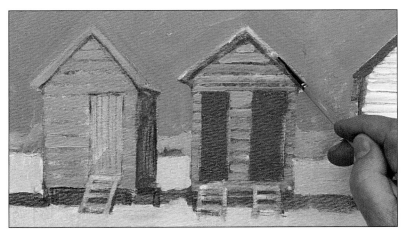

14 ▲ **Add highlights to the huts** Add more white to the phthalo blue and white mixture used in step 9 and paint highlights on to the steps of the turquoise and blue huts. Paint over the eaves of the blue hut.

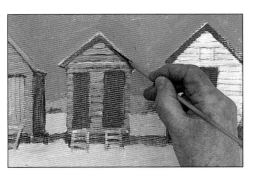

15 ▲ **Add the final touches** Mix cadmium red, red oxide and white and 'draw' the vertical slats on the door of the white hut. Mix white with cadmium red and paint the door slats of the blue hut; use the same colour under the eaves. Finally, mix white with turquoise green and paint over the shaded wall on the right of the turquoise hut, using horizontal strokes.

THE FINISHED PICTURE

A Strong sky
The strong blue of the cloudless sky enhanced the bright colours of the beach huts with their variations of light and shade.

B Energetic colour
The interplay between solid and translucent colours on the huts created a strong contrast with the shadow beneath them.

C Texture of sand
The texture of sand and small rocks was achieved by picking up different colours on the brush and allowing traces of the purple wash to come through.

Landscape with trees

Use a sea sponge to capture the glorious, golden foliage in this peaceful Scottish landscape.

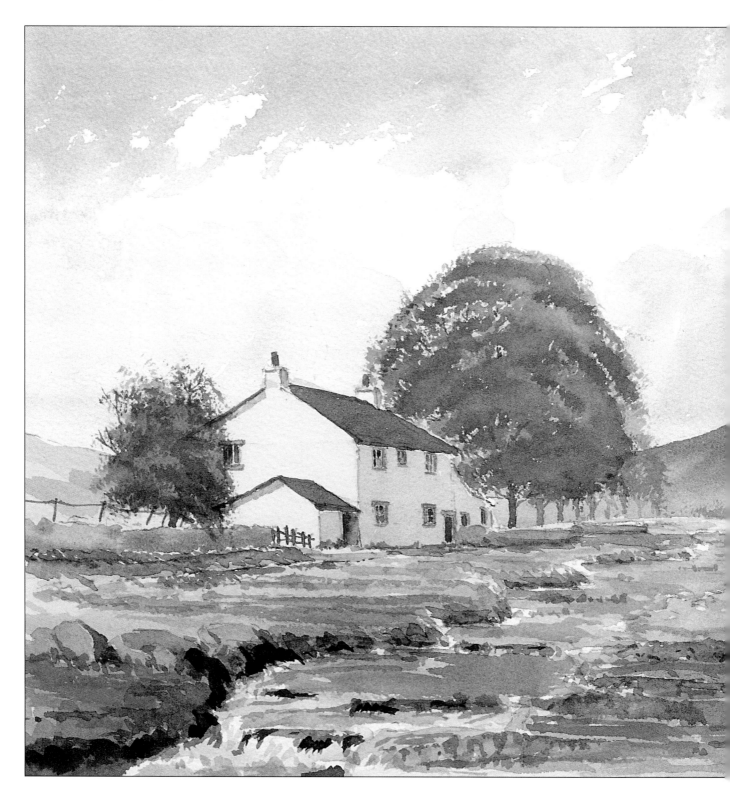

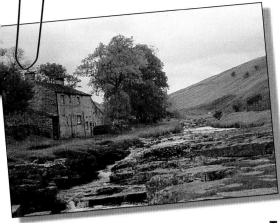

Of all the elements in a landscape, trees often play the most important part. They are particularly useful for lending a sense of scale to a scene. Deciduous varieties give visual clues to the season in which the painting was done, since their leaf cover and colouring vary with the time of year.

Trees in composition

Furthermore, trees play an important compositional role. An overhanging tree, for instance, can lead the eye into the picture by providing a frame within a frame. Alternatively, a tree can serve as a focal point to the whole picture. This is the case in this autumnal scene – the eye is inevitably drawn up the stream to the large, golden-coloured tree at the centre of the composition.

Depending on the position of the trees in the picture, the detail will vary.

◄ **The underlying glow of autumn light was created by washing burnt umber over the landscape and by using mixes made from warm, earth colours.**

Trees in the foreground can be painted with more detail, such as individual sprigs of leaves, the texture of the bark and the tracery of small twigs. Trees in the middle ground or background, as in the step-by-step, should be painted more impressionistically.

A variety of tools can be used to give the impression of foliage on trees – brushes, feathers, or even toothbrushes – but small pieces of sponge are particularly good for creating soft, rounded effects, especially when used with watercolours. A sea sponge, such as the one given away with this issue, gives a more naturalistic effect than a synthetic one as it has irregular holes.

Suggestion, not detail

The technique of sponging works well in this composition because the trees are in the middle ground. To create recession in the picture, therefore, their shape and leaves need to be suggested rather than defined in detail. The sponge is excellent for this and for putting on colour in soft arcs of different tones to give the trees their three-dimensional shape.

YOU WILL NEED	
Piece of 640gsm (300lb) rough watercolour paper 28 x 38cm (11 x 15in)	Mixing palette or dish
4B pencil and putty rubber	7 watercolours: Winsor blue, red shade; Burnt umber; Alizarin crimson; Ultramarine; Burnt sienna; Light red; Raw sienna
Brushes: 50mm (2in) and No.10 flats; Nos.16, 6 and 3 round	Small piece of sea sponge
Two jars of water, one for paints and one for cleaning brushes	Masking tape and kitchen paper

FIRST STEPS

1 ▶ Rough in the scene Use a 4B pencil to sketch in the main features of the composition. Work lightly to avoid damaging the surface of the paper and use a putty rubber to erase any unnecessary lines.

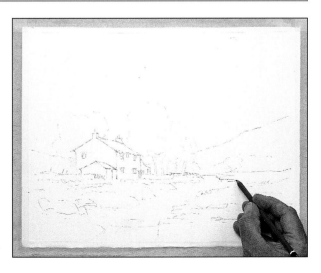

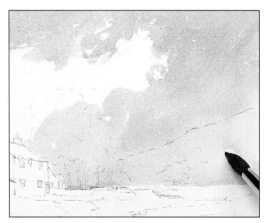

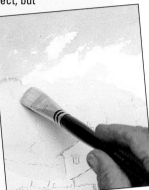

SMOOTHING HARD LINES

TROUBLE SHOOTER

When laying down the washes for the sky, you need to work fast to maintain the soft effect, but any harsh lines can easily be smoothed out. Use clean water to take off hard edges, scrub them with a No.10 flat brush and then blot them gently with kitchen paper.

2 ▲ Add the sky wash Use a 50mm (2in) flat brush to wash clean water over the sky area. Change to a No.16 round brush and mix Winsor blue, red shade, and burnt umber. Working quickly, loosely brush the wash across the top of the sky. Leave white paper showing for the clouds.

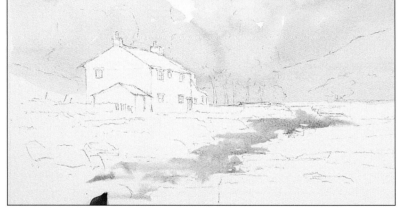

3 ▲ Define the horizon Add a touch of alizarin crimson to the blue mix. Take the wash down to the horizon line. Work around the buildings, but lay it on over the trees and far hill.

4 ▲ Paint the stream Work over the stream with clean water. Add a little more burnt umber to the original blue mix and, keeping your brush strokes horizontal, put in the water; leave white patches to give the effect of ripples. Describe the reflections from the sky, using the purplish sky mix.

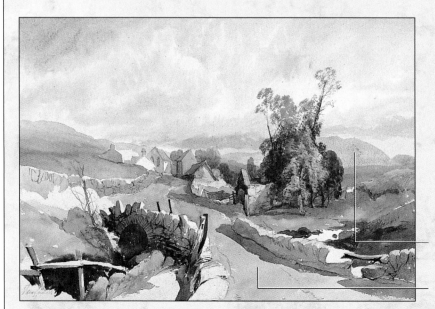

Master Strokes

James Burrell-Smith (*fl. 1824–97*)
Country Road with Cottages

In terms of composition, this watercolour is very similar to the step-by-step project – the colours, however, differ greatly. Here, the overall colour harmony is cool – with dark blue-greys dominating the foreground and lighter, fresher blues in the distance and sky.

A pale, granulated wash of blue gives a convincing impression of distant peaks.

The road leads the eye into the image in a similar way to the stream in the step-by-step.

DEVELOPING THE PICTURE

The cool tones in the composition have now been blocked in. Warm up the landscape with umber and sienna washes, then begin to add definition and work up the features.

5 ▶ Add warm washes Using a mix of ultramarine and burnt umber, define the hill, softening the colour near the house. Mix burnt sienna with a little light red and burnt umber for the bracken, softening the wash into the blue hill. Wash raw sienna over the foreground, excluding the river but including the house.

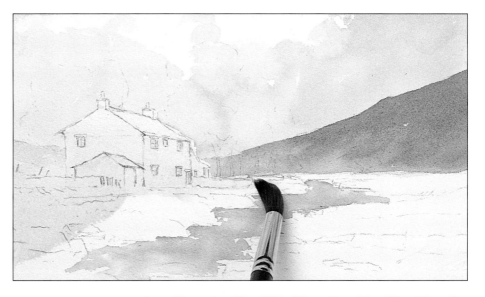

6 ▼ Introduce autumn tones With the bracken mix, streak colour across the river plain. Make a muted green from raw sienna and ultramarine and streak this over the foreground.

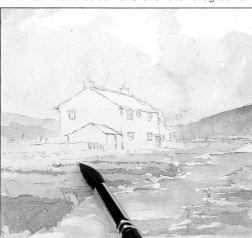

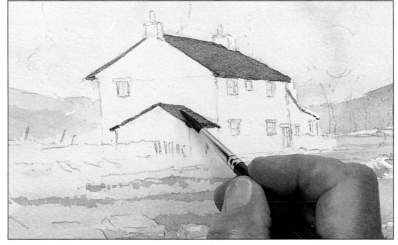

7 ▲ Add the slate roofs Mix together ultramarine and a touch of burnt umber. With a No.6 round brush, paint in the roofs of the house and outbuildings, keeping the tip of the brush to a fine point.

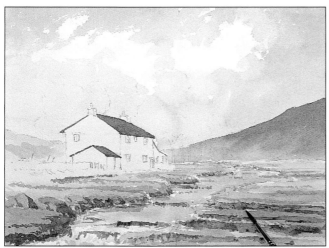

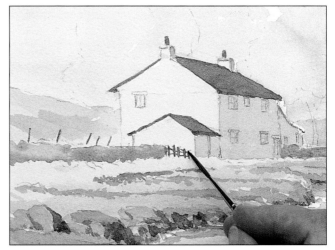

8 ▲ Paint the rocks Water down the roof mix, add a little of the bracken mix and paint reflections in the stream. Add touches of blue and green palette mixes and paint rocks in the water. Now, with grey-browns made from the palette mixes, paint rocks along the riverbank and in the foreground.

9 ▲ Work on the house Use raw umber to put in shadows on the house and chimneys. Change to a No.3 round brush and define the chimney-pots in light red. Put in the stone wall, using raw umber, with a touch of blue for the shadows. Add the poles and fence in a dark-grey mix from the palette.

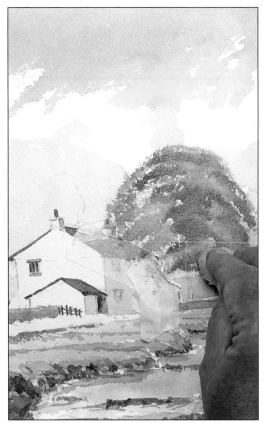

The landscape is now basically complete, but you might like to do some fine-tuning by bringing up the rugged ground in the foreground and other details in the picture. In particular, shadows under the roof of the house will increase the sense of the building's solidity.

11 ▼ **The tree in front of the house** Use the same sponging technique for the small tree to the left of the house. Begin with the autumn colours from the palette, then add a touch of blue for the shadows, particularly at the base of the crown. With the No.3 round brush, use grey mixes to add shadows, trunks and branches to the trees. Finish the details of the house, using a blue mix for the windows and burnt sienna for the door.

10 ▲ **Sponge in the trees** Add the door and window to the house in a grey mix from the palette, with raw umber for the lintel and sill. Leave the painting to dry. Now protect the tree side of the house and roof with short strips of masking tape. Begin to sponge on the foliage of the line of trees. Use layers of burnt umber, sponged in arcs, and vary the depth of colour to give the trees their rounded form.

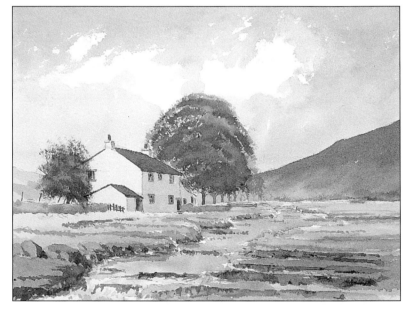

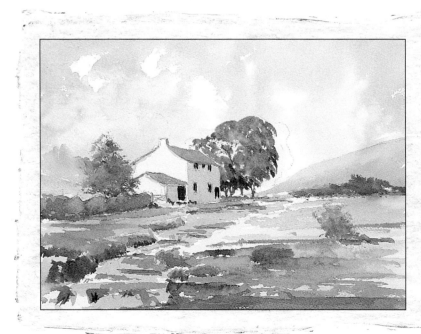

Express yourself
Subtle changes

This version of the scene is very similar to the step-by-step project – yet there are important differences. The artist has used wet-on-wet washes to depict the foliage of the main tree rather than sponging on colour. As well as giving the foliage a completely new texture, this technique suggests the tree is swaying gently in the breeze. Note also how the distant hill has a paler, softer colour than the dramatic blue of the step-by-step. The impression is of mist rolling in over the higher ground.

12 ► Add definition to the foreground

To emphasise the grass growing around the rocks, use the No.6 round brush to add bands of muted green between the lines of grey rocks. Mix the grass colour from raw sienna and ultramarine. Leave the painting to dry.

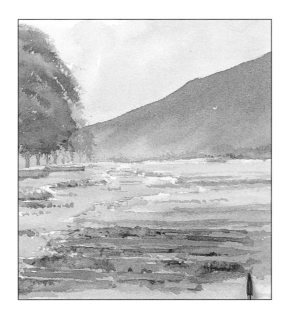

13 ▲ Refine the details
Mix ultramarine and burnt umber. Paint shadows along the base of the house and under the eaves. Put in the fence wires with the No.3 round.

THE FINISHED PICTURE

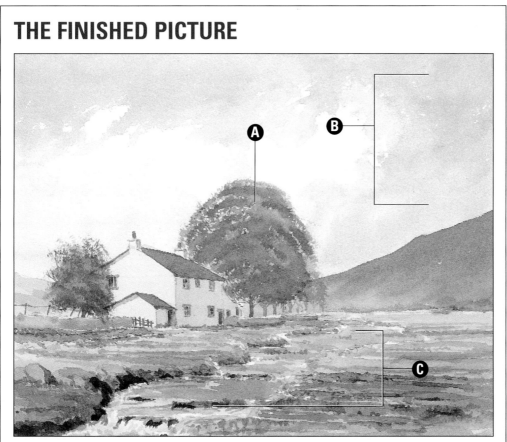

A Sponged foliage
The leaf cover of the trees was sponged in as a series of shapes rather than in detail. If the detail had been more defined, the trees would have looked odd – as if they were looming forward.

B Graduated sky
The sky area was shaded from a brighter blue at the top to a paler purple at the bottom. By varying the strength of colour towards the horizon in this way, the sky was given a sense of distance.

C Receding rocks
To emphasise the feeling of recession in the landscape, the bands of rock and their reflections in the stream are painted closer together the further back in the picture they are.

Seasonal palette – autumn

Whether a riot of copper, crimson and gold or a restrained display of browns, the colours of autumn leaves define the countryside at this time of year

Depending on the weather and climate, autumnal trees can be brilliantly coloured or they can be neutral and understated. New England, USA, is famous for its spectacular fall where the colours of a typical autumn are crimson, orange and gold, often set off by a bright blue sky.

Sometimes, however, autumnal tints are subtler. In a damp climate, the greyness of the weather is often reflected in the colours of the leaves. An overcast day or an autumn mist can make them appear subdued and restrained. Although less dramatic than bold reds and yellows, understated colours can be equally beautiful and will often include mellow earth tones such as umbers and ochres, browns, greys and dark greens.

A quiet scene

For the painting shown opposite, the artist deliberately chose a rather muted scene. There is no direct sunlight to bring out the colours, so the mixtures are quiet and restrained.

Subtle colours are not necessarily dull colours, however. The bronzes and coppers in this painting were mixed from a full palette of pigments, including cadmium red, alizarin crimson and cadmium yellow. The brightness of the palette colours is reflected in the glowing transparency of the mixtures. There are cooler colours too, particularly in the shadows, sky and green grass.

Be experimental

As the colour swatches on the right demonstrate, autumnal hues can be mixed from the colours you are likely to have on your standard palette. However, if you feel like being adventurous, now is a good time to experiment with more unusual pigments.

For example, brown madder is a rich brownish-purple – an excellent colour for capturing mellow, autumnal tones. Earthy reds – including Venetian red, Indian red and terra rosa – are all warm and natural, ideal for autumn leaves and trees. For shadows, try Mars violet or purple lake. Alternatively, if you have ever wanted an excuse to use the exotic-sounding caput mortuum violet or perylene maroon, these are cool purples that are excellent in autumnal mixtures.

Painting trees

The foliage on any tree is usually multi-coloured, visible as tiny flecks of colour and tone that represent the leaves. The palest flecks are the highlights – reflections caused by the bright light on the leaves; darker flecks are the shadows on the underside of the foliage. A helpful technique for capturing the effect of broken colour in foliage is that used by the Pointillist painters Georges Seurat (1859-91) and Paul Signac (1863-1935).

These artists were referred to as Pointillists because of the way in which they applied colour. For example, instead of mixing red and yellow to make orange, thereby losing the intensity of the colours, they would dab separate dots, or points, of red and yellow on to the picture. The two colours merge in the eye of the viewer to create a vibrant orange. A similar approach was used in this landscape. Loosely dabbing on small patches of colour gives an impression of leaves swaying in the breeze.

Hues for autumn

Although the autumnal landscape shown opposite is characterised by subtle browns and gentle greens, the artist chose a full palette of warm and cool watercolours to create it (below). You might also try grabbing a handful of the leaves you intend to paint, matching their hues to paint colours, and then adding these to your palette.

| Cadmium red | Alizarin crimson | Cadmium yellow | Sepia |
| Payne's grey | Burnt sienna | Sap green | Phthalo blue |

MIXING COLOURS FOR AN AUTUMN SCENE

Not all trees turn brilliant shades of red and gold in the autumn. Here, you can see how the brighter colours in the basic autumn palette on the previous page have been toned down to create the mainly brown shades in this peaceful scene. The brown leaves are set against a pale blue sky mixed from dilute phthalo blue with a little burnt sienna to subdue the colour.

A basic leaf colour is made from cadmium red, cadmium yellow and sepia.

Redder leaves are mixed from cadmium red, burnt sienna and cadmium yellow.

For the distant trees, a mix of burnt sienna and cadmium yellow is used.

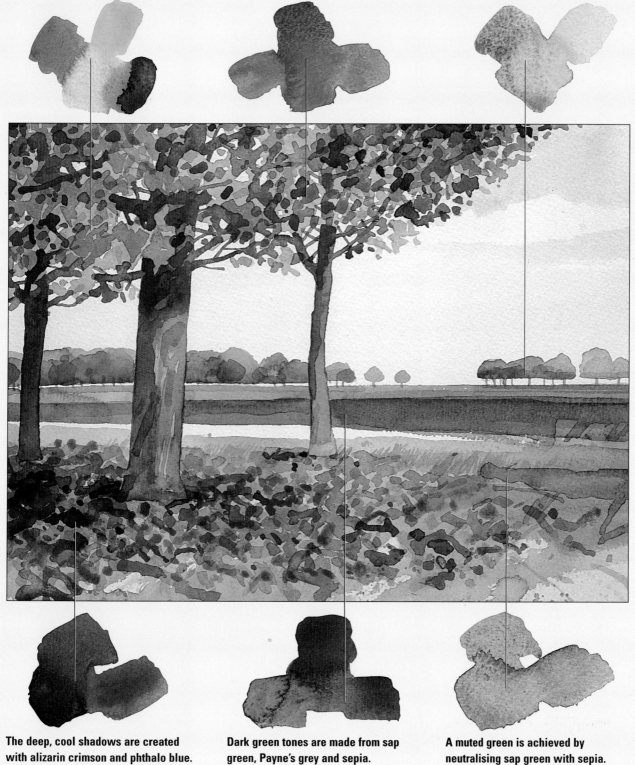

The deep, cool shadows are created with alizarin crimson and phthalo blue.

Dark green tones are made from sap green, Payne's grey and sepia.

A muted green is achieved by neutralising sap green with sepia.

A walk in autumn woods

Strong acrylic colours and a Pointillist painting style help convey a riot of autumnal colour.

YOU WILL NEED

Primed canvas board 61 x 46cm (24 x 18in)

2B pencil

Ruler

9 acrylic paints: Cerulean blue; Titanium white; Vermilion hue; Raw umber; Sap green; Cadmium yellow; Dioxazine purple; Mars black; Yellow ochre

Brushes: 10mm (³⁄₈in) flat; No.4 round

This autumn scene is a symphony of greens and orange-browns, with strong variations of light and shade. It is also a study in complementary colours, the reddish tones of the fallen leaves and the greens of the foliage making a vibrant combination. The colour finder given away with this issue will help you to mix these hues.

Optical colour mixing

The painting also demonstrates aspects of Pointillism, a technique perfected by nineteenth-century French artists such as Georges Seurat (1859-91) and Paul Signac (1836-1935).

In Pointillism, small dabs of pure colour are applied very close together. When viewed from a distance, these points of colour react together and appear much more luminous than they would if they had been physically

mixed together on a palette.

The painting in the step-by-step project is created in a similar way by building up dabs of colour in layers, keeping the tones as pure and vibrant as possible. Not only do the marks represent a mass of individual leaves, but the contrasting hues create an exciting visual effect.

If you want to get a feel for the technique of Pointillism without worrying about a perfectly finished result, you could try painting this scene with just the three primaries – cerulean blue, vermilion and cadmium yellow – together with white and black.

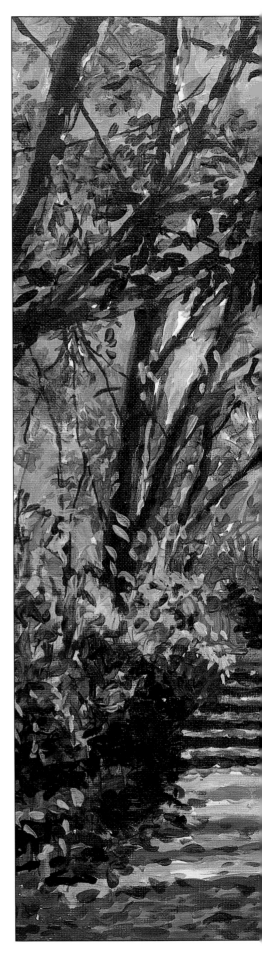

▶ **Fast-drying acrylic paints are ideal for building up the layered and textural effects in this vividly coloured scene.**

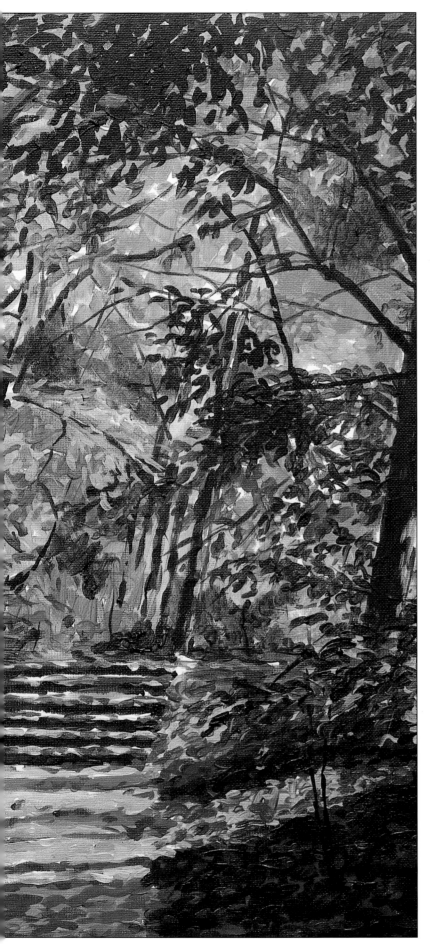

1 ▼ **Paint negative shapes** Before you begin, rule out a faint rectangle about 50 x 41cm (19½ x 16in) on the canvas board and work within this frame. Mix cerulean blue with a little titanium white and carefully paint in the negative shapes in the background – the glimpses of sky between the branches – using a 10mm (⅜in) flat brush.

2 ▼ **Start on the leaves** Mix a red from vermilion hue with a touch of raw umber and paint the darkest areas – the fallen leaves and the steps. Make a mix of sap green with a little cadmium yellow and titanium white, and use it to dab leaves on the upper branches and around the base of the trees.

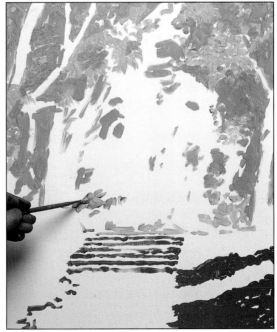

3 ▼ **Continue the underpainting** Add sap green to the red mix from step 2 and block in the dark shadows in the bushes – apply the paint quite roughly as these areas are still part of the underpainting. To create the effect of filtered sunlight, dab on some cadmium yellow leaves in the treetops.

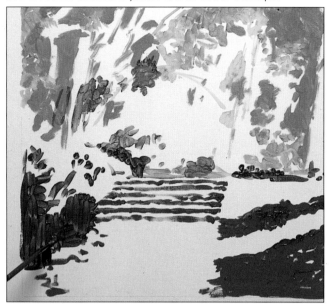

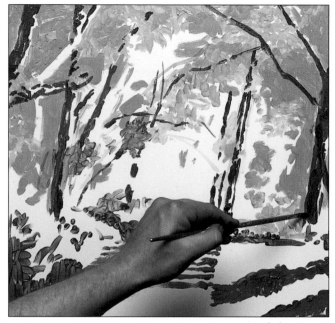

4 ▲ **Paint the trees and branches** Start painting the trees, working some of the trunks and branches in dioxazine purple and others in a reddish-brown made from a mix of sap green, vermilion and raw umber.

Master Strokes

Gustav Klimt (1862–1918)
The Birch Wood

As in the step-by-step project, this painting by Austrian artist Klimt focuses closely on the colours and textures of tree-trunks and leaves. Here, however, the emphasis is more on the dense carpet of fallen leaves than on the fresh, new foliage. Klimt has meticulously built up the woodland floor with layer upon layer of individual brush marks in rich hues of orange, russet, yellow and brown. This creates a wonderfully decorative surface typical of his style. Notice how the dabs of paint get gradually smaller towards the top of the picture, creating a convincing sense of recession. In the distance, the colours become darker and more mysterious.

Horizontal bands of soft grey perfectly describe the silvery bark of birch trees. They are slightly curved to convey the rounded forms of the trunks.

Blue flowers attract the eye by bringing in a touch of cool colour that stands out vividly against the warm shades of the woodland floor.

5 ▼ Colour the foreground Paint the shadowy path with bands of a blue-grey mix of cerulean blue with touches of white and Mars black. This cool colour contrasts well with the warmer hues around it. Scumble darker mixes of cerulean blue and dioxazine purple over this.

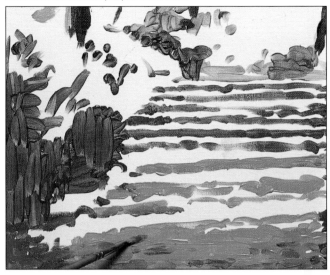

6 ▼ Create optical colour mixing Dapple some dioxazine purple over the red in the foreground to suggest different coloured leaves. When viewed from a distance, these colours will appear to merge, translating as the reddish-brown shades of autumn.

DEVELOPING THE PICTURE

With the main features now in place, the next stages concentrate on developing the foliage with a range of oranges, browns and greens.

7 ▼ Build up the foliage Paint the sunlit fallen leaves on the steps and at the side of the path with a mix of cadmium yellow and yellow ochre. Then, combine vermilion, yellow ochre and raw umber, and paint some orange-brown leaves among the green and yellow ones.

8 ◄ Build up the tree-trunks Change to a No.4 round brush and, using the same orange-brown from step 7, work over the purple tree-trunks with patches and lines of paint. Adding this extra tone helps to make the trees appear more three-dimensional.

9 ▲ Adjust the tones Fill in the dense foliage with a range of greens and browns mixed from sap green, cadmium yellow, yellow ochre and raw umber. Add more raw umber to paint the tracery of fine twigs and to darken some of the branches. Dab on the very dark leaves with a mix of cerulean blue, yellow ochre and dioxazine purple.

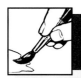

EXPERT ADVICE
Controlling fine lines

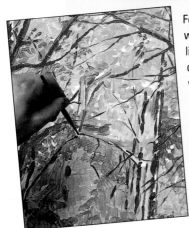

For maximum control when making very fine lines – such as the ends of the branches – work with the canvas flat or slightly tilted and hold your brush loosely at a 90° angle to the picture. Paint with just the tip of the brush, moving your whole arm.

Express yourself

Black-and-white study

This sketch reduces the scene to its essentials – the network of branches and canopy of foliage, the leaf-strewn banks and the horizontals along the path. It was worked with a chisel-tipped felt pen, using lively marks – similar to oriental calligraphy.

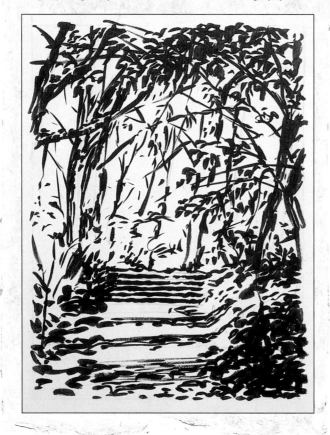

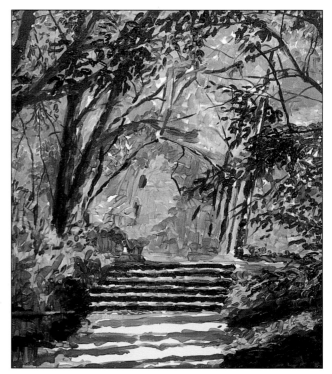

10 ▲ **Overpaint the dark bush** To indicate individual leaves on the dark brown bush at the bottom left, mix a dark green from cerulean blue, yellow ochre and a touch of dioxazine purple. Dab on the paint with short strokes, using the No.4 round brush.

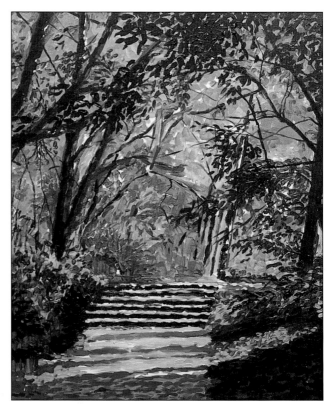

11 ▲ **Put in some highlights** Add more white to the blue-grey mix from step 5 and fill in the pale bands of sunlight across the path. Lighten the mix with more white and dab highlights on to the leaves on the steps. Build up the leaves in the foreground with a range of dark, mid and light greens from the palette.

Only minor adjustments are needed now. Strengthen the tonal variation, making the darks darker and the lights lighter to suggest the effects of the sunlight as it pierces the canopy of leaves.

12 ▼ Add pale leaves Dot white highlights on to the path. Mix sap green with a touch of raw umber and form pale leaves by rolling the body of the brush over the surface and then lifting it so that its tip creates the tip of the leaf.

13 ▲ Accentuate the dark tones Dot some more dark green leaves on to the overhanging branches on the right. This dark area at the front of the picture, with lighter tones behind, strengthens the sense of recession.

THE FINISHED PICTURE

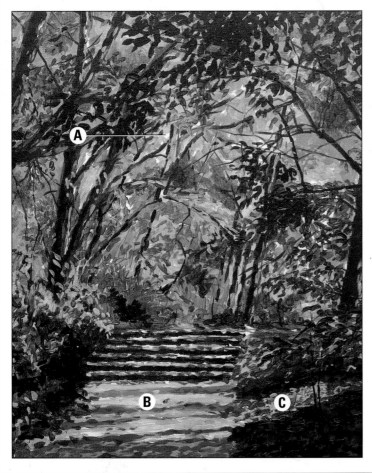

A Areas of white
Unpainted areas of canvas lift the colours around them, at the same time giving the impression of sunlight filtering through the trees.

B From brown to blue
The artist deliberately painted the brown path in blue to create an exciting complementary contrast with the hot reds and oranges of the leaves.

C Optical mixing
Adjacent flashes of strong, saturated colours – reds, oranges, yellows and greens – create a picture surface with a vibrant, luminous quality.

After the harvest

Panoramic landscapes offer great painting opportunities.

This broad vista has been approached in an expressive, imaginative way.

This painting was inspired by a visit the artist made to France just after the harvest had been taken in. It is not a conventionally pretty landscape, but the starkness of the rolling farm land uninterrupted by hedges and fences provides an arresting image. Big landscapes are mirrored by big skies, and the frothy white cumulus clouds are an important component of this image. The lines of stubble have a bold, graphic quality and lead the eye across the landscape and into the distance. The tawny colours and spiky textures were also an inspiration.

▼ **Layers of scumbled gouache and pastel, together with a variety of textural marks, create a paint surface with plenty of visual interest.**

A sense of space and place

The artist painted this image in the studio, with the aim of capturing the sense of space and place, rather than creating a precise topographical description. He used photographs as a resource, but also relied on his memory of the scene and his experience of the landscape, the light and the mood.

Working from photographs

Indeed, the most rewarding results are achieved when you use photographs as a jumping-off point – a trigger for the imagination rather than a template to be copied exactly. Most artists treat photography as a tool alongside sketching and drawing, a valuable aid and a source of inspiration. Photos are especially useful for landscape artists because time spent on location is often limited, not least because the weather can close in.

When you find a subject that interests you, don't take just one photo, but run off a whole

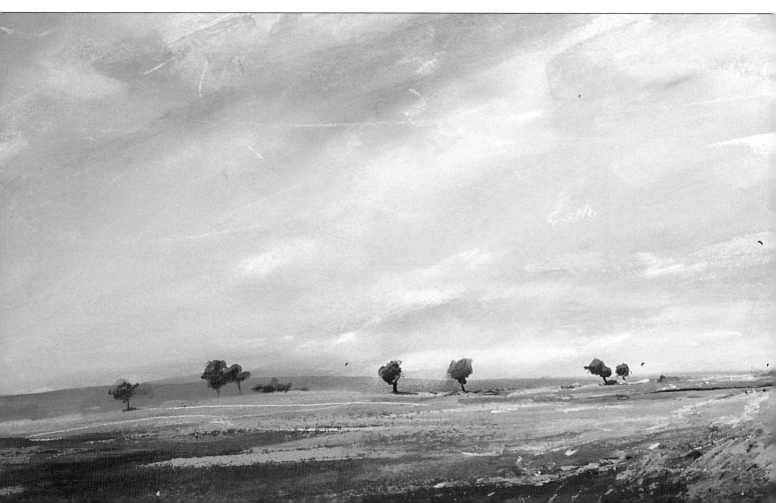

film. Take a series of overlapping photographs (see left) and tape the prints together to create a panorama that will give you a choice of compositions. Try different formats and crops: a broad vista will feel spacious and airy while a tight crop can produce a more dynamic image.

In this project, the artist was inspired by the trees marching along the skyline, and the colours and the beautiful sky full of light, wispy clouds. However, the field in the foreground was 'borrowed' from another series of pictures and the house was moved to the right side of the image.

Perfect partners

A combination of gouache and pastel was used for the painting. These two media, one wet and one dry, have many qualities in common. Both are strongly coloured, have a matt opaque finish and can be used as solid colour or as semi-transparent scumbles.

An underpainting in gouache establishes the division between sky and land, and sets the colour key for the image. Further colour is applied with broad strokes of the gouache or pastel, but these are knocked back by subsequent layers. Later, some layers are recovered by scratching back with a blade. Gradually the image comes into focus, but sometimes it dissolves as an area disappears under a layer of colour only to emerge in a different guise. This technique of losing and finding gives the final image a freshness and spontaneity which is often absent in more orderly and conventional methods of painting.

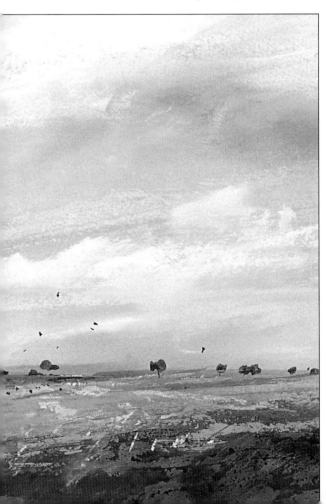

YOU WILL NEED

Piece of 300gsm (140lb) Not watercolour paper

Brushes: 50mm (2in) decorator's brush; Nos. 20, 10 and 4 rounds; No.16 filbert; squirrel mop

9 gouache paints: Azure blue; Madder carmine; Cadmium orange; Titanium white; Raw sienna; Burnt sienna; Alizarin crimson; Winsor green; Cobalt blue

Palette and jar of water

14 soft pastels: Cobalt blue; Indian red; Titanium white; Sage green; Sap green; Burnt umber; Cadmium yellow; Lemon yellow; Yellow ochre; Dark green; Cobalt blue; Lilac grey; Dark grey; Pale blue

Hard eraser

Kitchen paper

Blade

L-shaped card croppers

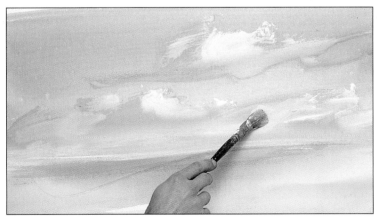

FIRST STEPS

1 ▲ Block in the underpainting Wash in the sky with a 50mm (2in) decorator's brush and a large quantity of azure blue gouache with a touch of madder carmine. Apply a broad wash of cadmium orange to the foreground to provide a warm undertone for the cornfield. Dry the painting with a hair-dryer. These areas of colour establish the broad divisions of the composition.

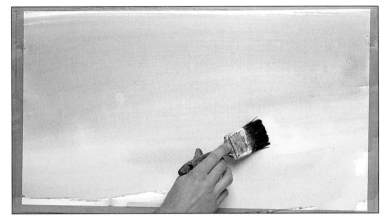

2 ▲ Lay in the clouds Using a No.20 round brush, scumble titanium white gouache into the sky, pushing the paint around to create cloud formations. Mix a little madder carmine with white and a touch of azure blue and drag this colour over the lower sky and horizon – this gives the lilac for the shadows on the undersides of the clouds.

3 ▶ Develop the sky Use the side of a mid-toned cobalt blue pastel to lay a band of broken colour across the orange just below the horizon. With a No.10 round brush, lay a narrow band of pure azure blue along the horizon. Use the No.20 brush to work more of the pale lilac into the upper sky, pushing the paint backwards and forwards with vigorous strokes to create descriptive marks.

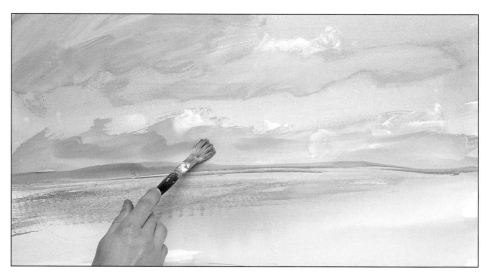

4 ▶ Add foreground colour Load a No.16 filbert and lay broad, sweeping bands of a mix of cadmium orange and raw sienna across the foreground. The paint is distributed unevenly, covering thickly in some places, glancing across the surface in others to give a dry-brush effect. These bands describe the patterns of light and shadow on the field.

DEVELOPING THE PICTURE

The broad division between sky and land has been established and the orange foreground and blue/lilac sky set the colour key for the painting. Now it is time to introduce more texture in the foreground and develop the clouds on the right. The white house provides a focal point.

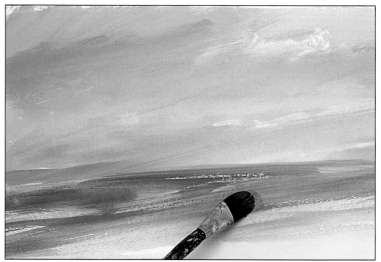

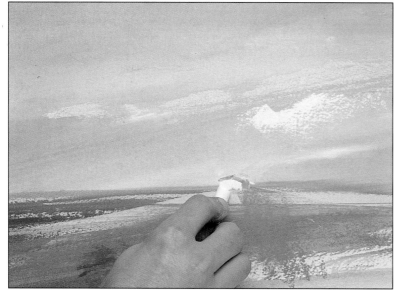

5 ▲ Introduce a focal point Add texture in the foreground by skimming Indian red pastel across the foreground. Now put in the white house with titanium white pastel, giving it a mid-grey roof. Located on the horizon at a key point about a third of the way up and a third of the way in from the right, the white house draws the eye and helps to tie the composition together.

6 ▲ Develop the clouds Use a hard eraser to lift out colour to create white areas of paper that stand for clouds. Apply white pastel in the cloudy areas on the right – the different qualities of the paper white and the pastel white suggest the changing nature of the clouds.

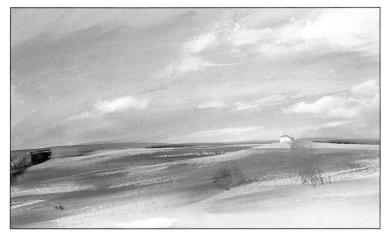

7 ▲ Darken the horizon Mix azure blue and burnt sienna gouache to give a dull green and lay a thin wash of this over the azure hills on the horizon, linking them to the foreground.

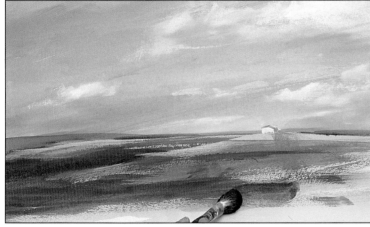

8 ▲ Knock back the foreground Add alizarin crimson to the azure blue/burnt sienna mix to produce a rich brown. Wash this colour in bold gestural marks over the foreground with the squirrel mop brush. This creates areas of solid and broken colour that describe the shadows cast over the landscape by the clouds.

9 ▶ Soften the horizon Make a pad from crumpled kitchen paper and rub this lightly over the white clouds to soften them in some areas. Then gently rub the pad over the horizon – the pastel sticking to it will soften and diffuse the colours.

TROUBLE SHOOTER

TESTING A COLOUR

If you want to make a major change to the painting, test the effect before you commit yourself. Lay a sheet of paper over the relevant area and apply the new colour to this.

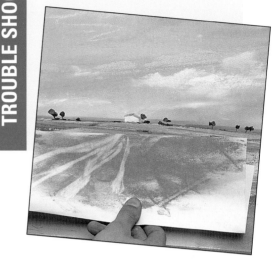

10 ▲ Add linear marks Pastel is both a drawing and a painting medium. Use a sage green pastel to create lines that echo the marks in the stubble and lead the eye to the house on the horizon. These lines link the foreground to the background and create a sense of travel within the picture. Select a sap green pastel to lay in a solid block of green under the house. This provides an accent colour that draws the eye.

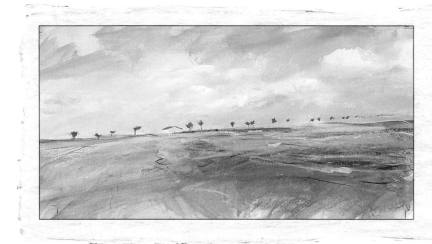

Express yourself
Shifting the viewpoint

This composition, also worked in gouache and pastel, shows an alternative viewpoint. The house has been moved to the left of the picture and is not such a prominent feature. The hills have been left out, so that the trees stand out more starkly against the pale clouds, linking land to sky.

11 ▼ **Add the trees** Mix azure blue, Winsor green and alizarin crimson gouache to create a dark green. Use the tip of the No.10 round brush to dot in the silhouetted tree shapes, painting the trunks with the tip of the brush.

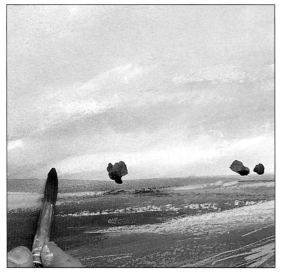

12 ▲ **Lighten the foreground** Scumble a thin wash of titanium white gouache over the foreground – pastel picked up by the wash modifies the colour, introducing interesting random effects. While the paint is still wet, use a blade to scrape off areas of paint, revealing the underlying layers. This 'losing and finding' is part of the creative process. Stand back and review your handiwork – you might find it useful to leave it for a while so that you can come back and study it with a fresh eye.

EXPERT ADVICE
Frame the picture

It is easier to see how a picture is progressing if you contain it within a card frame. Try different crops with four strips of card or two L-shapes. Judge how the composition is working within the rectangle of the picture area and make adjustments if you wish.

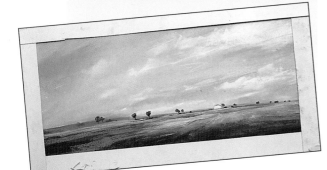

13 ▶ **Develop the textures** Mix Winsor green, cobalt blue and alizarin crimson to create a dark brown and wash this over the foreground. Leave to dry. Now apply gestural marks on top with a burnt umber pastel. Use cadmium yellow, lemon yellow and yellow ochre pastels to develop the sunlit central areas.

14 ▲ **Add more texture** With L-shaped card croppers in place (see Expert Advice on page 1493), add more texture and detail in the foreground. Use flicks and stipples of lemon yellow, yellow ochre and white pastels to suggest the texture of stubble and straw.

15 ▼ **Add details to the trees** Use a dark green pastel to refine the shapes of the trees and add texture to them. The silhouettes should remain crisp, but they will look more convincing if there is a variation of tone.

Master Strokes
~∽~

Stanley Royle (1888–1961)
The Marshes at Sunset

Painted in oils on canvas, this richly coloured picture presents a broad vista with a wide, open sky. As in the painting in the project, trees and a house break the skyline, interrupting the horizontal aspect of the composition. The interlinked bands of colour that make up the foreground give a patterned, almost abstract quality to the flat landscape.

Brush marks in the thickly applied oil paint imply the form of the clouds. The sunlit areas are particularly heavily textured.

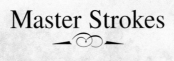

Lit by the setting sun, the yellow field makes a bright splash of colour among the gentler blue, green and brown hues of the marshy landscape.

16 ▼ **Develop the sky further** It is important to achieve a sense of recession in the sky as well as on the ground. Make the sky at the top of the picture darker, with larger, more emphatic clouds forms, and leave the clouds near the horizon smaller and less defined. Scumble cobalt blue pastel over the upper sky, then add a little lilac grey.

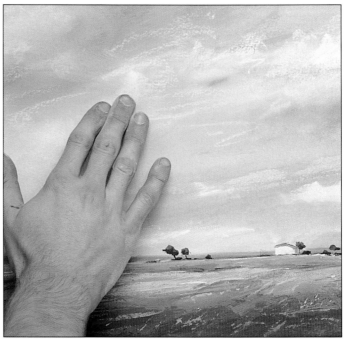

17 ▲ **Blend the sky** Use a dark grey pastel to scumble shadow under the closest cloud formation. Then use your fingertips to soften and blend all the pastel marks across the sky.

18 ◄ **Develop the sky** Apply pale blue, lilac grey and mid grey pastel on the undersides of the clouds, using diagonal marks to give the sky a sense of movement. Blend the colour by brushing it lightly with your hand or with a piece of crumpled kitchen paper.

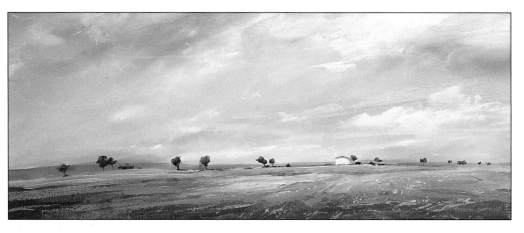

A FEW STEPS FURTHER

Once the painting was almost complete, the artist studied it for a while and decided that the central area needed more work. It is a good idea to leave an almost-finished painting for a while and come back to it fresh – it will often then be obvious what still needs to be done.

19 ◄ **Knock back the green field** The sap green field no longer looks quite right as a single band of colour. Begin modifying it to give it a more subtle look by applying an initial layer of cadmium yellow pastel.

20 ▶ Modify the strong yellow
Skim lemon yellow pastel over the field to lighten it. Then use a blade to scratch off some of the colour so that layers underneath are revealed.

21 ◀ Put in the birds Add a layer of burnt umber pastel to the field and scratch back once more with the blade to create broken colour. Make a dark mix of Winsor green and alizarin crimson and use the tip of a No.4 round brush to dot in birds flying over the stubble. This final flourish provides a sense of scale and movement.

THE FINISHED PICTURE

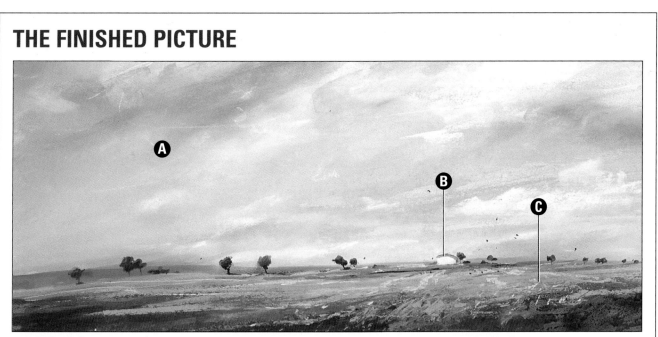

A Luminous sky
Layers of semi-transparent gouache and scumbled and blended pastel were used to capture the shifting, ever-changing luminosity of the sky.

B Focal point
A tiny white house located at a key point on the horizon provides a solid anchor for the composition. The eye travels around the image but constantly returns to this point.

C Spiky stubble
Pastel flecked, stippled and dashed over the foreground captures the dry spikiness of the stubble. The layered approach suggests the complexity and depth of the surface.

Seasonal palette – winter

Every season demands a different palette – for a winter landscape, all you need is a small selection of subdued colours.

Even if it isn't covered with snow, the winter landscape rarely contains bright colours. Although bold red and yellow pigments may be invaluable in the other seasons, they are usually unnecessary in winter. Even bright greens may have limited use, as winter foliage tends to be dull and subdued – particularly the dark evergreen of conifers and the faded, grey-green of grass that has lost its summer freshness.

The scene on the right was painted with a palette of just five muted watercolours (see below), with the addition of a little white gouache in the final stages. The result is a moody, realistic evocation of a rather forbidding winter landscape.

Winter light

With so few local colours present in a typical winter landscape, your choice of colours will be dictated largely by the weather and the light. On a cloudy day, the landscape can almost appear monochromatic – simply a range of blacks, whites and greys with subtle tinges of green, blue and brown. In this case, the emphasis may be on the most neutral colours – Payne's grey and burnt umber.

This was certainly the case for the scene on the right. The ultramarine used for the sky was toned down with a lot of Payne's grey. And the sap green used for the trees was neutralised by adding both Payne's grey and burnt umber.

Coloured shadows

If you're painting a winter scene in sunshine, however, the brighter colours of the palette come into their own. The sun brings out a spectrum of blues and warm golds that require the addition of ultramarine and burnt sienna. And grass and foliage lit by direct sunlight will demand large amounts of sap green in your mixes.

As the sun appears closer to the horizon in winter than in summer, it creates characteristic longer shadows. These shadows often contain a lot of colour, particularly blues and greens. Against the bright whiteness of snow, they can appear very attractive – translucent and alive with colour.

Contrasting tones

Snow creates extreme tonal contrasts. The lightest tone is the dazzling white-ness of the snow itself; the darkest tone is created by the silhouettes of trees and other objects in the otherwise white landscape.

Watercolour is the perfect medium for a wintry subject because you can use the unpainted white paper to represent the snow. Inevitably, the bright white-ness of snow makes everything else in the landscape appear dark in comparison. For example, in this painting there is very little detail in the pine trees and fence posts. They are painted as dark silhouettes which stand out as sharp shapes against the white background.

Opaque white

In addition to the five watercolours on the winter palette, our artist introduced a little opaque white in the final stages of the painting. This can be seen in the spattered snowflakes, which lend a decorative and realistic touch to the scene – an effective detail, which you can add to any snowy landscape.

Simply spatter the finished painting lightly with white and grey (made up from a mixture of white and palette mud). The white will show up against the dark

Five-colour palette

A palette of five watercolours was used for the winter landscape on the right. The slightly cool Payne's grey is a good starting point for all your mixes. Use it with ultramarine for the sky and cold shadow colours; with sap green to capture foliage; and with burnt umber and burnt sienna for the warmer tones.

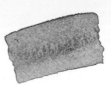

Payne's grey **Ultramarine** **Sap green** **Burnt sienna** **Burnt umber**

SNOW-COVERED HILLS

Three of the main colour mixes used by the artist for this winter landscape are shown below. Note how the strength of these mixes has been varied in the picture. For instance, the ultramarine and Payne's grey mix is quite dark below the trees, a little lighter in the sky and almost transparent in the bottom left corner. The use of the same mix across the picture helps give it a visual unity – while varying the dilution prevents it from becoming too repetitive.

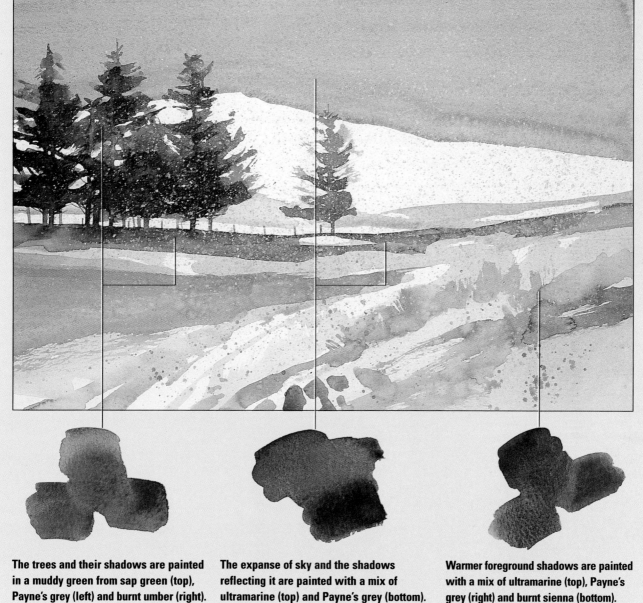

The trees and their shadows are painted in a muddy green from sap green (top), Payne's grey (left) and burnt umber (right).

The expanse of sky and the shadows reflecting it are painted with a mix of ultramarine (top) and Payne's grey (bottom).

Warmer foreground shadows are painted with a mix of ultramarine (top), Payne's grey (right) and burnt sienna (bottom).

tones; the grey stands out from the white snow. You can create a full-scale blizzard by spattering across the entire picture!

Use either white gouache or Chinese white watercolour for this finishing touch. However, remember that white paints contain chalk. When white is added to other pigments the resulting colours become pale and chalky, and this can destroy the natural transparency of watercolour paints. Unless you posi-tively want a cloudy, opaque colour, don't mix white with other colours. Reserve it for special effects only.

Cold weather warning

Painting winter landscapes is exhilarat-ing but it can also be very cold. You will need to protect yourself against the elements with warm clothing. A padded waistcoat or coat lining keeps your body warm but leaves your arms free to manoeuvre the paint brush. Fingerless gloves are another good idea, keeping your hands warm but your fingers free.

However, the fact remains that paint-ing on-the-spot winter landscapes is a chilly business. A practical, more comfortable alternative to working out-doors is to paint a view from a window. Another option is to make rapid on-the-spot colour sketches and take photos, and then do the painting at home.

Snow scene in watercolour

Use a range of watercolour techniques to paint this tranquil landscape under a blanket of snow.

Snow transforms the landscape, softening edges and imposing a tonal harmony. In bright sunshine, its reflective quality gives the landscape a dazzling brilliance, with trees and other features standing out in contrast to the prevailing whiteness.

When painting a snow scene in watercolour, you need to work logically from light to dark, conserving the white of the paper for the snow and applying washes carefully to the surrounding areas. Use masking fluid for details such as the snow on the bridge.

Warm and cool colour contrasts are very evident in snowy landscapes. Shadows are a characteristic blue-lilac colour and were often depicted in winter scenes by Impressionist painters, who understood how they complemented the yellowish orange of the winter sunlight. In this project, the warm browns and oranges of the trees contrast with the stark white snow and the cool, blue shadows, emphasising the chilly conditions.

▼ **Dark, crisp foreground details contrast with softly blended, washed colours in this peaceful winter scene.**

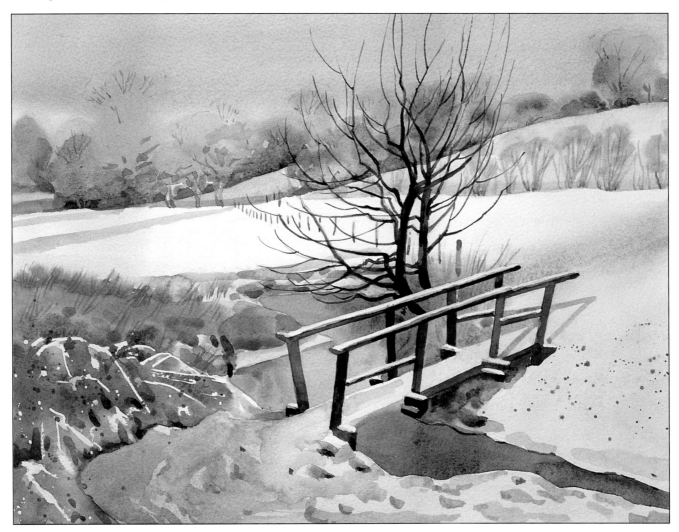

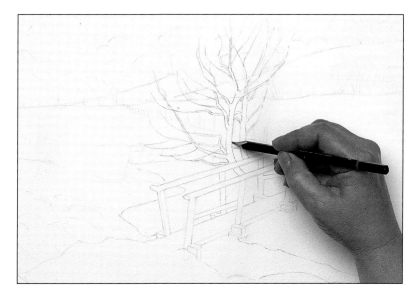
FIRST STROKES

1 ▶ Draw the landscape To create a white border for the finished picture, stick strips of masking tape around the edge of the stretched paper. Using a 2B pencil, make a drawing of the landscape, leaving the snowy areas white. Work lightly in the background and use crisp, emphatic lines for the bridge and tree in the foreground.

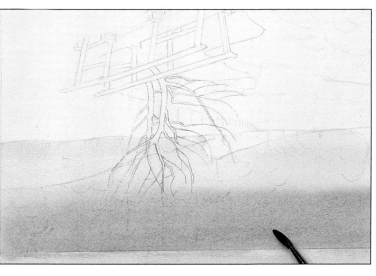

2 ◀ Lay a graduated wash Turn the picture upside down and prop it at a shallow angle (see Expert Advice, page 8). Wet the sky area with a No.10 brush dipped in water. Lay in the area just above the horizon with a yellow ochre wash. Then lay a band of Winsor blue wash under the yellow ochre. The washes will blend to create a soft edge.

▲ **Winsor blue, a cool blue, is ideal for painting a chilly, wintry sky. It was allowed to bleed into yellow ochre towards the horizon to create a delicate neutral undertone for the trees.**

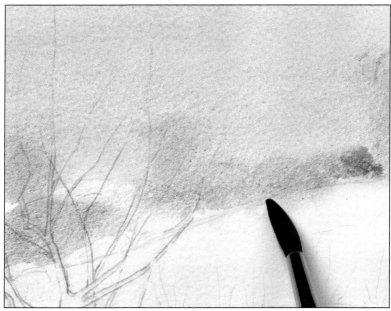

3 ▲ Indicate the distant trees While the sky is still wet, lay in the shapes of the distant trees, using mixes of burnt umber and ultramarine for the darker trees, and cadmium orange and cadmium red for the orange ones. The paint will bleed, creating soft edges. Leave to dry.

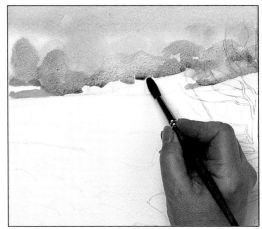

4 ▲ Add darker woodland Use darker versions of the same mixes to paint another layer of trees. Mix Winsor blue with burnt umber or cadmium orange for the darkest areas, working wet on wet. While the area is still wet, apply touches of Winsor blue mixed with ultramarine along the edge of the woodland. Leave to dry.

5 ▲ Spatter on masking fluid Before applying masking fluid to the vegetation on the left, protect the adjacent areas with sheets of paper. Dip an old brush in the masking fluid, then tap it with your finger to deposit droplets and streaks over the area. Leave to dry.

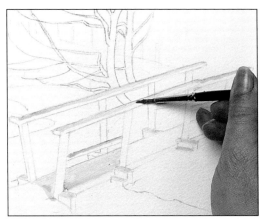

6 ▲ Mask the bridge Paint masking fluid over the walkway of the bridge and the tops of the plinths, then lay a band of masking fluid along each rail. Let the mask dry thoroughly.

DEVELOPING THE PICTURE

With the sky and background established and the snowy details in the foreground masked, you can get on with applying the washes and fine details that will pull the picture together. Because the white of the paper is a positive element rather than simply blank paper, the picture is actually further advanced than would be the case with any other subject.

7 ▶ Lay shadows on the snow Wet the paper where you are going to work. Using a No.7 brush, lay a very dilute wash of cadmium orange over the sunlit snow on the right. While the paper is still wet, lay a dilute wash of ultramarine over the areas of cast shadow. The edges of the orange and blue washes will bleed. Leave to dry naturally.

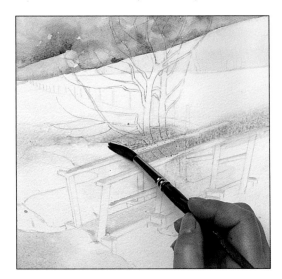

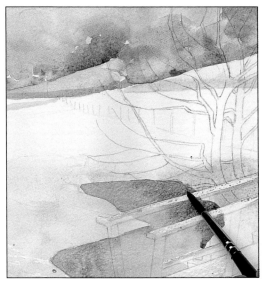

8 ◀ Paint the stream Mix a wash of Winsor blue for the stream and apply it using the No.7 brush. While the blue is still wet, introduce a touch of burnt umber for the reflections of the vegetation beside the stream. Add a touch of cadmium orange here and there.

EXPERT ADVICE
Painting winter trees

In order to paint trees, particularly leafless ones in a winter scene, consider their structure and growth pattern carefully. Use the flat of the brush for the main branches and the tip of the brush for the smaller ones. When you paint towards the end of a branch, the line will naturally become thinner as you complete the stroke, creating a realistic effect.

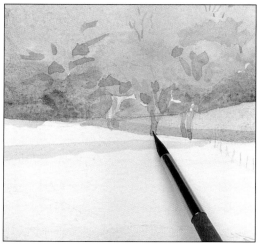

9 ▲ **Add details to the distant trees** Using a No.4 brush with raw umber and a touch of Winsor blue, apply light, delicate brush strokes to suggest the trunks and main branches of the distant trees. Use the very tip of the brush to paint in the smaller branches.

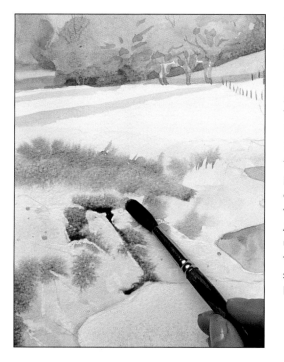

10 ◄ **Add foreground detail** Paint the fence and the hedge on the right with a mix of burnt umber and cadmium orange. Wet the paper on the left, then, with a No.10 brush, use the same wash to paint the vegetation, creating spiky stalks with the brush tip. Add Winsor blue and ultramarine, then dab touches of the raw sienna here and there. Leave to dry.

Master Strokes

Claude Monet (1840–1926)
The Magpie

Monet painted this atmospheric snow scene around 1870, when he had already become interested in working in the Impressionistic style for which he is renowned. The effects of light and shade are one of the main features of the painting.

The white of the snow is broken up by flecks of yellow, suggesting the reflections of winter sunlight glinting from the surface of the snow. The shadows are a pale grey-blue – a cool colour complementing the warmer tones of the bright snow.

The dark shape of the magpie, which stands out distinctively against the snowy landscape, forms the focal point of the painting.

Dabs of yellow and blue with a few touches of pink enliven the surface of the snow in the foreground.

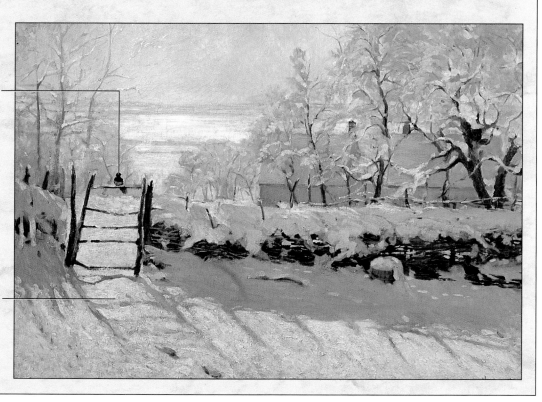

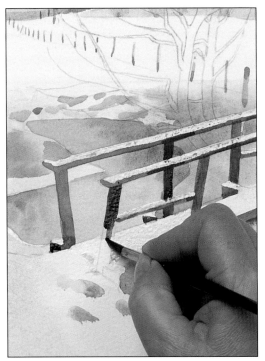

11 ▲ **Paint the bridge** Change back to the No.4 brush and paint the bridge with sepia. This man-made structure is an important focus in the picture, as its geometric shape contrasts with the soft forms elsewhere in the composition. Leave to dry thoroughly.

The painting is now well established. By contrasting the warm sunlight with the cool shadows on the snow, the artist has captured the sparkling light and chill of the scene. Add more texture in the foreground if you wish.

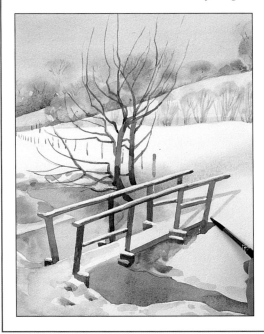

13 ◄ **Add shadows** Use the No.4 brush and an ultramarine wash to paint the shadows in the trampled snow in the foreground. With the same wash, paint the crisp shadows cast by the rails of the bridge.

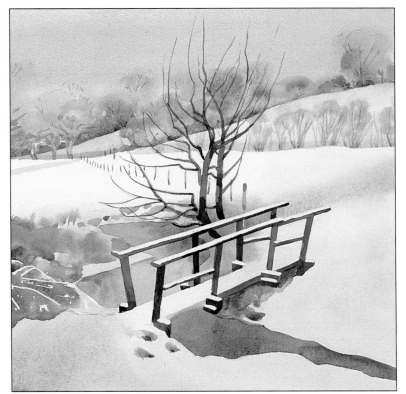

12 ▲ **Paint the trees** Remove the masking fluid from the bridge and the vegetation on the left by gently rubbing the surface with your finger-tips. Then use sepia and the No.4 brush to paint the trees by the bridge. Make them dark and well defined to contrast with the distant trees and create a sense of recession from foreground to background.

Express yourself
Introduce a figure

The watercolour snowscape in the step-by-step has a sense of tranquillity and solitude. By introducing a figure, the artist has created an entirely different mood. The man trudging through the snow suggests a narrative – we wonder where he is going and why. The tree on the left has changed the dynamic of the composition, providing both a counterpoint for the single human figure and another route to lead the eye into the picture.

14 ▲ **Add spattered textures** Protect adjacent areas by covering them with sheets of paper. Dip the No.4 brush in the ultramarine wash and spatter colour on the snow by tapping the brush briskly with your forefinger. Load the brush with raw sienna and repeat the process.

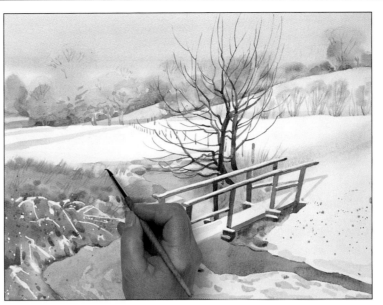

15 ▲ **Paint the dry grass** Mix a raw umber wash and, using the tip of the No.4 brush and a firm yet gentle flicking gesture, paint in some tufts of dry grass in the left-hand foreground area.

THE FINISHED PICTURE

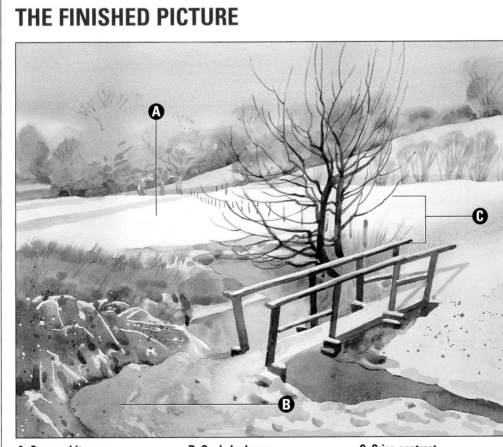

A Snow white paper
The snow is represented by the white of the paper itself, washed in places with yellow ochre and in others with ultramarine.

B Cool shadows
Cool, violet-blue shadows provide a complementary contrast to the orange sunlight of winter.

C Crisp contrast
The dark, crisply painted bridge and trees create a focal point which draws the eye into the painting.

Impressionist landscape

This rendering in the Impressionist style evokes the crisp chill and fleeting light of a winter landscape.

Capturing the mood of a landscape involves much more than simply copying what you see. This dramatic oil painting in the Impressionist style is as much about feeling as seeing. The Impressionists, who dominated European and North American art in the late nineteenth century, challenged established painting conventions by experimenting with colour and loose brush strokes in order to convey atmosphere and a sense of light in their paintings. Like the Impressionists, our artist has used colour, texture and lively brushwork to 'describe' rather than copy this woodland scene. An initial dull red wash was applied all over the canvas, and this warm colour helps to unify the landscape. Red is the complementary colour of green, and here it has the effect of both intensifying the greens in the landscape and of preventing the winter scene from looking too stark.

▼ **Many dabs of colour create texture in this evocative interpretation of a wood in winter.**

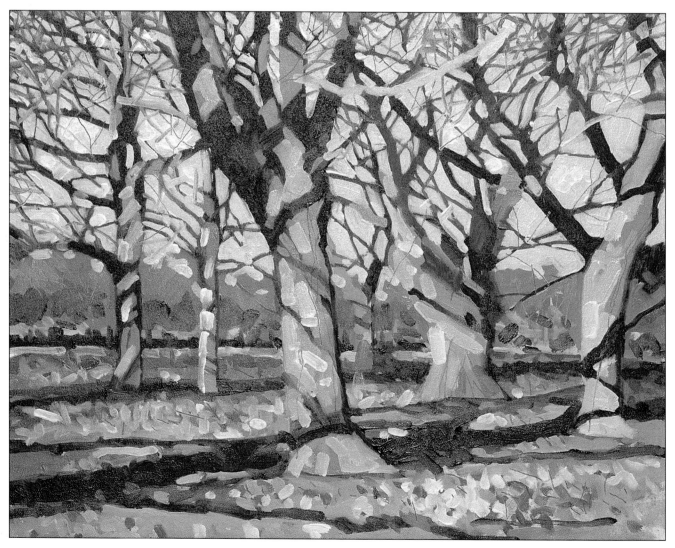

FIRST STROKES

1 ▼ **Sketch in the landscape** Use a soft pencil (2B or similar) to sketch the basic shapes of the landscape on to the canvas. Pay special attention to the forms of the trees, and draw in the prominent areas of shadow. This painting is in the Impressionist style, so think in terms of shapes, forms and areas of light and dark, rather than of trees, sky and woodland floor.

YOU WILL NEED

Stretched canvas 43 x 53cm (17 x 21in)	Turpentine for thinning the paint
2B pencil	Oil paints: Alizarin crimson; Burnt umber; Cerulean blue; Payne's grey; Yellow ochre; White; Raw sienna; Cadmium red; Sap green; Monestial blue; Permanent mauve; French ultramarine; Chrome yellow
25mm (1in) decorator's brush	
Oil-painting brushes: Nos.3 and 1 flats	
Palette	
White spirit for rinsing brush	

2 ◄ **Lay a red background wash** Use a 25mm (1in) decorator's brush to apply a very thin dull red wash of alizarin crimson mixed with just a little burnt umber over the whole canvas. Allow the wash to dry.

3 ▲ **Add the most prominent shadow areas** Mix cerulean blue and Payne's grey in equal parts for the darkest areas of the painting. Apply using a No.3 flat brush, working with loose brush strokes.

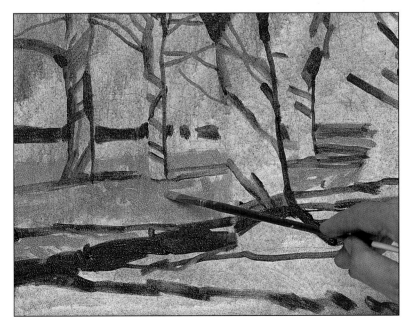

4 ► **Block in the woodland floor** Add yellow ochre and a touch of white to your dark mix for the slightly lighter shadows in the landscape; apply this using a No.3 flat brush. Redden the mix slightly, using raw sienna and a little cadmium red, and apply it to the woodland floor, working with loose brush strokes to suggest the many textures here.

DEVELOPING THE PICTURE

With the basic framework of trees completed and the woodland floor blocked in, you can begin to develop tone and detail in the scene.

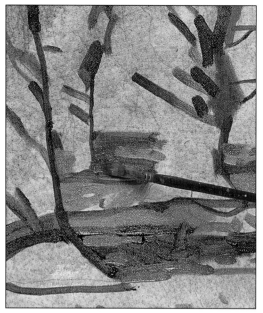

5 ▲ Introduce detail to the woodland floor Add a little more cadmium red to emphasise the fallen leaves on the ground. To lift the painting, you can cheat nature a little by using colours that are slightly stronger than the ones actually in the scene.

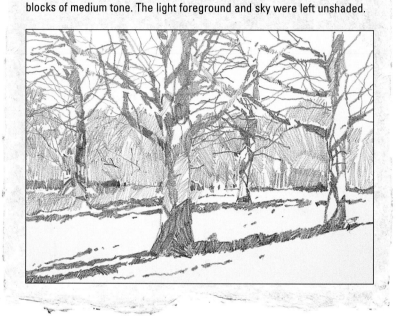
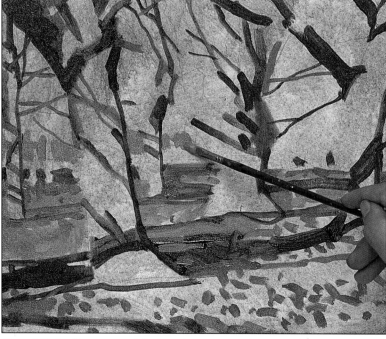

6 ▲ Add the distant trees Mix in a tiny amount of white, and add some sap green to the woodland floor mix used in step 4 to give a dull but definite green. Apply this to the background to suggest distant trees. As the green is added, it plays against the complementary red wash, creating a vibrant colour effect.

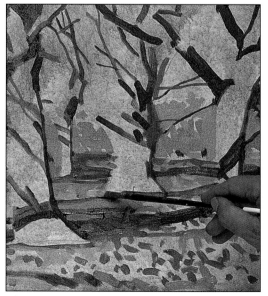

7 ▲ Apply the middle-distance highlights The middle distance is the natural focus of a painting. Mix half yellow ochre with half white and apply dabs of this colour to add another layer of interest to this part of the composition.

8 ▼ Block in the foreground trees Add lots of white and some yellow ochre to the green mixture used in step 6. Apply this to the trunks of the trees in the foreground. Then mix in a little more white to create a paler colour suitable for the lighter areas on the trunks, the upper branches and the woodland floor.

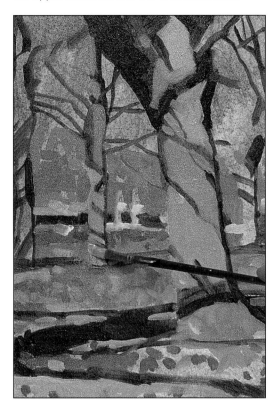

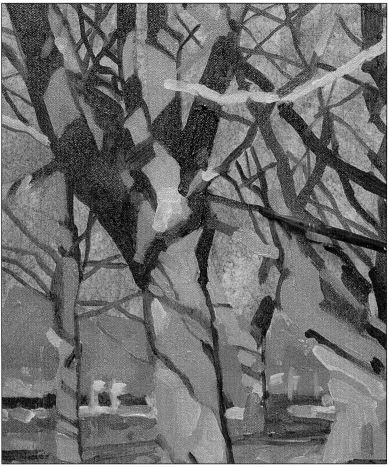

9 ▲ Complete the framework Mix monestial blue with a little Payne's grey. Use this dark colour to draw in the smaller branches, and to strengthen and add cool tones to the shadows.

Master Strokes

Alfred Sisley (1839–99)
The Walk

Seeking to convey the interplay of light and shade in the landscape was a major concern of Impressionist artists such as **Alfred Sisley**. In this peaceful autumnal scene, the multitude of colours in the turning leaves are captured with loose, almost random dabs of paint.

The viewer is drawn into the picture by the converging lines of the avenue of slender trees.

The shadows of the trees falling across the brightly sunlit path provide emphatic tonal contrasts.

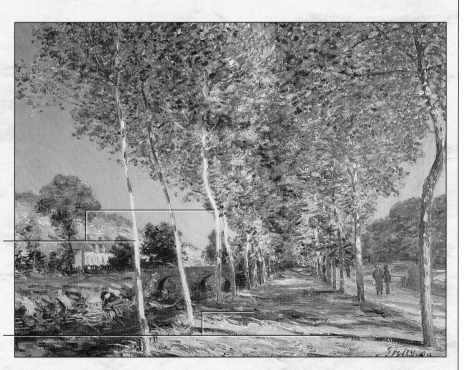

10 ▼ **Block in the sky** Mix cerulean blue with a lot of white to create a cool, wintry sky, applying the colour with a No.1 flat brush. Although this is quite detailed work, allow a little of the red background wash to show through to maintain a rosy glow.

11 ▲ **Suggest the clouds** Apply white on its own to indicate the clouds. Use a loose dabbing action to give plenty of texture.

12 ▲ **Colour the shadows** Mix permanent mauve, cadmium red and a little Payne's grey. Work this very dark colour into the shadows among the trees, using a dabbing action. The shadows here are not just dark – they contain a multitude of colours. By using colour to differentiate between different areas of shadow, you can capture the quality of light of the original scene. Mix French ultramarine into mauve to add the finest, vein-like branches.

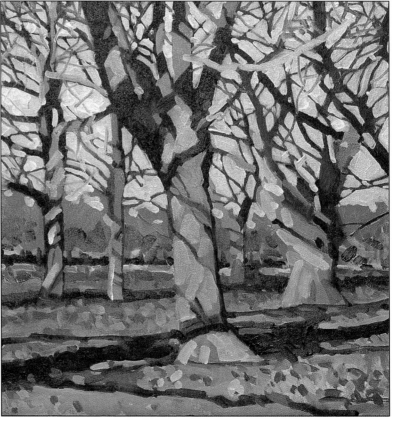

13 ▲ **Add highlights to the scene** Lighten the green mix used for the palest areas in step 8 by adding even more white paint to it. Use this soft, pale colour to put in additional highlights here and there on the tree trunks and branches in the foreground.

A FEW STEPS FURTHER

The Impressionist interpretation of the woodland scene is now well established. You just need to brighten the foreground with a few extra highlights. Return to your sketching pencil to draw in the finest details.

14 ▲ **Accentuate the light** Mix the sky colour with a little yellow ochre to put more highlights on the trees. Add chrome yellow for the highlights on the fallen leaves.

15 ▼ **The finishing touches** Use a 2B pencil to draw the finest branches and the details on the tree trunks and the ground, adding another level of texture.

THE FINISHED PICTURE

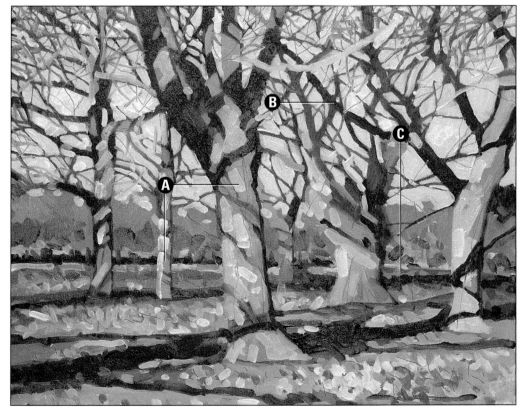

A Loose brushwork
Lively strokes and dabs of colour in the Impressionist style give an effect of shifting light and shade in the wood.

B Delicate lines
The fine tracery of branches and twigs makes an irregular patchwork pattern across the sky.

C Warm undertones
The underlying dull red wash unifies the painting and softens the chilly winter mood.

A beach in winter

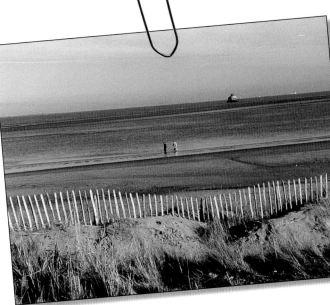

Recreate the stark beauty of a windswept beach on a cold winter's day. Coloured inks give just the right density of colour.

Coloured inks are a bright and vibrant medium, and are used in a similar way to watercolours. They are less transparent than watercolours, but they dry faster and the colours retain their brilliance, even when dilute.

You can choose between waterproof and water-soluble inks, depending on how you want to work. For this seascape the artist used waterproof inks as he wanted to apply several thin layers of colour to achieve a rich density of tone. As the colours are waterproof when dry, it is possible to apply one hue over another without disturbing the underlayer – often a problem with watercolours.

Mixed media

Coloured inks combine well with coloured pencil, pastel and gouache, all of which produce opaque colours that stand out well against the transparent ink. In this painting, the inks are combined with liquid acrylic – a fluid form of acrylic paint that has a natural affinity with coloured inks. Liquid acrylics are slightly more opaque, allowing you to add light tones over dark ones.

Try it first

Both inks and liquid acrylics can be used straight from the bottle for strong, intense colours. They can also be mixed with water for more delicate washes.

If you normally work in watercolour, you will need to get used to the more intense hues of inks – and the fact that you cannot lift out a colour if it's wrong! Inks are dye-based and have stronger staining power than watercolours.

▼ **A sense of distance is created in this scene by using definite pen and brush strokes in the foreground, while reverting to broader washes for the sand and sea.**

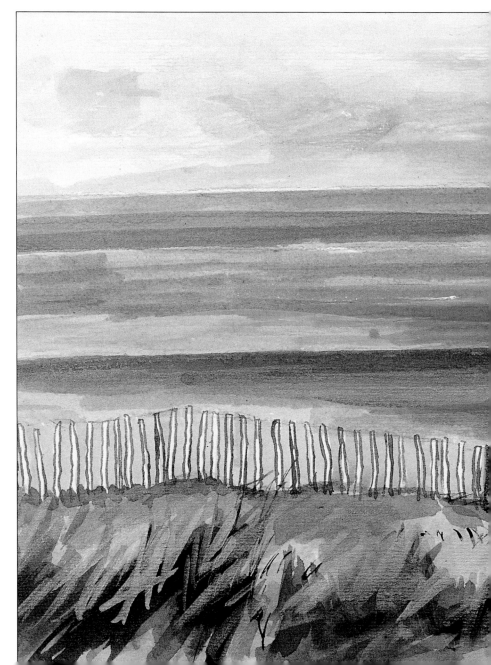

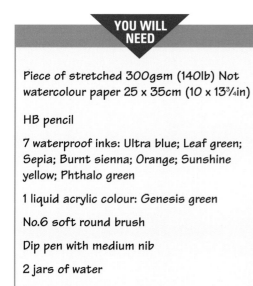

YOU WILL NEED

Piece of stretched 300gsm (140lb) Not watercolour paper 25 x 35cm (10 x 13¾in)

HB pencil

7 waterproof inks: Ultra blue; Leaf green; Sepia; Burnt sienna; Orange; Sunshine yellow; Phthalo green

1 liquid acrylic colour: Genesis green

No.6 soft round brush

Dip pen with medium nib

2 jars of water

Dishes for mixing washes

FIRST STEPS

1 ▼ **Sketch the composition** Using an HB pencil, sketch the main elements of the scene – the stretches of sky, sand and sea, the dunes and the distant fortification. Make the horizontal bands of the composition narrower as they approach the horizon to increase the feeling of distance.

2 ▼ **Establish sky and foreground** Dilute ultra blue ink to a pale tone and use the tip of a No.6 round brush to put in the blue part of the sky. Moving down to the foreground, use short, upward strokes of the dip pen to suggest the grasses with leaf green and sepia.

3 ▼ **Return to the sky** Mix burnt sienna with a hint of ultra blue and dilute well to make a warm undertone for the rain clouds. Allow this to dry. Overlay a stronger, less dilute wash of ultra blue with fast, zigzag strokes of the brush to suggest cumulus clouds.

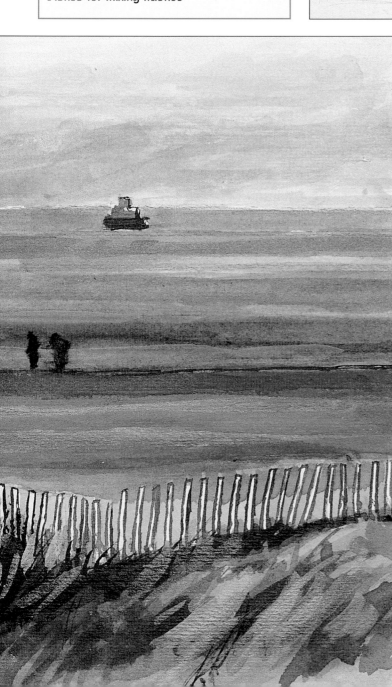

4 ▼ **Start painting the sea** Add a touch of orange to the blue wash to darken it. Fill in the far strip of sea, working around the fort. Add a touch more orange to darken the mix and fill in the near strip of sea – the tonal difference will push the far strip back. Introduce hints of leaf green into the water.

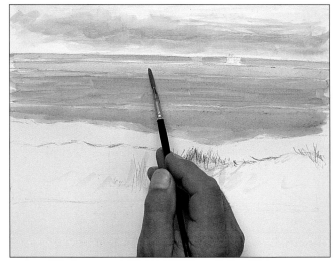

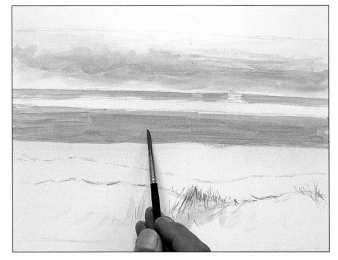

5 ▲ **Paint the sand** Mix orange with a touch of leaf green and burnt sienna and dilute to make a muted yellow. Fill in the distant spit of sand. Strengthen the wash with more sepia and paint the sandy shore in the middle distance, moving the colour around to introduce variations of tone.

Master Strokes

Peder Severin Krøyer (1851–1909)
Summer Evening on the Skagen Southern Beach

Norwegian-born Danish painter Krøyer was a prominent member of a colony of artists based in Skagen – a seaside village in Denmark. Inspired by the beautiful beach there, Krøyer conjures up a peaceful atmosphere filled with light and pure air. The horizon is barely discernible where blue sea meets blue sky, suggesting a heat haze in the distance. The picture area is divided in two by the diagonal slant of the shore line, the sea and sky above it contrasting with the pale sand below it. These areas are linked by the figures of the two women. In the distance, the sweep of the sand dunes retains the eye within the picture.

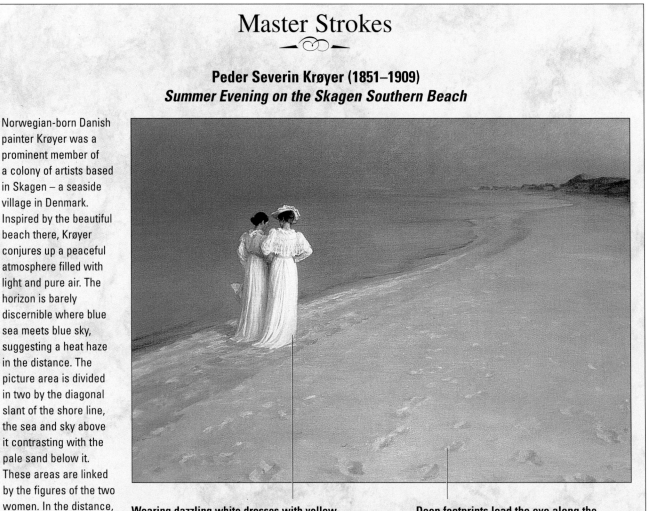

Wearing dazzling white dresses with yellow accessories, the pair of strolling women dominate the foreground and reflect the brilliant sunshine in the scene.

Deep footprints lead the eye along the beach and right into the heart of the picture. Their hollowed-out shapes suggest the soft, powdery texture of the sand.

DEVELOPING THE PICTURE

You have now established the compositional framework of your picture with broad washes of colour and can start to develop the image in more detail. Keep to a fairly narrow range of tones, so as to capture the feeling of a chilly, overcast winter's day.

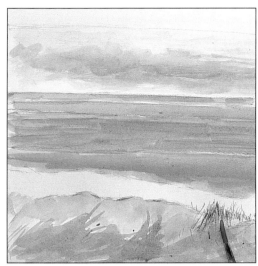

6 ▲ Paint the sand dunes Dilute the yellow wash and use it to paint the sand dunes in the foreground. Allow to dry, then mix a dilute wash of leaf green as a base for the tall grasses in the immediate foreground. Add a speck of ultra blue to the wash to strengthen it and build up the tone with further strokes and washes to suggest clumps of grass.

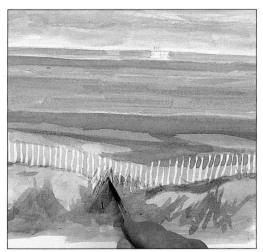

8 ▲ Introduce some dark tone Mix sunshine yellow and sepia to make a dark yellow. Wash this over parts of the sand spit and the shore to give tonal variations that suggest cloud shadows and patches of wet and dry sand. Use it in the foreground to show the shadows in the grass and hollows in the dunes. Dilute the colour and sweep a little into the foreground sea as well, where the sand is visible through the shallow water.

EXPERT ADVICE
Overlaid washes

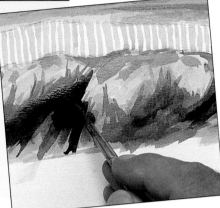

As with watercolours, your results will be more successful if you start with the lightest tones and build up gradually to the darks. It's a mistake to go too dark too early, because you lose the luminosity of the medium – and remember, coloured inks dry water-resistant, so you can't lift out colour afterwards.

7 ▶ Work on the fence Represent the white wooden fence-posts 'negatively' by painting the sand visible between them with the yellow wash. Work quickly, and deliberately avoid being too neat – remember that the fencing is old and weather-beaten.

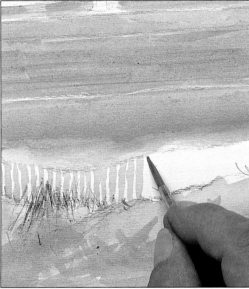

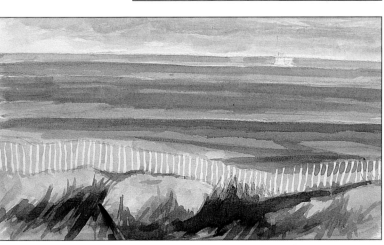

9 ▲ Add more darks Build up more tonal contrasts on the sand with superimposed washes of the dark yellow mix. Make a fairly strong wash of ultra blue and sepia and wash it loosely over the nearest band of water, leaving parts of the lighter underwash showing (see Expert Advice, above). This suggests shadows on the water cast from the clouds above. Mix a strong dark from sepia and ultra blue and work over the foreground with diagonal strokes.

Express yourself
Equipped for a sketch

One of the simplest and most convenient drawing tools you can take when out sketching is an ordinary black ballpoint. In this black-and-white version of the seascape, the artist has used the tip of a ballpoint to produce quite delicate and detailed effects, such as the clouds and the grasses. The loose, lively marks help suggest the the wind blowing across the scene. For the strips of beach and sea, however, he deepened the tone, by exerting more pressure and closing up the shading lines. Remember this takes more time than laying in washes of ink. (Note also how the fort has been changed to a boat in this version.)

10 ▼ Build up the details Paint the fort on the horizon with a strong mix of sepia and ultra blue. Then brush some strokes of pure sunshine yellow on to the sand dunes in the foreground. Dilute the yellow with plenty of water and put in the warm clouds at the top of the picture.

11 ▶ Strengthen the foreground Introduce some dark grasses and shadows in the foreground with sweeping diagonal strokes of phthalo green ink. Leave to dry, then use the dip pen and sepia ink to suggest grass stalks in the foreground with swift upward strokes. Use the same colour to outline the white fence-posts, varying the strength of tone and the thickness of the lines.

12 ▶ Darken the sea Now that the foreground is stronger, the dark patch of water also needs to be strengthened. Mix some orange and ultra blue, slightly dilute, and apply one or two strokes over this area. Use the same mix to touch in the shadow along the base of the fence.

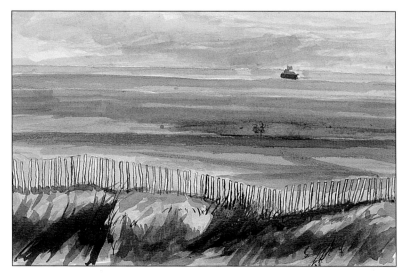

Now is a good time to assess your picture. The grasses in the foreground need to be developed a little further, and a couple of figures on the beach will add interest and emphasise the vastness of sea and sky.

13 ▼ **Develop the grasses** Pick out a few sunlit blades of grass with strokes of Genesis green liquid acrylic (being opaque, it allows you to work light over dark).

14 ▲ **Add the figures** Decide where you want to position the figures, then sketch them in with the dip pen and sepia ink. Treat them very simply, as silhouettes.

THE FINISHED PICTURE

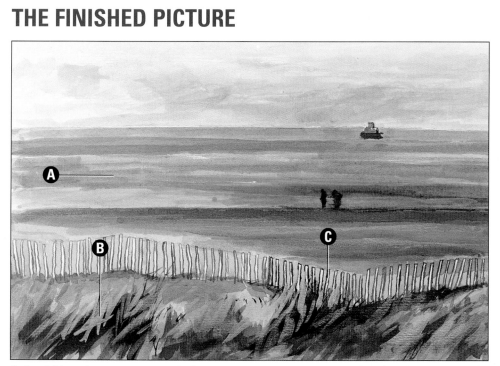

A Overlaid washes
Tonal interest is achieved by overlaying successive washes of coloured ink, working from light to dark and allowing each one to dry first.

B Contrasting marks
Energetic brush marks in the foreground set up an exciting contrast with the broad, flat shapes in the distance.

C Keeping a balance
The verticals of the fence, figures and the fort break up the horizontals of sky, sand and water, preventing the eye from wandering out of the picture.

Composing skies

When painting skies, don't be afraid of a little artistic licence – you can arrange the colour, tones and shapes to complement the rest of your scene.

I n most landscapes and seascapes, the sky occupies a significant proportion of the picture area, so it's important to treat it as an integral part of the composition and not just as a backdrop.

When you find a scene you want to paint, you must first ask yourself: 'Is this a landscape or a skyscape? Do I want the sky to be the main theme,

or is it to play a subordinate or complementary role in the landscape?'.

If you want to emphasise a dramatic sky, place the horizon line low down in the picture area and keep the landscape simple. If the landscape is the focus of interest, place the horizon higher up and keep the sky relatively simple. Avoid placing the horizon across the middle

▲ In Jacob van Ruisdael's *The Shore at Egmond-aan-Zee* (*c.*1675), sky and land are linked by a sweeping S-shape formed by the clouds and beach. The curves of this 'S' are echoed on a smaller scale by the ship's sails, the dunes and even by the women's dresses. Look also at the tonal balance – the dark sea has a black cloud above it, the pale sand has a patch of light cloud above it.

of the picture as this can make for a monotonous composition.

The arrangement of colours, tones and shapes is just as important in the sky as it is in the land or sea. Where the sky is the main feature of the painting, it is a good idea to have a point of interest that draws the eye, such as a patch of colour, a contrast of tone, or perhaps a shaft of sunlight cutting through the clouds. (In the Ruisdael painting on the left, for instance, the fluffy white cloud provides a place for the eye to rest.)

This accent should be positioned off-centre; if placed in the middle of the sky, it cuts the picture in half, but too near the edge of the picture and the composition will be unbalanced and the eye will

▼ The German Expressionist Emil Nolde created brooding landscapes and seascapes in watercolour. Here in *Frisian Landscape* (*c*.1930) he has matched the dark tone for the land with an equally dark one for the sky. Note also how the mysterious dark mark in the sky echoes the house in the field.

Tips for successful skies

● If you have a busy landscape, keep the sky simple; if you want to emphasise a dramatic sky, set it against a relatively low, simple landscape.
● Make sure that sky, middle ground and foreground fill unequal spaces.
● Avoid painting clouds all the same size and shape, with equal spaces in between. Group them together in an interesting way, letting one dominate.
● A good way to check that your sky composition works is to look at it in a mirror, or turn the picture upside-down; this will make any imbalance immediately apparent.
● You will find it useful to build up a reference library of cloud studies, as Constable did, which you can refer to when planning a picture.

be drawn off the edge of the painting. A large shape on one side of the sky needs to be balanced by a smaller one on the other side, and this can be either a smaller cloud or an accent on the landscape.

A strong accent in the sky can also be used to balance a landscape element; for instance, a large tree on the right of the picture may be creating a lopsided effect. If the strongest weight in the cloud

forms is positioned on the left side of the sky, the balance in the painting can be restored. Similarly, if the focal point of your painting is a sunlit building on the left side of the picture, it might help to have a secondary accent on the right side of the sky to counterbalance it.

One way to integrate the sky and the landscape is to use the shapes, tones and colours of clouds to echo or complement

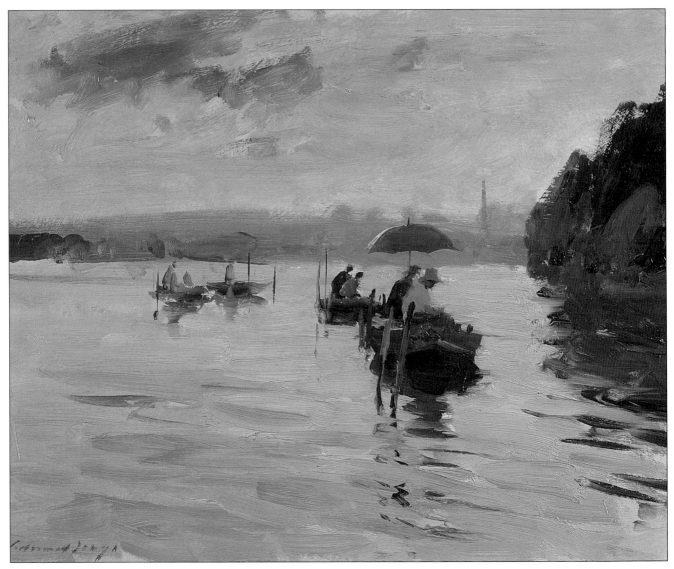

▲ In *Anglers on the Seine at Vernon* (*c*.1950), Edward Seago has painted both the sky and the river with the same muted palette of yellows, greys and browns. This helps create a harmonious, integrated painting.

features in the land below. The rounded shapes of cumulus clouds, for instance, find their echo in the soft contours of hills or clumps of trees, thus creating a series of pictorial links that lends harmony to the composition.

Work continuously

Do not treat the sky and the land separately but work continuously on all areas of the picture, using similar colours and brushwork in both sky and land. Visual links such as these act as 'stepping stones', subtly leading the eye from one part of the picture to another and giving the viewer the pleasing sensation of actively participating in the scene.

Remember, the sky is a moveable feast: you don't have to paint what's there because it is constantly changing anyway. You are perfectly at liberty to move clouds around, change their shape, make them lighter or darker, all in the interest of enhancing the design and the mood of your landscape.

The directional lines of clouds, and their weights and masses, can be cunningly placed to nudge the eye towards a point of interest in the landscape. Or you can use the diagonal thrust of a cloud mass to complement the horizontal shapes in the land and create a feeling of deep space.

Don't forget that the sky and clouds have perspective, just as the land does. The biggest, tallest shapes are in the foreground and they appear to become smaller, flatter and greyer as they recede into the distance, one behind the other. You can take advantage of this to pull

the viewer's eye into the painting and give a feeling of movement, as well as creating the illusion of receding space. Placing an accent of light, colour or tone in the sky near the horizon will also help to draw the eye into the picture.

Abstract design

When composing your sky, think of it as an abstract design made up of clouds and the spaces between them. Consider not only the 'positive' shapes of the clouds, but also of the pattern created by the 'negative' shapes of sky between them.

Look carefully to see that these shapes are an integral part of the overall composition. The patch of blue sky between clouds is an assertive shape and can easily become more dominant than the clouds themselves, so you may need to lighten its colour or add more clouds in order to harmonise the composition.

Depth in skies

The sky is just as important a feature in a landscape as hills, fields and trees – it should contribute to the sense of open space and vast distance.

To bring a feeling of depth and space into your landscapes, you need to create an impression of the sky stretching away towards the horizon. This involves using both linear and aerial, or atmospheric, perspective.

Aerial perspective

Conveying the illusion of recession in the sky is a matter of observing and recording the effects of aerial perspective (see Aerial perspective, page 270), just as you would for the landscape itself. Think of the sky not as a vertical backdrop to the landscape, but as a huge dome stretching from above your head down to the horizon. The sky is clearer directly overhead than at the horizon

because we see it through less atmospheric haze. The further into the distance we look, the more dust particles and moisture droplets there are 'veiling' the sky and landscape. This is why the colours of clouds, trees and hills appear cooler and more muted as they recede from our view.

Linear perspective

The rules of linear perspective also apply, with the clouds directly above us appearing bigger and more clearly defined than those further away. Clouds overlap each other and appear smaller, flatter and closer together as they recede into the distance, often merging into a haze at the horizon. Contrasts of colour,

▲ In *Path in the Gardens of By, May Morning* (*c*.1891) Alfred Sisley has created the impression of depth in his sky by changing his brushwork – from large, bold brush strokes at the top, to smaller, blended ones near the horizon.

tone and shape also become less distinct the further away they are. When painting landscapes, you can accentuate the feeling of depth in the sky by blurring the edges of the furthest clouds wet-on-wet and reserving any crisp edges for those in the foreground.

The art critic John Ruskin (1819–1900) described clouds as 'sculptured mist' because, although they are soft and vaporous, clouds are

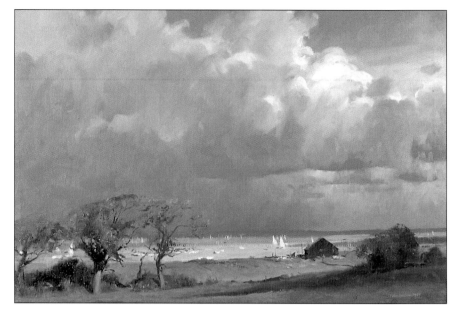

also three-dimensional and have distinct planes of light and shadow. Clouds need careful handling as too heavy an application of paint can result in a dense, rock-like mass. The answer is to use thin, transparent layers of paint to retain the luminosity of the clouds, and to use warm and cool colours to bring out their forms.

Modelling clouds

Warm colours advance, because our eyes are more receptive to them. Cool colours recede. So the contrast of warm and cool colours can be used to suggest the advancing and receding planes of clouds. The lit areas of cumulus clouds, for example, contain warm colours reflected from the sun, so try adding hints of yellow and pink to the whites in these areas. The other side of the clouds, in shadow, may be reflecting blue sky, so will appear a cool blue-grey.

Too many hard outlines make clouds appear 'pasted on' to the sky and destroy the illusion of form. To avoid this, partially blend the shadow edges of

▼ The edges of the dark cloud blend subtly into the surrounding white clouds in John Constable's *Hampstead Heath* (*c.*1828). And by dragging some of the dark colour downwards the artist has suggested rain.

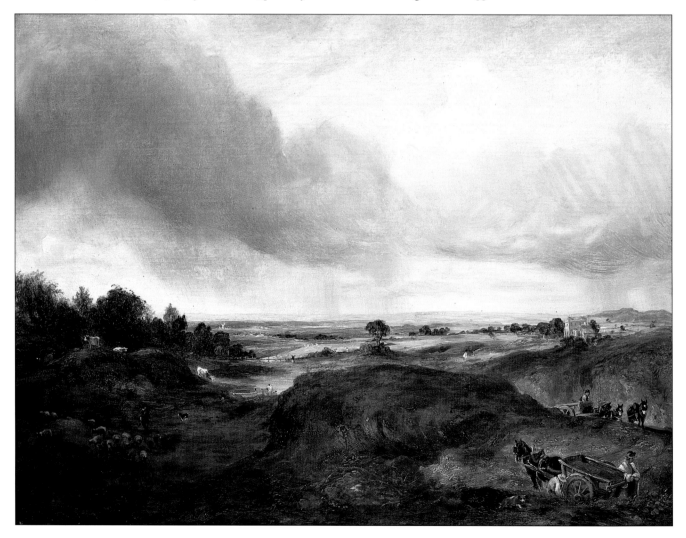

the clouds into the sky with just a few crisp contours, defining the furrows and ridges within the clouds. This contrast of hard and soft edges emphasises form and adds interest, but remember that the contrast should be less pronounced as the clouds recede into the distance.

It is easy to overstate the blue of a summer sky and make it too bright and too uniform in colour, so that instead of receding into space it comes forward like a wall.

Clear skies

When painting a clear sky, it's a good idea to mix three colours – one for the top part of the sky, one for halfway down and one for the horizon area. Start at the top with a rich, warm blue, such as ultramarine, perhaps mixed with a touch of alizarin crimson or violet.

As you work down to the horizon, introduce progressively cooler blues – cobalt and then cerulean, subdued with touches of raw sienna (plus white if you are using an opaque medium). At the horizon, there might be no blue at all; depending on the weather and the time of day, there could be pearly greys, pale pinks or yellows.

Blended brushwork

While the paint is still wet, blend each 'band' of colour into the next so that they merge gently into one another to give a smooth gradation from warm to cool. Avoid too many smooth, horizontal brush marks, though, as they will lead the eye off the edges of the picture. Instead, use lively, broken brush strokes that give the sky a feeling of movement and shimmering light. Remember, too, to use progressively smaller strokes as you work down to the horizon.

▲ In *Sunlight and Shadow, Pin Mill* (*c.*1950), Edward Seago helps give the clouds a real sense of volume by using warm yellows for the sunlit areas and cool blues and turquoises for the shadowed sides. Note also how the brush strokes are much more definite at the top of the sky. Towards the horizon they become more diffuse, creating a strong sense of distance.

Achieving sky effects

In oils, vary the brush strokes and the consistency of the paint to recreate the amorphous nature of clouds and sky. Creamy, opaque colour will suggest groups of dense, advancing clouds; thinly applied, transparent colour gives the impression of atmospheric haziness and recession, and is ideal for portraying distant clouds and sky. Instead of painting the sky as a flat area, try scumbling broken colours (cool blues, pinks and violets) over a warm-toned ground. The interaction between the warm ground and cool colours gives a vivid impression of shimmering, vibrant light.

In watercolour, achieve recession in the sky with a graduated wash of blue, which pales into the white of the paper as it nears the horizon. The luminosity of the white paper glowing through a transparent wash of colour helps give the feeling of space, light and air.

Atmospheric skyscape

Conjure up a feeling of melancholy and even loneliness by painting a vast sky with a bleak winter landscape below it.

Part of the pleasure of painting lies in actually applying the colour on to the canvas, moving it around with the brush, lifting it off and scraping it back to create the effect you want. The way you do this becomes part of your 'signature' as an artist: compare the emotionally charged swirls and whorls of Vincent van Gogh's brushwork to the cool restraint of David Hockney's smooth, flat colour areas.

Spontaneous brushwork

The artist who painted this skyscape uses acrylics because they are quick-drying yet flexible, allowing for sponta-neous brushwork. He enjoys using dry, almost chalky paint, rapidly scumbled and drybrushed on to canvas to create a shimmering haze of colour. The charac-ter of the brushmarks is as crucial to the painting as the arrangement of the colours, their softness creating the effect of misty early-morning light.

As the artist had no specific reference for this painting, imagination, improvi-sation and visual memory came to the fore. He did a preliminary painting (above) to establish the composition, but for this work decided to use cooler colours to evoke a more melancholy mood. Working rapidly, he built up the image in layers, allowing underlying colours to show through. Acrylics are ideal for this broken-colour technique – you can work on each layer almost immediately since the paint dries so quickly.

▶ **The low horizon, empty landscape and diagonal thrust of the large cloud mass create a powerful sense of drama.**

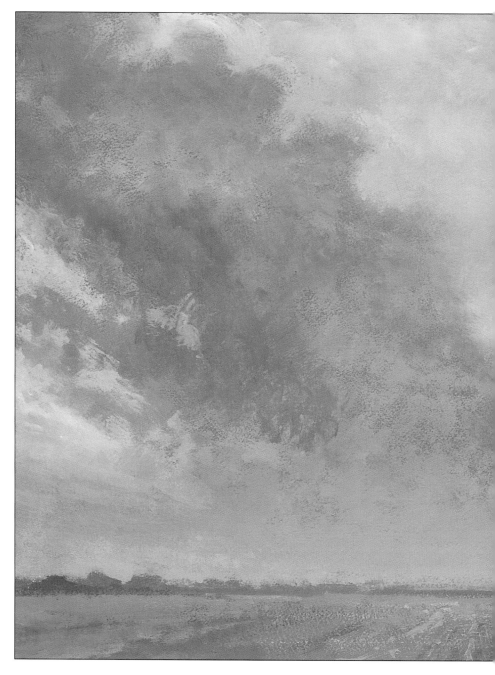

Stretched, acrylic-primed canvas 66 x 86cm (26 x 34in)

Brushes: No.10 flat; Nos.8 and 4 rounds; No.8 filbert

Small sponge

Palette and jar of water

7 acrylic colours: Process yellow; Titanium white; Magenta; Cerulean; Quinine purple; Raw umber; Emerald green

FIRST STROKES

1 ▶ Lay the foundation With the No.10 flat brush, block in the main colours with thin paint. Mix process yellow, white and a little magenta for the fields at the bottom. For the sky, start with cerulean at the top and work down to the horizon with subtle, softly blended mixes of cerulean, white and magenta. Darken the mix with more magenta for the cloud mass. Use the No.8 round brush to put in distinct strokes of almost pure white and pure blue.

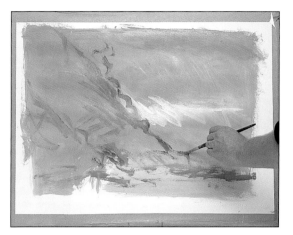

2 ▼ Block in the cloud Mix cerulean, quinine purple and a small amount of raw umber and roughly fill in the shape of the cloud with the No.8 filbert brush. Then use circular motions with a sponge to blend and drag the wet paint to give form, substance and a feeling of movement to the cloud.

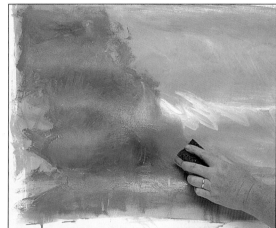

3 ▼ Work on the sky With the No.8 filbert brush, mix magenta and white to paint the lower part of the sky, which is tinged pink by the rising sun. Mix the paint with just a little water – it should have a creamy, fairly dry consistency. Paint the yellow-tinged sky above this with various mixtures of process yellow, white and magenta, merging the colour into the blue strip at the top.

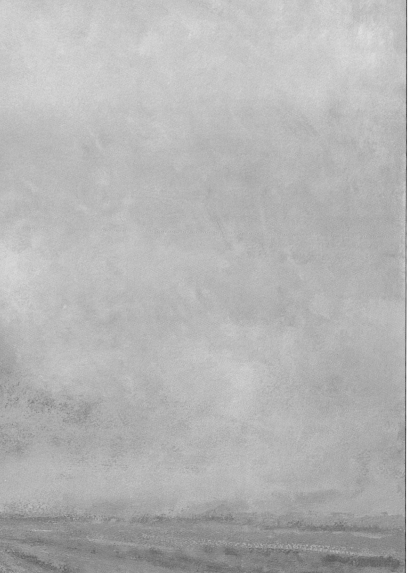

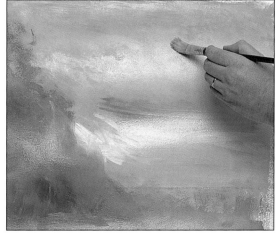

4 ▼ **Soften the colours** Mix together process yellow and white and, with a thirsty brush, scumble lightly over the upper part of the sky. This will blend and soften the colours and give a vaporous effect. Add some magenta to the mix, plus more white if necessary, and work down to the horizon in the same way.

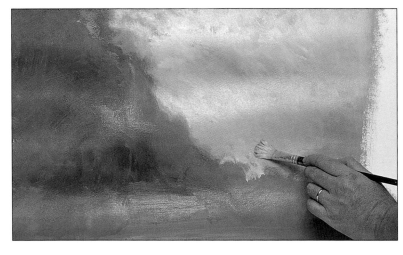

DEVELOPING THE PICTURE
The large masses of the composition are now established and you can go on to build up the subtle hues in the scene, using a network of broken touches applied layer on layer.

Most of the sky mixes have white added to give a sense of luminosity. Be careful, however – acrylic paints have strong tinting properties, so only a very small amount of colour should be added to white to produce pale tints.

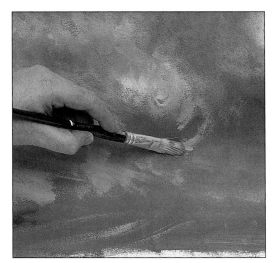

5 ▲ **Develop the cloud** Mix a purple-grey from cerulean, raw umber and a little quinine purple. Use this to paint the darker parts of the cloud mass and also to wet the edge where it meets the sky. Work the colour loosely with the No.8 filbert to create an active texture in the brushmarks.

6 ▶ **Soften edges** Continue to work over the pink part of the sky with a dryish mix of white, magenta and a little process yellow. Vary the mix to create subtle shifts in hue, rather than applying an area of flat colour. Blend the fresh paint on the edge of the cloud into the sky colour so that the two merge together softly.

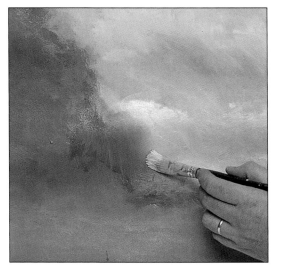

7 ▲ **Work light over dark** Use white, tinged with a hint of cerulean and yellow, to work over the light parts of the cloud mass. Keep the brush dry and scumble lightly over the underlayer with quick, circular movements. This produces broken brushmarks that suggest the thin, wispy clouds floating in front of the dark cloud mass. Begin marking in the chalky furrows of the field with the same colour.

8 ▶ Paint more clouds Now it's time to work on the horizon area and give the picture a feeling of space and distance. Use white, magenta and touches of process yellow to paint the warm-coloured clouds on the left with small, broken touches of a dry brush. Mix a soft greenish-blue from cerulean, white and a little yellow and put in the tiny, feathery clouds scudding just above the horizon.

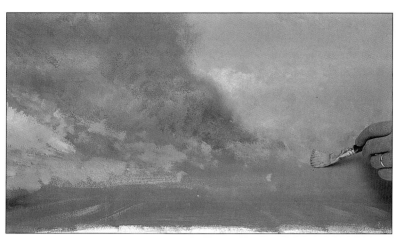

9 ▼ Merge sky and land Add a touch more white to the greenish mix and continue to work over the line where sky and horizon meet. The paint should have a thin, dryish consistency. Scumble lightly with the brush so that the colour beneath breaks through. This will give the effect of a misty haze in the distance, where the sky seems to merge with the land.

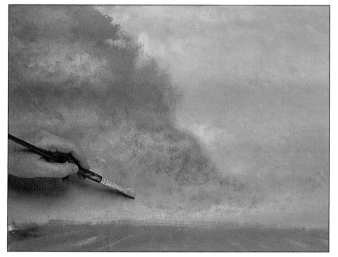

10 ▲ Blend sky and cloud Step back from your painting at frequent intervals and assess it as a whole. If there are any sharp edges or harsh tonal contrasts, soften them by scumbling over them with dry paint. Here, the upper edge of the dark cloud mass is softened by scumbling over it with a mix of magenta and white.

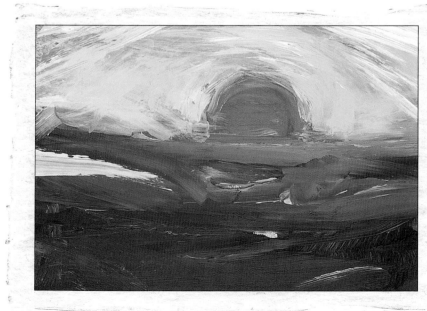

Express yourself
Be an expressionist

Although this acrylic sketch of a sunset is very different to the step-by-step painting, it was also created from the artist's imagination. Indeed, here the artist has taken great delight in the visual qualities of colour and paint texture. Swathes of thick, juicy paint are slurred across the canvas, conveying the artist's emotional response to the subject. The sun is depicted in fiery red and surrounded by a fierce yellow sky. These colours, together with the bold brushwork, help convey the elemental forces of nature.

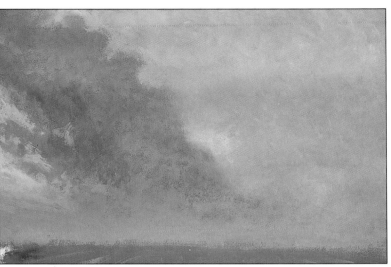

11 ▲ **Develop the cloud mass** Add a touch of warmth to the cloud mass with a lightly scumbled patch of quinine purple. Work loosely with broken strokes to create a ragged-edged shape in the centre of the cloud. This will give the cloud mass a three-dimensional appearance.

12 ▲ **Add more subtle colours** Rework the painting as a whole to enhance the hazy, luminous effect. Add some more of the pink/yellow/white mixtures to the pink area of sky and soften the upper sky with more layers of white, blue and yellow. Flick in a few yellowish wispy clouds on the left of the cloud mass. Remember to keep the paint thin and dry.

Master Strokes

John Constable (1776–1837)
Cloud Study

One of the greatest English landscape painters, John Constable excelled at skies. Unusually for an artist of his era, he made numerous sky studies *en plein air* (outdoors) – capturing the changing light effects and the movement of the clouds across the sky. The cloud study here is from 1821 and shows how he managed to convey the luminosity of the sky and the ethereal nature of the clouds.

Subtle use of greys and browns for the undersides of the clouds gives an impression of their three-dimensional form.

Clouds become smaller and less distinct in the distance, helping to give a sense of recession.

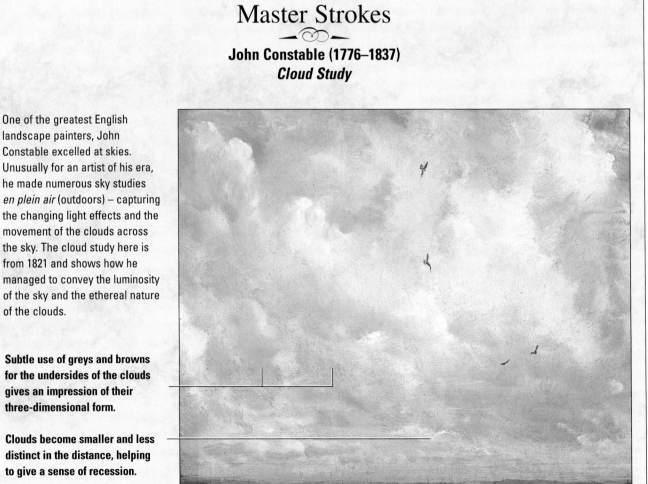

The sky is now complete and all that remains is to work on the foreground field, developing detail and texture. Although the field occupies a tiny portion of the picture, it is important in setting the sky in context.

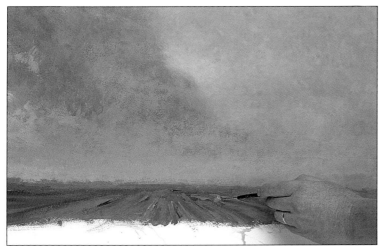

13 ▲ **Paint the cabbage field** Mix a mid-toned blue from cerulean, white and quinine purple. Work with the No.4 round brush to paint a series of radiating lines that will suggest the long rows of vegetables disappearing into the distance.

14 ▲ **Complete the field** Paint between the blue lines with warm greens mixed from yellow ochre, cerulean and white. Work along the back of the field with a cool, bluish green mixed from emerald green, cerulean and white (leave a ragged line of dark blue above it to suggest distant trees and buildings). Skim over the field with very dry mixes of both greens, plus some white, to suggest early morning frost on the field.

THE FINISHED PICTURE

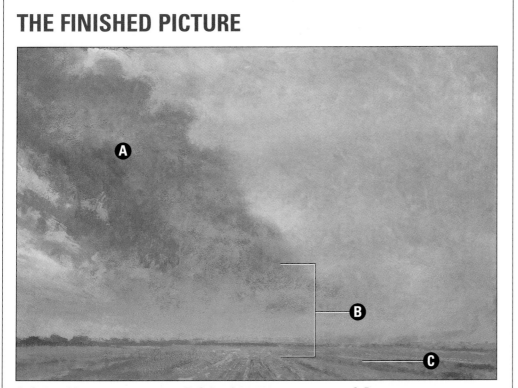

A Composition
The voluminous form and dark tone of the cloud give it an ominous presence.

B Colour harmony
The blue of the cloud is mirrored in the landscape, adding a rather bleak harmony to the picture.

C Deep space
Converging lines in the foreground 'throw' the eye to the horizon, enhancing the sense of vast space.

Skyscape with drifting steam

Create this unusual industrial scene with six striking acrylic paints and one hard pastel.

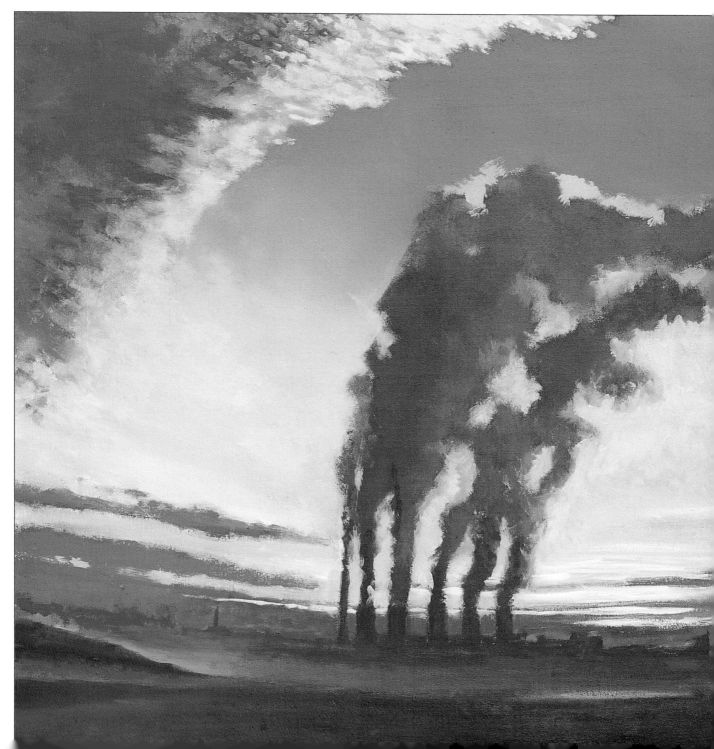

Since the quality of light constantly changes throughout the day, a landscape presents different moods at different times. This idea was central to the art of landscape painters such as J. M. W. Turner (1775–1851) and Claude Monet (1840–1926). These artists were not interested in describing 'things' with great accuracy – they were more concerned with capturing the poetic effects of the light and atmosphere that envelop those things. In Monet's own words, 'For me, a landscape does not exist in its own right, since its appearance changes at every moment, but its surroundings bring it to life – the air and the light, which vary continually.' Following this principle, even a mundane or unattractive scene can be transformed into one worthy of attention, given the right conditions.

Choose the right light

This painting in this project proves the point that just about any subject can appear beautiful when the light is right. The scene depicts an industrial location in the north of England – a power station close to the artist's home and known locally as 'Eight Towers'. (In the view the artist chose only six are visible.) On a dull day, this unlovely landscape can be less than inspiring; but when it is viewed in the early morning or late afternoon, in certain types of bad weather or dim light, the setting takes on a certain awesome beauty that would certainly have had Turner and Monet reaching for their brushes.

Having painted this scene over the years, the artist has a keen knowledge of local weather conditions and the infinite varieties of light and colour effects they create. This version was painted at dawn in January, with the sun breaking through a haze on the horizon. Plumes of steam rise from the cooling towers and stand out dramatically against the sky.

◀ **The strong tonal contrast, bright colours and bold diagonals all add to the drama of this industrial scene.**

YOU WILL NEED

Stretched and primed canvas 66 by 86cm (26 x 34in)	Mixing palette or dish
	Jar of water
Dark blue hard pastel	6 acrylic colours: Cerulean blue; Quinine purple; Process yellow; Titanium white; Raw umber; Magenta
Bristle brushes: No.8 filbert; No.10 flat	
Soft brush: No.8 round	
Small sponge	

FIRST STROKES

1 ▼ **Sketch in the composition** For the initial sketch, use a dark blue hard pastel, as this will blend in with the blues in the picture. Plot the position of the low horizon line on the canvas. Then sketch the main elements of the composition – the cooling towers in the centre, the columns of steam and the clouds.

2 ◀ **Block in some blues** Use the No.8 filbert brush to brush in the blue sky loosely with a fairly thin wash of cerulean blue. Add a hint of quinine purple to the wash for the warmer blues and the dark cloud mass on the left, but leave the light clouds unpainted for now. Darken the mix with more purple and start to rough in the columns of steam with sweeping lines and curves.

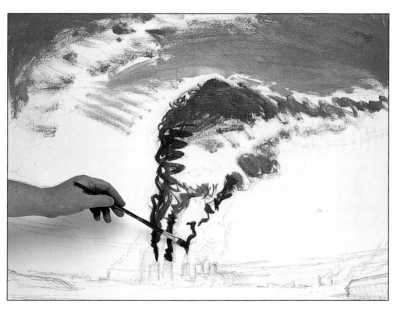

3 ▼ Complete the blocking in Finish painting the steam, using both the tip and body of the brush to convey the way it billows thickly out of the towers and drifts off in thin wisps higher up. Put in the cooling towers, then suggest the light and dark tones of the landscape with sweeping strokes, using the same blues as you mixed in step 2.

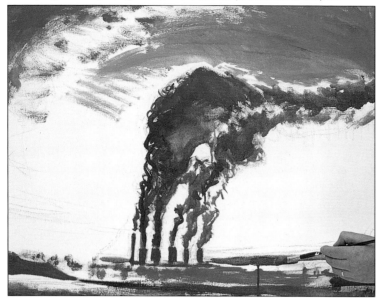

DEVELOPING THE PICTURE

With the tonal structure laid in, start creating colour and atmosphere. The paint is applied in various ways, such as scumbling and smoothing with a sponge, to give the effect of hazy light.

4 ▼ Finish blocking in the sky Mix process yellow with a touch of titanium white to lighten it, and a tiny spot of quinine purple to warm it. Paint the lower two-thirds of the sky with broad, sweeping strokes, using the No.10 flat brush. Suggest the wispy horizontal clouds near the horizon with a darker mix of process yellow and raw umber.

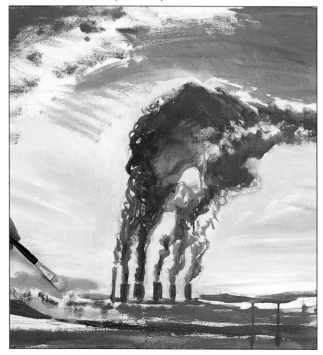

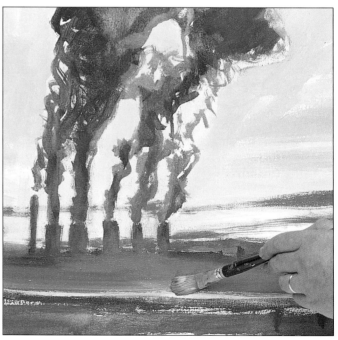

5 ▲ Work on the horizon line Put in streaks of dark blue cloud just above the horizon. Mix a murky, greenish-grey from process yellow, raw umber and quinine purple. Apply it thinly over the cooling towers, then sweep it across the horizon in a broad band, dark at the base and becoming lighter near the sky. The idea is to suggest the grey mist where earth meets sky, but without losing the definition of the horizon line.

6 ▶ Paint the light clouds Mix titanium white, magenta and process yellow to create a range of warm pinks. Using the paint more thickly now, dab on the pink-tinged edges of the clouds that catch the light from the sun. Work with the edge of the brush to apply the paint wet-on-wet.

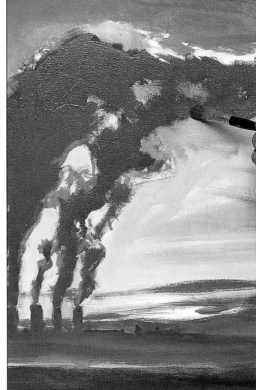

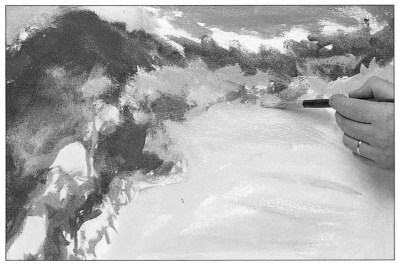

7 ▲ Work on the steam The thin steam high above ground also reflects warm light from the sun; paint this using the same pinks mixed in step 6, but this time applied with smoother, longer strokes. Lift the pressure off the brush at the end of each stroke to suggest the thin, vaporous steam disappearing into the atmosphere.

8 ▲ Strengthen the steam Mix cerulean blue with a little raw umber and quinine purple and strengthen the tone of the dark parts of the steam – the addition of brown to the mixture gives the colour a suitably murky, industrial quality. Soften the outer edges of the steam by scumbling this area with a dry brush.

Express yourself
A foggy day

The artist has taken the same subject and the same composition with a low horizon and wide sky, but this time he has painted it on a foggy day to produce a very different mood. The steam from the chimneys, weighed down by the damp atmosphere, hangs heavily in the sky in a great cloud and an eerie, yellow-tinged fog envelops the entire scene. The weather may be inclement, but it produces a soft, impressionistic image with close-toned, harmonious colours.

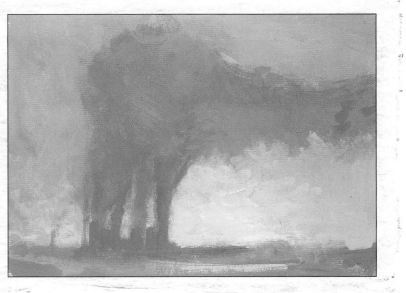

9 ▶ Darken the cloud Mix a pale blue from white, cerulean blue and a hint of purple, and work this over the mid-section of the sky. Blend the colour into the deeper blue above and the yellow below. Work over the dark cloud on the left with a strong blue made from cerulean blue and a little quinine purple. Darken the mix with more purple and use the No.8 soft round brush to scumble over the pink edge.

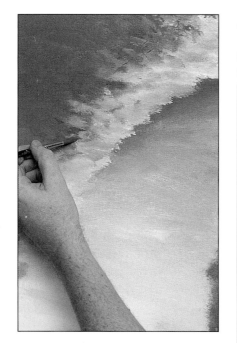

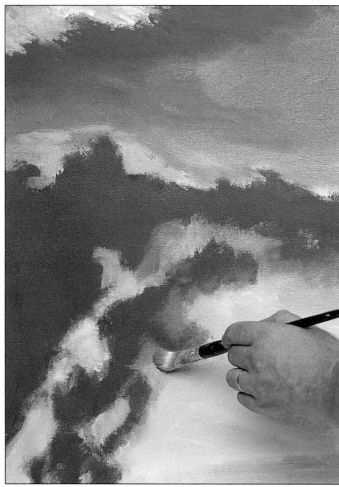

11 ▲ Soften the steam Lighten one of the pink mixes from step 6 with white. Use the No.10 flat to work this into the steam on the right. Keep the brush quite dry and work the colour in with light, circular movements. Before the paint dries, scumble in some of the pale blue from step 9 between the dark blue and the pink parts of the steam, softening the edges where the colours meet by working them wet-on-wet.

10 ▼ Warm up the sky Make a fleshy orange colour from titanium white, yellow and a hint of magenta. Scumble this mix softly into the sky above the cooling towers, working it in between the columns of steam.

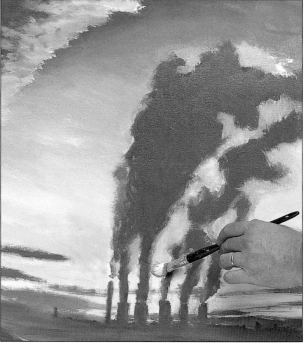

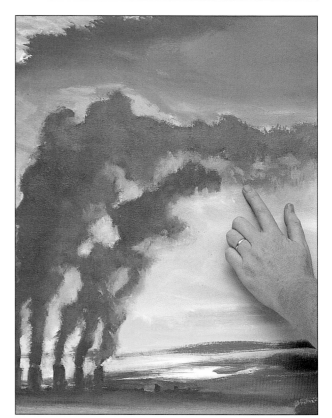

12 ▲ Add more wisps of steam Mix a purplish-grey from titanium white, quinine purple and a little raw umber. Use your fingertips to scumble this lightly over the trails of steam on the far right of the picture, letting the blue underlayer break through. This gives the effect of wisps of steam being caught in the wind currents.

13 ▼ **Work on the horizon** Using the No.8 round, work over the low cloud near the horizon with a mix of cerulean, quinine purple and white. Make a dark blue from cerulean and quinine purple and use the tip of the brush to suggest the dark shapes of the buildings on the skyline. Mix white, purple, magenta and process yellow and scumble over the sky on the right with the No.10 flat. Re-define the sky between the towers.

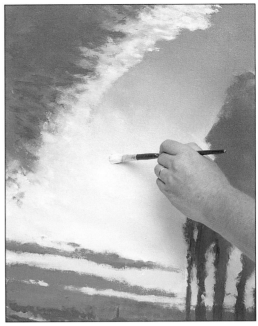

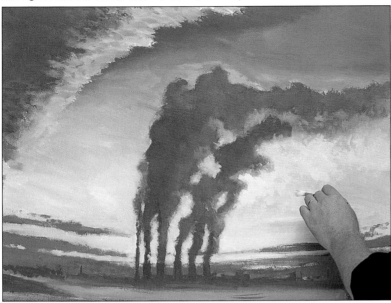

14 ▲ **Lighten the sky on the left** Still using the No.10 flat brush, mix titanium white with a little process yellow and quinine purple. Smooth and soften the misty area of sky just above the streaky clouds on the left.

Master Strokes

Constantin Emile Meunier (1831–1905)
In the Black Country

Belgian artist Constantin Meunier was well known for his paintings of industrial landscapes and manual workers. This scene of mine-workings and factories belching smoke was painted in 1890 and presents an altogether grimmer picture than our step-by-step painting, in which the brilliant sky lightens the atmosphere. The paint is applied in dabs and dashes of colour to suggest the texture of the slag-heaps and rough brick buildings.

Grey plumes of smoke almost obliterate the blue sky, which can be glimpsed in places through the haze.

The diagonal slant of the railway leads the viewer towards a bright focal point – the red rooftops in the middle ground.

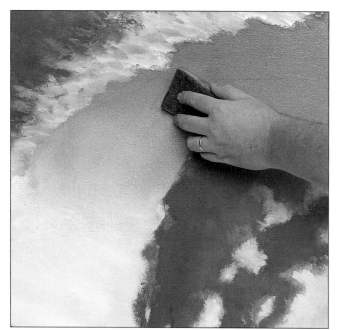

15 ▲ **Graduate the sky** With the No.8 round brush, apply a dry mix of cerulean and white to smooth out the blue sky above the steam. Add more white plus a little yellow to the mix and smooth and soften the pale sky closer to the horizon. Working quickly before the paint dries, use a sponge with light, feathery strokes to bring up the pale yellow into the blue and merge the colours.

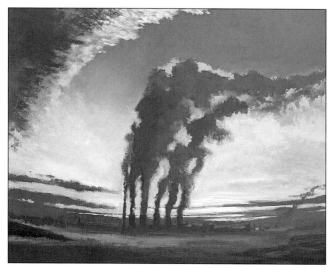

16 ▲ **Enhance colours and details** Step back from your picture and look at it overall. Have you achieved a smooth progression of tone and colour from the top of the sky down to the pale horizon? Make any necessary adjustments, scumbling the paint over the dry surface to give a soft effect. Mix magenta and white and add some touches of pale pink to the steam near the chimneys.

A FEW STEPS FURTHER

At this stage the painting is almost complete. You have succeeded in expressing the drama of the dark steam plumes against the glowing sky; all that remains is to refine some details and develop the landscape a little more.

17 ▲ **Complete the cloud bank** Using a small amount of the pale pink mixture on the tip of the No.8 round brush, feather over the area between the dark blue clouds and the pink clouds, particularly near the horizon. Use very light, quick, back-and-forth brush movements.

18 ▲ **Suggest landscape details** Mix a brownish grey from cerulean, raw umber and quinine purple and work over the dark areas in the foreground. To give a misty effect, smooth and soften the strokes with the No.10 flat. Use the No.4 round brush to touch in misty highlights with titanium white and a touch of cerulean.

19 ▸ **Add more buildings** Finish off by painting the row of houses on the right with dark greys and blues. Be careful not to overwork this; they should give some definition to the horizon but not stand out too much. Blend the shape into the surrounding dark landscape.

THE FINISHED PICTURE

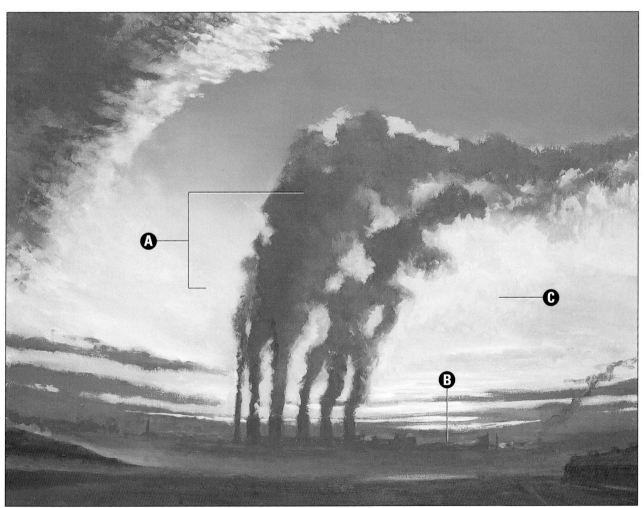

A Dramatic contrast
The light and dark colours in the scene were deliberately intensified to add to the drama of the composition.

B Low horizon
Placing the horizon in a very low position enhanced the vast scale of the steam columns rising into the sky.

C Misty haze
Layers of pink and yellow shades were softly scumbled over the sky to capture the bright yet hazy light of a misty winter dawn.

Stormy skyscape

Build up the brooding atmosphere of this moody coastal scene, beginning by painting the glimpses of sunlight.

In this moody coastal scene, occasional glimpses of sunshine appear between the dark clouds. To create this effect in oils the artist took the unusual approach of starting with the sunlight. This was established as a wash of dilute raw sienna wiped over the white board. The rest of the painting was then built up slowly and carefully in strokes of cooler colour so that patches of the transparent yellow glow through in the finished picture.

Unstructured beginnings

Apart from the boats, which are introduced in the final stage, there are no distinct landmarks to give this subject any sense of scale. In the early stages you are simply establishing clouds, sky and an expanse of undefined rocky ground.

With no definite shapes to guide you, you must try to create a sense of space and light using colour and tone alone. The artist achieved this by accentuating the broad band of sunlight along the distant horizon and painting the shadowy foreground and overcast sky in very dark tones.

Ghosting

In the initial stages, it is a good idea to apply colour in the normal way and then wipe off most of the paint with a tissue or dry rag. This leaves you with a stain, or 'ghost', of the original brush mark. In this way you can build up the tones and colours gradually – without clogging the picture surface with unworkable wet oil paint.

▶ The hazy atmosphere in this seascape is created by rubbing back paint with a tissue and blending colours with a soft brush.

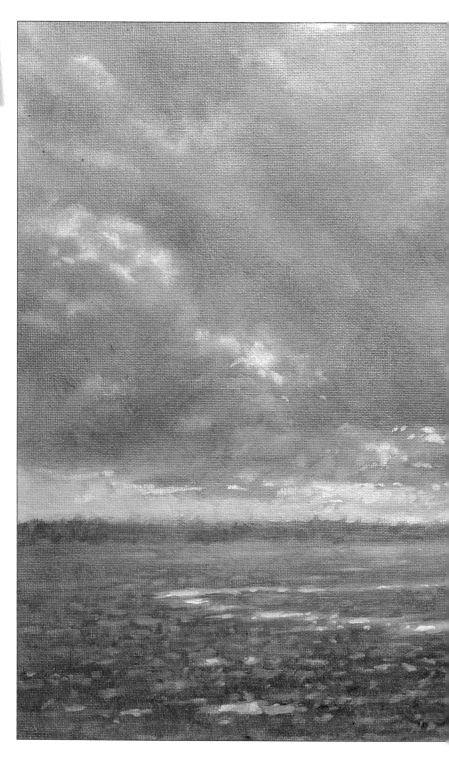

YOU WILL NEED

Canvas board
40.5 x 51cm (16 x 20in)

13 oil colours: Raw sienna;
Indian red; Payne's grey;
Ultramarine; Cerulean blue;
Titanium white; Lemon yellow;
Naples yellow; Emerald green;
Indigo; Yellow ochre; Cadmium
red; Alizarin crimson

Brushes: 6mm (¼in flat);
25mm (1in) filbert; 13mm
(½in) filbert; 38mm (1½in)
flat sable; No.4 round sable

Turpentine (for diluting
paint), rag and paper tissue

Mixing palette

FIRST STEPS

1 ▼ **Tint the board** Dilute raw sienna with turpentine; spread over the board with a rag. Allow to dry. Using a 6mm (¼in) flat brush, block in the distant land with a mix of Indian red, Payne's grey and ultramarine. Scumble the underside of the clouds with a mix of cerulean blue, Payne's grey and white.

2 ▼ **Rub back colour** Use the cloud mixture to paint reflections in the water, applying the colour in sketchy strokes. Soften the clouds and reflections by rubbing back the paint with a paper tissue.

3 ▼ **Suggest the clouds** Change to a 25mm (1in) filbert brush and apply a mixture of white and cerulean blue with a touch of lemon yellow to the clouds. Use a dry brush and work in feathery strokes to create an impression of moving clouds.

4 ▼ **Scumble the sky** Darken the water in the foreground with a mixture of Payne's grey and Indian red. Strengthen the sky in cerulean blue mixed with a little Payne's grey, rolling the brush to create irregular patches of scumbled colour. Add white to the blue-grey mixture and use this for the pale clouds.

5 ▼ **Strengthen the tones** Darken the water in the foreground with Payne's grey and a little Indian red. Strengthen the top of the sky with a mixture of Payne's grey and Naples yellow. These dark bands of tone along the upper and lower edges of the painting will make the horizon appear lighter in comparison and will create a sense of distance.

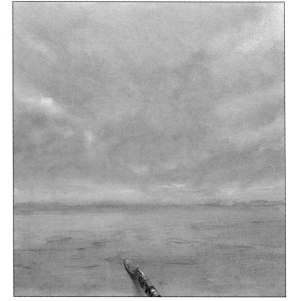

6 ▼ **Lighten the horizon** Using a 13mm (½in) filbert brush, paint the reflections in the water and strengthen the sunny highlights on the clouds in white with Naples yellow. Use the same mixture to lighten the sky along the top of the horizon.

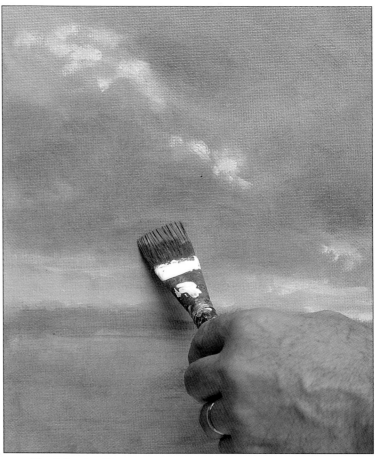

7 ▲ **Blend the sky** Change to a 38mm (1½in) flat sable brush and work into the cloud shadows with Payne's grey. Use the soft bristles to blend the colour smoothly into the surrounding sky area.

8 ▼ Suggest sunlight Change to a No.4 round sable and add flecks of sunlight to the sky just above the horizon, using white tinted with a tiny amount of Naples yellow. These bright patches will contrast effectively with the dark tones.

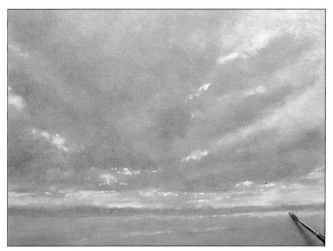

9 ▲ Add emerald green Continue to build up the light and dark tones, introducing touches of emerald green in the foreground. Mix a little emerald green with Naples yellow and white and paint pale green reflections along the horizon on the right-hand side of the picture.

10 ◄ Introduce texture Mix indigo, Indian red and a touch of cerulean blue and, using a dry No.4 round sable brush, apply texture in the foreground with short vertical strokes. Use the same colour to outline the shaded edge of the creek.

Express yourself

Paint it in pastel

If you enjoyed painting the step-by-step scene in oils, try creating the same moody atmosphere using a different medium, such as soft pastels. Pastels, being easy to smudge and blend, lend themselves very well to effects such as the haze on the distant horizon and the amorphous masses of the storm clouds. In the foreground, textural marks suggest the rocks just as the strokes of oil paint do in the main picture. The blues and mauves used here are echoed in the clouds, giving the composition an overall harmony.

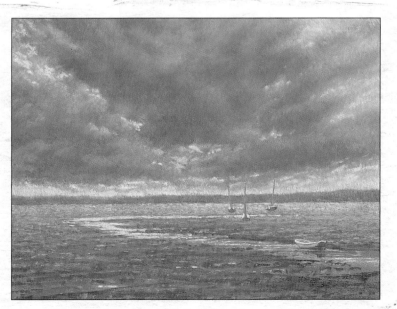

DEVELOP THE PICTURE

The only things missing from this beautiful seaside setting are the boats! Although a focal point of the composition, they are too far away to see in detail. You will find it more effective to suggest all the boats with a few strokes rather than attempting to pick out particular features.

11 ▼ **Develop the water** Paint the reflections in the creek, using a mixture of white and cerulean blue with a touch of yellow ochre. Work in horizontal strokes to suggest the flat surface of the water.

12 ▲ **Add the distant boats** Establish the smaller boats as blocks of pale tone mixed from white and a little Payne's grey. Suggest the hulls and interiors with dots of pure Payne's grey.

Master Strokes

John Constable (1776–1837)
Study of Sea and Sky

A thunderous sky dominates this sketch in oils by Constable – and note how its deep tones are reflected in the sea below. As in the step-by-step, a warm underpainting glows through the clouds, offering a rosy contrast to the cold slate blues. Apart from a few sailing boats dotted along the horizon, there is nothing to interrupt the broad vista of the ocean.

Clearly visible brush marks define the forms of the billowing clouds

Streaks of dragged paint suggest a sudden squally shower.

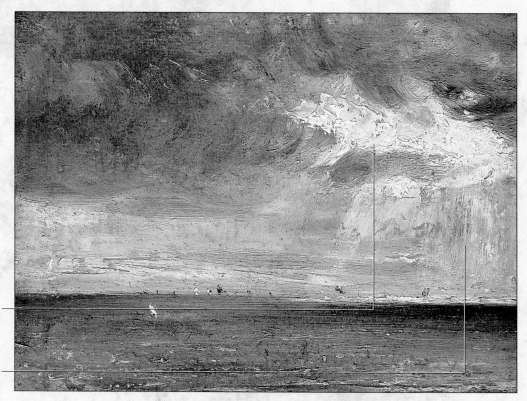

13▾ Paint the large boat Block in the foreground boat with a mix of Indian red and cerulean blue. Using the brush tip, define the hull edge with a narrow band of white mixed with Naples yellow.

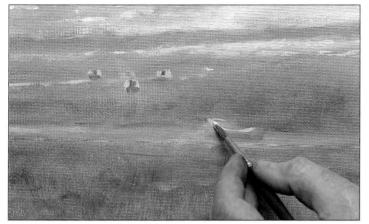

14▸ Describe the hull Paint the exterior of the hull in a slightly thicker mixture of the colour used for the hull edge. Indicate its curved form by using a pale tone on the upper edge and a darker one on the underside.

15▾ Add the masts Paint the masts of the small boats as fine lines of Payne's grey applied with the tip of the brush. Vary the angle of the masts very slightly to get a realistic effect.

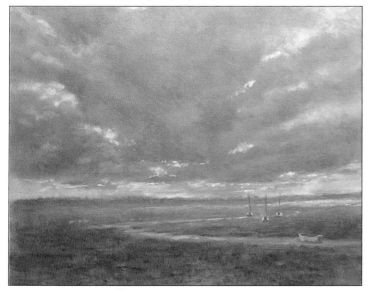

TROUBLE SHOOTER

PAINTING LINES

When you are establishing masts and other linear shapes, use dilute paint applied with the tip of a round sable brush. If the paint is too thick, it is difficult to overpaint the wet lines should you want to modify the colour and tone.

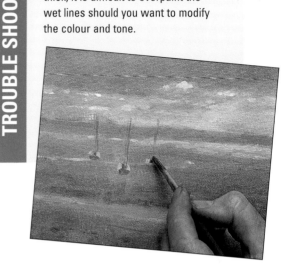

A FEW STEPS FURTHER

The painting could be considered complete at this stage. However, the composition is still rather soft and you might want to add a few dramatic touches. For example, our artist decided to enlarge the creek to create a striking angular shape in the lower half of the painting.

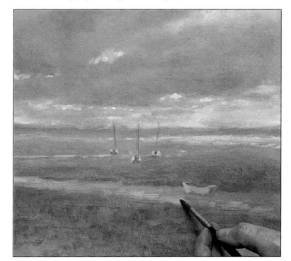

16▴ Widen the creek You can accentuate the perspective by widening the creek in the foreground with a mixture of white, Payne's grey and cerulean blue. Work in horizontal strokes to retain the impression of a flat surface on the water.

17 ▼ **Extend the creek** Alter the shape of the creek to create a more dramatic angle on the left-hand side. Add bright reflections to the extended water with a few horizontal strokes of pure white.

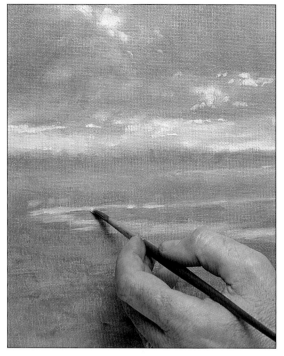

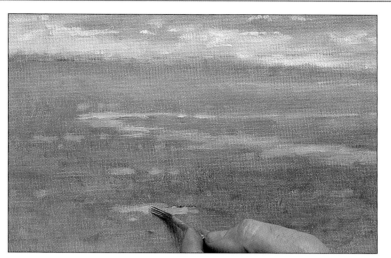

18 ▲ **Add the rock pools** Paint the pools of water in white with touches of cerulean blue and yellow ochre. The foreground pools should be larger and more pronounced than those in the background to preserve the illusion of recession.

EXPERT ADVICE
Finger blending

Visible brush strokes made in the early stages of the painting will destroy the moody atmosphere you are striving to create and will detract from the textural effect of the lighter dashes of colour. You can soften any remaining heavy strokes or other hard shapes by smudging the wet paint with your finger.

19 ◄ **Develop the rocks**
Build up the texture of the rocky foreground with small horizontal strokes of light tone and colour. Paint these in white tinted with varying amounts of ultramarine, cadmium red and yellow ochre.

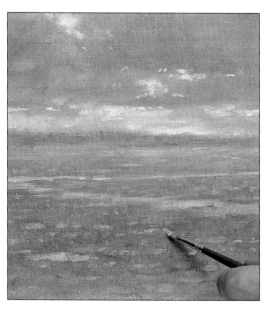

20 ▼ **Add light tones** Add colour to the sky above the horizon with pale pinks and mauves mixed from white, ultramarine, yellow ochre and alizarin crimson. Brighten foreground highlights with white.

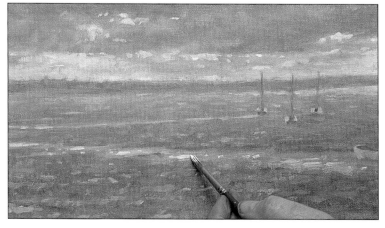

21 ▶ Develop the masts
Refine the masts in mixtures of Payne's grey and white. To help the masts stand out more against the background, clearly paint them in a dark tone against the paler sea and sky, and a lighter tone against the dark land.

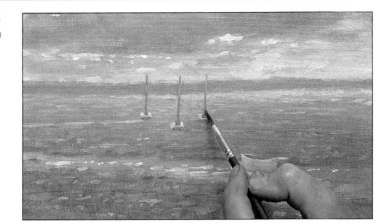

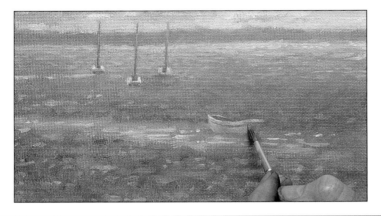

22 ◀ Complete the boat
Finally, paint a clean white highlight around the edge of the large boat and add a narrow decorative stripe mixed from Indian red and Payne's grey.

THE FINISHED PICTURE

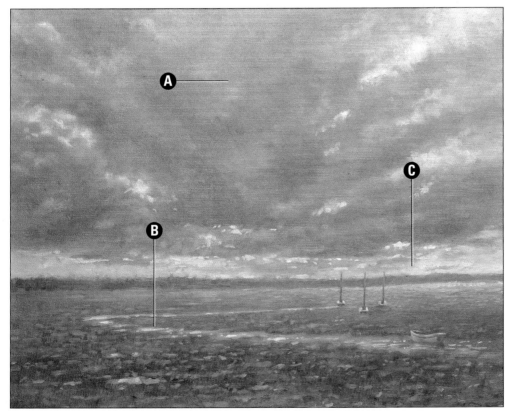

A Golden underpainting
A preliminary wash of dilute raw sienna shows through the brush strokes to generate an overall feeling of light.

B Directional shape
The pale zigzag of the creek breaks up the dark mass of the foreground rocks and leads the viewer's eye into the distance.

C Luminous light
A broad band of light sky above the horizon represents infinite distance and creates a feeling of space in the painting.

Painting a sunset in oils

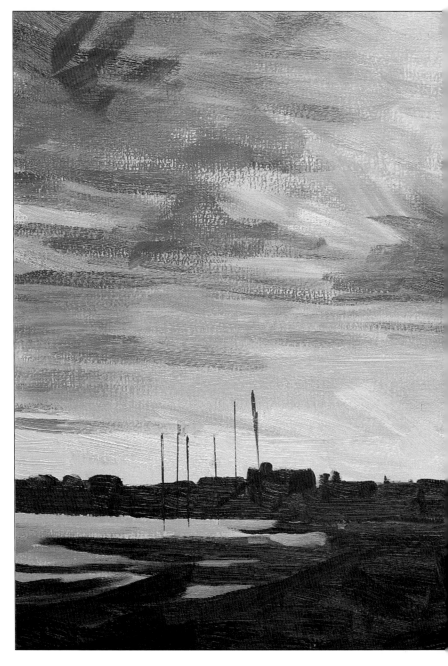

Sunsets have always intrigued and challenged artists. With brisk, spontaneous brush strokes, you can convey the dramatic effect as the last rays of the sun vanish below the horizon.

▼ The sky is the dominant feature of this oil painting. Use vigorous, expressive brush strokes and bold colours to re-create it.

The sky changes constantly, especially on a blustery day when the wind sends clouds scudding over the landscape. At sunset, a sky can be particularly dramatic, with bands of pink and orange spreading across it to create a spectacular display of colour.

Expressive technique

This sky study in oils gives you an opportunity to use some expressive, flowing brush strokes in order to capture the movement of the clouds and the golden light of the setting sun. As you build up the painting, try to work with a bold, free style, avoiding too much blending or over-working. Allow the brush to make its mark, so that each stroke remains visible.

The orange and blue colours are an important element of the composition, as is the positioning of dark against light. As orange and blue are complementary colours, they work well together, adding impact with their strong contrast.

Keep it simple

Cloud shapes, especially if they are well defined, can be very intricate and complex. There is always the temptation to put in every swirl and mark. This could result in a sky which looks too 'solid', so to avoid a heavy-looking effect, simplify the clouds and use the minimum of brush marks to define them.

As you progress with the painting, you may be tempted to complicate some areas by putting in additional detail. For best results, try to do the opposite! Make a conscious effort to keep the brush strokes simple and vigorous. Finish the painting by judiciously adding a few highlights with titanium white and either cerulean blue or cadmium orange. As titanium white is a particularly opaque paint, it creates dense, eye-catching patches of light.

41 x 51cm (16 x 20in) canvas board

Oil painting brushes: No.6 round;
Nos.6 and 8 flats

Mixing palette

White spirit for diluting paint

8 oil paints: Ultramarine violet;
Cadmium orange; Cadmium yellow
medium; Cadmium yellow lemon;
Cerulean blue; Titanium white;
Phthalo blue; Cadmium red deep

Medium-sized painting knife

FIRST STROKES

1 ▶ Establish the land and sunset Using a No.6 round brush and sweeping horizontal strokes, block in the land with a mix of ultramarine violet and white spirit. With a No.8 flat brush, apply a thinned mix of cadmium orange and cadmium yellow medium to the lower half of the sky.

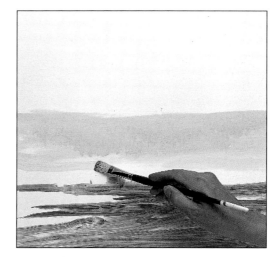

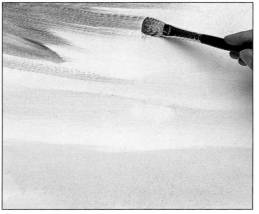

2 ◀ Block in the sky Clean the brush and use it to cover the top of the sky with a mix of cerulean blue and titanium white, thinned with white spirit. Mix cerulean blue with a little violet and white and darken the sky in the top left-hand corner.

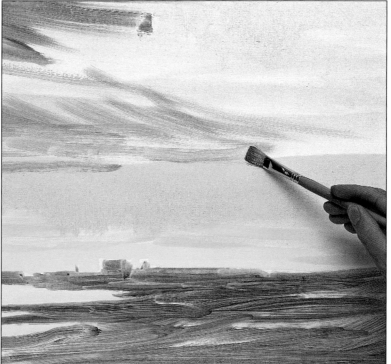

3 ▲ Develop the sunset Add some cadmium yellow lemon to titanium white and apply flat stripes close to the horizon, using a No.6 flat brush. Fill in the sea on the left with the same colour to show the reflections. Make a grey, using cadmium yellow medium, violet and white. Paint feathery diagonal lines to create the effect of wispy clouds.

DEVELOPING THE PICTURE

With the sky blocked in to denote the varying colours of the sunset, you can start to increase the contrast between the ground and sky, and add more movement to the clouds. Don't thin the paint at this stage, as a thicker texture needs to be applied using vigorous strokes.

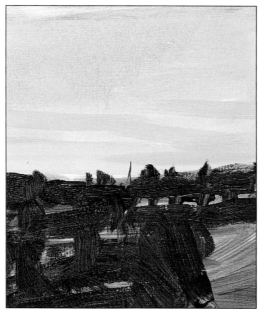

4 ▲ Darken the foreground Make a dark mix of ultramarine violet and cerulean blue. Paint the ground with short horizontal strokes, letting some of the underpainting show through to give textural interest. When painting a sky study, too much detail in the land area can detract from the picture, so this should be kept plain and simple.

EXPERT ADVICE
Painting realistic-looking clouds

Clouds, just like other objects, have shadows and highlights. When painting them, determine the position of the sun, then darken the areas of cloud facing away from it. This will create a three-dimensional effect. Leave the brush strokes visible to give a windswept impression.

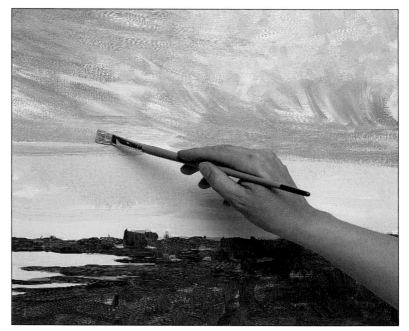

5 ▲ Work on the sky Mix cerulean blue and titanium white and use the No.6 flat to brush this into the blue area of the sky, working from right to left. As you go, add a little more blue to darken the sky towards the left. Using the same brush, add more form to the clouds with a mix of violet, cadmium yellow medium and white. Imply movement by keeping your brush strokes loose and flowing.

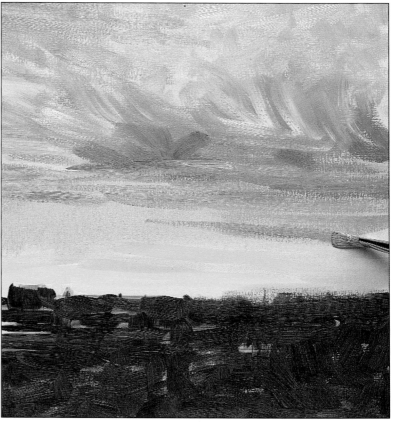

6 ▲ Add dramatic colour Add some cadmium orange to titanium white and apply this in horizontal strokes underneath the clouds with the No.8 flat brush. Keep your strokes vigorous and flowing, and don't strive for detail. By making the marks narrower as they get nearer the horizon, you will give perspective to the sky, making it appear to recede.

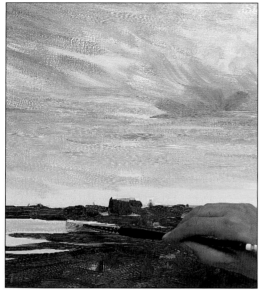

7▲ Create a sense of distance Blend cadmium yellow lemon, cadmium yellow medium and titanium white to make a paler, yellower colour than the one used in the last step. Use it to continue painting strokes with the No.8 flat. Add white at the horizon and horizontal dashes to the sea, so the reflection mirrors the sky.

Express yourself
Adding reflections

Here, while maintaining the overall feel of the sky study, the artist has given the foreground more prominence by including reflections. The strong verticals of the reflected lights on the right balance the masts on the left, and there are more warm areas of orange and red near the viewer. The original painting was dramatic in its contrast between land and sky; this is less so. The pale blue strokes added to the horizon give a softer look and a sense of distance. Notice how the mood of the composition has changed.

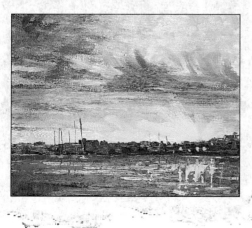

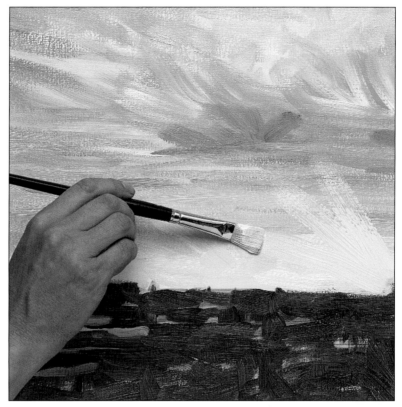

8▲ Add the sun's rays Mix cadmium yellow lemon, cadmium yellow medium and titanium white to produce a pale yellow. Brush some strokes along the horizon, but don't contaminate the brush with violet. You now have a contrast of sky and land. Take a little cadmium yellow lemon and add to the titanium white to make very pale yellow. Make several strokes fanning out from a central point, keeping the brush away from the dark skyline paint.

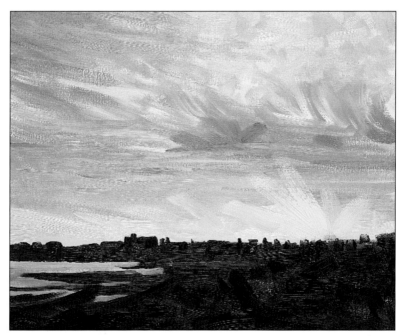

9▲ Finish the foreground Until now, the land mass has been one uniform colour. In order to make the land recede towards the horizon, mix a little phthalo blue with the violet. Use the No.6 flat to apply this very dark blue to the bottom of the painting and also to add some little touches of detail, such as chimneys or roofs, silhouetted against the sunset.

The painting could be considered finished at step 9. It is dramatic and vigorous with a lively, expressive sky. The intense dark blue foreground adds impact and gives the painting stability. However, with a few extra steps, you can warm up the sunset a little more and also add some sharp details with a painting knife.

10 ▶ **Intensify the sunset** Using the edge of the No.8 flat brush and a mix of cadmium orange, cadmium red deep and titanium white, make small red streaks along the lower edge of the clouds. This adds warmth and movement, as well as breaking up the areas of grey.

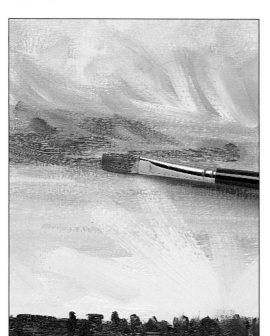

11 ▲ **Indicate yachts' masts with a knife**
Make a mix of cerulean blue plus a little titanium white. Spread the mix out very thinly on your flat palette, then scrape a little on to the edge of a painting knife. Push the knife's edge against the painting to create the effect of masts silhouetted against the sky.

Master Strokes

J. M. W. Turner (1775–1851)
Calais Pier

Turner was a master of dramatic skies – they were a prominent feature in his landscapes and seascapes, contributing to the overall sense of movement that he conveyed so well. He initially painted only in watercolour, but later worked in oils too. In this lively composition of a passenger boat arriving at the coast of France, the stormy sky takes up over half of the picture area and accentuates the activity on the choppy sea. A patch of blue shows through the clouds, providing a splash of colour in the otherwise mainly grey backdrop. Notice how the sunlit areas of the clouds are painted cream, while the main bulk of cloud remains grey. This colour change, as well as the directional brush strokes, help to describe form and distance.

The contrast of light against dark builds up drama and turbulence in the picture and is reflected by highlights on the waves' surface.

The dark area on the horizon depicts rain slanting diagonally down from the large storm cloud on the right of the picture.

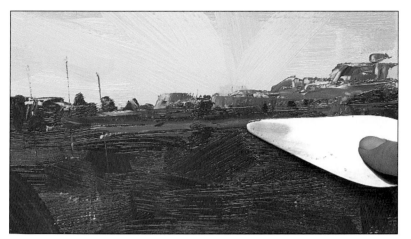

12 ▲ **Add further details with the knife** Using the knife again, make some short, angular marks by applying a paler mix of cerulean blue and titanium white to imply buildings catching the last of the light.

13 ▲ **Dot in some harbour lights** Using a pale mix of orange and white, apply a line of lights with the tip of the knife. Keep these to one area or the effect will be lost. By making the blobs near the horizon smaller, you will increase the feeling of perspective.

THE FINISHED PICTURE

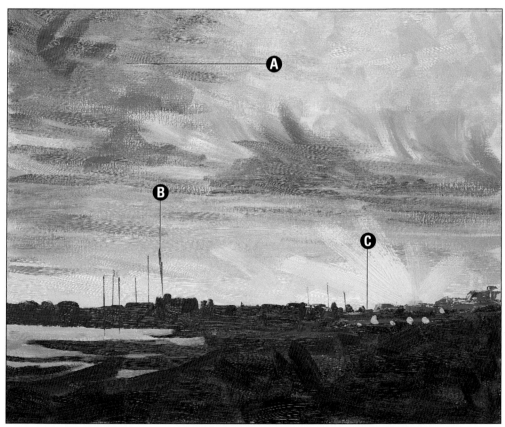

A Expressive brushwork
The clouds were painted with the minimum of brush strokes. Each mark stands alone, with little blending, and no attempt was made to overwork the painting.

B Limited use of detail
Detail was restricted to a few small areas to allow the composition to remain a sky study. Even where there was detail, the simplest marks were made to imply shapes.

C Low horizon line
Putting the horizon low down can produce exciting compositions. Here, the vibrant use of colour and brushwork in the sky was given ample room to create mood.

The drama of the sky

Watercolours aren't usually associated with textural marks. However, by mixing them with ordinary paper glue, you can create thick, exciting brush strokes.

Two hundred years ago, J. M. W. Turner (1775-1851) mixed flour paste with watercolour to paint atmospheric clouds and mists. This landscape has a similar drama, but here the watercolours are mixed with paper glue to make the colour thick and viscous.

Glue delays the drying time of the paint, allowing you to move the colour around on the paper. The thickened paint also retains the brush marks to give a good texture. Alternatively, by adding water to the mixture, the colour can be spread thinly and flatly.

Which glue?

For this technique, use the paste-type, liquid paper glues available at stationers – Gloy is a well-known brand. Water-soluble glues are particularly good – if you make a mistake, you can simply wet the area and wipe the colour away.

For pale colours, use only a touch of paint with the glue – about 5% watercolour is a good starting point. Increase the paint-to-glue ratio for stronger colours. Most of the colours in this image were about 20% paint and 80% glue. However, this is by no means an exact recipe. The best method is to pour some glue next to the colours on your palette and mix the two until you get the desired result.

As creative expression is the name of the game when using glue, the artist took a few liberties with his reference photo, including adding some bright red flowers. Use the mauve and sap green paints, free with this issue, for this painting.

▶ **Using watercolour with glue allows you to emphasise the brush strokes – as if you were working in oils or acrylics.**

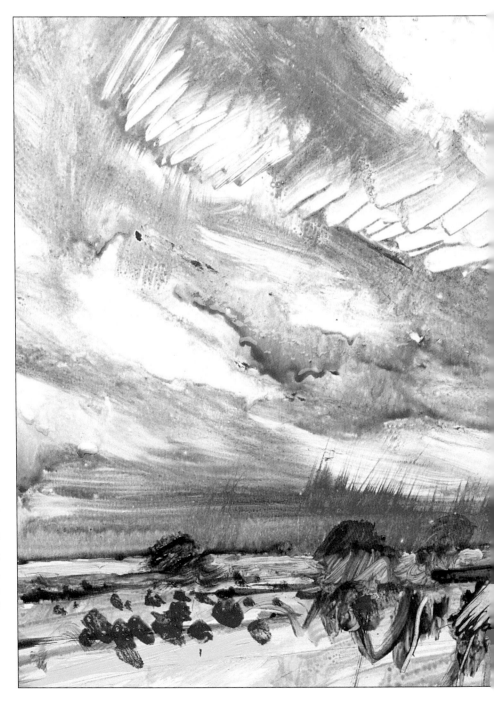

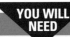
Piece of 400gsm (200lb) Not watercolour paper 41 x 51cm (16 x 20in)

7 watercolour paints: Cerulean blue; Mauve; Ultramarine; Prussian blue; Lemon yellow; Sap green; Cadmium red

Brushes: No.4 soft round; 25mm (1in) decorator's brush; Nos.12, 4 and 6 stiff flats

Mixing palette or dish and a jar of water

Paste-type paper glue (eg Gloy) and tissue

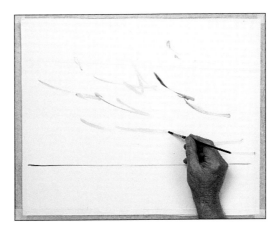

1 ◄ Paint the basic outlines Make a well-diluted wash of cerulean blue and water. Using a No.4 soft round brush, mark the position of the horizon and paint in the main cloud formations.

2 ► Start painting the sky Mix mauve and ultramarine with plenty of glue – the ratio here is about one part colour to four parts glue – then add enough water to make the mixture easy to spread. Using a 25mm (1in) decorator's brush, establish the cloudy sky in free sweeps.

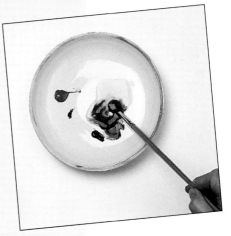

EXPERT ADVICE
Mixing glue and paint

Mix the watercolour paint and glue on a white palette or dish. Against a white background, you can control the strength and transparency of the mixture more easily and assess how dark or pale the colour will appear on the white paper. Note that using glue and watercolour on their own produces a stiff mix, suitable for highly textured work. For general brushwork and washes, dilute the mix with water.

3 ▼ **Add pure blue** Still working with lively strokes, dip the brush in water and spread the sky colour unevenly across the paper. Mix ultramarine with glue and water and add diagonal streaks across the centre of the sky.

4 ▲ **Establish the horizon** Start to build up the colour in the lower part of the sky by painting a strong mixture of Prussian blue and glue along the horizon line.

5 ◄ **Develop the sky** Put a large blob of the Prussian blue and glue mixture in the middle of the sky. Use a crumpled paper tissue to smear the paint upwards and outwards to create an eruption of colour spreading from the centre of the picture.

6 ▲ **Use a dry brush** Start to manipulate the wet, viscous colour to give a turbulent, windswept effect. Use a dry decorating brush and drag it across the sky to create shafts of diffused sunlight.

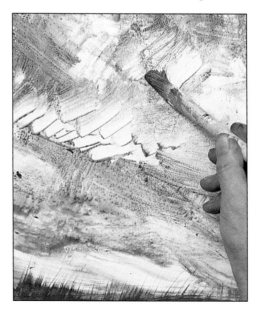

7 ◄ **Define the clouds** Using a clean, dry No.12 stiff flat brush, work further into the wet colour with short, stubby strokes. This reveals the white paper to suggest light on the clouds. If the colour has already begun to dry, simply wet the area with a little clean water before using the dry brush.

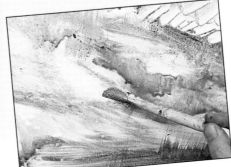

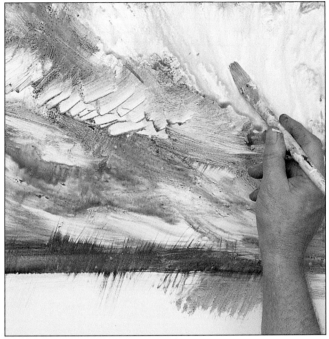

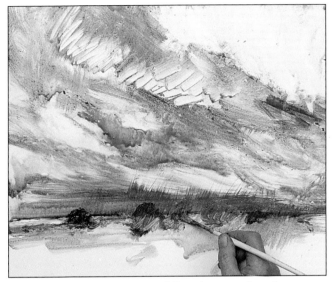

DEVELOP THE PICTURE

Now that the sky is complete, move on to the landscape, painting it in clear, bright colours with lively, textural strokes.

8 ▲ **Remove colour** Wet the top right-hand sky area and use the dry bristles of the No.12 flat brush to wipe off the colour, creating a large white cloud.

9 ▲ **Add the distant landscape** Mix pale green from lemon yellow and little sap green. Add glue and paint this along the horizon with a No.4 stiff flat brush. Mix a deeper green from ultramarine and lemon yellow and add a few trees.

Master Strokes

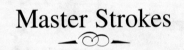

Nicolas Roerich (1874–1947)
Skyscape

While Roerich paints the receding hills with flattish colours, he makes the clouds into fully modelled, sculptural forms. Indeed they seem to be more solid than the land. The resulting effect is rather menacing – almost as if we are looking at an alien world.

The brown clouds in the distance take on the appearance of upturned hills – almost as if the landscape is reflected in the sky.

To convey distance, aerial perspective is used – the hills get progressively bluer in the distance.

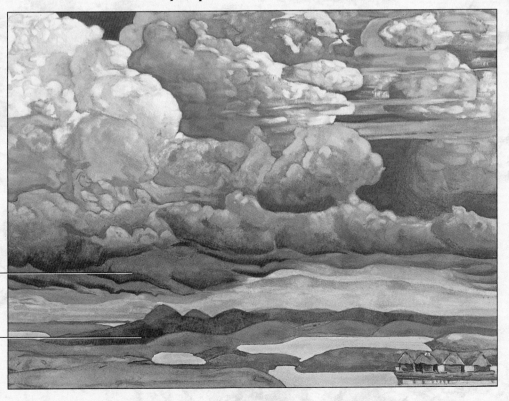

10 ▶ Paint the foreground grass

Make a dilute mix of lemon yellow with a touch of ultramarine to create a light lime green. Using long, sweeping horizontal strokes, paint the grass right across the foreground.

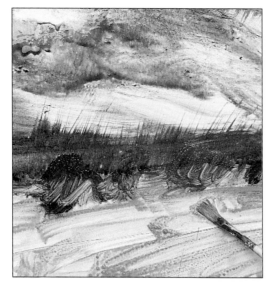

As it stands, the painting could be considered complete – a dramatic landscape with a turbulent sky and windswept fields. However, you might wish to add a little more colour, giving an indication of the yellow flowers in the field and perhaps also adding some red ones for variety.

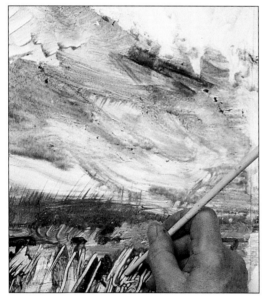

11 ◀ Scratch in some texture

Paint long vertical streaks of grass, using the deep green tree mixture from step 9. While the colour is still wet, use the tip of the brush handle to scratch bold, scribbled texture into the grass.

Express yourself

Washes of watercolour

This sketch shows how different sky effects can be achieved by using watercolours without glue. The loose, stretched-out washes of paint capture the blustery atmosphere in a very immediate way. The dark grey shapes in the distance have been applied wet-in-wet and give the impression of distant trees.

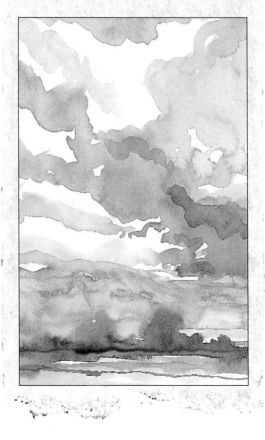

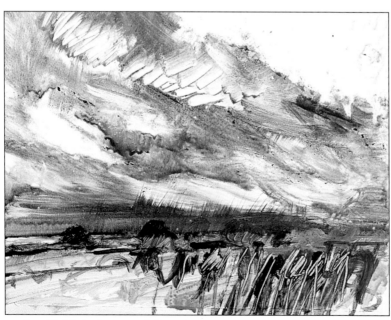

12 ▲ Finish the foreground
Complete scratching back the grass, and allow the painting to dry before moving on to the next stage.

13 ▼ **Paint sunlit fields** Using the No.6 stiff flat brush, mix lemon yellow with a little glue and apply this in broad horizontal strokes to depict light on the fields. Add a few dabs of thick lemon yellow for the flowers.

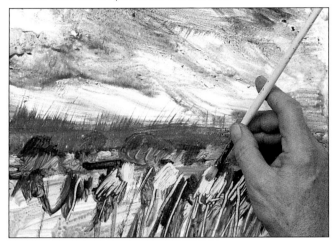

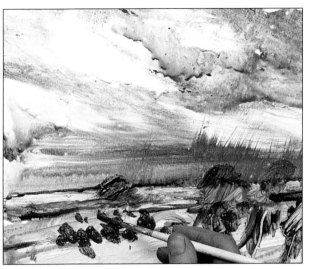

14 ▲ **Add red flowers** Finally, mix cadmium red with a little glue and dot in clusters of poppies to show up against the yellow and green grass.

THE FINISHED PICTURE

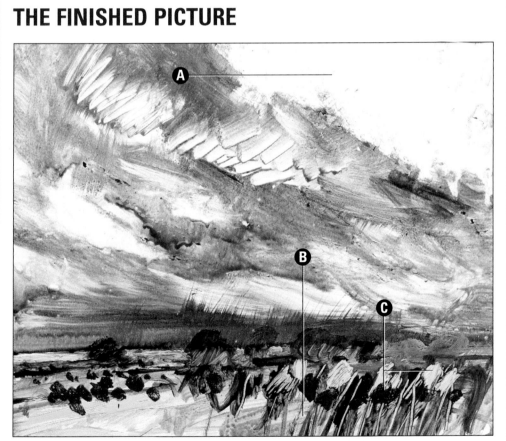

A Revealed white
A dry brush was used to wipe back wet colour in the sky, revealing pale clouds and creating a sense of movement.

B Sgraffiti
Long grasses were scratched into the viscous colour with the tip of the brush handle, creating lively texture in the foreground.

C Pure colour
Many of the colours are used unmixed. For example, the flowers are painted in pure lemon yellow and cadmium red.

Birds in flight

Arctic terns give structure and scale to this energetic study of the churning seas off the remote Farne Islands in the North Sea.

You don't have to be a dedicated ornithologist to enjoy watching, drawing and painting birds. Apart from their variety and grace, they enliven a composition, leading the eye into or around a picture. They are especially useful in seascapes, where there are no sight lines and few other spatial clues. Birds wheeling over the sea inject a sense of scale into a marine study.

Emphatic shapes

There are other ways in which birds can contribute to a composition. In flight, birds create a series of emphatic shapes. The fully extended wingspan provides a strong horizontal which becomes a dynamic diagonal when tilted, while the beating wings make a series of V-shapes. These forms can become an important element within a composition, especially when the birds are placed to the front of the picture space.

Broad characteristics

When you are painting birds as part of a landscape, you won't need the same degree of detail as an artist dedicated to bird studies. It is more appropriate to capture their broad characteristics and sense of movement in a simple way. The birds depicted in this painting are Arctic terns, which are closely related to gulls, but are smaller and more slender in build with narrow, tapering wings, a forked tail and long bills. Most have whitish plumage with black caps.

The terns in the foreground were first sketched in silhouette, using light-coloured pastels. Simple tonal shading built up the birds' forms, which were then refined by adding the characteristic markings and bright orange bills and legs. The bird in the background was more simply drawn.

Find the right approach

When you are working on your painting, avoid the temptation to give more attention to the birds than to their

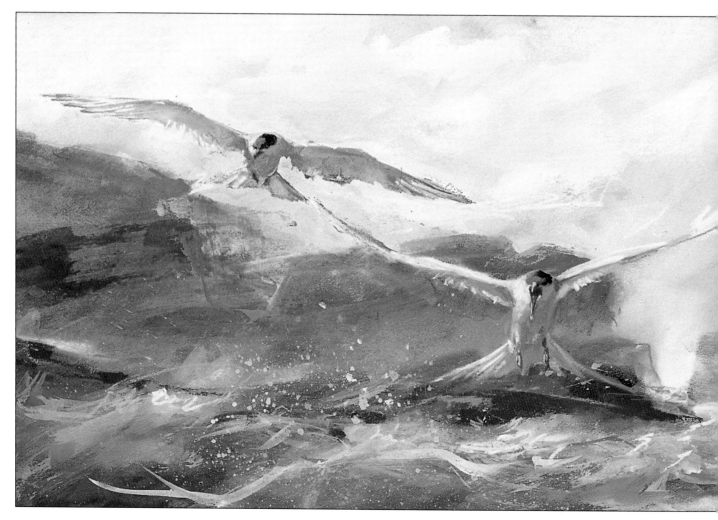

surroundings – if they become more resolved than the rest of the painting, then the picture will jar.

For example, if your style is loose and impressionistic, render the birds in the same way. If you tend to work in a tighter, more closely focused way, then apply that approach over the entire support, depicting the birds in more detail.

▼ **This image captures the graceful flight of Arctic terns as they dip and wheel above the surging waters of the North Sea.**

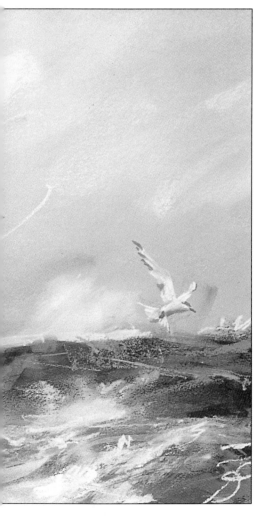

YOU WILL NEED

Piece of 300gsm (140lb) Not watercolour paper 56 x 76cm (22 x 30in)

Brushes: No.20 flat; 75mm (3in) hake; No.20 filbert; Nos.4 and 8 rounds

9 gouache paints: Prussian blue; Burnt sienna; Marine blue; Winsor green; Naples yellow; Ultramarine; Permanent white; Ivory black; Indian red

Piece of thin plastic for scraping

16 soft pastels: White; Sky blue; Putty grey; Light grey; Lemon yellow; Off-white; Light blue; Yellow ochre (light tint); Raw umber; Dark grey; Burnt orange; Pale yellow; Cobalt blue; Cerulean blue; Pale blue; Ultramarine (light tint)

Paper tissue and cotton cloth

Putty rubber

Strips of card to crop the image

PICK AND CHOOSE

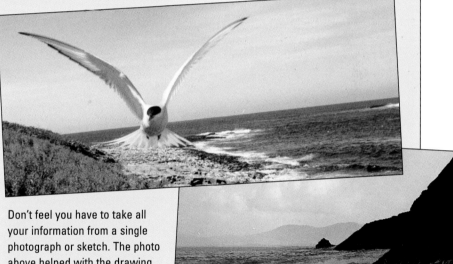

Don't feel you have to take all your information from a single photograph or sketch. The photo above helped with the drawing of the far left tern, while the photo on the right was used for the sea and spray. Reference books can also be invaluable for establishing bird shapes.

FIRST STEPS

1 ▶ Block in the rocks
Mix Prussian blue and burnt sienna gouache to create a deep blue colour for the rocky promontory. Use a No.20 flat brush and big gestures to apply the colour. Work broadly and try to 'feel' your way around the looming bulk of the rocks.

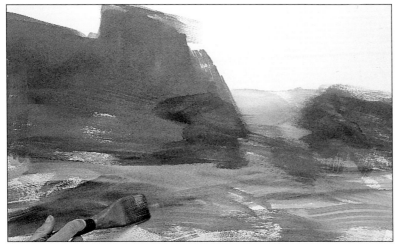

2 ▲ **Block in the sea** Using the same brush and a wet wash of marine blue, apply broad strokes of colour to the sea. Do the same with a thin wash of Winsor green. This transparent blue-green provides an effective base for the heaving sea.

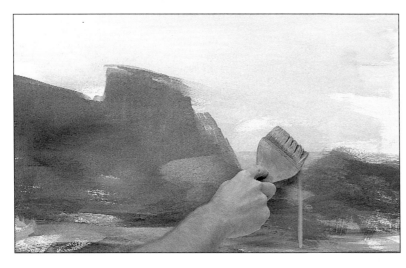

EXPERT ADVICE
Scraping back

By scraping paint from the support, you can create light tones and interesting textures and reveal underlying paint layers. This technique is very effective with gouache, which has more body than watercolour. The best scraping tools are slightly springy – a piece of scrap plastic, an old credit card or a plastic painting knife.

3 ◄ **Apply base colour to the sky** Mix a wash of Naples yellow and block in the sky, using a 75mm (3in) hake to give broad coverage. The creamy yellow hue captures the sense of sunlight. Mix in a little marine blue on the right.

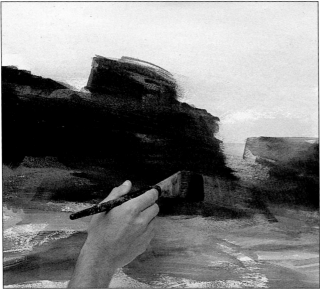

4 ▲ **Add dark tones** Mix ultramarine and burnt sienna to make a deep, almost black tone. Returning to the No.20 flat brush, apply this colour over the surface of the rocks, using broad, sweeping strokes.

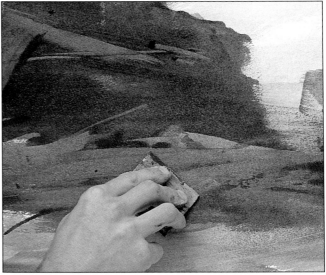

5 ▲ **Scratch through the paint** Use a piece of thin plastic to scrape through the dark paint at the base of the rock (see Expert Advice, above). This lightens the area and restores the transparency of the paint layer. Work into the rock forms, using your scraping tool to reveal the planes of the rock surface.

DEVELOPING THE PICTURE

As both soft pastel and gouache are opaque and slightly chalky, they complement each other very well. Alternating one with the other as the painting develops gives a range of effects.

6 ▼ **Apply soft pastel** Start to work into the rocks with pastel sticks which allow you to make more precise marks. Apply highlights in white, sky blue, putty grey and light grey. Use the tip of the stick to make narrow lines and the side of the stick for broader swathes of colour.

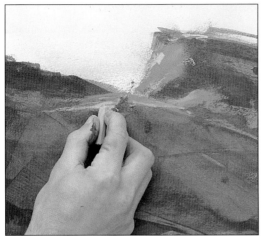

7 ▼ **Add highlights on the water** Change to a No.20 filbert brush and apply washes of permanent white gouache at the base of the rocks, where the sea swells against them and breaks up into spray. Brush on the paint with a series of energetic marks.

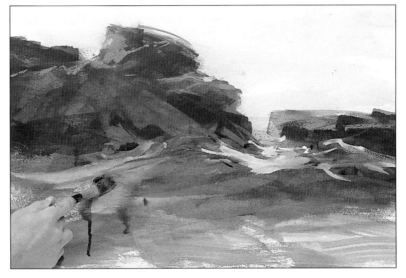

8 ▼ **Develop the rocks** Take white gouache over the sky. Refine the silhouette of the rocks and apply brushy marks over their surface. While the paint is still wet, soften the marks with your fingertips to create a thin veil of scumbled colour. Where the paint covers the pastel marks, it becomes tinted with the pigments.

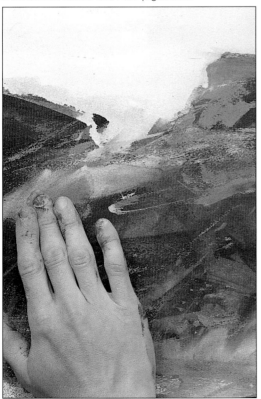

9 ▼ **Apply pale pastel across the sky** With the stick held on its side, work lemon yellow pastel into the sky. Then use the tip of the pastel to draw back into the rocks, highlighting some of the edges.

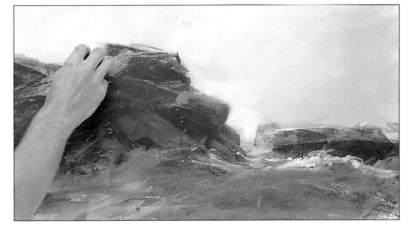

10 ▶ **Block in the tern** Sketch the silhouette of the tern in the centre of the composition, using a combination of off-white, light grey and light blue pastels. Look only for the main shapes at this stage – leave the details for later.

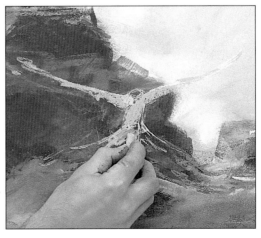

11 ▶ **Add details to the bird** Using a yellow ochre (light tint) pastel with a few touches of raw umber, add warm tones under the tern's body. Put in some dark grey shadow and white highlights. Use a No.4 round brush and ivory black gouache for the bird's characteristic black cap, the long curving beak and the legs.

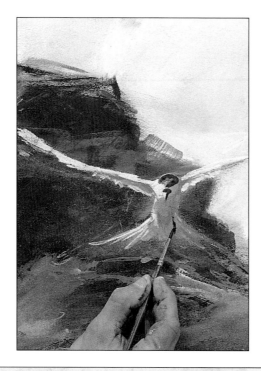

12 ▼ **Work colour details** The Arctic tern has a distinctive orange bill and legs. Use a burnt orange pastel to apply colour to them.

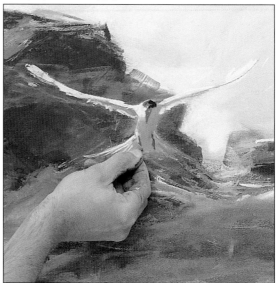

Master Strokes
—∞—

Winifred Nicholson (1893–1981)
Sandpipers, Alnmouth

In this simple, semi-abstract composition, the flock of birds together with the curved shapes of the seascape form a simple, graphic image. Note how the birds echo the curve of the inlet. The colours in the painting are restricted to shades of blue and honey brown, with a few emphatic strokes of dark grey and white for contrast. This gives an overall effect that is light, airy and harmonious.

Thickly applied oil paint leaves brush marks visible on the sea, giving an impression of its rippling surface.

A glaze of light brown applied over the water in the shallow inlet suggests reflections of the sandy banks.

Scattered over wet paint in the foreground, a sprinkling of sand creates a granular texture on the beach.

13 ▼ **Develop the sea** Add pale yellow pastel highlights on the tern's bill and legs. Apply dark grey pastel to the tern's head and to the rock behind the bird. Develop the sea, using cobalt blue and cerulean blue pastels, then soften the marks with your fingers or a tissue to create a film of colour.

14 ▼ **Add dark tones in the sea** Mix Prussian blue gouache with a touch of Indian red to make a deep blue tone. Using the No.20 filbert brush fairly dry, make a succession of vigorous, sweeping marks that follow the undulations of the waves around the rocks.

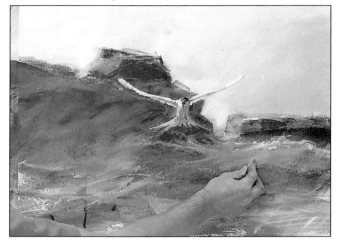

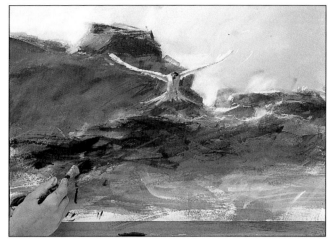

15 ▼ **Indicate spray** Scumble cobalt blue pastel over the sea and rocks, using the side of the stick. Make a pad from a piece of cotton cloth and work this over the surface of the pastel, spreading it thinly to produce a veil of pigment that suggests spray.

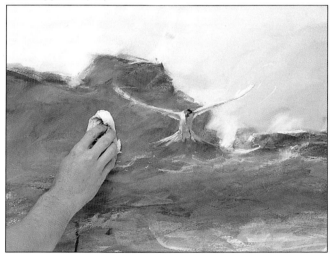

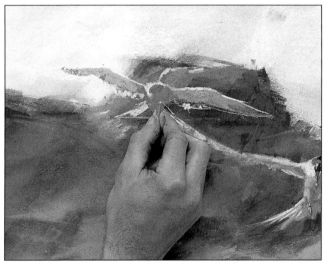

16 ▲ **Add a second tern** Outline the second tern with white pastel. Block in the shadows under the body and wings with light grey, dark grey, yellow ochre and raw umber pastel. Work broadly, looking for light and dark areas and warm and cool tones rather than details such as the feathers.

17 ◄ **Build up layers on the sea** Finish the second tern by indicating the black cap and burnt orange bill and legs. Add touches of pale blue to enliven the shadows on the bird. The sea in the foreground needs more texture and detail to pull it forward in the picture plane. Using the No.20 filbert and a wash of permanent white gouache, start to apply the colour with sweeping gestural marks that follow the shapes of the waves. Note that the white paint picks up the cobalt blue pigment from step 15 and tints the white to a very pale blue in places.

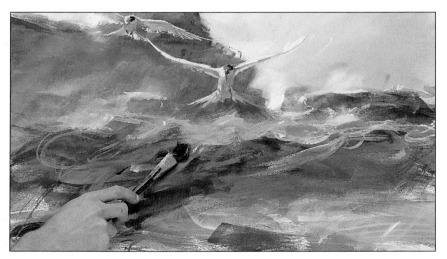

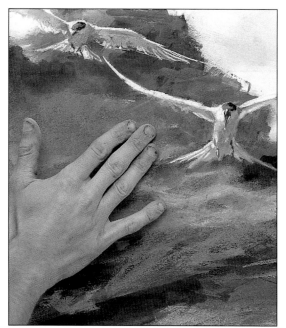

18 ▲ Add more blue Skim an ultramarine (light tint) pastel over the surface of the sea on the left. Blend and soften the pigment with your fingertips to add a further glaze of colour to the sea.

19 ▲ Paint a third bird Use off-white, white and light grey pastels to draw a third tern in the distance. With a No.4 brush, paint the bill and legs with burnt sienna gouache and the cap and wingtips in pale grey mixed from permanent white and ivory black. By showing birds at different sizes, you create a sense of recession in the painting.

Express yourself
Solo flight

If you are interested in birds, devote some time to making studies of different species in their natural habitat. Here, a gannet is depicted in mid-flight against an impressionistic sky. Seen in profile, the shape of the head and the characteristic long, pointed beak are clearly discernible, while the upstretched wings, poised for a down beat, give a sense of imminent movement. As in the main step-by-step painting, a combination of gouache and pastel provides soft passages of layered colour.

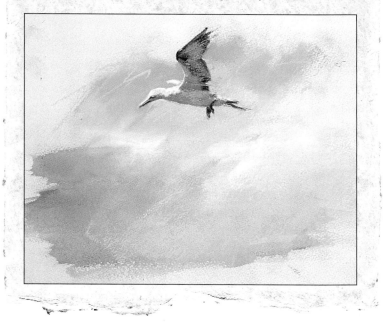

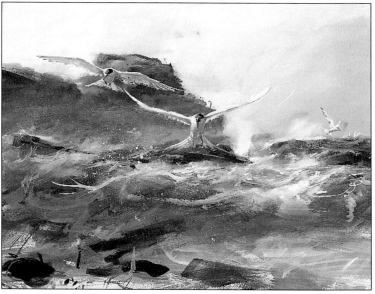

20 ▲ Create more texture Load a No.8 round brush with a thinned wash of permanent white paint and describe a few foam-tipped waves in the centre ground with linear marks. Draw more swirling lines with the white pastel. Using the tip of the brush, flick white paint across the sea and rocks to suggest spray.

Before continuing, tape strips of card over the painting to crop it to a wide format known as a 'marine' format (see The Finished Picture, below). This emphasises the birds in the composition, but makes the left-hand rock look too dominant. Correct this by adjusting the rock's silhouette to fall below the bird.

21 ▼ **Overpaint the rock** Apply light grey pastel over the rock behind the left-hand tern, working carefully around the bird. Work freely over the rock to suggest waves breaking over it.

22 ▲ **Soften the pastel** Use a putty rubber to soften and smear the light grey pastel – this enhances the effect of water streaming off the rocky surfaces.

THE FINISHED PICTURE

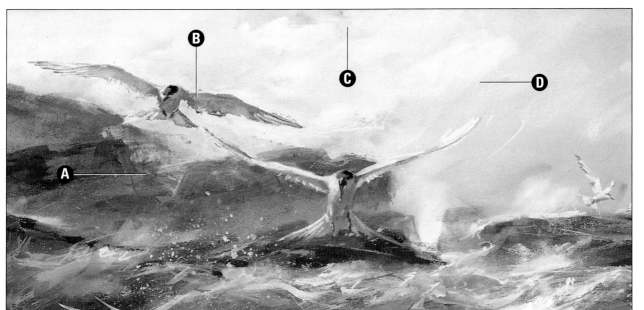

A Layered colour
The shifting mass of the sea was suggested with layers of scumbled and dry-brushed gouache, and with pastel applied as blended veils of thin colour.

B Selective editing
The left-hand tern creates a dark shape against the light background of the sky. This is in contrast to the other tern, which appears light against dark.

C Warm sky
An underwash of Naples yellow worked across the sky glows through subsequent layers, suggesting sunlight glimpsed through scudding clouds.

D Bright lights
Touches of opaque white pastel and gouache above the rocks capture the misty effect created by spray and foam thrown up by the crashing waves.

Into the garden

Handled well, oil pastels give you controlled mark-making and intense colour – an ideal combination for this garden scene.

Oil pastels are sometimes regarded as a poor relation to other, more familiar, media, and their painterly possibilities are often overlooked, even by experienced artists. However, the chunky sticks have many exciting qualities and are well-suited to making vigorous textural strokes and building up layers of rich colour. Here they have been used to create bold, intense blocks of colour, subtle optical mixes, blended gradations of tone and a carefully worked paint surface.

Zigzag pattern

Composition is an important aspect of this painting, giving it a solid underpinning that holds the decorative surface and colourful imagery together. The artist worked on black paper and started by mapping out the composition in blue pastel. He concentrated on putting the various elements in the right place – in relationship to each other and to the edges of the support.

He was looking for important outline shapes and major reference points that he could refer to as he developed the picture. In this case, he was conscious of a zigzag pattern which leads you from the pots, up the path to the lawn and the shed and sky in the background.

Working from photographs

Remember that the subject is simply a jumping-off point for a painting. If you work from a photo, don't be confined by it – it is no more real than your experience of the scene, or the interpretation you evolve on your support. A photo merely traps a moment in time. If you do work from photos, use several to supplement sketches made on the spot and your memories and experience of the scene.

When you begin the project, block in the main areas, drawing shapes and laying in approximate base colours. Stroke the pigment on to the support, gradually building up a web of colour.

Losing and finding edges

In the process, shapes become softened and edges are sometimes lost, but you can use black or a dark colour to 'find' and refine those edges. The painting process is one of continual readjustment, losing and finding edges, refining and defining shapes and forms. This gives the image a lively quality which it would not have if you simply 'filled in' areas of colour.

However, try not to overwork the painting. With oil pastel, it is easy to lose the image and the freshness of the colour. You can avoid this by fixing the pastel halfway through to isolate the first working. Then apply more pastel over this fixed image.

Finish off with egg tempera

As a final flourish, the artist applied egg tempera paint here and there. He used it for colours such as the pale blue of the sky and the bright yellow of some of the flowers. Oil pastels tend to be too transparent and do not have the intensity required. The paint should be applied very dry – put it on a piece of scrap paper first so that some of the binding medium soaks away, leaving almost pure pigment.

▶ **Oil pastels give a wide range of effects in this picture, from the lively textural marks used for the foliage to the subtle blends of colour in the paving.**

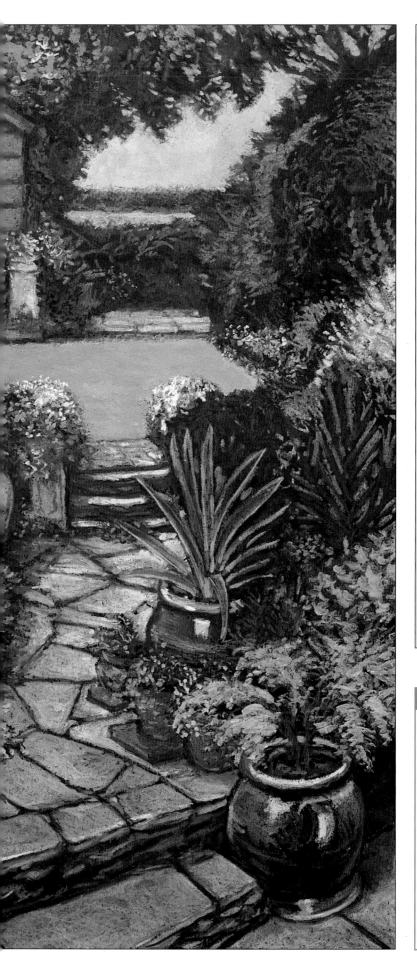

PREPARATORY WORK

The garden that the artist chose to paint provided a variety of possible compositions, as his photographic 'joiner' above shows. He made a few pencil sketches on the spot to help him explore the benefits of different compositions – an example is shown, right. In the end, he opted to focus on the path in an elongated view. This really pulls the eye up and through the picture area. He also painted a landscape version (on page 1314) in which the eye is encouraged to linger in the foreground before travelling up the path.

▼ **YOU WILL NEED**

Piece of 150gsm (72lb) black paper 49 x 42cm (19¼ x 16½in)

Craft knife

19 oil pastels: Cobalt blue; Pale blue; Yellow-green; Grey; Black; Yellow ochre; Grey-green; Dark green; Olive brown; Brown; Purple; Orange; White; Prussian blue; Very

pale blue; Pink; Pale orange; Red; Vermilion

3 egg tempera paints: White; Pale blue; Cadmium yellow

Brushes: Nos.0 and 3 soft rounds

75mm (3in) decorator's brush

Mixing dish or palette

Fixative spray

FIRST STROKES

1 ▼ **Sketch in the underdrawing** Use a cobalt
blue pastel to sketch in the main outlines.
Blue is a good choice – it shows up well against
black and, as blue is a recessive colour, it will
not conflict with subsequent layers of colour.

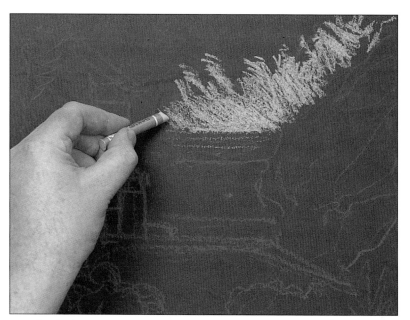

2 ▲ **Lay in the blue of
the sky** Using the
tip of the pale blue
pastel, start to hatch
in the sky, using light,
scribbled strokes.
The aim is to build
up a web of broken
colour without
pressing too hard.

3 ▶ **Apply colour to
the lawn** Working
with gentle, feathery
strokes, use a yellow-
green pastel to apply
broken colour to the
patch of lawn. This
area of bright green is
a pivotal point in the
painting. The eye is
inevitably drawn to it,
so it is important to
establish it at an early
stage. Apply grey to
the paving stones,
varying the direction
of the strokes to
create texture. Use
black for the spaces
between the stones,
at the same time
redefining the shapes.

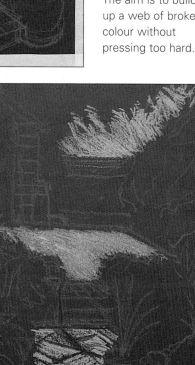

4 ▲ **Continue the underpainting** Apply a light
layer of yellow ochre to the plant pots – this
is an undercolour, not the final colour. Use grey-
green and dark green to define the ferns. Use
yellow-green to add more contrast to the leaves.

◀ **Cobalt blue
(top) is used for
the initial pastel
sketch. Dark
green (centre)
and yellow-green
(bottom) are two
of the hues in the
lawn and foliage.**

5 ▼ **Add more broken colour** Work into the pots with yellow ochre, olive brown and brown. Then work into the paved area with a range of colours – cobalt blue, purple, pale blue and yellow ochre.

6 ▶ **Develop the paving stones**

Apply more blue and ochre colours to the paving stones with a gentle stroking action, building up layers of broken colour to give an opalescent look. Draw the steps with orange and white pastels, then warm up some of the pots with orange, picking out highlights in white. Add light touches on the chimney-pot and paved area beyond the lawn with yellow ochre and white.

DEVELOPING THE PICTURE

At this stage, the three important blocks of colour are established – the blue sky, the green grass and the pearly grey of the steps and path. These areas tumble like a waterfall through the painting, leading the eye in a pleasing zigzag through the picture. Make any necessary adjustments at this point, as the layer of pastel is still relatively thin.

7 ▲ **Block in the shed** Use grey-green, yellow-green and Prussian blue to indicate the different forms and growth patterns of the plants and shrubs. Work into the foliage area with dark green. Moving up the picture, use brown, orange and yellow ochre to block in the pots and flowers around the shed. Use strokes in different directions to follow the structure of the shed.

8 ◀ **Develop the background**

Work up the paved area and chimney-pot beyond the lawn with pale blue and white, adding yellow-green foliage near the shed. Apply a light glaze of very pale blue over the sky. Don't obliterate the underlying blue, which will show through to create an optical mix.

9 ▶ **Add more detail**
Lightly add some white flowers on either side of the steps. These light details create focuses in this area, drawing the eye up through the painting. Develop the foliage around the roof of the hut with the grey-green and yellow-green pastels. Use a mix of dark green and black pastels for the dark foliage at the very top of the picture area.

10 ▼ **Add flower colours** Start to work up the detail in the foliage and borders. Use touches of pale blue and pink, applied with the tip of the pastel, for the flowers in the middle of the painting. Like the white flowers, they draw the eye, and the touches of warm colour sing out against the prevailing greens. Use cobalt blue to roughly mark a dark base tone on the left side of the picture.

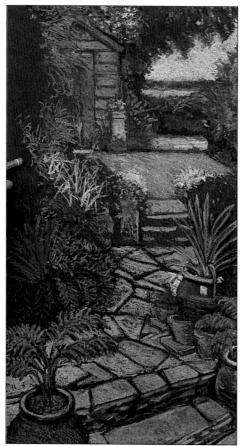

11 ▶ **Fix the painting**
Continue working over the painting, adding touches of light and dark tone and refining shapes. The surface is now becoming saturated with colour, so further blending will be a little messy. At this stage, you need to freeze what you have done by spraying the surface with fixative – this isolates the first layer of pastel and allows you to work on top without disturbing the underlying layers. Work in a well-ventilated room.

12 ◀ **Intensify colour**
Now that the surface has been sealed with fixative, you can start to apply more layers of colour – without this fixing stage, it would be difficult to build up the surface in this way. Apply a further layer of yellow-green pastel to the lawn. Use a little more pressure to lay the pastel on to the surface, but try to avoid disturbing the underlying colour too much.

13 ▼ Develop the paving Start to work over the paved area, using pale orange and white. Work gently, slicking on the colour in different directions to build up a complex web of broken colour which is very subtle. The effect is remarkably painterly.

◄ Purple (left) and pink (centre) are ideal for dotting in bright flowers amidst the greenery. Yellow ochre (right) is a useful undercolour for the plant pots.

14 ► Refine the picture Add details, such as the flowers and foliage, gradually bringing the picture into tighter focus. Use the tip of the pastel to dot in vibrant touches of red and vermilion for the flowers in the border – notice how the scarlet sizzles against the complementary greens, and draws the eye into and around the picture area.

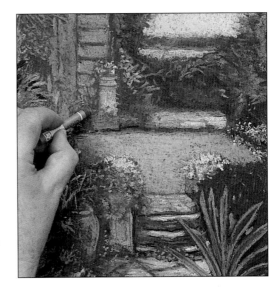

Master Strokes

Vincent van Gogh (1853–90)
The Garden at Arles

Van Gogh painted this intensely personal view of a garden just after he moved to Arles in the south of France in 1888. The painting is built up from vigorous, swirling brush strokes of oil paint which combine to create an exciting textural surface. Diagonal shapes divide up the picture area – the path leads the eye from right to left, while bands of different coloured flowers take the gaze up towards the wall on the right.

The sky is the only area of relatively flat colour, offering a calm backdrop to the vibrancy of the garden.

While most of the flowers and grasses are suggested by dots and dashes of colour, some are roughly outlined to show their shape better.

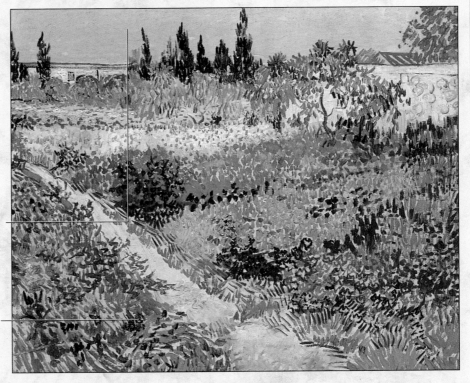

15 ▼ Cutting back with pastel Use the pale blue pastel to firm up the outline of the tree at the top of the picture. Rather than defining the shape of the tree with foliage greens, use the pale blue you used for the sky to cut back into the foliage, defining the leafy outlines as negative shapes.

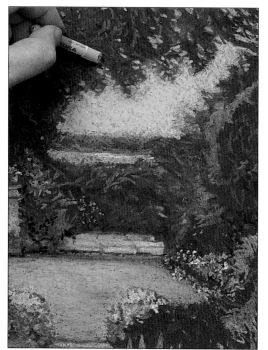

16 ▼ Continue adding details Work over the entire surface of the painting, dotting in more bright colour to enliven the flowers and adding extra dashes of green to the foliage.

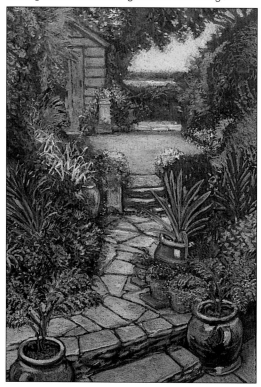

A FEW STEPS FURTHER

The painting is almost finished, but would benefit from one or two brilliant details to lift it. As it is hard to achieve the required intensity of colour with oil pastel, use egg tempera – a quick-drying, opaque pigment – to give luminosity.

17 ▼ Clean up the sky Mix white and pale blue egg tempera and use a No.3 round brush to skim on a thin glaze of colour to the sky tint.

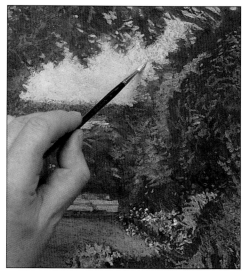

Express yourself
A broader vista

One study will not necessarily say all you have to say about a subject. Each time you address a particular subject, you see different possibilities. Here the artist has chosen a landscape format for the same garden. This allows the eye to travel from side to side, giving a more leisurely progress through the picture area. It also provides more space for the flowers and foliage on either side. A more linear technique has been used, with less blending and layering of colour.

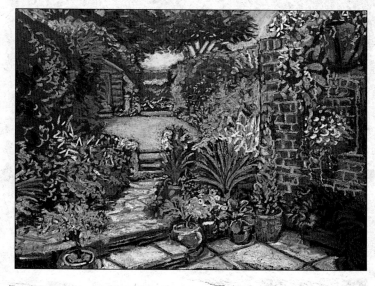

18 ▶ Add bright yellow Yellow is a very transparent colour in oil pastel. In order to achieve an intense yellow for the flowers on the right, use cadmium yellow tempera. Apply the paint with the No.3 brush, varying the marks to suit the form of the flowers.

19 ▲ Add details to the spiky plant Use a No.0 round brush to mark fine yellow lines on the striped leaves of this striking plant. Use the paint quite dry by squeezing it on to a piece of paper so that some of the binder is leached out.

THE FINISHED PICTURE

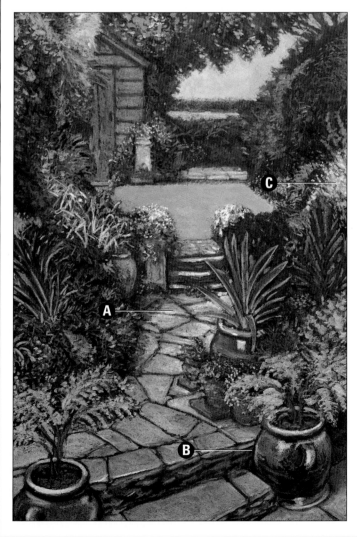

A Broken colour
Dabs, dashes and strokes of different colours, applied layer upon layer on the paving stones, blend optically in the eye to create colour that has depth and luminosity.

B Black background
The black support shows through the layers of pastel here and there across the whole picture. These glimpses of dark tone hold the image together and read as shadow and depth.

C Tempera paint
Bright yellow paint was used for the eye-catching group of sunshine yellow flowers – oil pastel yellows lack the opacity and intensity required to convey this colour successfully.

Country garden

Soft pastels are the perfect medium for capturing the vivid colours and diffused light of this beautiful garden scene, with its flower borders, clipped yew trees and sundial.

A good way to approach a detailed pastel composition like this one is to start with a gouache underpainting. Block in the main shapes and dark tones using a large brush and broad strokes. This bold underpainting will provide a lively first stage, ready for the more explicit detail and colour to follow with the soft pastels.

Be aware that the gouache underpainting affects the colour of the pastels and is also visible in the finished painting. Although the main purpose of the underpainting is to establish the tones, a little colour at this stage can enhance subsequent pastel colours. For example, the pale yellow path in this picture was first painted in complementary purple to make the yellow pastel look brighter.

Effects in soft pastel

Two pastel techniques are used in this painting – impasto and glazing. Impasto is used in the foreground on the flowers, leaves and pebble path, where the colour is built up in short, dense strokes.

In the background, the colour is 'glazed', or broken, by applying the soft pastel thinly with the side of the stick so that you can see the underlying colour. This creates a sense of haze and distance.

▶ **Strong pastel strokes capture the bright flowers in the foreground, while more muted areas of colour suggest the background foliage.**

YOU WILL NEED

Piece of beige pastel paper
50 x 40cm (20 x 16in)

Red pastel pencil

25mm (1in) soft flat brush

6 gouache paints: Burnt sienna; Cerulean blue; Raw sienna; Yellow ochre; Cobalt blue; Bengal rose

Mixing palette or dish

24 soft pastels: White; Pale yellow; Yellow; Pale green; Crimson lake; Blue-green; Dark green; Pink; Magenta; Cadmium red; Very pale burnt sienna; Green-grey; Orange; Violet; Ultramarine; Pale pink; Pale blue; Pale violet; Pale raw sienna; Purple; Burnt sienna; Olive green; Pale purple; Pale Indian red

FIRST STEPS

1 ▶ **Make a light drawing** Using a red pastel pencil, sketch in the key elements of the subject. Draw with a light dotted line so that you can move things around and change the composition if necessary.

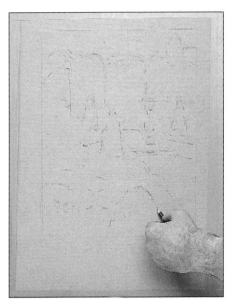

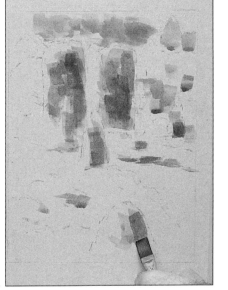

2 ◀ **Paint the dark tones** Working in gouache, applied with a 25mm (1in) soft flat brush, start to block in the shadows and dark shapes in neutral tones mixed from burnt sienna and cerulean blue. Apply the paint thinly and loosely, allowing areas of the warm paper colour to show through between the cool, dark tones.

3 ▶ **Add colour** Mix in varying quantities of raw sienna, yellow ochre and cobalt blue gouache to the neutral mixture and continue to block in the dark shapes. Work in broad, lively strokes, using the narrow edge of the bristles for the smaller areas. Remember, at this stage you are basically feeling your way, so work cautiously and build up the dark areas gradually.

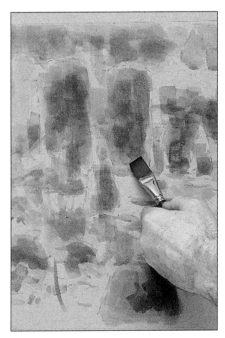

4 ▼ Block in the background and path Add more cobalt blue to the neutral mix to enhance the bluish shadows on the trees. Make a pinkish-purple by adding Bengal rose to the existing mixtures and use this to block in the background and the garden path – this coloured underpainting will show through succeeding pastel strokes and will be visible in the finished painting.

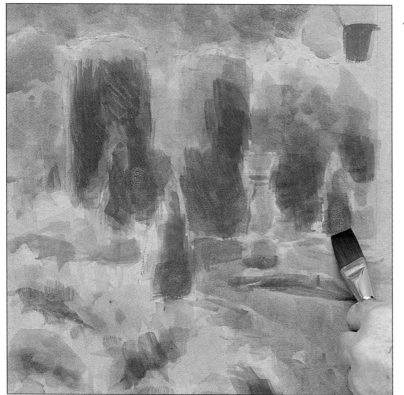

5 ▼ Introduce soft pastel Put the brush aside for the time being and start work with the soft pastels. Beginning with the lightest colours, establish the highlights on the illuminated side of the sundial in white and pale yellow. Use yellow and pale green for the highlights on the trees, bushes and clumps of foliage.

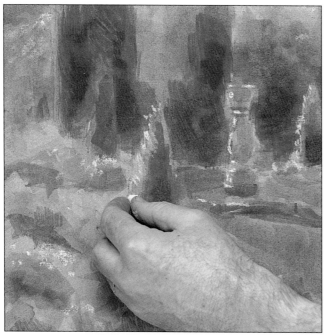

6 ▲ Strengthen the underpainting Move to the garden and dot in a few flowers and a little foliage with the crimson lake and blue-green pastel. Because you have established some of the lightest and brightest colours, you should now be able to determine whether the painted shadows need strengthening. If so, go back to the gouache and reinforce some of the dark tones. Here, for example, the deep shadow around the bush is built up with burnt sienna and cobalt blue.

DEVELOP THE PICTURE

The gouache underpainting is now complete. Using this as a base, build up an impression of light and atmosphere in soft pastels.

7 ▼ Add flowers and foliage Establish the flower leaves in dark green, pale green and yellow, then take these colours into the background trees. Add a dark green shadow to the sundial and dot in flowers in pink, magenta and cadmium red. To create a sense of perspective, make the distant flowers smaller than those in the foreground.

8 ▲ Establish the path Develop the centre of the picture by adding a few more flowers in magenta and blocking in the sunlit path with pale yellow, very pale burnt sienna and white. Apply the path colours in short, horizontal impastoed strokes to create the impression of a pebbled surface.

9 ◄ Develop the yew trees Add flecks of dark green and blue-green on the yew trees. Sketch the far tree-trunks in green-grey. Using very pale burnt sienna, dot in highlights along the tops of the yews. Start to build up local colour on the yews with layers of orange, violet, pink and blue-green applied with the sides of the pastel sticks.

Express yourself
Focus on flowers

Soft pastels are excellent for capturing the effect of sunlight on flowers and foliage, and can be used to make quick sketches that record the main colours in a garden. Here, the artist used bright colours for the flowers and leaves, then added a paler version of each colour to represent the sunny highlights. The scarlet poppies, for example, have been given pink highlights, and the leaves are lightened with pale green and the occasional stroke of bright yellow. The support – a buff pastel paper – provides a mid-toned, muted background that lets the floral colours really sing out.

Master Strokes

George Samuel Elgood (1851–1943)
A Corner of the Garden

This atmospheric watercolour shows a corner of a beautifully tended, English country garden similar to the one in the step-by-step. Mature trees, rose bushes and a well-stocked flower-bed are presided over by a classical statue. Elgood has built up the form of the trees with skilful handling of paint, working from light to dark to create areas of highlight and deep shadow. Although the flowers are not painted in detail, the general shape of the flower-heads and the structure of the plants are carefully observed so that they retain recognisable features.

The muted colours and lack of detail in the trees in the distance lend a sense of recession to the painting.

Lichen growing on the stone statue echoes the greens of the foliage, so that the figure harmonises with its surroundings.

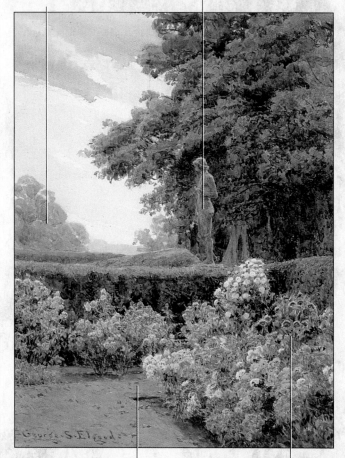

The lawn turns a corner, leading the viewer's eye to the tall, white flowers and upwards to the statue.

Flowers of many kinds in the herbaceous border create a riot of colour amid the greens and blues of the rest of the painting.

10 ▲ **Develop the garden in pastel** Working in flecks of impressionistic colour, add more flowers in ultramarine, cadmium red, violet and magenta. Build up the garden foliage in yellow, blue-green and pale green, using linear strokes for the spiky leaves.

11 ▲ **Add the sky** Create a sense of atmospheric haze in the distance by working lightly into the background with pale pink and pale blue pastels. Suggest small patches of light in the sky, using the pale tones of the yellow, violet and blue pastels.

12 ► Lighten the tones overall

Generally work across the whole picture, adding light tones and breaking down any background areas that appear too dark. Lighten the space between the yew trees in pale yellow, pale raw sienna and pale green. Add more flecks of yellow and pale yellow to the trees and bushes in the background.

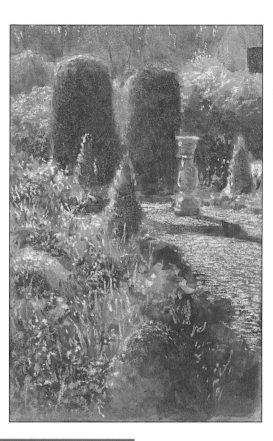

EXPERT ADVICE
Testing your colours

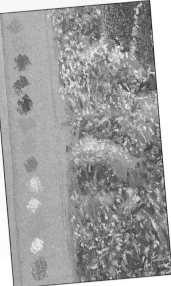

Even with an extensive gouache underpainting, the tone and colour of your paper will affect the colour of the pastel marks. Before introducing a new colour to the image, it's a good idea to test it, either in the margin of the work, as here, or on a separate sheet of paper of the same colour.

A FEW STEPS FURTHER

The image has been built up gradually, using tiny strokes of pastel colour. At this stage, stand back to see how the picture works as a whole. The background is still rather dark and the yew trees are too dominant. Put this right by using layers of glazed colour on the background and trees. This will also enhance the sense of space and make your picture more atmospheric.

13 ► Add glazed colours

Lighten the two yew trees by glazing over them with pale tones of violet, blue and pink. Work lightly, using the side of the stick so that the texture of the paper remains visible.

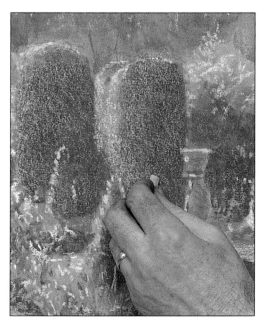

14 ▲ Add more foreground flowers
Continue glazing lightly over any dark background bushes and trees until they appear to recede into the distance. Using cadmium red, purple, pink and pale green, add more foreground flowers, working in short, dense strokes.

15 ▼ Describe the sundial Develop the sundial, using overlaid purple, pink and burnt sienna for the local colour of the stone. Describe its rounded form by adding olive green to the shaded area, and strong highlights in white and pale yellow to the sunlit side.

16 ▼ Add highlights to the foliage Move to the lower half of the picture, adding white and pale tones of green, yellow and blue pastel to the flowers and foliage. Use flecks of pale yellow to suggest sunny highlights on the bush in the foreground.

17 ▼ Soften the shadow Make the sundial more prominent by strengthening the surrounding tones and colours. Using the side of the pastel stick, soften the shadow of the sundial by glazing with pale purple and pale Indian red.

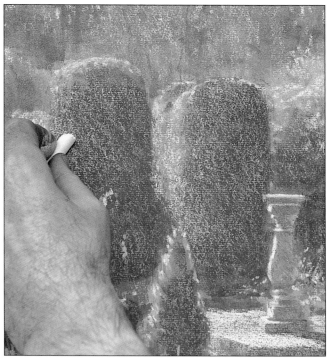

18 ▲ Modify the tones Make any necessary adjustments to the overall tones, using pale colours to lighten any areas that are still too dark, such as the left-hand yew tree. Glaze it lightly with the pale pink pastel.

19 ▲ **Develop the building in the corner** Block in the background building, using purple for the shaded front wall, violet for the roof and white over pale Indian red for the sunlit gable.

20 ▲ **Glaze the sky** Finally, glaze lightly over the sky area with white. This will create a misty background and further increase the sense of recession and distance.

THE FINISHED PICTURE

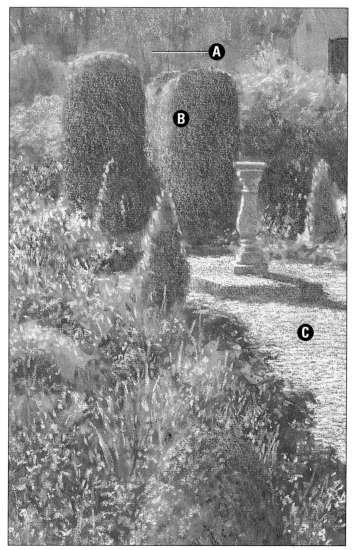

A Toned paper
The warm neutral tone of the paper plays an important role in the finished work, especially in the sky and background where patches of beige paper are visible between the pastel colours.

B Pastel glazing
The dark green colour of the yew trees was softened with layers of lightly glazed pale tints of violet, blue and pink. In this way, the trees do not appear too dominant in the composition.

C Underpainting
The initial gouache underpainting was planned to complement the subsequent pastel colours. For example, the pale yellow path was underpainted in complementary purple.

Tree-lined road

Transform a bleak, monochrome winter scene into a warm, atmospheric watercolour by adding a little sunshine and touches of colourful autumn foliage.

The two stately trees dramatically outlined against the sky are a major feature of this village scene. The reference photograph was taken in the winter – a good time for artists to study trees, as, devoid of foliage, their shape, structure and proportions are easier to see. What you learn from painting winter trees will reap rewards when you come to paint trees in summer and autumn.

With his long experience of observing and painting trees, the artist felt free to add some clumps of autumn foliage to the bare winter ones in the photo to give them added colour and interest.

By using warm colours throughout and adding a blue sky, the artist has created a lively interpretation of the subject.

To enliven further the colours and emphasise the contrast, the artist added sunlight to the overcast scene. In the painting, the sun is low and off to the right, throwing long shadows across the road. It also brings out the cylindrical form of the trees and the angular form of the cottage.

Using a rigger brush
The branches of the trees were painted with a rigger brush. This has extra-long hairs and can make very expressive marks. If you've never used one, make some practice strokes first to learn how to control the brush.

Try sketching some simple trees. Hold the brush near the ferrule to make small marks, but if you want to exploit the flexibility of the brush for creating elegant, tapering lines, hold it lightly, nearer the end of the handle. Keep your hand still and move the brush with your fingers, letting the long hairs twist and bend to make delicate strokes.

▼ **Warm, sunlit areas contrast with cooler shadows and an expanse of blue sky in this picturesque study of a tree-lined road.**

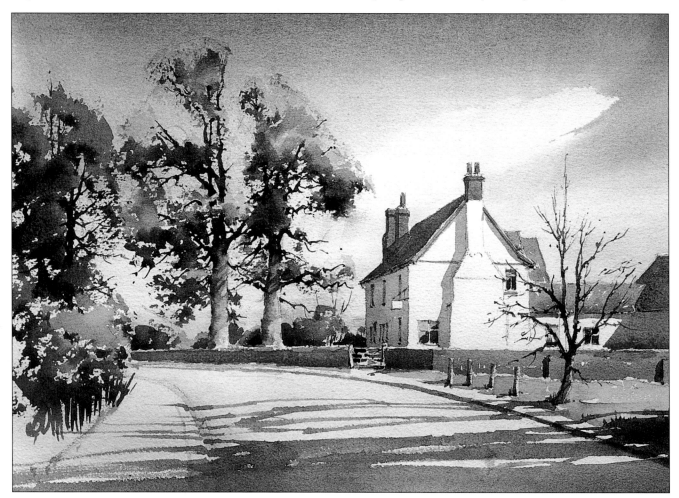

FIRST STEPS

1 ▶ Sketch the scene
Using a 4B pencil, make an outline drawing of the scene. You might find it helpful to mark the horizon line lightly and visualise the lines of the cottage roof and walls receding to the vanishing point. Feel free to omit ugly details such as the street light and road markings.

2 ◀ Lay down the initial wash
Tilt up your board slightly. Using a 38mm (1½in) flat brush, dampen the paper, except for the cottage area, with clean water. Change to a 19mm (¾in) flat and mix a pale wash of raw sienna – make the colour a little stronger than you need, as it will dilute on the damp surface of the paper. Brush the wash across the lower part of the sky and the foreground.

3 ▼ Add warmth to the sky While the paper is still just damp, sweep a band of thinly diluted cadmium red across the lower sky, just above the band of raw sienna. Allow it to melt softly into the raw sienna to give a touch of autumnal afternoon warmth.

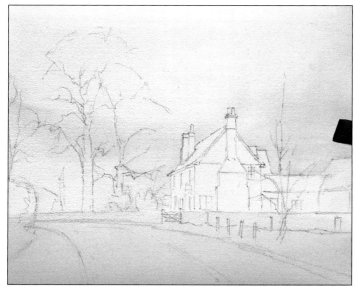

DEVELOPING THE PICTURE

These initial blushes of colour will establish the overall warm tonality of the scene, as they will glow through the overlaid washes of colour to come.

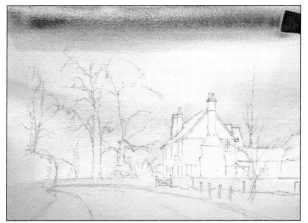

4 ▲ Paint the upper sky Mix a wash of ultramarine and a little cobalt blue. Still using the 19mm (¾in) flat brush, sweep this across the upper sky, letting the colour drift gently down the damp paper in a graduated wash.

5 ▼ **Finish the sky** Lighten the wash with more water as you work down the paper. Make flicking diagonal strokes at the edges of the picture to give some movement to the sky (as long as the paper is still damp, these will dry as soft shapes). Leave the mid-section of the sky untouched.

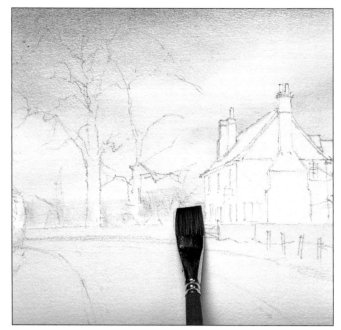

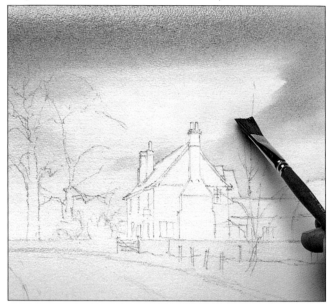

6 ▲ **Block in the background** Use some of the ultramarine sky colour to make an underwash for the line of trees glimpsed in the far distance. Make a series of short, vertical strokes with the tip of the brush.

Master Strokes

Jean-Baptiste-Camille Corot (1796–1875)
Outskirts of a Village near Beauvais

French painter Corot is renowned for his realistic landscapes, which he composed after making sketches directly from nature. In this oil painting, the clump of trees in the centre dominates the composition, dwarfing the houses in the background and the figure of the woman. The portrait format of the canvas emphasises the great height of the trees. Their magnificent, luxuriant foliage is painted with textural, soft-edged brush marks, built up to produce a dense covering of paint. The tonal variation in the greens gives a sense of form and depth to the trees.

Corot was considered one of the forerunners of Impressionism, and this painting, completed in 1850, helps to show why. The paint handling is loose and lively, composed largely of short, juicy brush strokes.

Short, impressionistic strokes of pale green capture the sunlight dancing on the thick foliage. Paler dabs of blue suggest the sky showing through the leaves.

The strong white highlight around the door draws the eye along the path. The houses are rendered with loose dabs of paint, helping to create a sense of depth.

7 ▼ Underpaint the trees Lightly place a few broad, vertical strokes of burnt sienna around the tops of the trees, keeping the brush almost dry. Pick up a little more raw sienna on the brush tip and paint the tree-trunks with short, horizontal strokes.

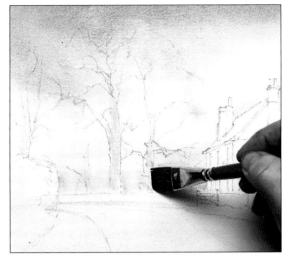

8 ► Paint the cottage roof Add some cadmium red to the raw sienna on your palette to warm it. Change to a No.14 round brush and paint the roofs of the cottage, leaving flecks of white paper to stand for the branches of the small tree on the right.

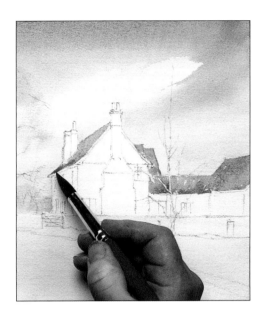

9 ▼ Paint the chimneys Darken the mix slightly with a hint of ultramarine and, using a No.6 round brush, paint the chimneys and chimney pots. Leave slivers of bare paper for the flashing at the top and base of the chimneys.

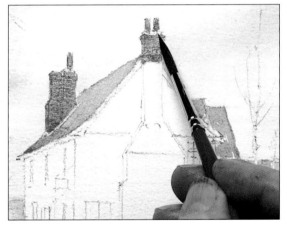

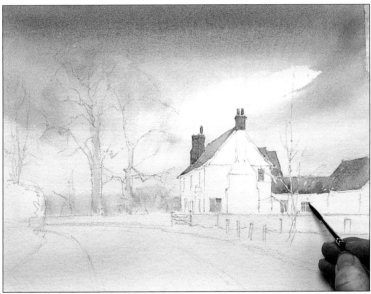

10 ▲ Put in the windows Use a very dilute mix of ultramarine and cobalt blue to show the sky reflected in the window panes, varying the tone to suggest light and shadow. Leave the glazing bars white, but blur them slightly so that they are not over-defined.

11 ◄ Paint the garden wall Mix together cadmium red, light red and a touch of ultramarine to make a slightly cooler red than that used on the roof. Paint the garden wall with the tip of the No.14 round brush, leaving flecks of white here and there. Paint around the posts in the foreground. Mix a green from lemon yellow and ultramarine and use this to suggest moss and foliage growing on the wall.

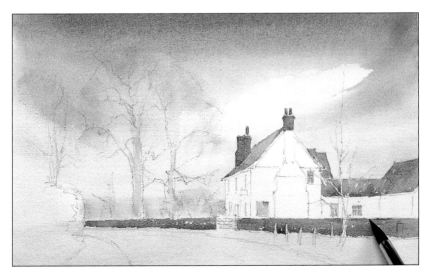

12 ▶ **Return to the trees** Mix lemon yellow and a little raw sienna to make a light, warm yellow. With the No.6 round brush, start to define the main clumps of foliage on the tall trees. Hold the brush almost parallel with the paper and work it with a sideways motion, letting the colour break up on the textured surface of the paper.

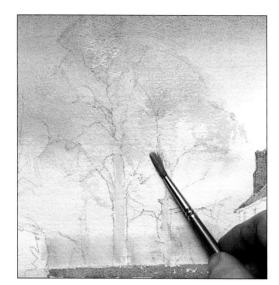

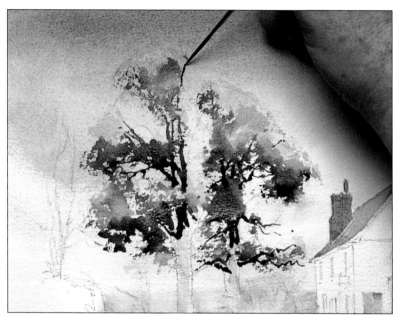

13 ▼ **Paint dark foliage** Add more raw sienna and some ultramarine to the wash. Put in the dark green clumps of foliage, again laying the brush almost flat to the paper and skipping it lightly across the surface with a sideways motion to make broken-edged marks, as before.

14 ◀ **Paint the branches** Use broken strokes of burnt sienna to suggest clumps of brown leaves, letting the colour blur into the green. Mix a near-black from ultramarine, raw sienna and light red and paint the branches with a No.1 rigger brush. Start at the trunk and pull the brush in the direction of growth, skipping in and out of the foliage clumps. Vary the pressure on the brush to make the lines swell and taper.

Express yourself
Pen and colour wash

This country scene has a similar composition to the one in the step-by-step. The curve of the road leads the eye into the picture and tall trees dominate the sky area. This time the scene is worked up in more detail. The initial line drawing is made with a dip pen and waterproof Indian ink and is then washed over with watercolour. The ink lines give structure to the image and sharpen up architectural features, while the freely applied washes create a fresh, lively feel. The pen has been used in a similar way to the rigger brush to suggest the tree branches.

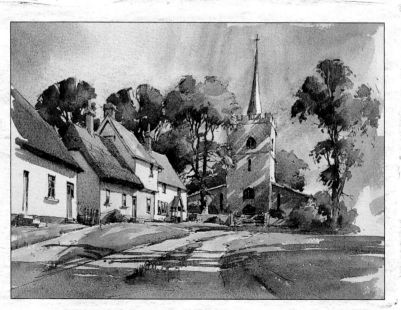

15 ▶ **Put in distant trees** With the No.6 round brush, model the tree-trunks by painting their shadowed sides with a mix of ultramarine and light red (see Expert Advice, right). Suggest the slanting shadows cast on to the trunks by the branches. Paint the more distant trees with varied mixes of ultramarine and light red, leaving a broken glimmer of white paper along the top of the wall.

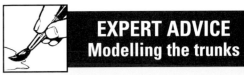
To suggest the cylindrical form of the tree-trunks, first dampen them with water and then put in the shadow colour down one edge with a slightly wavering vertical stroke. The colour will fade out softly on the damp surface, creating a tonal graduation from dark to light.

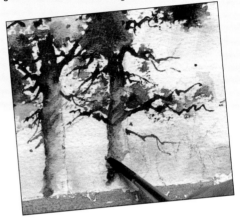

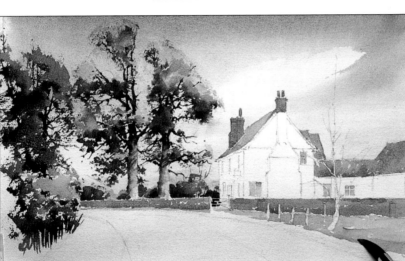

16 ◀ **Work on the foreground** Use the same colours and techniques as for the two main trees to paint the foliage and grass on the left (paint these slightly more freely – elements on the edges of the image should be understated, so as not to compete with the centre of interest). Mix lemon yellow with a touch of ultramarine and paint the grass verge on the right with loose strokes of the No.14 brush.

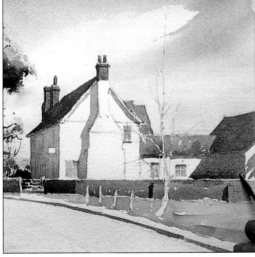

17 ▲ **Model the cottage** Suggest the kerb with light red and ultramarine. Mix a dilute wash of ultramarine and a hint of light red. Using the No.6 brush, paint shadows on the brick wall, roofs and chimneys. Clean your brush, then put in the shadows on the cottage.

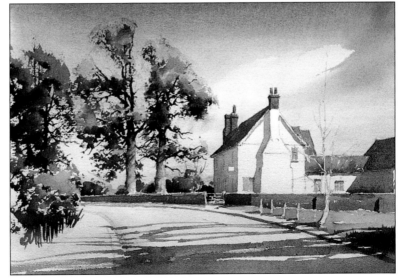

18 ▲ **Add cast shadows** Indicate the kerb on the left with curved strokes of raw sienna greyed with ultramarine. Leave to dry, then use the ultramarine/light red mix to put in the shadows cast across the road by the small tree on the right. Darken the mix slightly for the broken shadow in the immediate foreground, cast by unseen trees to the right.

The picture is almost complete, the contrast of warm and cool colours capturing the atmosphere of a crisp, bright autumn day. All that remains is to bring in a few dark details to give the image a bit of punch.

19 ▼ **Finish painting the cottage** Paint the barge boards at the gable end of the cottage with the ultramarine/light red mix. Steady the brush by resting the ferrule on the edge of a ruler held at an angle to the paper.

20 ▲ **Paint the small tree** Use the rigger brush and mixes of raw sienna and ultramarine to put in dark reflections in the cottage windows and to paint the small tree on the right. Vary the tones to evoke the play of light and shadow on the trunk and branches. Skip the brush lightly over the paper to suggest finer branches.

THE FINISHED PICTURE

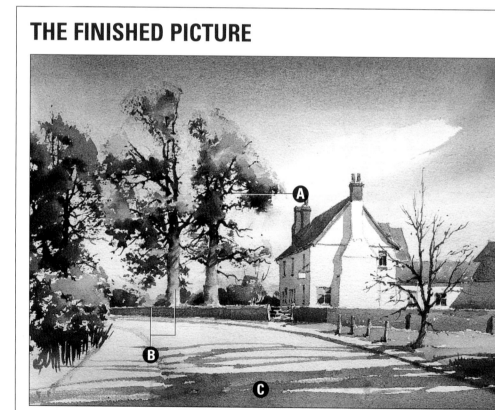

A Calligraphic strokes
The fine rigger brush makes expressive strokes that suggest the gnarled and twisted forms of the branches.

B Stable design
Both the horizon line and the tallest tree have been positioned according to the 'rule of thirds', creating a balanced composition.

C Foreground shadows
The blue-grey shadows cast by unseen trees in the foreground help to 'frame' the scene along the bottom edge.

Seaside studies

Explore the different effects you can achieve by using white and tinted watercolour papers for two atmospheric seaside studies.

The colour of the support has a profound effect on the character of a watercolour painting. White paper maximises the brilliance of watercolour washes, while tinted papers create atmosphere and a sense of unity. These differences are illustrated by the two small watercolours of beach scenes on the following pages – one worked on white watercolour paper, the other on a pale blue paper.

Popular white

The most popular support for painting in watercolour is white or off-white paper. A white ground gives maximum luminosity to the layers of transparent watercolour washes.

With white paper, you work from light to dark, reserving the white areas by painting around them or masking them with masking fluid or paper. The areas of unpainted white provide light local colour and bright highlights.

Moody tints

An advantage of using a tinted paper, on the other hand, is the way it instantly sets a mood. Yellow and buff tones create a warm, cheering image, while blues and greys produce more restrained studies and moody landscapes.

Tinted paper inevitably shows through here and there in a painting, pulling elements together and imposing a sense of unity. With broken-colour techniques, such as scumbling or stippling, the tinted ground can be glimpsed between the patches of overlaid colour – the paint colours combine with the colour of the support to create an optical mix. With a tinted paper, your lightest tone in a painting is the colour of the paper. If you need a lighter area or some highlights, you'll need to use semi-opaque white (Chinese white) or body colour mixed from this. In the second step-by-step project, on page 2235, Chinese white has been used to achieve the effect of white clouds against a blue sky.

If you can't find the coloured support you want or if you'd like to experiment,

▼ **White watercolour paper left unpainted enhances the sparkle of strong sunlight on water in this lively beach scene.**

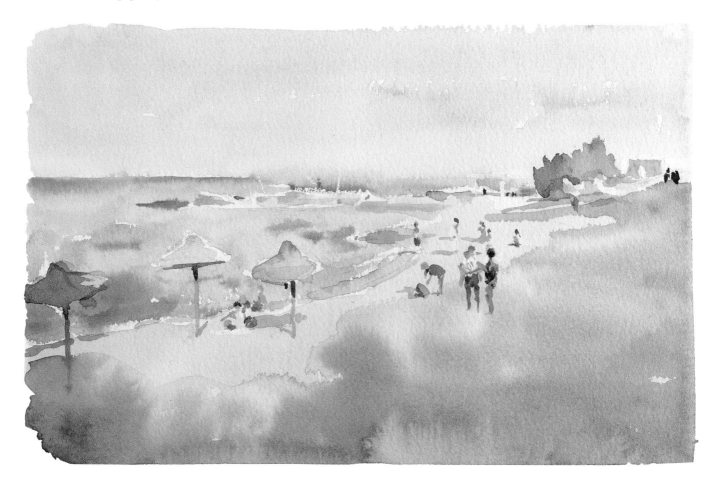

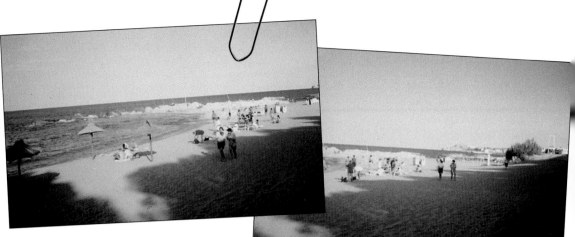

PROJECT 1

BEACH SCENE ON WHITE PAPER

Exploit the light-reflective qualities of white watercolour paper for this sparkling study of a sunny beach scene. The image was created quickly, using washes applied wet-on-wet to create soft blendings of colour and tone. To pull the image into focus, use wet-on-dry techniques to add a few crisp points of interest – the beach umbrellas and figures. Keep your work simple and avoid unnecessary detail. (The painting was based on the left-hand photo above, although the background bush was taken from the right image.)

you can create your own tinted paper very simply by laying a flat wash, using a large wash brush or a sponge. The advantage is that you can produce any colour or tone you like – you can even introduce a scumbled or mottled texture. By using an acrylic instead of a watercolour wash, you'll reduce the chance of the background colour dissolving and mixing with subsequent layers of wash.

1 ◀ **Lay in the sky** Tilt your drawing board so that it is resting at a shallow angle. Use a 3B pencil to make a very simple drawing, indicating the horizon, the shoreline and the parasols. Mix cobalt blue and phthalo blue watercolour and, using a No.12 round brush, apply a basic wash to the sky area.

2 ▶ **Paint the sea** Brush water over the sea, working around the parasols and the rocky outcrop. Apply cobalt blue and phthalo blue wet-on-wet, so that the colours bleed together. Leave to dry.

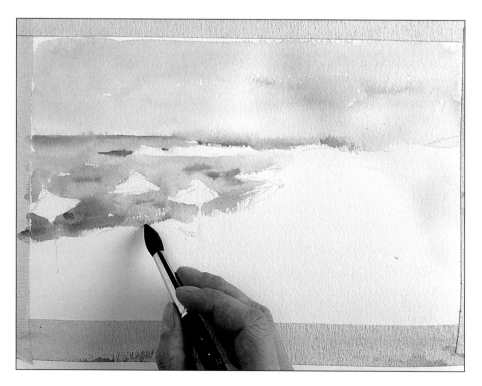

3 ▶ Paint the parasols

Mix Venetian red and gold ochre, then lay a pale wash of this over the sandy beach. Add touches of the same colour to the straw parasols and along the rocky outcrop.

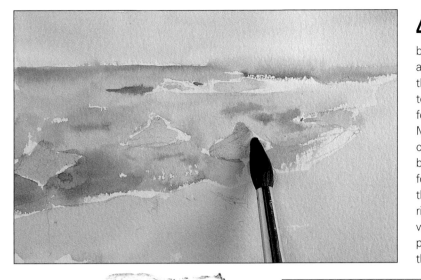

4 ▼ Add shadows to the beach

Mix phthalo blue and gold ochre and apply this colour to the distant bush. Add touches of pure colour for a variegated effect. Mix a wash of alizarin crimson and cobalt blue to create a violet for the shadows. Wet the beach area on the right and flood in this wash, allowing the paint to seep across to the left. Leave to dry.

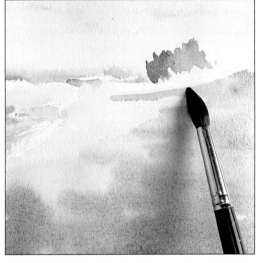

Express yourself
A tinted background

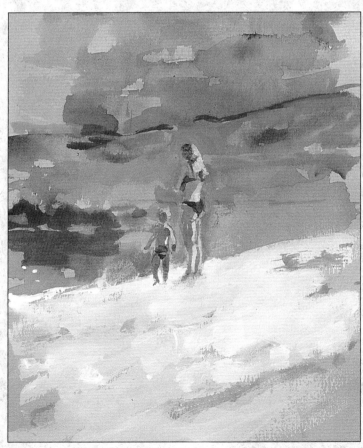

The tinted paper used for this small sketch in acrylics provides a warm undercolour for a more intimate beach scene. The buff shade is left unpainted in places, unifying the composition and extending the palette of blues, greys and creams used for the water, rocks and sand.

EXPERT ADVICE
Creating soft edges

If you want to create a soft edge without blending two colours wet-on-wet, wait until the previous wash has dried, then wet the area where the new wash is to be applied. Flood paint into the centre of the wet area. The colour will bleed outwards from the centre, creating a softly graduated edge.

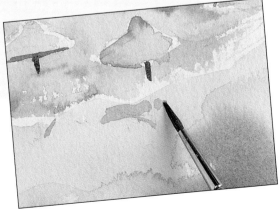

5 ▶ **Add details** Mix Venetian red and cobalt blue and paint the parasol poles. Use the same colour to indicate the figures on the beach. Strengthen the mix to add dark shadows on the parasols. For the figures' clothing, touch in dabs of alizarin crimson and a mix of alizarin and phthalo blue.

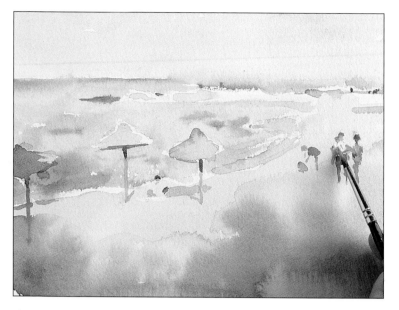

▲ **Mix colours to create subtle shades: use phthalo blue and cobalt blue for the sky; gold ochre and Venetian red for the beach; and alizarin crimson and ultramarine for the cast shadows of the figures.**

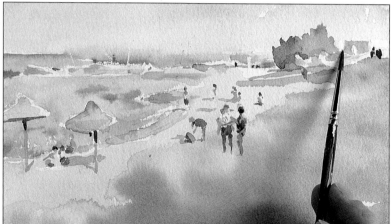

6 ◀ **Add cast shadows** Add some smaller figures in the distance – their diminishing size creates a sense of recession and space in the picture. Mix alizarin crimson and ultramarine, then add shadows under the figures. These anchor them to the beach and show the direction of the sunlight.

THE FINISHED PICTURE

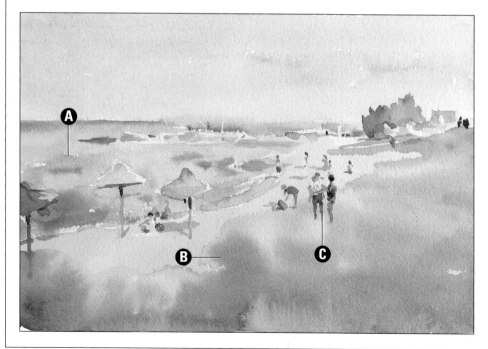

A Sparkling water
The white of the paper – showing through the blue wash – suggests sunlight sparkling on the water.

B Soft shadows
A wet-on-wet technique gives soft, naturalistic edges to the shadows falling across the beach.

C Simplified figures
Simple dabs and dashes of colour come together in the eye to suggest convincing figures.

PROJECT 2

WATER SCENE ON TINTED PAPER

Use pale blue paper and a limited palette of colours to create this tranquil scene. The blue ground is allowed to stand for the distant hills and the highlights on the water. It also establishes the serene mood and provides a linking tone that holds the entire image together.

1 ▼ Lay in a wash for the sea Make a pale mix of Winsor blue watercolour. Starting at the horizon, use a No.12 round brush to apply a loose wash to the blue paper. Take the wash downwards, leaving unpainted areas where the water is lightest – the pale blue of the paper stands for the bright surface of the water.

2 ▼ Paint the clouds Mix a wash of Chinese white. Scumble this semi-opaque colour over the sky – work around the shapes of hills, which should be left as unpainted silhouettes.

▼ **Watercolour papers are available in a range of tempting soft shades, such as green, blue, yellow and cream.**

YOU WILL NEED

Piece of pale blue 190gsm (90lb) watercolour paper 18.5 x 28cm (7¼ x 11in)

8 watercolours: Winsor blue; Chinese white; Ultramarine; Gold ochre; Phthalo blue; Purple lake; Venetian red; Viridian

Brushes: Nos.12 and 3 rounds

Mixing palette

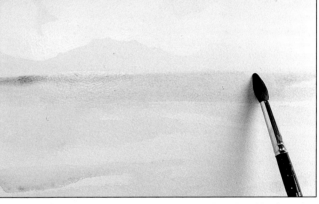

3 ▲ Establish the horizon Load the No.12 brush with clean water and wet an area along and just below the horizon. Mix a wash of ultramarine and flood the colour into the wet area, creating a darker blue along the horizon.

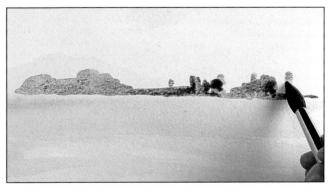

4 ▲ Paint the edge of the bay Mix gold ochre with phthalo blue. Apply this colour to the trees and vegetation that edge the bay, using the tip of the brush to describe their silhouettes. Add more blue to the mix to vary the tone on the vegetation on the right.

5 ▼ Darken the sea Wet the area of sea where the jetty will be, then flood in a pale wash of phthalo blue. While that is still wet, touch in a band of ultramarine. Notice how the paint spreads and merges subtly into adjacent wet areas.

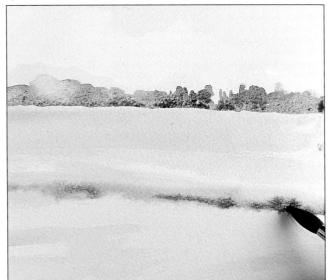

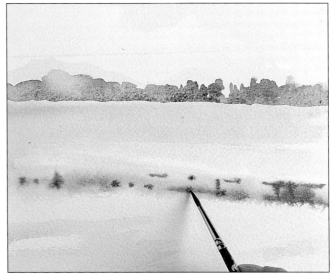

6 ▲ Start to paint the jetty While the sea is still wet, make a mix of Winsor blue and purple lake. Using the tip of a No.3 brush, indicate the shadows on the jetty supports and under the walkway. Mix purple lake and Venetian red for the darkest shadows. Allow to dry.

Master Strokes

John Wonnacott (b. 1940)
Chalkwell Beach, Floodwater Overflow, Late Afternoon

This beach scene, painted in oils, is full of life. Figures running, playing and engaged in various other seaside activities animate the foreground. The composition is slightly unusual in that it is divided exactly in half horizontally. However, this half-and-half division is prevented from being static by the dominant diagonal of the jetty, which brings a dynamic element into the picture.

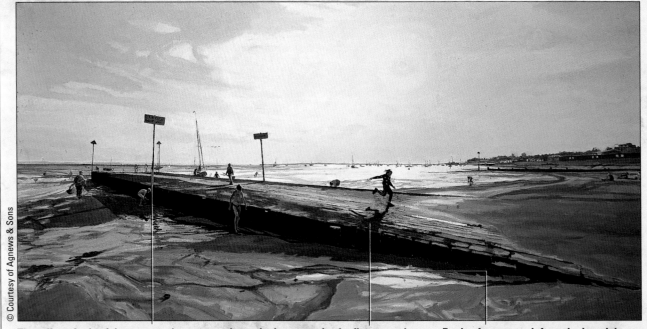

The tall verticals of the posts and masts jutting into the sky link the upper and lower halves of the picture.

Long shadows cast by the figures and the posts suggest the time of day in the painting – late afternoon.

Pools of seawater left on the beach by the receding tide add eye-catching patches of white, pale blue and grey.

7 ▼ **Work detail on the jetty** When the support is dry, mix a wash of Venetian red and use the tip of the No.3 brush to paint the jetty's walkway and the posts supporting it.

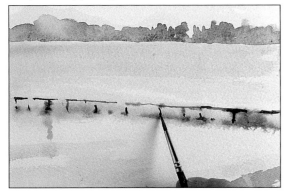

8 ▼ **Add light tones** Add a touch of gold ochre and Venetian red to Chinese white, and use this creamy mix for the top surface of the walkway, which is catching the light. Use the same mix for the lightest supports and for the figures on the jetty and their reflections.

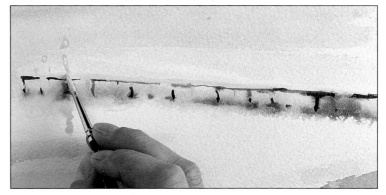

9 ▶ **Develop the figures** Use mixes of viridian and phthalo blue to paint the clothes on the figures. Then mix a brown from viridian and Venetian red for the dark areas on the figures – the hair, the shadows on the flesh tones, and the standing figure's vest. Use the same warm colour to add definition to the structure of the jetty.

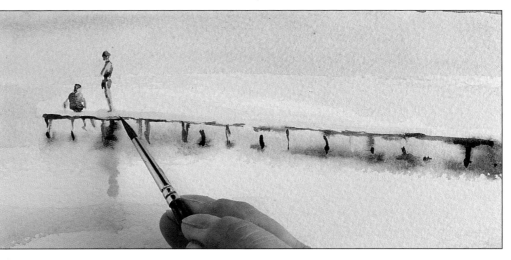

THE FINISHED PICTURE

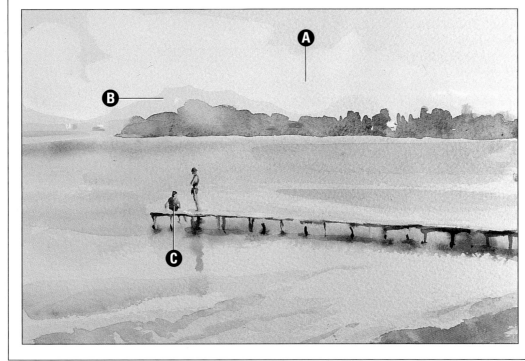

A Hazy sky
Semi-opaque Chinese white was scumbled over the blue ground to capture the effect of a hazy blue sky.

B Blue hills
The pale blue of the support was left unpainted to stand for the hills in the distance.

C Focal point
The two figures at the end of the jetty form a point of interest in an otherwise uninterrupted landscape.

Acrylic seascape

Use acrylic paints to help you recreate an atmospheric summer seascape.

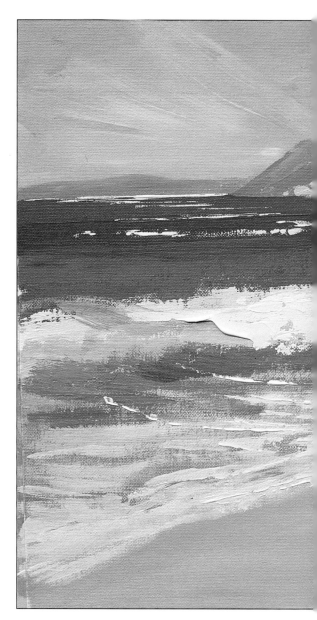

On a sunny day the sea changes constantly from brilliant blue to emerald green to deep turquoise. The water reflects the sun and sky above and picks up the earthy colours of the sand below.

It is little wonder that so many artists have been drawn to the subject and have been tempted to capture the magic of the sea on canvas.

The phthalo colours

Before embarking on this vivid seascape, you will need colours on your palette to match the brilliance of the colours in the subject. Both phthalo blue and phthalo green are just right for this. Not only are they bright and exceptionally strong – a little of either goes a long way – but when mixed together they produce an equally brilliant turquoise.

Phthalo blue is cold and clear, good in mixtures which capture the cool, hazy blueness of distance. Phthalo green is excellent for mixing the range of bluish greens necessary for seascape painting.

Because the phthalo pigments are so strong, the colours appear dark unless mixed with white. Always start with the white and add the colours a little at a time. If you do it the other way round, you could end up using a lot of white paint! Also, it is worth bearing in mind that acrylic paints often darken as they dry. This is particularly true of the phthalo colours, so make allowances for this when you mix.

▶ **The texture of the waves and the sense of movement in the sea have been skilfully created with thick acrylic paint.**

YOU WILL NEED

Canvas-covered board about 41 x 51cm (16 x 20in)

Brushes: No.4 round; No.6 flat

8 acrylic colours: Phthalo blue; Phthalo green; Burnt sienna; Cadmium yellow deep; Cerulean blue hue; Titanium white; Cadmium red light; Ultramarine blue

Painting the sea

To look convincing, the sky should be lighter than the sea where the two meet on the horizon. Remember, acrylics will dry darker, so make the sky even paler than it looks.

Texture is important in this painting and the sand, seawater and hilly background provide opportunity for variety. Use undiluted colour with a painting knife for chunky waves and heavy spray; for the smaller ripples, apply thick colour using the tips of the brush bristles.

Clear colours

It is crucial to keep colours clear and bright. Make sure you wash your brush before mixing the sea colours – the hill and sand colours will make blues and greens muddy. For the initial outline drawing, use paint rather than soft pencil or charcoal, which would smudge.

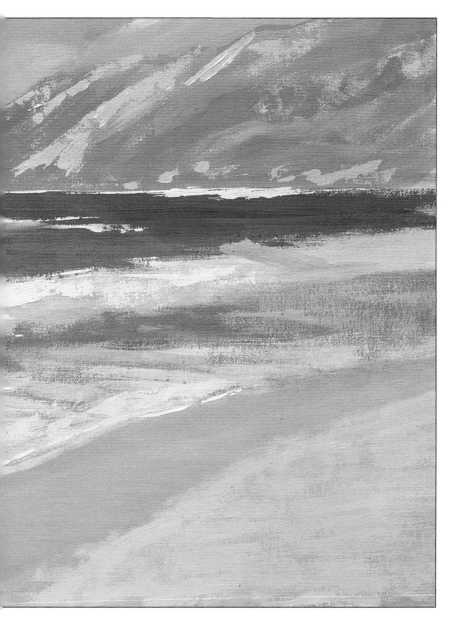

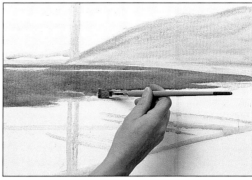

2 ▲ **Block in the main areas** With a No.6 flat brush, fill in the main colour blocks. For the dull green hills, add cadmium yellow to the mixture of phthalo blue and burnt sienna. Don't worry if the colour is not exactly right – the tone is more important. Paint the foreground sea in long horizontal strokes with phthalo blue thinned to the consistency of single cream.

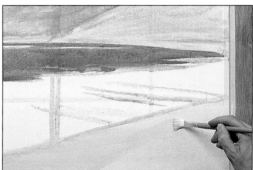

3 ▲ **Establish the sky and sand** Paint the sky in a mixture of equal parts cerulean blue hue and phthalo blue with an added touch of white. For the sand, mix white with cadmium yellow and burnt sienna and work in horizontal strokes to convey a flat beach. While the paint is wet, mix a browner version of the same colour by adding a little more burnt sienna and a touch of cadmium red and paint this along the surf line over the existing yellow. The darker colour represents wet sand on the edge of the water.

FIRST STROKES

1 ▶ **Start with the outline** Mix equal amounts of phthalo blue and burnt sienna and dilute to a watery consistency. Using a No.4 round brush, divide the canvas into a grid of nine sections to help get the scale of the picture correct. Do an outline painting of the subject, putting the horizon about a third of the way down the canvas and drawing the coastline as a gentle curve.

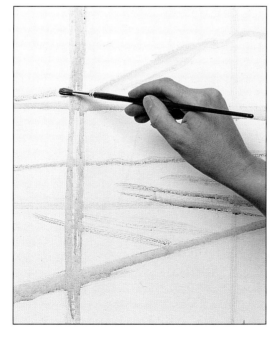

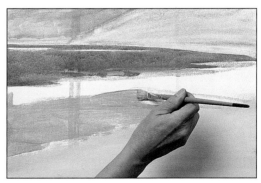

4 ▲ **Paint the rolling waves** For waves and shallow water, mix a turquoise by adding green and burnt sienna to white. Horizontal strokes help convey the movement of water.

5 ▼ **Complete the sky** Overpaint the existing sky area in a mixture of approximately one part cerulean blue to four parts of white. Mix a slightly paler version of this by adding a little white and indicate the clouds with a few vigorous brush strokes. By lifting the brush at the end of each stroke, you will create a light feathery mark, which conveys the idea of wind and movement. Still using the paler colour, add a few long brush strokes radiating from the horizon to give the impression of sunlight.

EXPERT ADVICE
Testing colours

Acrylic colours tend to darken as they dry. To make sure you have mixed the colour you want, make a test on a scrap of paper and wait for this to dry before using the colour in your painting.

▶ **When using phthalo colours, which are very intense, start with the amount of white paint you will need, then add the blue and green gradually to achieve the final tint you want.**

6 ▶ **Paint the background**
For the distant hills, add a touch of ultramarine to the sky mixture and paint the hills in loose, broad strokes. Then add a little cadmium yellow to this mixture and paint the foreground hills.

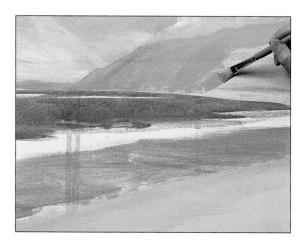

DEVELOPING THE PICTURE

With the main areas of colour now established, you can begin to develop the sea. Acrylic paints used thickly provide a good texture suitable for the waves and foam.

7 ▶ **Develop the water** For the cold distant blue of the sea, mix one third phthalo blue to two thirds white. Work in horizontal strokes, leaving the ridges of thick paint which form between the strokes to represent waves. Add phthalo green to darken the mixture as you work down the canvas.

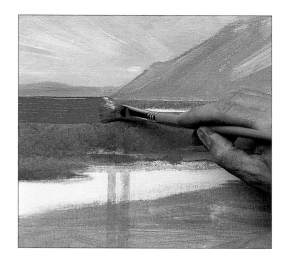

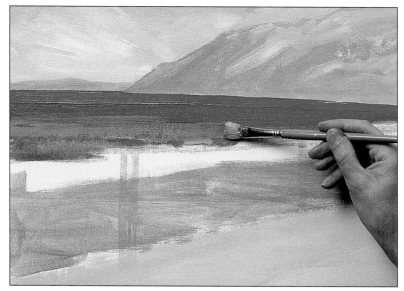

8 ▲ **Vary the sea colours** Still using horizontal strokes of thick colour, add a small amount of phthalo green and a little white to the existing sea colour to paint the water in the foreground.

9 ▲ Paint the foam Now, mix a tiny touch of the phthalo green with undiluted white for the froth on the breaker. Drag the colour lightly along the edge of the breaker.

10 ▶ Capture light on the waves Add phthalo blue to the foam colour for the pale translucent blue-green of breaking water. Dip the brush in the colour and drag it along the underside of the waves. Apply parallel strokes to capture light on water in the foreground.

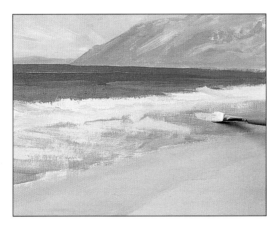

Express yourself

Adding a figure

The mood and atmosphere of the acrylic seascape is completely transformed by the introduction of a lone windsurfer. Whereas the blue and green shades of the original painting created a cool, calm ambience, the warm red and yellow colours of the windsurfer's striped sail appear to jump forward from the background, adding a lively focal point to the scene.

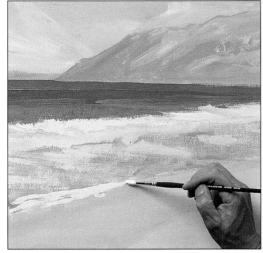

11 ▲ Paint the ripples Change back to a No.4 round brush and mix an off-white by adding a minute dab of cadmium yellow to white. Using undiluted colour, drag the brush along the edge of the surf. Paint thick white lines, allowing the colour of sand to show through in places.

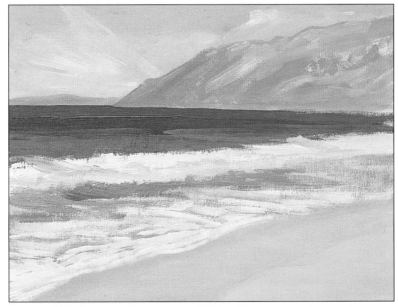

12 ▲ Add shadow under the waves With a No.6 brush paint the deep turquoise shadow on the underside of the waves. For this shadow, mix about two thirds white and one third phthalo blue with an added touch of phthalo green.

The basic seascape can now be considered complete. However, you can add life to the scene by creating more texture with a painting knife. A knife makes an enormous difference to a painting and is especially effective for adding details in these final stages.

14 ▲ Smudge with your finger Choose one or two of the distant waves and soften the effect of the knife-painting by smudging the wet paint with your finger.

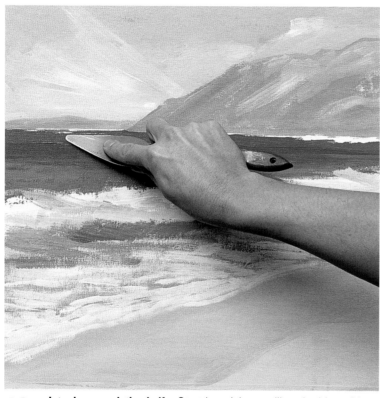

13 ▲ Introduce a painting knife Start by mixing undiluted white with a hint of cadmium yellow, then use the edge of the blade to print narrow lines for the distant waves.

15 ▲ Add wedges of white To liven up the picture, scoop up a knife full of white with an added touch of cadmium yellow and apply broad wedges of paint along the waves using the flat side of the knife blade.

16 ▲ Complete the knife effects Finish the sea by knife-painting the white and yellow mixture on to the foreground ripples. Finally, use the knife to brighten up the hill with broad swathes of sunlight. Do this with white with added touches of phthalo blue and cadmium yellow, painting with the flat side of the blade.

HOW TO PAINT OVER A MISTAKE

Acrylics dry quickly, so it is no problem to correct mistakes. If you apply the wrong colour, simply wait a few moments for the paint to dry, then brush over the mistake using the correct colour.

Master Strokes

James McNeill Whistler (1834–1903)
The Shore, Pourville

Whistler's oil painting shows the sea in quite a different mood from that in the project. Instead of invigorating blue waves tipped with frothy white, the water is a dull grey-green with a choppy motion suggested by the irregular patches of foam. The only bright area of the painting is the sky. As in the acrylic project, the oil paint has been applied thickly so that it retains the texture of the brush marks. There is little demarcation between the sea and beach, giving an overall impression of wetness. The figures have been added sketchily so that they look windswept and almost ghostly.

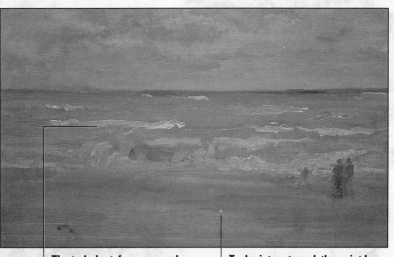

The turbulent, foam-capped waves are suggested with thick oil paint and swirling, textured brush strokes.

To depict wet sand, the paint has been applied in thin horizontal streaks in a tone and colour similar to the sea.

THE FINISHED PICTURE

A Brilliant sea colours
Phthalo blue and phthalo green are responsible for the strong colour mixtures used for the water – vivid blue in the distance and bright turquoise in the foreground.

B Chunky slabs of paint
Thick colour was applied with a knife to enliven the surface of the paint and was effectively used to describe the hills and the foamy water.

C Two-tone sky
The sky was simplified into two tones of pale blue. The darker of the two colours is the underpainting, while the lighter one represents the clouds.

Crashing surf

Capture the excitement and energy of waves breaking on a rocky shore, using a combination of fluid washes of gouache and vibrant soft pastels.

The sea is a very beguiling and absorbing subject to paint, and has fascinated artists through the centuries. It poses the challenge of rendering the fluidity and transparency of water, capturing the play of light across its surface and conveying a sense of distance with only a few spatial clues.

Light on the sea

For the project, the artist stood at an upright easel, using big brushes to flood in broad washes of gouache. Once he had established the important divisions of sky and sea, he concentrated on arranging the areas of light tone within the composition. Light is one of the important themes in the painting, and these tonal areas give the composition a solid and coherent underlying structure.

The light comes from the right of the picture and illuminates the breaking waves on the left. It passes through the aquamarine wave between the rocks, so that this appears to be lit from within. Light travelling across the painting and the change of light areas against dark ones set up rhythms that lead the eye around the picture.

At the early stages, the image is loose and free. The broken and scumbled application allows the viewer to look through the paint layers and suggests the depth and transparency of the water. As the painting progresses, the artist brings it into focus with touches of solid pastel and impastoed gouache.

Creating distance

A challenge when painting seascapes is creating a sense of recession and space when there are few clues to scale and relative distance. The patterns made by the foam on the water's surface, the texture and tone of the rocks in the foreground and the seabirds wheeling over the surface of sea all become significant clues. The artist had to orchestrate them with great care in order to create the space that appears to open up behind the picture plane.

This project was painted from two photos (right) the artist took on the west coast of Scotland. He used the top photo for the crashing wave on the right and the bottom one for the foreground rocks.

▼ Spattered gouache, scribbled strokes of soft pastel and patches of impasto paint all help to create the drama of the sea crashing against a rocky coast.

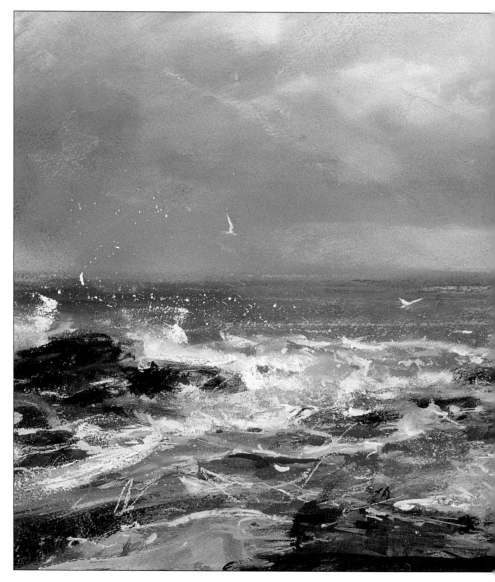

YOU WILL NEED

Piece of 300gsm (140lb) Not watercolour paper

Brushes: Nos.20 and 10 rounds; large hake; 50mm (2in) decorator's brush

12 gouache paints: Naples yellow; Geranium lake; Prussian blue; Winsor green; Phthalo blue; Alizarin crimson; Ultramarine; Burnt sienna; Permanent white; Cobalt; Yellow ochre; Ivory black

14 soft pastels: Pale blue; Dark blue; Cobalt blue; Very pale blue; Titanium white; Dark grey; Black; Yellow ochre; Pale turquoise; Lilac; Turquoise; Mid burnt sienna; Light burnt sienna; Burnt umber

Kitchen paper

Craft knife

FIRST STROKES

1 ▶ Block in the underpainting Mix Naples yellow and a touch of geranium lake with a large quantity of water. Load a No.20 round brush and, using broad, loose strokes, apply colour in the sky and horizon area. This will provide a warm undertone for the sky. Mix a pale wash of Prussian blue, Winsor green and geranium lake and apply this across the support. Leave to dry.

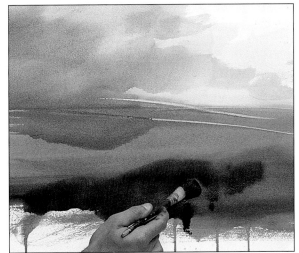

2 ▲ Start to apply bold colour Mix an intense wash of phthalo blue, load the No.20 brush and apply the colour to the sea area with broad sweeping gestures. Hold a large hake close to the bristles and, using the dry brush and a sweeping back and forth gesture, 'soften' the edges of the water, pulling the colour up into the sky.

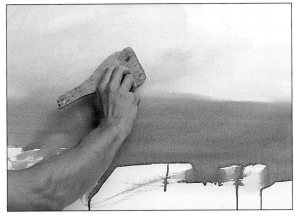

3 ▲ Build up the sea and sky Working freely with the No.20 round, apply seeping marks in the sky and sea area: Prussian blue and Winsor green, blended with streaks of alizarin crimson in the sky, and an intense wash of Prussian blue in the foreground. Leave the painting to dry or use a hair-dryer to save time.

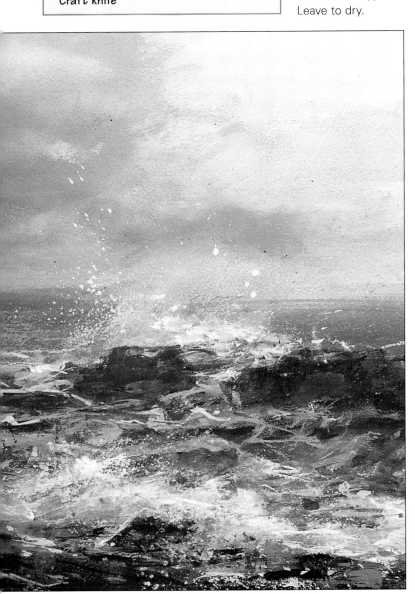

4 ▼ Apply more gestural marks Dry the No.20 brush on a piece of kitchen paper, dip the tip of the bristles in the lighter washes on your palette and work vigorously over the sky to give a dry brush effect. It is generally a good idea to work from light to dark to start with, building up colour and tone gradually in all parts of the picture. This preliminary underpainting allows you to assess aspects such as the play of light.

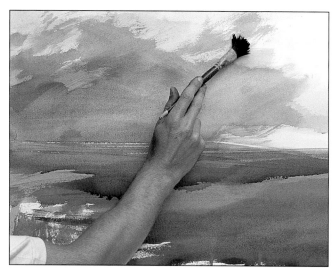

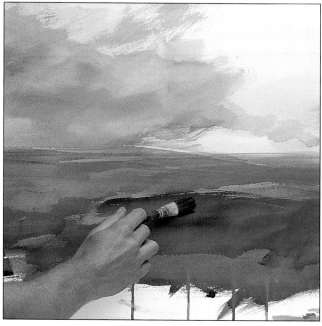

5 ▲ Build up washes in the sea Working wet-on-wet, lay down washes of ultramarine, phthalo blue and Prussian blue across the sea. Move back and forth between sky and sea in these early steps, as the sea borrows its colour from the sky. Leave to dry.

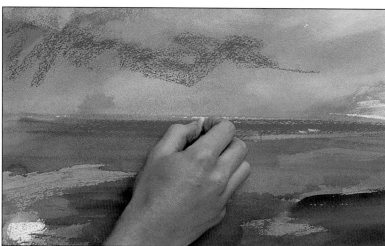

6 ▲ Start to apply pastel Use a pale blue pastel on its side to scumble colour into the sky, changing to dark blue under the clouds. Apply a band of dark blue on the sea along the horizon and bands of cobalt blue in the middle distance. Mark a thin pale blue line just above the horizon.

► **The colours of gouache used for the sea, sky and rocks are echoed by similar shades of soft pastel.**

Phthalo blue

Ultramarine

Burnt sienna

Yellow ochre

Naples yellow

Prussian blue

Pale blue

Turquoise

Dark blue

Burnt umber

Yellow ochre

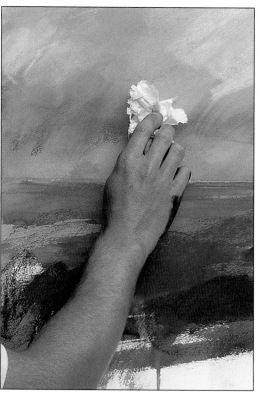

7 ▲ Soften the pastel Apply swathes of dark blue pastel to the sea in the foreground. Blend and soften the pastel in the sky by rubbing it lightly with a piece of kitchen towel. This removes surplus pigment, leaving a thin film of colour. Use sweeping, downwards gestures to pull the pigment down, creating broad marks that suggest shafts of light.

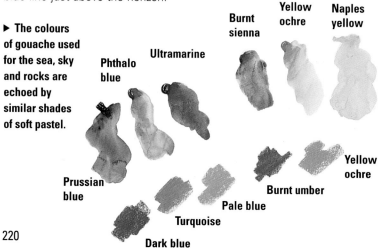

8 ▲ **Apply pale pastel** The light in the right side of the sky is an important element in the composition. Lighten this area by scumbling on very pale blue pastel, then soften the marks with kitchen towel.

9 ▲ **Paint the rocks** Mix ultramarine and burnt sienna gouache to create a dark tone for the rocks in the foreground. Apply this with a No.10 round brush, pushing and pulling the paint to create varied shapes and variegated tones that suggest the rocky forms emerging from the water.

DEVELOPING THE PICTURE

The dark tones in the foreground give the painting a sense of space and recession, so that the eye travels from the foreground over the horizontal surface of the sea towards the light sky above the distant horizon. It is now time to tackle the broken water in the foreground. This is achieved using a combination of white pastel and white gouache.

EXPERT ADVICE
Use a viewfinder

From time to time, stand back and view your work from a distance. Try isolating different areas of the painting using a viewfinder or a pair of small L-shapes (right). This is a good way of finding those areas that work and should be left alone, and those that are weak and need more work.

10 ▲ **Paint the breakers** Suggest the broken water by making short and varied marks with a small piece of titanium white pastel. Try twisting the pastel as you apply it. Smear some of these areas with your finger to suggest mists of spray and spume and then add more marks to create areas of solid white.

11 ▶ **Spatter on white gouache** Load a 50mm (2in) decorator's brush with permanent white gouache. Hold the brush in front of the painting and flick the bristles forward with your forefinger to deposit droplets of paint on the support. Continue doing this, moving the brush gradually across the painting.

12 ▼ **Build up the breakers** Mix permanent white paint to a creamy consistency and apply to the breakers with the No.10 brush. Use a variety of marks, pressing the bristles on to the surface to smear the paint in some places and trailing paint with the tip of the brush in others. Here and there, apply paint straight from the tube to give patches of impasto.

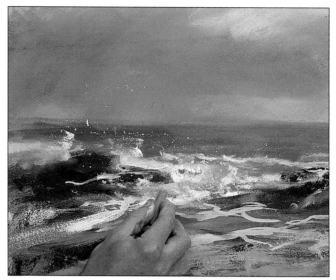

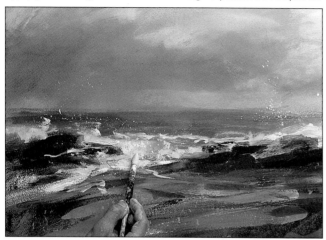

13 ▲ **Develop the water** Add more texture and colour to the water surging between the rocks. Pale blue pastel skimmed over and worked into the white gouache captures the transparency and complexity of the water's surface.

Master Strokes

Ando Hiroshige (1797–1858)
Stormy Sea at the Naruto Rapids

Japanese artist Ando Hiroshige was master of the coloured woodblock print and this highly stylised seascape is a beautiful example of his work. The focus of the picture is the turbulent water in the foreground, giving way to calmer sea in the distance. The far shore is framed by foaming waves on either side, creating a strong and unusual composition. By using only two shades of blue for the sea, the artist enhances the bold, graphic effect created by the whirlpool and veins in the water.

The birds flying off into the distance add interest to an otherwise plain sky. They are depicted very simply with a few economical lines, yet convey a sense of movement.

Almost abstract in form, the swirling dark and light blue patterns in the sea suggest the power of the water's motion around the rocks.

14 ▶ **Develop the rocks** Continue working on the water in the foreground with a mix of cobalt and white paint scumbled on with the No.10 brush. Dry the paint with a hair-dryer. Scribble dark grey, black and yellow ochre pastel over the rocks. Emphasise the surface of the water by drawing wavy lines with pale turquoise and lilac pastel – use a range of broad and thin lines applied with the edge of the tip.

▲ The artist's palette shows the blues, sea-greens, yellows, ochres and earthy red-browns used to build up the sky, water and rocks in the seascape.

15 ▼ **Warm the rocks** Apply a mix of burnt sienna and yellow ochre gouache to the near rocks, scumbling the colour on with the No.10 brush. Allow to dry. Work turquoise pastel into the water between the rocks.

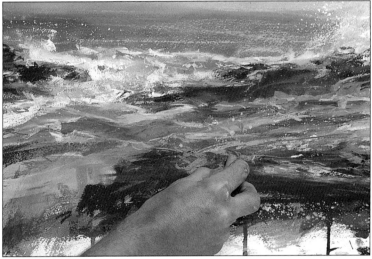

16 ▲ **Continue to develop the foreground** Work into the rocks with mid and light burnt sienna and burnt umber pastels. Use scribbled marks to create a web of broken colour – this gives the area texture and depth, improves the spatial relationships and prevents the rock colour looking too solid.

Express yourself
Wind and waves

In contrast to the step-by-step, this seascape is enhanced by the diagonal emphasis of the composition. The wave on the left, the rocks and the brushwork in the sky all create dynamic diagonals that help convey the wild force of the weather. Note how the rocks – with their dark tones and touches of red and orange – provide a pleasing contrast to the sea and sky.

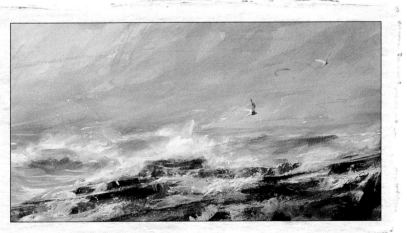

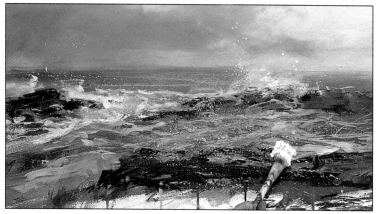

17 ▲ **Paint the breakers** Apply more spattering with white gouache in the foreground. Load the No.10 brush with the white gouache mixed to a creamy consistency and use a dabbing gesture to apply passages of paint where the waves break over the foreground rocks.

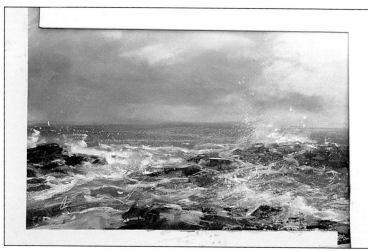

18 ▲ **Crop the painting** Use your finger to smear white paint over the sea on the left to create a semi-opaque film. Now drop a set of L-shapes over the painting, so that you can assess the composition. The artist decided to crop the sides and bottom slightly.

EXPERT ADVICE
Drawing with your nail

Try using your fingernail to incise lines in the paint in order to define forms or create texture. There is a notable precedent for this – the great seascape painter, J.M.W. Turner (1775-1851), kept one of his fingernails long in order to sgraffito the paint surface.

A FEW STEPS FURTHER

The painting is now a convincing image of a heaving sea, with breakers crashing over rocks. To finish it, knock back the detail on the rocks slightly and put in some seagulls to add scale to the scene. Fix the L-shapes to the paper with masking tape and work within the cropped outline for the last few steps.

19 ▲ **Knock back the rocks** Make a blue-grey mix from white with a touch of Prussian blue and ivory black. Load the large hake and drag it across the rocky area to create a thin veil of colour. Work over the area, applying a tracery of paint and pastel lines in blues and blue-greys.

20 ▲ **Add the birds** A few swooping seagulls will give the painting a sense of scale. Flick these birds in with a light touch, using the tip edge of the titanium white pastel. Practise on a piece of scrap paper first – the image will lose its lovely sense of freshness if the birds are too laboured.

21 ▼ **Mute the foreground rocks** The scribbled pastel colours on the foreground rocks are rather distracting, so knock them back by applying a dark wash mixed from Winsor green and burnt sienna.

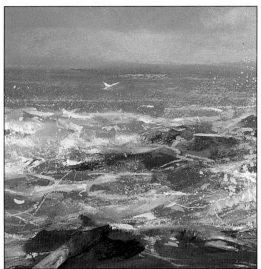

22 ▲ **Scrape through the paint** Use a craft knife blade to scrape off some of the surface paint, revealing the colours underneath.

THE FINISHED PICTURE

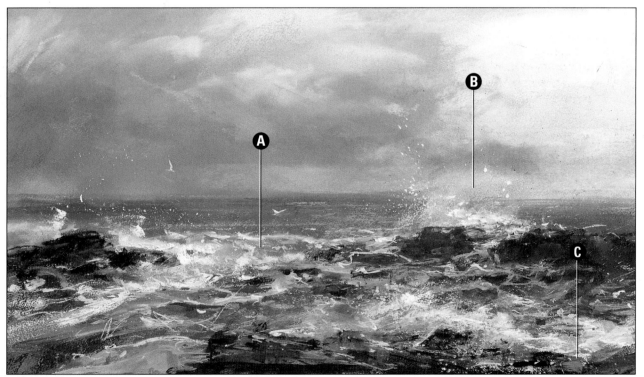

A Textural colour
Layers of scumbled and broken colour in both gouache and pastel suggest the movement, depth and volume of the sea.

B Sparkling spray
White gouache paint spattered on with a brush captures the sparkling effect of breaking waves and foam.

C Warm rocks
Touches of warm colour on the rocks in the foreground pull this area convincingly to the front of the picture plane.

Roman bridge at Cordoba

This painting of a historic city has as its foundation an unusual pencil drawing that brilliantly conveys the complex vista with a tracery of straight lines.

The technique of pencil and wash is well suited to architectural studies. Pencil is an unrivalled medium for conveying architectural line. The strength of line can be varied depending on the pressure of the hand on the pencil, and the artist has the choice of rendering either crisp, strong lines or soft, sketchy ones. Often, a combination of both works best – and this picture helps prove the point.

Line work

For this study of the bridge at Cordoba in Spain, the bulk of your time will be spent with pencil in hand to render the perspective, scale and detail as effectively as possible. Focus on a small section at a time, working with multiple short lines to build it up gradually.

Concentrate on replicating the main horizontal and vertical lines of the scene, rather than the detail. Stand back frequently from your work to get an overall view, so you can assess the positioning of elements as the drawing progresses.

Moody washes

Once the pencil work is complete, apply the washes quickly and spontaneously. The washes are largely intended to convey mood and atmosphere, but they also help create a sense of perspective and distance. Windows and doors are key details in any architectural study and painting these in dark or bright colours will add definition to your work.

▶ **The pencil lines that define the buildings are visible through the loose washes and give this painting its distinctive character.**

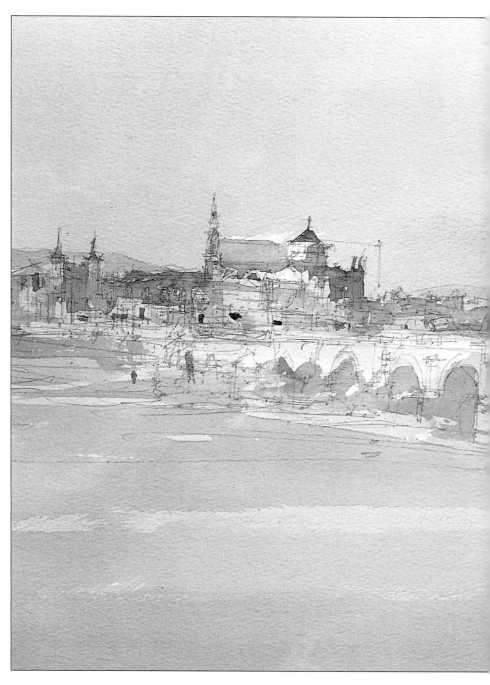

Piece of 300gsm (140lb) Not watercolour
paper 38 x 58cm (15 x 21½in)

HB pencil

5 watercolours: Prussian blue; Alizarin
crimson; Yellow ochre; Cadmium orange;
Hooker's green

Brushes: 50mm (2in) and 13mm (½in)
flats; Nos.3 and 2 rounds

Mixing dish or palette

Clean water

FIRST STEPS

1 ▼ Mark in the main features Starting on the left with an HB pencil, mark in the river wall and draw a line to indicate the top of the bridge. Sketch the buildings above the river wall, using short vertical and horizontal strokes. Add the rooftops and turrets. Then sketch the church – the main building in the scene. Working towards the right, outline the skyline above the bridge.

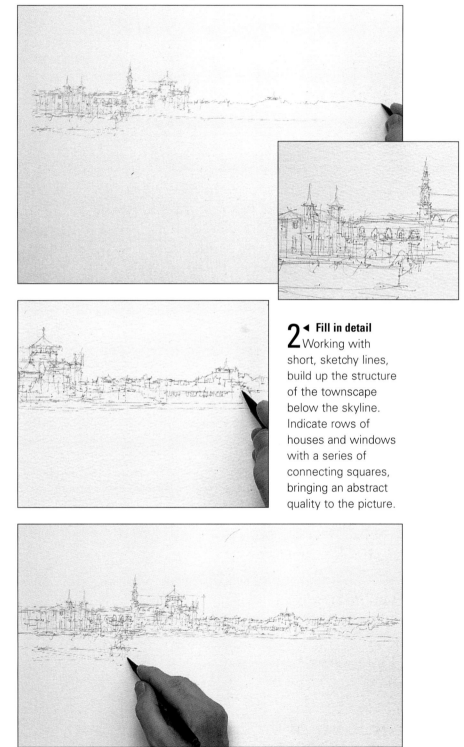

2 ◄ Fill in detail Working with short, sketchy lines, build up the structure of the townscape below the skyline. Indicate rows of houses and windows with a series of connecting squares, bringing an abstract quality to the picture.

3 ▲ Complete the skyline Continue working from left to right across the paper, adding detail to the skyline. Outline the trees just above the bridge. Then start work on the bridge itself, putting in the first of the arches and supporting buttresses.

4 ▼ **Draw the arches** Again working from left to right, draw the structure of the bridge, using the landmarks on the skyline as a guide to help you position each arch and buttress. Concentrate on correctly rendering the rounded tops of the arches – each arch should be slightly broader than the last, to give a sense of perspective (see Tricky perspective, page 1795).

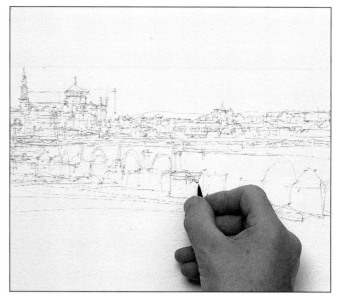

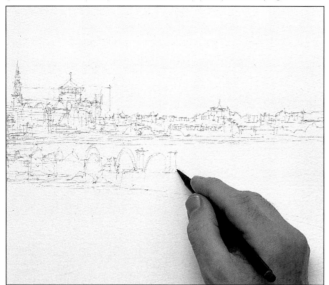

5 ▲ **Vary the weight of the pencil lines** Complete the arches and buttresses, then strengthen key areas, such as the central buttress, with heavier pencil lines. Roughly mark in the stonework along the top of the bridge. Lightly outline the hillside in the background and draw a few soft, broad lines at the base of the bridge, to suggest the water.

Master Strokes

Bernardo Bellotto (1720–80)
The Arno in Florence with the Ponte Vecchio

The architecture in this view of Florence is rendered in superb detail by Bellotto, a nephew of the Venetian master painter Canaletto (1697-1768). The scene is also full of human interest, inhabited by ordinary people going about their everyday business. A serene blue sky, taking up over half the picture space, forms a light backdrop to the more sombre tones of the townscape.

Scumbled layers of ochre and grey oil represent the weathered surface of old stone.

The arches of the bridge and their reflections form three slightly elongated circles that draw the eye to the centre of the painting.

The two colourful figures in the boat act as a bright focal point in the foreground.

DEVELOPING THE PICTURE

The main pencil work is now complete, and you are ready to start applying some watercolour washes – keep these well diluted.

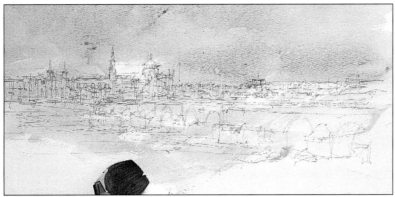

When you are laying down the washes over the bridge and water, there is no need to cover every bit of the paper. Lift the brush from time to time to leave some areas unpainted. This will lend light and shade to the composition.

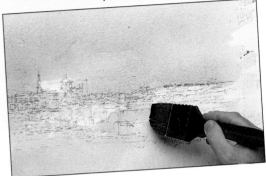

6 ▲ Apply the first washes Create a dilute violet wash from Prussian blue, alizarin crimson and yellow ochre. Be sure to make up a good supply of this mix as it will provide the basis for subsequent ones. Make another wash of yellow ochre. Using a 50mm (2in) flat brush, apply the violet wash across the sky and the yellow ochre wash across the horizon. Dip the brush into the violet wash again and paint lightly across the bridge and water.

7 ▶ Paint the church Using a No.3 round brush, fill in the church roof with yellow ochre with touches of the violet wash. Add more alizarin crimson and a touch of Prussian blue to make a darker brown. Fill in the right-hand end of the church, leaving some sections unpainted.

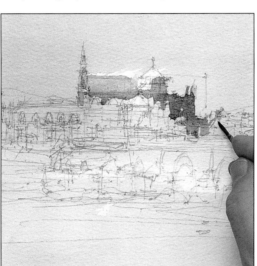

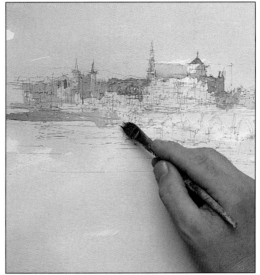

8 ▲ Paint more buildings Continuing with the same wash, work on the buildings to the left of the church. Add a little cadmium orange to the mix for the warmer colour on the far left. Mix the violet wash from step 6 with Prussian blue to make near-black and fill in the turrets and spires. Add more water to this mix and, with a 13mm (½in) flat brush, apply it over the river wall on the left.

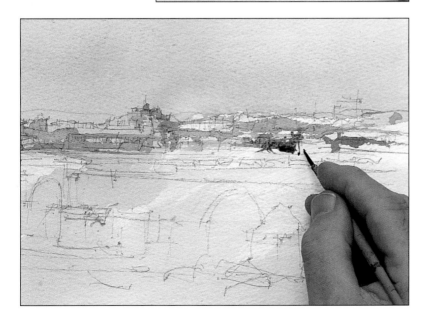

9 ◀ Fill in along the skyline Mix the violet wash from step 6 with a dab of Prussian blue. Using the No.3 brush, 'sketch' a few lines of colour across the townscape, leaving some areas unpainted. Add more Prussian blue to the mix and dab on just above the bridge.

10 ▼ **Add roof colours** Mix cadmium orange and some of the violet wash from step 6 and paint the roofs of the houses. Add a little Prussian blue to your mix to make khaki and fill in under the rooftops to soften any hard lines and create a sense of shadow. Next, mix Prussian blue with a touch of alizarin crimson and block in the hills above the town.

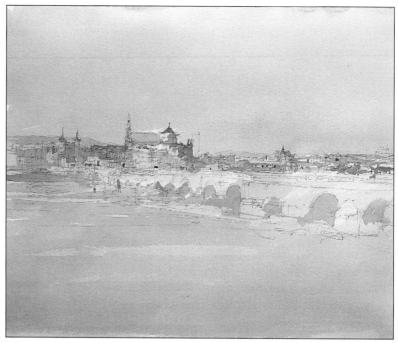

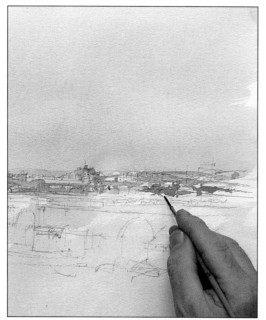

11 ▲ **Fill in the arches** Mix some of the violet wash with Hooker's green and, using a No.2 round brush, fill in the arch on the far right. Mix violet with yellow ochre to make taupe for the second, fourth and fifth arches. Paint the third arch with yellow ochre and the sixth with Hooker's green. For the remaining arches, combine the ochre and green. Finally, mix some of the taupe with Prussian blue and paint in some of the windows and doorways.

Express yourself

An imposing crescent

In this unusual composition of a grand Regency crescent in Bath, England, the intricacy of the buildings is offset by the large, empty area of green lawn in the foreground. The curved row of buildings cuts a bold line across the top of the paper, and the eye is drawn up to it by the railings coming in from the bottom right. The eye is eventually led to the exquisite greys, greens and browns of the autumn trees on the far left-hand side.

In this painting, the strength of the washes is more intense than in the step-by-step project, and the pencil work has been emphasised in places with black ink.

The architectural study is essentially complete, but strengthening some of the pencil lines will add density and reinforce the structures.

12 ▼ **Reinforce pencil lines** Pick up the HB pencil again and go over some of the buildings, where the colour washes have obscured the pencil lines. Strengthen the arches, the buttresses and the top of the bridge.

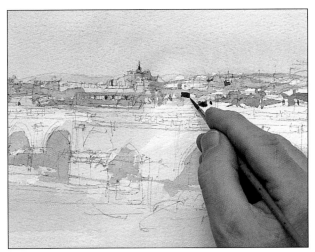

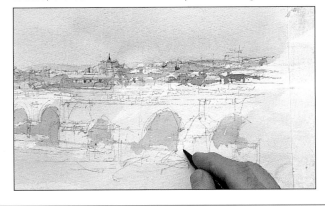

13 ▲ **Add orange highlights** Using the No.3 brush and cadmium orange, apply a few small blocks of colour in among the buildings where a door or window might be. This draws the eye in immediately, and sets off the subtle tonal variations overall.

THE FINISHED PICTURE

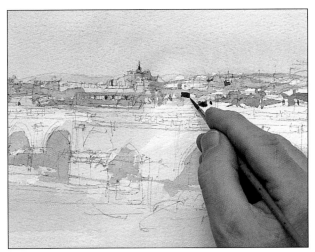

A Visible pencil lines
Sheer watercolour washes allow the interesting pencil work that describes the buildings to be clearly visible.

B Lively style
Unpainted areas of paper read as the light tones in the picture and lend a feeling of spontaneity and vitality.

C Tonal values
Most of the colour mixes in the painting are based on the main violet wash. This subtle approach creates a mood of harmony.

Leaving the subject behind

Sometimes a scene strongly suggests a particular treatment or interpretation. The cluster of old houses in this hill town lends itself perfectly to an abstract rendering.

This Italian hill town is certainly picturesque enough to be the subject of a figurative painting. But look at it again and you will see that it also has lots of potential for an abstract treatment. The apparently higgledy-piggledy mass of buildings is held together by the strong underlying repetition of the triangular roofs and rectangular walls, and this pattern-like quality is reinforced by the interlocking shapes of light and shadow on the buildings.

Abstracting from nature

Even if you have no particular interest in non-representational art, abstracting from nature can be a valuable exercise because it makes you more aware of the basic pictorial elements – shape, colour, pattern, texture and so on – and how they can be used to make an image work for you in a particular way. A scene like this one is ideal to start with because it is composed of simple geometric shapes. Or you might choose a landscape of fields, hedgerows and hills, which can be seen as a series of rhythmic shapes.

Significant shapes

When you are abstracting from a subject, you don't have to worry about whether your painting looks realistic; you can select the shapes, forms and colours which you see as the most significant and leave out the rest. Simplify, exaggerate or distort them in the interests of making an expressive statement and you'll soon find that you are 'leaving the subject behind'.

You may find it easier to work from a photograph as the image is already two-dimensional. A photo taken with a telephoto lens (like the one above) is good as space will appear compressed.

▶ **This painting fairly bursts with energy – an effect created through the use of simplified form and exaggerated colour.**

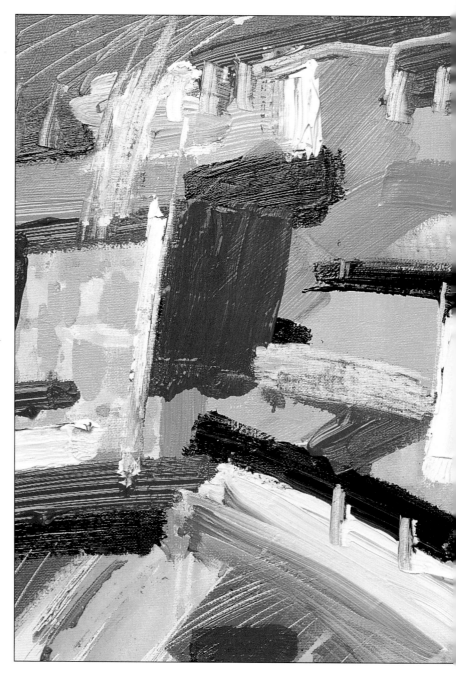

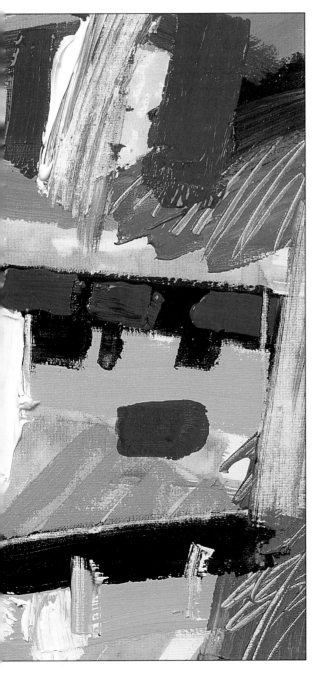

YOU WILL NEED

Canvas board 40 x 50cm (16 x 20in)	sienna; Ivory black; Violet
2B pencil	2 brushes: 25mm (1in) decorator's brush; No.10 long flat synthetic
White wax candle	
9 acrylic paints: Cadmium red; Bronze yellow; Emerald green; Cadmium orange; Yellow ochre; Titanium white; Raw	Jar of water
	Palette or dish
	Craft knife or penknife

A PROCESS OF ELIMINATION

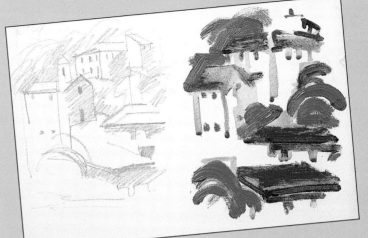

If you want to try an abstract treatment of a scene, it helps to make a simple drawing of the subject (above left). This will help you to identify the most significant shapes and tones. Then make a colour sketch (above right), working directly with the brush and reducing the scene to its bare essentials. When you start your painting, abstract the elements still further.

1 ▶ Apply some wax Sketch the outlines of the walls and rooftops with a 2B pencil. Use the wax-resist technique (see Creating highlights, p.983) to introduce texture and pattern to the image – hold a white wax candle like a pencil and scribble randomly with the tip over some of the roofs. Use the same method to suggest the brickwork on some of the walls.

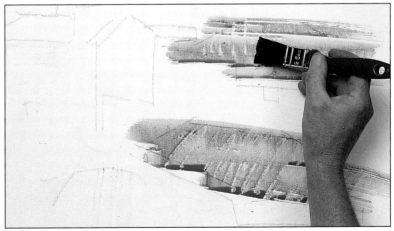

2 ▲ Paint the red roofs Mix a thin wash of cadmium red acrylic paint, and brush this over the red rooftops, using a 25mm (1in) decorator's brush. The colour will stain the canvas except where the waxy marks resist the watery paint.

3 ▼ **Start to paint the walls** Mix a thin wash of bronze yellow and apply this over the walls that you have marked with wax. Again, the wax resists the colour and suggests texture and pattern. Sweep the paint on quickly, letting it run down the canvas to form rills of darker tone that help to suggest the rough, weathered appearance of the ancient walls.

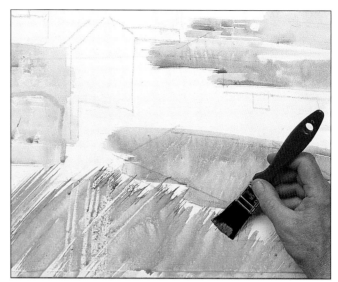

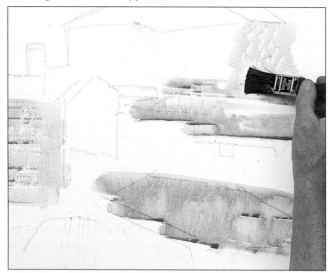

4 ▲ **Block in the foliage** With the wax candle, draw two or three swift diagonal lines across the foreground foliage area. Then mix a thin wash of emerald green acrylic and fill in this foreground area with sweeping diagonal strokes. Work quickly, leaving the edges of the strokes ragged. The wax-resist lines help to break up the solid colour.

DEVELOPING THE PAINTING

From now on you will be using thick, juicy paint. Work quickly and intuitively, breaking down the subject into simple flat shapes without blending or shading the colour.

5 ▶ **Paint more rooftops** Using a No.10 long flat brush, paint the rooftops at the top and left of the scene with broad strokes of cadmium orange, diluted with just a little water. With the paint that is left on the brush, dry-brush some diagonal strokes over the red rooftop.

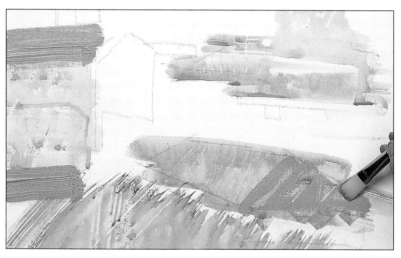

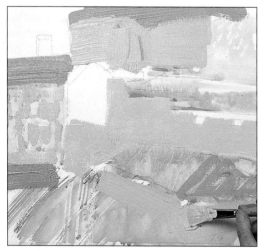

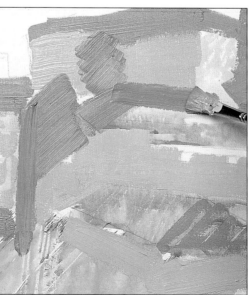

7 ◀ **Block in the dark tones** Use pure raw sienna acrylic to block in the walls of the buildings that are in shadow. Apply a thick mix of the paint, so that the marks of the brush show clearly.

6 ▲ **Block in the light tones** Mix a soft, creamy colour from yellow ochre and titanium white and apply it with thick, textured strokes over the light-struck walls of the houses. Keep thinking in terms of the patterns created in the photograph rather than attempting to create a realistic scene.

8 ▼ Paint the foliage areas Look for the trees peeping between the buildings and interpret them as simple blocks of colour, using pure emerald green. Work the brush in different directions to give movement to the shapes.

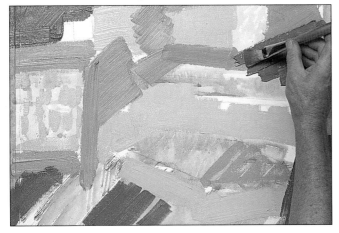

9 ▼ Use sgraffito for texture While the areas of green paint are still wet, use the sgraffito technique to create some texture and pattern – with the tip of a craft knife or penknife, work back to the bare canvas, making loose, scribbled marks.

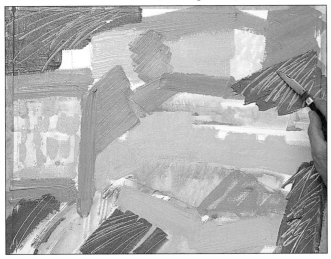

Express yourself
Tone alone

Here the artist has painted a similar Italian townscape, but with a different approach. He has eliminated colour altogether and reduced the subject to a series of light and dark shapes, using thin washes of burnt umber acrylic paint. Although the interpretation is very free, the artist has kept to the basic tonal values in the scene and added a few details such as windows and figures. The subject is easily recognisable as a town street, but there is – as in the step-by-step project – an enjoyment of brush strokes for their own sake.

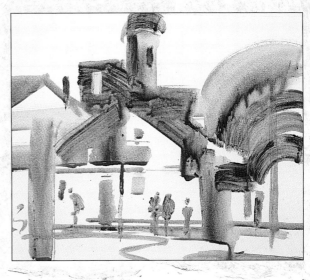

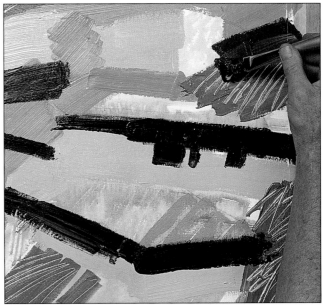

10 ▲ Paint the cast shadows Look for the deep shadows under the eaves of the houses and block these in simply with broad strokes of ivory black. Paint only the major shadows – if you introduce too many small marks, you will lose the impact of the statement.

235

11 ▼ **Introduce bright colour** Use pure, unmixed cadmium red to highlight the brightly lit parts of the red rooftops, once again using single strokes of colour to emphasise the pattern-like quality of the image.

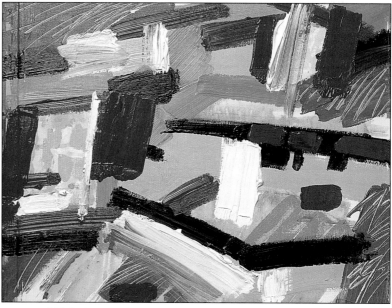

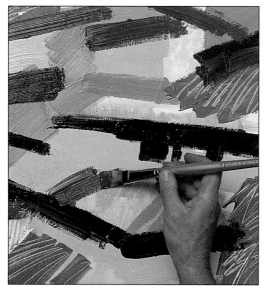

12 ▲ **Add shadows and highlights** Exaggerate the mid-toned shadows by painting them with strokes of pure violet. Then look for the areas of lightest tone in the image and block them in with strokes of pure titanium white. Apply the paint liberally against the adjacent colours.

Master Strokes
—⟨∞⟩—

Samuel John Peploe (1871–1935)
Kirkcudbright

Samuel John Peploe was one of the Scottish Colourists, whose work was influenced by French art at the beginning of the twentieth century. This scene of a small town in Scotland is characterised by bold handling of paint and a strong emphasis on the geometric shapes of the rooftops and house walls.

The pale houses are outlined with fine, dark brush strokes applied with quite dry paint. This softly defines them and delineates their features.

The contrast between the rooftops and the sides of the buildings creates a bold, slightly abstract tonal pattern in the bottom half of the painting.

The painting could be considered complete at this point. You have established a lively pattern and all that remains is to add a few details such as doors and windows.

13 ▶ **Use sgraffito again** Pick out the most prominent windows on the houses at the top and bottom of the picture and suggest them by scraping into the paint with the blunt edge of the craft knife or penknife to make short, vertical marks.

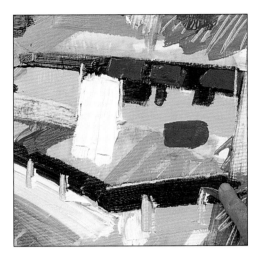

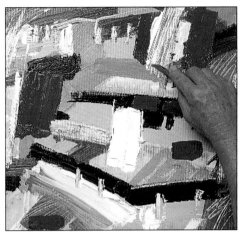

14 ▲ **Break up some shapes** To finish off, break up one or two of the bigger shapes by scraping into the paint with the edge of the knife blade. Use sweeping strokes, so that the colours mingle together.

THE FINISHED PICTURE

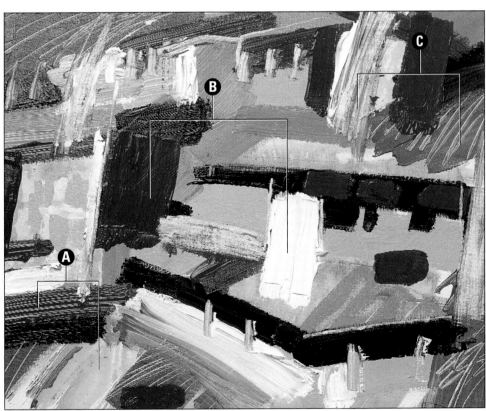

A Thick and thin
The contrast of thick impasto and thin washes creates textural variety and gives the painting a lively surface quality.

B Colour blocks
The subject is pared down to a series of simple block-like shapes made with individual brush strokes and strong colours.

C Sgraffito technique
A linear element is introduced by scratching and scraping into both the wet and dry areas of colour.

Rural view in pastel

Interpret this country scene in an individual way, using broad sweeps of bright pastel on textured paper.

Although it is best to work directly from the subject whenever you can, this is not always practical. You may be planning a painting that is too large to complete in one sitting or you might want to catch the fleeting effects of light in the landscape.

The camera is an invaluable tool, allowing you to record lots of information in a second. Working from a photograph, however, does have its drawbacks. Colours are rarely true, with shadows often appearing as completely black areas. You will also be restricted to viewpoints that might not be ideal.

Adapt the composition

The solution is to use a photograph merely as a starting point and be willing to create parts of the landscape or move elements around to suit your intended composition. In this photo, the foreground lacks interest. To remedy this, a larger area of field and extra fence-posts have been created, giving a livelier feel and retaining the eye within the picture.

Figures in a landscape are a useful device for adding interest and a sense of scale, but the ones in the photo are not very colourful. The artist decided to keep just one figure and reduce it to simple strokes of bright colour.

To complete the painting, Conté and soft pastels were used almost interchangeably – use whichever you have the right colours for. To help you, two soft pastels are given away with this issue.

▶ **The effectiveness of this landscape owes much to the artist's imagination.**

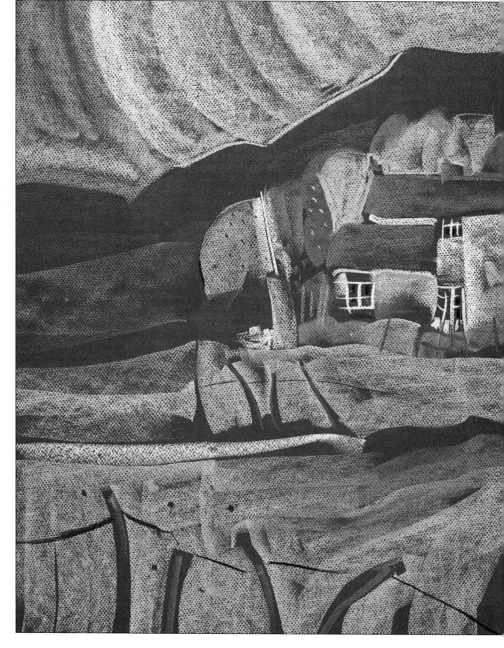

YOU WILL NEED

Piece of dark blue pastel paper
55 x 75cm (21½ x 29½in)

7 Conté pastels: White; Orange; Mid
green; Yellow-green; Light grey; Viridian;
Terracotta

15 soft pastels: Pale pink; Olive green;
Cadmium yellow; Raw sienna; Salmon
pink; Dark green; Lilac; Purple; Turquoise;
Payne's grey; Light green; Crimson; Light
blue-violet; Light blue; Mid blue

Charcoal pencil

Spray fixative

FIRST STEPS

1 ▶ Establish the focal point Use a white Conté pastel on its side to block in the front of the cottage, establishing the positions of the windows. Lay in the line of the roof with a broad sweep of orange Conté. A pale pink pastel gives the warm colour of the foreground building. Suggest the greenery on the right of the cottage with olive and mid green pastels.

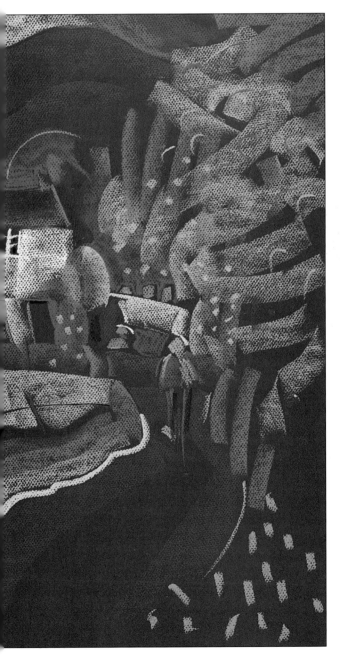

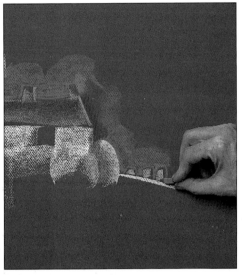

2 ◀ Build up foliage Scumble over the mid green bush with a yellow-green Conté pastel to show the sunlight falling on it. Mark a line of pale pink, then select a light grey stick to put in gravestones above it. Block in the background with viridian Conté, reserving an outline of blue paper around the stones to give them solidity.

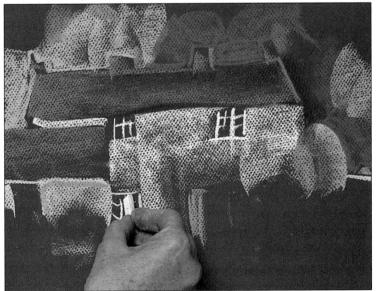

3 ▲ Draw the window frames Block in some yellow-green trees behind the cottage. Then draw in the window frames with the tip of the white Conté stick. Don't worry too much about architectural detail; aim to capture the overall impression of the cottage.

4 ▼ **Extend the greenery** Add more trees in the background, using viridian, mid green, cadmium yellow, raw sienna and yellow-green. A line of white indicates a telegraph pole. Mark the door uprights with salmon pink, warming up the brickwork with the same colour. Draw a brick wall to the left of the picture, using the side of a terracotta Conté stick and a vertical sweep of pale pink. Block in the hedge in front of the cottage in mid green and viridian, then use the yellow-green stick on its side to create the field, drawing around the fence-posts to create negative shapes.

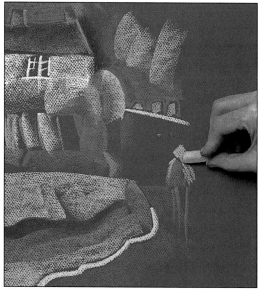

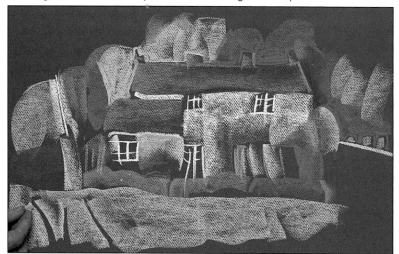

5 ▲ **Draw the figure** Use flowing strokes in dark green, viridian and yellow-green for the hedgerow. Achieve the dark tones on the road with lilac and purple pastels, edging them with pale pink. Begin on the figure, using cadmium yellow for the head, turquoise for the body.

Master Strokes
—⟨∞⟩—

Paul Gauguin (1848–1903)
Landscape at Pont-Aven

Gauguin painted this peaceful Impressionist landscape while he was living in Brittany. Each element in the composition is built up with lively strokes of oil paint in a wide range of greens, orange-browns and slate blues. These brilliantly convey the play of sunlight across the scene and also effectively suggest texture on areas such as the roof tiles and the cottage thatch.

The spire on the church provides a strong vertical element in the composition, leading the eye up from the middle ground towards the sky.

The contours of the land in the foreground are indicated with directional brush strokes that sweep outwards from the central hollow.

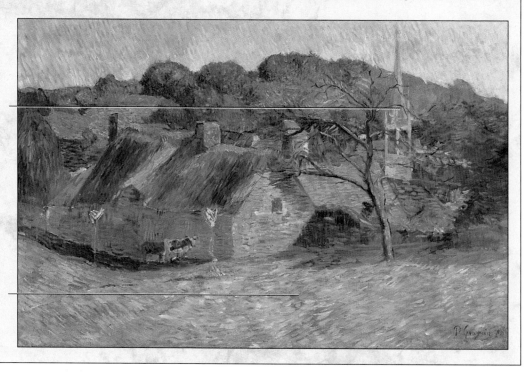

DEVELOPING THE PICTURE

Having established the central area of the composition, start extending the picture top and bottom to bring in the purple mountains and the green field. Build on the picture at the sides, too, using your imagination to work beyond the photo.

6 ▼ **Create the mountain peaks** Using the side of the purple pastel, begin blocking in the distant mountains with broad, continuous strokes. The top edge of the band of purple describes the outline of the mountain peaks against the sky.

7 ▲ **Add texture to the trees** Begin to suggest the trees on the right of the road with vertical strokes of mid green. Apply dabs of colour with a light green pastel stick to add a leafy texture to the trees.

8 ▼ **Introduce new colours** Sweep across the mountains with bands of Payne's grey pastel. Extend the wall to the left with pale pink and terracotta sticks, and create a bright line across the field with cadmium yellow. Now dot crimson and cadmium yellow over the trees.

EXPERT ADVICE
Adding black details

Although the blue paper forms a uniform dark tone across the painting, the deepest shadows benefit from a touch of black. A charcoal pencil is ideal to mark in small dark areas such as the windows and is useful for linear details such as the fence, too.

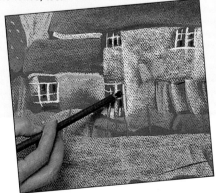

9 ▼ Draw the fence Outline the trees above the roof with strokes of yellow-green and highlight the chimneys with orange. Draw the fence-posts in purple inside the negative shapes left for them in step 4. Use the terracotta pastel to draw the gate.

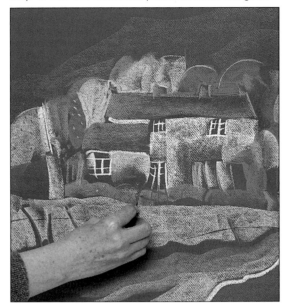

10 ▶ Build up the foliage texture Create a splash of colour in the garden on the right with patches of turquoise, orange, purple and Payne's grey, blocking in the walls on either side with pale pink and salmon pink. Add texture and interest to the foliage on the right with thin curls of colour in yellow-green and mid green.

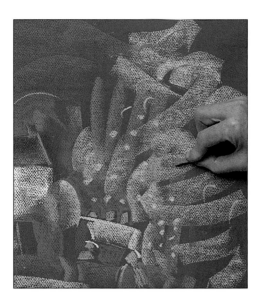

Express yourself
Five-minute sketch

In this picture, the artist has used the same pastel technique used in the step-by-step to capture a different scene. Here, the artist could have used the church tower as a focal point but instead the eye is directed to the graveyard – in particular, to the cross and the bright red hut. The tree and the tower help this movement by serving as a frame within a frame. Note how the shape of the tree is pleasingly echoed by the strokes of blue used for the sky.

11 ▲ Revise the composition To prevent the eye from travelling off the bottom left of the paper, add some foreground interest to retain it. Block in yellow-green grass, leaving negative spaces to form fence-posts. Draw these in salmon pink with pale pink highlights.

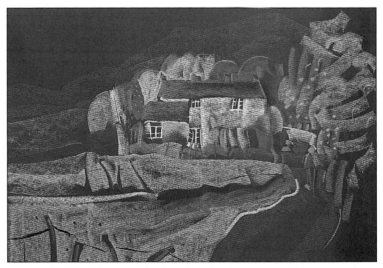

12 ▲ Apply bright spots of colour Dot in crimson poppies across the field to add some spots of high colour. Draw a line of crimson on the figure to catch the eye on the right of the painting.

242

Once the landscape is complete, create a lively sky with broad bands of colour applied with the side of the pastel. Try being a little more flamboyant by dotting some bright flowers across the picture.

13▶ Paint a rolling sky
Sweep bands of light blue-violet and light green across the sky, outlining the edge of the mountain with light green.

14▲ Create focal points
Add a block of cadmium yellow to the left of the telegraph pole and apply some dots of purple and light blue to the trees and fields. Spray the entire picture with fixative.

THE FINISHED PICTURE

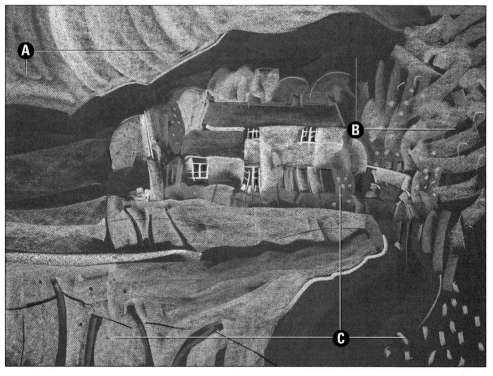

A Defining the mountains
The bands of turquoise and mid blue add definition to the far mountains on the right and help this area of the painting to recede into the background.

B Creating depth
These dots and dashes of rich purple pastel create a sense of shadowy depth in the trees. The marks also effectively echo the colour of the mountain range in the background.

C Adding interest
Short strokes of light blue create interest in the foreground, which would otherwise be flat and dull. The same colour is used in the field and in front of the cottage to carry the eye round the picture.

Wild West landscape

Use the intense colours and versatile textural qualities of acrylic paints to capture the drama of one of nature's most breathtaking landscapes.

This magnificent landscape, with its combination of desert and red rock formations, lies near Sedona in northern Arizona. Native Americans view it as a sacred centre of the southwest, a point where spiritual power and extraordinary natural beauty converge.

Depth and texture

For a painter, there are two main issues to consider when trying to portray on canvas this huge expanse of desert. The first is how best to convey the sense of depth in the vast landscape, which encompasses shrubs in the foreground, rock formations in the middle distance, and mountains as far away as the eye can see. The second consideration is how to differentiate the wide range of textures, from clear blue sky to spiky bushes and trees to craggy, broken rock.

Making your mark

To achieve a feeling of depth, make use of the effects of aerial perspective, in which colours in the foreground appear warmer and stronger than those in the far distance. Here, reddish tones near the base of the picture make the foreground appear to advance while cool blue-greys along the horizon make the mountains recede.

In order to create a range of textures, vary the way you apply the paint, using a combination of brushes and the painting knives given away with this issue. The sky texture is achieved with the flat of a knife, since this allows you to apply paint quickly and evenly. The spiky shrubs and broken rock can be depicted by jabbing with the tip of a brush or using the tip or edge of a knife. Practise making different marks with each to see which works best for each texture.

▶ **This picture is worked directly in acrylic paint without any preliminary drawing. Lively gestural marks give it a feeling of immediacy.**

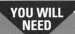

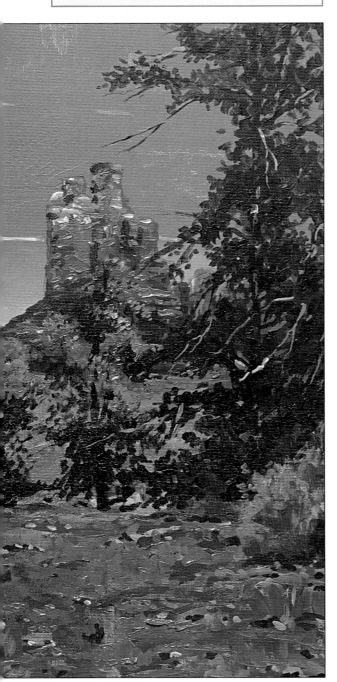

Primed canvas board 46 x 61cm (18 x 24in)	um yellow medium
2B pencil; ruler	Two painting knives: Long, narrow shape; Trowel shape
9 acrylic paints: Cerulean blue; Titanium white; Dioxazine purple; Cobalt blue;	Brushes: 10mm (³⁄₈in) hog's hair flat; Nos.4 and 2 synthetic rounds
Sap green; Raw sienna; Vermilion; Yellow ochre; Cadmi-	Acrylic gel medium Paper tissue

FIRST STEPS

1 ▼ Block in the sky Using a 2B pencil, rule a rectangle on the canvas board just in from the edges. Mix cerulean blue and titanium white plus a little dioxazine purple to make a thick paste. With a long, narrow painting knife, block in the sky, smoothing out the paint as you go.

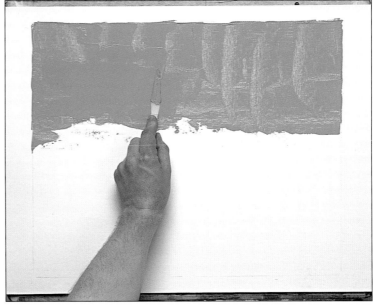

2 ▼ Graduate the colour With a 10mm (³⁄₈in) hog's hair flat brush, paint a strip of white just below the blue area. Blend the colours together with the long, narrow painting knife, so that the sky gets lighter towards the bottom.

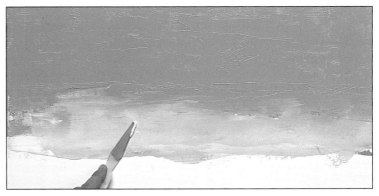

3 ◄ Build up a sense of perspective To create the hazy grey-green of the distant mountains on the left, mix some cobalt blue with sap green and white. (Cobalt blue is a cooler blue than cerulean blue and so is good for creating shadows.) Change to a trowel-shaped knife and block in the shapes of the mountains.

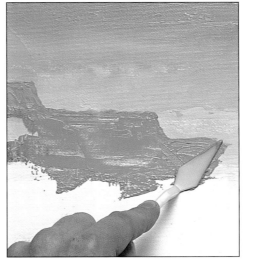

4 ▼ Block in the desert rocks To create a pink shade for the scrubby land in the foreground and the rock formation in the distance, combine raw sienna with some vermilion, yellow ochre and white, mixing up enough to cover the whole area. With the long, narrow painting knife, block in the foreground. Change to a No.4 round brush and 'draw' the outline of the rock formation.

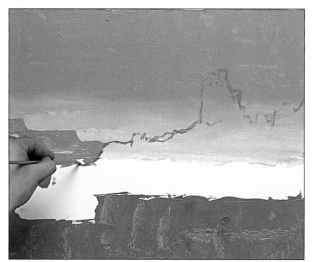

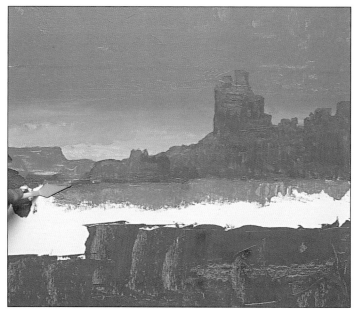

5 ▲ Create the middle distance Block in the rocks with the pink shade, using the long, narrow knife. For the vegetation, mix sap green and cerulean blue. Use the trowel-shaped knife to start filling in the areas of green, starting from the top.

Master Strokes

Thomas Moran (1837–1926)
The Grand Canyon of the Yellowstone

This dramatic oil painting shows the awe-inspiring landscape of Yellowstone in the state of Wyoming in the USA. It was painted in 1872, the same year that Yellowstone became a national park.

The strong, symmetrical composition is based on two dark triangles enclosing a pale, inverted triangle in the centre. This contrast of colour and tone adds to the impact of the scene.

The eye is pulled towards the warm golden hues of the central triangle. Various textures of the rock faces are meticulously described here, from the dark brown crag heavily veined in white to the rough, pitted surface of the grey rocks. Distant rocks are painted more softly in order to create a convincing feeling of depth.

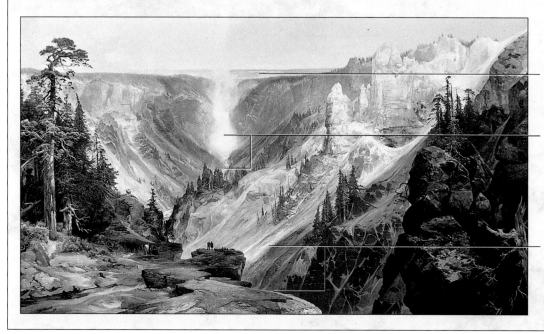

Cool, hazy colour in the distance shows aerial perspective at work, giving an illusion of depth.

The white spray of the waterfall and the blue water of the river provide focal points among the warm rock tones.

The composition is based around strong diagonals that help add to the drama of the subject matter.

DEVELOPING THE PICTURE

Most of the background area is in place and you can now start working on the details. The sense of perspective already created in step 3 can be exaggerated by adding highlights and shadows.

6 ▼ Start on the detail Add raw sienna and white to the pink mixed in step 4. Use the No.4 round in short strokes along the base of the mountain and at the top to describe patches of light.

7 ▼ Foreground interest The bush on the left forms a focal point for the eye. Block it in roughly using the hog's hair flat brush and a mixture of cerulean blue and cadmium yellow medium. While this dries, move on to the expanse of rocky ground at the front. With the trowel knife, scumble some pink – a mix of white with a touch of vermilion – on to this area, working it into the darker pink.

To create an entirely different mood, the artist rendered the same landscape in coloured pencils. Unlike the step-by-step project, this is an initial, spontaneous response to the subject – the lively scribbled pencil marks inject a sense of life, as does the play of warm oranges against the cooler greens.

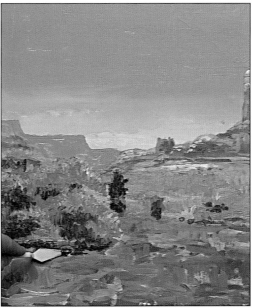

8 ▲ Add lights and darks Continue working on the left-hand bush, using the flat brush and the cerulean blue/cadmium yellow medium mix. With the trowel-shaped knife, scumble a mix of white and vermilion on to the foreground. Build up texture on the foliage with a clean trowel knife. For the light areas, add more cadmium yellow medium to the green mix, and cobalt blue and dioxazine purple for the dark ones.

9 ▼ **Add shadows to the rock face** Mix dioxazine purple and vermilion for the darker areas on the rock face. Apply this with a No.2 round brush, using short, horizontal strokes that follow the layered formation of the rocks.

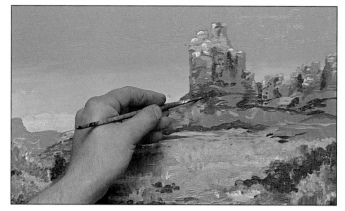

10 ▶ **Paint the tall tree** Continuing with the dark mix from step 9, dab flecks of texture on to the foreground. Then dab on highlights here with a very pale pink made from white with vermilion and cadmium yellow medium. Describe the tree-trunk with a dark mix of dioxazine purple, cobalt blue and sap green, using the tip of the No.2 brush.

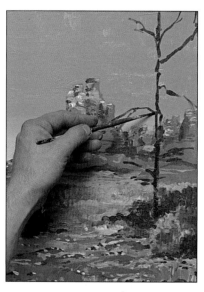

11 ▼ **Add more trees** Paint in two more bare trees, as in step 10. Add the dead branch lying beside the left-hand bush, highlighting it with the very pale pink mix from step 10. Mix sap green and purple with acrylic gel medium and dab leaves on to the tall tree (see Expert Advice, above right).

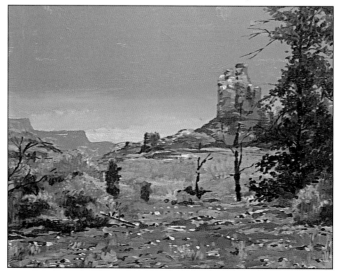

EXPERT ADVICE
Thickening the paint

Acrylic paints have a tendency to look rather flat, but you can alter their appearance by mixing in some acrylic gel medium. The gel thickens the paint and makes it slightly shinier, so is ideal when you come to paint the leaves. Add a little gel medium to your leaf mix and dab on with the No.2 brush.

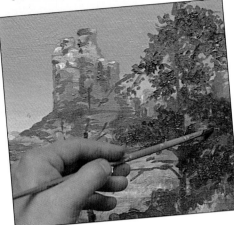

A FEW STEPS FURTHER

It's always difficult to know when to stop working. Here, the composition looks fine as it is, but, equally, it could benefit from some extra detail to add visual interest.

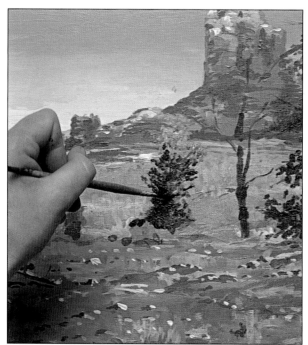

12 ▲ **Build up the trees** The twiggy growths at the centre of the picture seem rather bare and two-dimensional. Using the No.2 brush, build them up with light and dark leaves – yellow ochre and sap green for the lights, sap green and purple for the darks.

13 ▼ **Put in more highlights** The desert sun is strong, creating dark shadows and bright, reflected lights. Still working on the trees, pick out some of the branches on the right with very pale pink highlights.

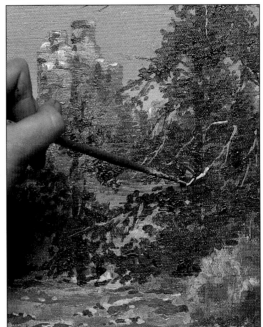

14 ▲ **Paint vapour trails** In the inspiration photo, the sky is a piercing blue – almost too perfect to be believable. This is where you can use a little artistic licence. Paint some fine lines of white across the sky and then smudge them with a paper tissue. These 'vapour trails' add visual interest and make the sky seem more real.

THE FINISHED PICTURE

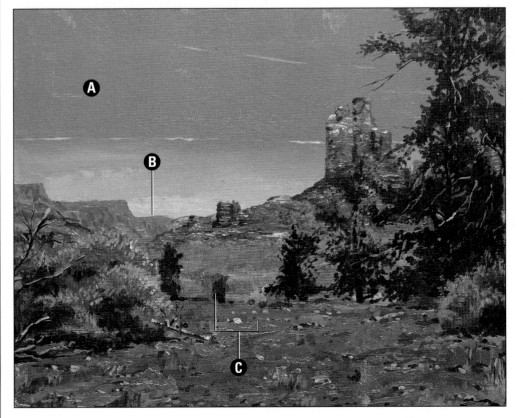

A Smooth texture
Working with a painting knife allows you to cover large areas quickly, as in the flat expanse of the sky.

B Hazy distance
A sense of recession was created by the use of blue-greys along the horizon, making the mountains seem many miles away.

C Contrasting colours
The use of complementary colours – the pinks of the earth against the green shrubs – adds to the vibrancy of the picture.

Picture postcards

Blank postcards made of watercolour paper are a great addition to a holiday painting kit – use them to send a unique record of your travels to your friends.

There is a long tradition of artists sending personalised, decorated correspondence. For example, artists such as Marcel Duchamp (1887–1968) and Kurt Schwitters (1887–1948) created individual picture postcards which they sent to friends and relatives. Why not follow in their footsteps, using the watercolour postcards given away with this issue?

Holiday postcards

A holiday away from home is a good time to try painting your own postcards, as you'll have plenty of inspiring material to work from. The challenge is to produce an image that works on a small scale – the postcards that come with this issue measure 10.5 x 15cm (4 x 6in). The secret lies in the composition – if you underpin the painting with a good, simple line drawing, you will produce an image that engages the viewer.

Working methods

To help you find a suitable composition, half-close your eyes and look at how lights and darks are distributed across the subject. See, too, if you can find interesting divisions or repeated shapes in the scene. Some thumbnail sketches will help you explore the possibilities.

▲ **A combination of pencil, oil pastel and watercolour on postcard-sized watercolour paper gives impressive results quickly.**

When working on location, you'll need a portable kit. The combination of pencil, watercolour and oil pastel used for the two step-by-steps shown on the following pages is simple but effective.

The pencil is used to make fluent, calligraphic marks that contribute to the final image rather than just plotting where the washes should go. Water-colour is a flexible medium that can be used for broad washes of transparent colour or for quite controlled detail. A

small box of pan watercolours is ideal for the travelling artist, as it is light and the colours can be accessed directly. Tube colours are more cumbersome – using them involves deciding which colours you need, fiddling with lids and then squeezing out blobs of paint (some of which you may choose not to use after all).

Sticks of oil pastel are portable and produce solid patches of vibrant colour as well as line. These solid areas contrast with the transparency of the watercolour. Also, because oil and watercolour are incompatible, the oil pastel is unaffected by subsequent washes.

Because of its waxy quality, white oil pastel can be used as a form of resist –

you can put it down on any areas of your painting that should read as white. You can then apply watercolour washes quite freely over the top. This method was used to retain the white windows on the building in the scene below. White oil pastel is more convenient than masking fluid, so is a useful addition to your travel kit.

YOU WILL NEED

Watercolour paper postcard 10.5 x 15cm (4 x 6in)

3B pencil

8 watercolours: Cerulean blue; Cobalt blue; Phthalo blue; Ivory black; Yellow ochre;

Alizarin crimson; Cadmium yellow; Cadmium red

4 oil pastels: White; Burnt orange; Scarlet; Crimson

Brushes: Nos.12 and 3 rounds

PROJECT 1

PLAZA MAYOR, MADRID

A café table gives you a ringside seat from which to watch the world go by and discreetly make a record of the scene. Give the image structure by simplifying the architecture and emphasising colours and shapes in the foreground.

1 ▶ Make a drawing Using a 3B pencil, plot the key verticals and horizontals, then add the chairs and tables in the foreground to give a sense of scale and depth. Work rapidly with fluent lines that give the drawing a sense of immediacy. Indicate the shadows within the arcade around the square.

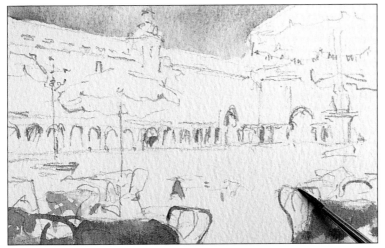

2 ▲ Lay in the sky Mix a pale wash of cerulean blue and cobalt blue and apply to the sky with a No.12 round brush. Use phthalo blue for the table on the left and add a little ivory black for the table on the right. Describe the curving chair-backs with the tip of a No.3 brush.

3 ▲ Paint the buildings Using the No.12 brush, mix yellow ochre, cobalt blue and alizarin crimson for the pale grey of the roofs, pavement and arcade. By adjusting the proportions of each colour, you can create subtle shifts in tone.

4 ▶ Apply oil pastel
Use a white oil pastel as a resist for the windows on the buildings – you can then wash over the façade without any fiddly brushwork. Dab colourful touches of burnt orange, scarlet and crimson oil pastel on to the parasols and the tables.

▲ The shades of maroon and brown used for the parasols are mixed from cadmium yellow, cadmium red, alizarin crimson and phthalo blue.

5 ▼ Paint the parasols For the orange parasols, mix cadmium yellow and cadmium red watercolour; apply with the No.3 round. For the undersides and darker parasols, make various mixes of phthalo blue, alizarin crimson, cadmium red and cadmium yellow. Use a dilute mix for the building's façade. Mix phthalo blue and black to make a grey for the shadowy arcade.

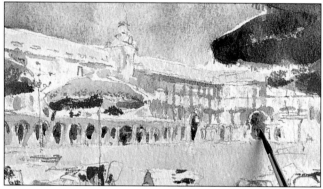

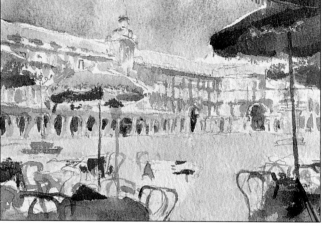

6 ▲ Add details Use the grey mix for the lamppost. Combine phthalo blue with alizarin crimson and wash over the shadow on the façade. Use the same colour and the reddish mixes from step 5 for linear details on the chair-backs and umbrella poles.

THE FINISHED PICTURE

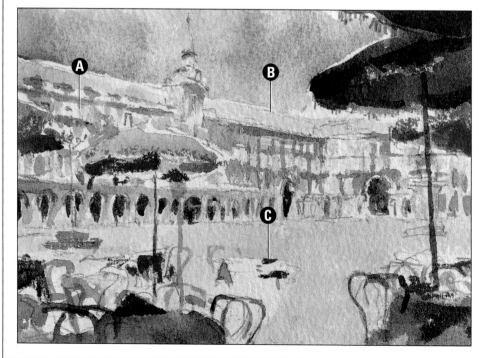

A White pastel resist
To avoid fiddly brushwork on the façade of the building, white oil pastel was worked over the windows in order to resist the watercolour wash.

B Lively pencil lines
A lively, fluent pencil line holds the image together and complements the loose painting style.

C Bright oil pastel
Emphatic touches of brightly coloured oil pastel add emphasis to the foreground, and encourage the viewer's eyes to dance across the foreground.

PROJECT 2

CHATEAU DE CHENONCEAUX, LOIRE

The turrets of the French château of Chenonceaux looming over the surrounding waters make a romantic subject that cries out to be painted. The soaring verticals of the towers pierce the broad triangle of the sky, while the dark water below provides visual stability.

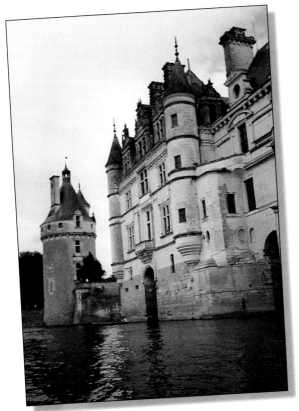

1 ▶ Make a drawing
Using a 3B pencil, make a drawing of the château. Start with the line of the water's edge and some other key perspective lines such as decorative bands along the façade. Where these curve around the towers, they help to describe their cylindrical forms. All these perspective lines should meet at a single vanishing point which, in this case, is beyond the picture area. Plot the verticals of the towers and check proportions and angles with your pencil at arm's length.

2 ▶ Add oil pastel Using yellow ochre, burnt sienna and black oil pastels, touch in small areas of colour on the façade of the building, echoed by reflections in the surface of the water. With blue and grey oil pastels, add the cool shadows on the slate-covered roofs.

▲ **Mixes of yellow ochre, alizarin crimson, cobalt blue and raw umber provide browns and greys for the château walls and their reflections.**

3 ▶ Apply a wash Mix a wash of yellow ochre watercolour with a touch of alizarin crimson. Using a No.12 round brush, loosely apply this ochre wash over the façade of the building to suggest the weathered character of the masonry. The tiny touches of opaque oil pastel applied in step 2 resist the watercolour, creating areas of lively, broken colour.

Express yourself
People in the picture

Holidays are as much about people as places, so give your postcard a personal touch by including family members or new friends in the scene. This card shows a different view of the château at Chenonceaux, with a rowing boat on the lake adding foreground interest. It was quickly and loosely sketched on the spot in pen and black ink and then watercolour washes were added later – a useful method of working if you don't want to take too many art materials out with you. The boat – the focal point of the scene – has been emphasised by the pink band around it.

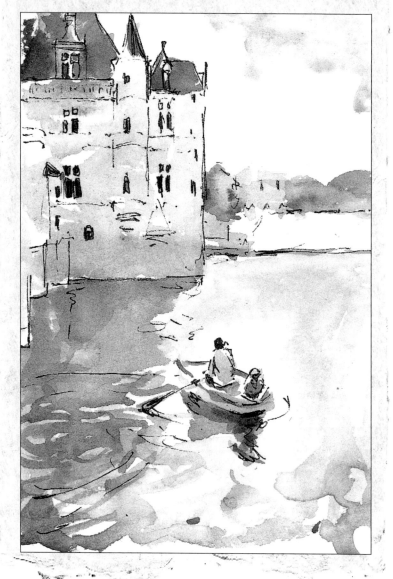

4 ▼ Paint the water Take the ochre mix from step 3 down into the water to show the reflected façade of the château, but leave parts of the paper white to suggest reflected clouds. Mix a raw umber and cobalt blue wash and paint on to the water to represent the darker reflections. Leave to dry.

5 ▼ Paint the roof Use a darker tone of the warm ochre mix to define the architectural details on the façade. Apply the same wash over the furthest tower. Mix cobalt blue and a touch of alizarin crimson watercolour for the slate roofs, taking some of the colour into the window openings.

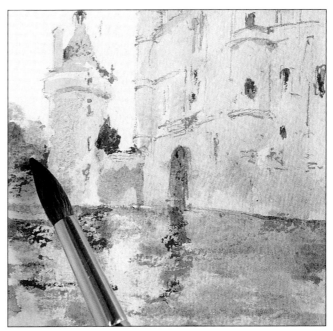

6 ▲ Add the trees The small clump of trees on the left is an important focus, drawing the eye through the painting. Apply touches of green oil pastel followed by a wash of raw umber and phthalo blue watercolour.

Master Strokes

Canaletto (1697–1768)
Dolo on the Brenta, with Church of St. Rocco

The Italian artist Canaletto is the supreme master of eighteenth-century scenic townscapes. His sweeping vistas of buildings stretching along the banks of canals or rivers are not only meticulous representations of the architecture but also show people going about their everyday business. In stark contrast to the rather impressionistic studies in the two step-by-step projects, this large canvas is worked in oil, painted with precision and packed full of details.

The white part of the main cloud is painted with impasto brushwork while the grey areas are created by applying a thin glaze over the blue of the sky.

Our eye is led into the picture by the curved river bank, taking us past the church and on to the rose-coloured buildings in the distance.

Simply depicted figures strolling along the river bank create a sense of bustle in the foreground. Our eye jumps from figure to figure as it travels along the river bank.

7 ▼ Lay in the sky Using the No.12 brush, apply a dilute wash of cerulean blue watercolour across the sky – work loosely, leaving large patches of white for the clouds.

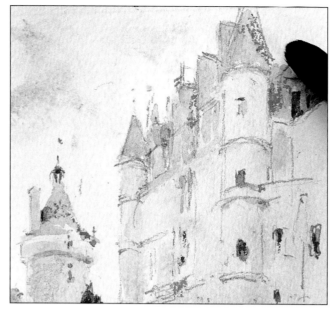

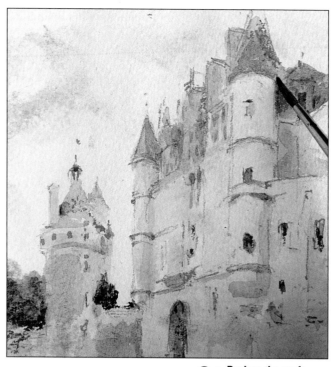

8 ▲ Darken the roofs Use a No.3 round brush and a mix of yellow ochre, alizarin crimson and raw umber to add more details to the building: the windows and the shadows down the sides of the towers. Using the cobalt blue/ alizarin crimson mix from step 5, add darker tones on the shaded roof areas.

THE FINISHED PICTURE

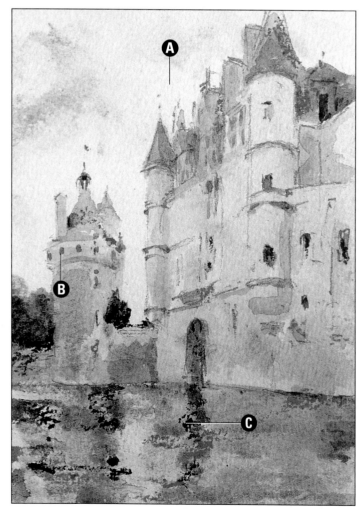

A Paper clouds
In the sky area, most of the white paper was left unpainted to stand for the fluffy summer clouds.

B Economic marks
A dark wash, dabbed on with the tip of a No.3 round brush, depicts with great economy window openings around the tower.

C Emphatic oil pastel
Streaks of black oil pastel were used to show reflections in the water. These opaque touches contrast with the transparent watercolour washes.